D0882424

MAPPING BEYOND MEASURE

**Cultural Geographies
+ Rewriting the Earth**

Series Editors

Paul Kingsbury, Simon Fraser University

Arun Saldanha, University of Minnesota

MAPPING BEYOND MEASURE

Art, Cartography, and the
Space of Global Modernity

Simon Ferdinand

University of Nebraska Press | Lincoln

© 2019 by the Board of Regents of the
University of Nebraska

Ackknowledgments for the use of copyrighted
material appear on pages xiii–xiv, which constitute
an extension of the copyright page.

All rights reserved

Library of Congress
Cataloging-in-Publication Data
Names: Ferdinand, Simon, author.
Title: Mapping beyond measure : art,
cartography, and the space of global
modernity / Simon Ferdinand.
Description: Lincoln: University of Nebraska Press,
2019. | Series: Cultural geographies + rewriting the
Earth | Based on the author's thesis (doctoral—
University of Amsterdam, 2017). | Includes
bibliographical references and index.
Identifiers: LCCN 2019003673
ISBN 9781496212115 (cloth: alk. paper)
ISBN 978149621758-5 (paper: alk. paper)
ISBN 9781496217882 (epub)
ISBN 9781496217899 (mobi)
ISBN 9781496217905 (pdf)
Subjects: LCSH: Maps in art. |
Cartography in art. | Cultural geography.
Classification: LCC N8222.M375 F47 2019 |
DDC 526—dc23
LC record available at
https://lccn.loc.gov/2019003673

Designed and set in Minion Pro by L. Auten.

Contents

Figures

Acknowledgments

This study of mapping and art has a geography of its own. Over six years and in several countries, a number of people have offered me their collegiality, friendship, and support, and I owe them a huge debt of thanks. The project was first conceived in 2011 while teaching in the History of Art department and completing an MRes dissertation at the University of Warwick. My initial conception of the book improved greatly thanks to the advice of my MRes supervisors, Daniel Katz and Margaret Shewring, as well as the more general guidance of Nicolas Whybrow and Nadine Holdsworth at the Theatre and Performance Studies department.

Mapping Beyond Measure stems from six years of work undertaken at the University of Amsterdam. I am grateful to Christoph Lindner for his initiative in securing my fellowship in Amsterdam in spring 2012. During the fellowship, I felt privileged to be part of the vibrant interdisciplinary research cultures of the Amsterdam School for Cultural Analysis (ASCA) and Amsterdam Centre for Globalization Studies (ACGS). The community of PhDs and more senior scholars transformed the potentially lonely process of writing into a shared and sociable experience. Thanks to Selçuk Balamir, Luiza Bialasiewicz, Britt Broekhaus, Adam Chambers, Andrés Ibarra Cordero, Erin la Cour, Karin Christof, Nadia Desscher, Zoénie Liwen Deng, Joe van der Eerden, Alejandra Espinosa, Moosje Goosen, Penn Ip, Aylin Kuryel, Josip Kesic, Tijmen Klaus, Halbe Kuipers, Asli Ozgen-Tuncer, Nur Ozgenalp, Flora Lysen, Geli Mademli, Niall Martin, Juan David Montoya Alzate, Paulo Nunes, Jeffrey Pijpers, Alexandre Poulin, Federico Savini, Rik Spanjers, Mikki Stelder, Robert Steltenpool, Hanneke Stuit, Margaret Tali, Birkan Tas, Vesna Vravnik, Thijs Witty, and Tim Yaczo, without whom the ASCA's seminars would hardly have been so stimulating, its offices so relaxed,

nor its *borrels* so fun. My desk mate, Peyman Amiri, has been unfailingly humorous and collegial, Melle Kromhout a great support (not least in developing this project into this monograph), Lara Mazurski a constant source of encouragement (especially in inviting me present developing ideas to her classes), and Lucy van de Wiel a model of optimism. I shall not forget Irina Souch's warmth and encouragement, Blandine Joret's verve and rooftop parties, nor Nathan van Kleij's indefatigable cheeriness. Whether in plowing the lanes of the Zuiderbad, discussing our intellectual (and other) quests, or cementing the larger group of *promovendi*, Irene Villaescusa has been a constant companion and coconspirator, not least in working together on our conference and edited book, *Other Globes: Past and Peripheral Imaginations of Globalization*. I very much enjoyed coorganizing the annual ASCA workshop in 2014 along with Artyom Anikin, Uzma Ansari, and Annelies Kleinherenbrink (aided greatly by Eloe Kingma and Jantine van Gogh at the ASCA office). Thanks especially to Annelies and her husband Sander for their friendship in recent years. As I have moved beyond the PhD stage, Mieke Bal and Harriet Hawkins have provided indispensable guidance and support.

The triumvirate at the heart of the ASCA's Cities Project—Pedram Dibazar, Miriam Meißner, and Judith Naeff—have been especially collegial and inspiring during the process of research. Both at the ASCA and subsequently while lecturing together at Amsterdam University College, Pedram's personal and intellectual fellowship has been invaluable. Since the start of my time at ASCA, and now from Lancaster and Maastricht, Miriam, for whose warmth and friendliness I am deeply grateful, has been a great support. I am similarly thankful to Judith for her energy and generosity, not least in allowing me to descend with tourists on her picturesque canal-side home.

Beyond the ranks of ASCA, I would like to thank the transient but close community of researchers with whom I lived on IJburg for their companionship and support: thanks to Hideki Kakita for his late-night postmodern musings, Effrosyni Mitsopoulou and Quentin Perrenoud for their friendship, Lutz Hofer for his *gezelligheid*, and especially Andrei Barcaru for his irony and good humor. Having befriended Milou van Hout on IJburg, I am glad that we are now colleagues at the university too. I have

enjoyed the messages, visits, and support of British friends, particularly Catherine Allen, Peter Atkinson, Gwilym Lawrence, Robert Paterson, and Rachel Robson. Even from the distances of Sheffield and Japan, Gwilym and Robert's friendship has been as important as ever. My family has been still another crucial source of support: thanks to my brother Joe, parents Helen and Paul, and the wider family for their encouragement throughout.

I am beholden to my mentor, Jeroen de Kloet, who brought his characteristic good humor to the process of helping me write this book. Jeroen's confidence in this project, and thoughtful advice, have been hugely important, and I am also grateful for his generosity in inviting me to participate in the opening, seminars, and wider program of the ACGS from the beginning of my time in Amsterdam. I can scarcely envisage bringing this project to a successful completion without the commitment, rigor, and trust of my other mentor, Esther Peeren. From my initial interview onward, her enthusiasm and doggedness have been indispensable not just in forming this book, but in guiding my academic pursuits more generally. Esther's support has transcended supervision to encompass something much more holistic and formative; to her I give tremendous thanks. I owe huge gratitude to my wife Suzanne Vonk, who, during the course of this research, has shared her home and love with me. Thanks to her and her family, David, Milan, Ronald, and Yvonne.

The book has benefited greatly from the feedback I have received on presentations to numerous different conferences, seminars, and workshops. Thanks to the organizers of these events, and to my interlocutors for their comments on my developing ideas. Versions of parts of chapters in this study have previously appeared in the following publications:

Chapter 1: "The Shock of the Whole: Phenomenologies of Global Mapping in Solomon Nikritin's *The Old and the New*," in *GeoHumanities* 2, no.1 (2016): 220–37.

Chapter 3: "Drawing Like a State: Maps, Modernity, and Warfare in the Art of Gert Jan Kocken," in *Environment and Planning D: Society and Space* 35, no. 2 (2017): 319–38.

Chapter 6: "Cartography at Ground Level: Spectrality and Streets in Jeremy Wood's *My Ghost* and *Meridians*." In *Visualizing the Street: New Practices of Documenting, Navigating, and Imagining the City*, edited by Judith Naeff and Pedram Dibazar, 137–59. Amsterdam: Amsterdam University Press, 2018.

Thanks to the editors of these publications—Deborah Cowen, Pedram Dibazar, Deborah Dixon, Judith Naeff, and Natalie Oswin—and to five anonymous reviewers for their time and feedback, which has fed into this study. I am also grateful to two anonymous reviewers of this book for prompting me to expand upon the work's methodology, sharpen several key arguments, and develop some latent themes. Thank you to Alison Hildreth (and her obliging assistants, Alina Gallo and Carter Shappy), Gert Jan Kocken, Satomi Matoba, and Jeremy Wood, for valuable discussions about their map art and or providing me with images of their work. Lastly, I am grateful to series editors Paul Kingsbury and Arun Saldanha for discussing this project early on in the process of publication, Emily Shelton for copyediting the manuscript so punctiliously, and to Ann Baker, Bridget Barry, Emily Wendell, and others at the University of Nebraska Press for seeing it through.

MAPPING BEYOND MEASURE

ИЛЬЯ ФЕЙНБЕРГ

1914-й

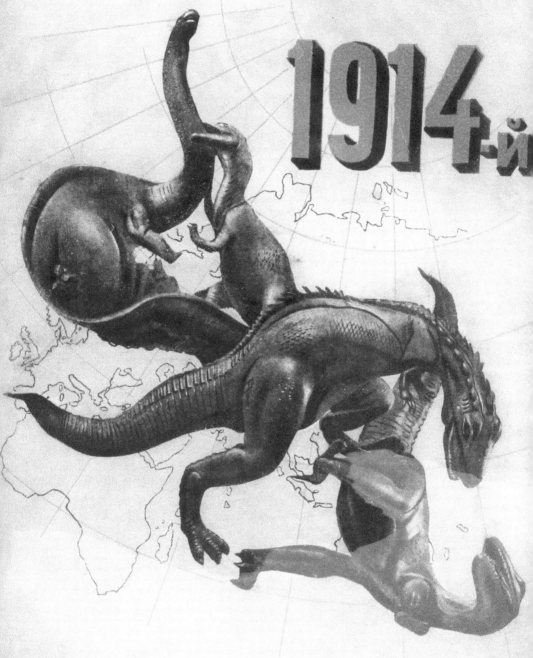

художник С. телингатер

Introduction

I Map Therefore I Am Modern

In 1934 the Soviet illustrator Solomon Benediktovic Telingater (1903–69) produced a graphic design for the cover of a short historical book, *The Year 1914*, in which the scholar Ilya Feinberg describes the beginnings of the First World War. It shows four dinosaurs, struggling to subdue one another in battling pairs (fig. 1). The furthest reptile is having its long neck torn by a stouter foe. Closer to the viewer, the largest and most muscular of the dinosaurs, its back lined with crenelated scales, presses an opponent to the ground. Though toppled vulnerably onto one side, the victim stares back up at its attacker defiantly, baring pointed teeth. In opening this book, it is less the scene of battling monsters in itself that interests me, though, than the space across which their struggle plays out. Behind the tangle of teeth and flailing tails, Telingater lays out the pale backdrop of a world map, centered on Asia. The map is synecdochical: so ubiquitous were cartographic images of the earth, in 1930s Soviet culture as today, that only finely sketched coastlines are required to signify a global geography. Admittedly, the continental outline tapers off toward Kamchatka, and the Americas are absent entirely. Yet the faint gratical geometry laid out over the terrestrial surface, while serving no actual function of cartographic projection, implies the continued curvature of a global earth.

This book is devoted to artistic experiments with cartography. As one such experiment, Telingater's now obscure book cover juxtaposes and

Fig. 1. Solomon Benediktovic Telingater. Cover design for Ilya Feinberg's *The Year 1914*. 1934. Printed dust jacket, 25 x 17.5 cm. Reproduced by permission of Eugene Shapiro Auctions.

attempts to distill the essential characteristics of two spatialities that have dominated modern history. On one side is globalism, manifested here in the world geography and segment of global graticule. In Soviet visual culture, as I discuss at length in the first chapter of this book, images of the globe and world maps like this triggered strong associations with scientific universality and political solidarity across laboring humanity. On the other side are nationalism and the state. Considered in relation to the unbordered world map extending out behind them—not to mention the ominous significance of the year 1914 emblazoned in red above—it becomes clear that the battling reptiles are metaphors for the nations fighting the First World War and their attendant colonies. Cast as isolated predators against the universality and modernity of global space, here nation states incarnate ancient, indeed prehistorical, impulses to enmity and division (despite three of the four dinosaurs belonging to a common species). Telingater's presentation, clearly, is loaded to the ideological advantage of socialist internationalism. Not only is the received geography of discrete nation states envisioned as a field of territorial contest between violent, irrational, and pitiless monsters; bitterer still is how their pyrrhic struggle has no greater purpose than that of internally dividing humanity, stifling the promise of the unified political geography imagined behind them.

The second image, which I would like to consider alongside the Telingater, is a collage of various print media titled *Mombasa* (fig. 2). It was made in the United States in 2002 by the feminist collagist and ceramicist Joyce Kozloff (b. 1942). Like Telingater's cover, it shows indiscriminate conflict, Kozloff having assembled a motley collection of combatants clipped from historical books, comics, and anthropological map insets. There are conquistadors, frontier musketeers, Napoleonic cavalrymen, and modern gunners, not to mention racist depictions of Arabs wielding machine pistols and pitch-black spearmen with leopard-skin shields and sometimes fezzes. Also like Telingater's cover, the background across which the conflagration takes place is cartographic. Copied from "Island and Ports of Mombas," a map made by the British navy in 1894, it shows the Kenyan city of Mombasa one

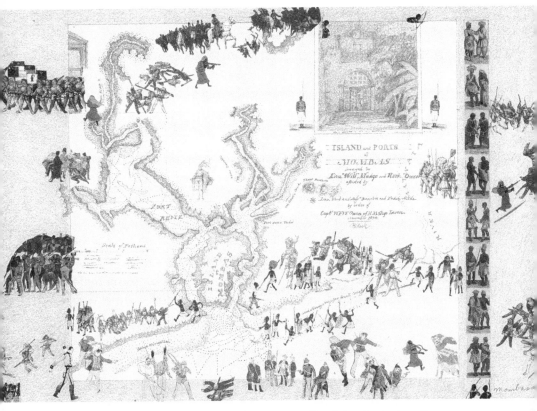

Fig. 2. Joyce Kozloff. *Boys Art #18: Mombasa*. 2002. Collaged found print/pencil on paper, 30.5 x 46 cm. Reproduced by permission of the artist.

decade after it came under the control of the British East Africa Company. Mombasa was occupied successively by the Portuguese, Omani, and British empires; its sheltered harbors, nestled midway along the east African coast, made for a strategic node in the imperial network. Despite the provenance of the underlying cartography, though, the various conflicts unfolding across it cannot be referred back to a specific battle in the city's fraught colonial past. The diverse and often anachronistic combatants depicted here, few of whom share a graphic style, let alone a common history, rather embody a transhistorical bellicose impulse, of which this colonial occupation, or that historical siege, are but local manifestations.

Ostensibly, the two images have much in common. Both foreground global interconnectedness and intergroup violence, and both posit maps as an encompassing backdrop. With regard to how they imagine the political significance of cartography in modern history, however, my two examples make an incongruous pair. The pristine world map depicted by Telingater holds out the image of a politically united global modernity awaiting release from nationalist enmity. At least in the cartographic theory of the time, the geometry fanned over the earth favors no one locale, signaling the promise of rational cooperation across received borders.[1] In selecting a flagrantly colonial map for *Mombasa*, by contrast, Kozloff implicates cartography directly in the events staged across its surface. In this work, as in her cartographic experiments more generally, Kozloff stresses the links between mapping and militarism: more than just an appropriate backdrop to imperial violence, here cartography constitutes a key medium through which wars are waged and empires established. In addition to this, Kozloff emphasizes cartography's gender politics.[2] *Mombasa* is the eighteenth artwork in a wider series named *Boy's Art*. Each collage presents a colonial or otherwise military map with disparate soldiers running amok, some drawn by Kozloff's young son, the others sourced from all manner of historical books and children's comics. In *Boy's Art*, then, cartography is presented as an imperialist and masculinist visuality, constructed by patriarchal institutions to better subdue foreign foes, and in so doing concentrating a much broader masculine will to violence.[3] The apparent levity with which Kozloff draws together colonialism and cartography, masculinity, and militarism into these carnivalesque cartographies only underlines the actual historical violence sublimated in her cartoon warriors.

Yet if *Mombasa* insists on cartography's patriarchal dimensions, to which Telingater's optimistic projection of an unbordered world geography seems oblivious, there are also ways in which the Soviet book cover complicates Kozloff's collage. Whereas *Mombasa* essentializes the will to synoptic control and violence it perceives in cartography, positing a universal masculine drive expressed as much in her son's drawings as in imperial maps and prehistoric warriors, Telingater offers a more differentiated perspective on

mapmaking. In two gestures, his cover undermines the intrinsic or universal quality Kozloff ascribes to mapping's masculinism and militarism. First, staging the scene under the scarlet numerals 1914 makes it impossible to generalize wildly from the image. The year localizes the represented scene, making it stand for the crisis of a specific global dispensation, not an abstract drive to cartographic domination. Second, in the Telingater image warfare is enacted only on the cartography's surface. In contrast to the specifically imperialist map chosen by Kozloff, it has no inherent connection with the depicted struggle. Here violence and coercion are epiphenomenal to the cartography behind, holding out the possibility of a mapping practice from which domination has been expunged. Indeed, the metaphor of dinosaurs implies the coming extinction of international and class strife, clearing the way for the world map to show forth as the symbol of a united, rationally established global modernity. True, these gestures might seem to let cartography off the hook by exorcizing its political dimensions. Considered as a pair, however, Telingater's and Kozloff's images qualify one another's shortcomings. *Mombasa* keeps attention locked on cartography's imbrication with coercive politics in the combined form of militarism, masculinism, and empire, while Telingater's design remains alive to alternative, even utopian, cartographic visions that do not reduce to the imperial beasts writhing over its surface.

Though they stem from disparate contexts, I bring these two artworks together in this introduction, first, to exemplify the kinds of map-based visual arts practice that constitute the subject matter of this book. Telingater and Kozloff are but two among a multitude of visual artists who, over the course of the last century, have looked to cartography for their work's formal and thematic substance. From embroiderers through videographers to walking performers, artists of all stamps have become entranced by the entwinements of truth and artifice, beauty and power, fantasy and functionality perceived in mapmaking. No pair of images could hope to stand in for such diversity. I offer my initial examples, then, as narrow but vivid openings onto the remarkably large and various field of artistic production

concerned with mapping. I shall refer to this field as "map art."[4] Alternative designations exist in the literature. Wystan Curnow refers to "map-based art," Ruth Watson to "artistic mapping practices," and Katherine Harmon to "map-enthused" art, which grasps the excitement often surrounding the experiments in question.[5] More than each of these other possibilities, though, the paratactic posing together of two classifications, two fields of practice, and two histories as "map art" is valuably blank and open ended. It provides an elastic descriptor through which I shall conjugate the relationship between mapping and art in several different ways.

Much of map art's fascination lies in how it challenges the seeming self-evidence of "space" as it is perceived, represented, and inhabited. This capacity to estrange taken-for-granted constructions of space has become especially urgent in recent decades: reflecting on the near-ubiquity of locative media in many parts of the world, Nigel Thrift has argued that digital mapping now structures the precognitive background to everyday practice, forming a new "technological unconscious."[6] Yet desensitizing viewers to prevailing cartographic discourses is only a stepping-stone onto the diversity of artistic interventions in mapping. Perhaps the major focus of critical attention in writing on the field is how map artists "reject the authority claimed by normative maps uniquely to portray reality" and thus affirm a rich diversity of mapping practices that cartographic institutions have long delegitimized and occluded.[7] Another is how map art provides radical cartographies of the present. Several commentators have considered whether map art fulfills Fredric Jameson's call for an "aesthetic of cognitive mapping," able to situate otherwise bewildered postmodern subjects amid the overbearing infrastructures and disorienting data flows of global capitalism.[8] Still another perspective, though, values map art precisely because it subverts any such need for orientation within a mapped totality, often by resituating mapping in an embodied realm of walking and urban practice.[9] These itinerant mappings, as David Pinder puts it, "leave behind fixed or elevated viewpoints in favor of mobile, grounded, and partial perspectives."[10]

Although my analysis of map art connects with each of these strands of criticism, Telingator's and Kozloff's artworks also serve to intimate the

distinctive focus and complexities of my argument in this book. As their depictions of clashing national and global spatialities and cartography's (masculinist and imperialist) will-to-power suggest, my approach to map art foregrounds how mapmaking is tied up with institutions and processes of global modernity. As such, it contrasts sharply with one other existing perspective on the field. Katherine Harmon opens the first of her two edited compilations of map art, *You Are Here: Personal Geographies and Maps of the Imagination*, with the suggestion that "humans have an urge to map—and that this mapping instinct, like our opposable thumbs, is part of what makes us human."[11] As a "motto" for this grasp of mapping, she redirects René Descartes' ubiquitous statement on subjectivity's basis in thought, "I think therefore I am," such that it reads: "I map therefore I am."[12] Although I will argue against it, Harmon's statement has the value of summing up, with an indelible formula, a widely held view of cartography, which I shall call "humanist," in that it takes mapmaking to be coextensive with—and in Harmon's case definitive of—human culture as such. From this humanist perspective, map art represents the artistic expression and celebration of a shared human mapping impulse: Harmon writes that, in surveying the range and idiosyncrasy of map art in her book, she has discovered "my own personal proof of the mapping instinct."[13]

The premise of my own approach to map art can be encapsulated by a second, counter-*détournement* of Descartes, which I have taken as the title for this introduction: "I map therefore I am modern." In opposition to the universality ascribed to cartography on the humanist account, which I shall go on to argue is unhistorical, even essentializing, this book rests on the premise that maps, as Richard Helgerson writes, are "the undeniable makers and markers of modernity."[14] But, whereas Helgerson here is referring specifically to the seventeenth century, I do not conceive modernity as a closed period, typically seen as reaching its apogee in the first half of the twentieth century before being succeeded by an era of globalization.[15] For, as this book demonstrates, map art troubles the construction of "modernity" and "globalization" as discrete periods, revealing how recent transformations remain dependent on a geometrical ontology inherited

from modern mapping, and, conversely, how modernity has always been tendentially global in scope, grounded as it is in universalist worldviews, colonialism and expanding markets. In framing this book, therefore, I borrow Arif Dirlik's term "global modernity," which stresses "important transformations in global relations" in recent decades while also acknowledging that modernity "has been globalizing all along."[16]

My reference to global modernity in the singular also requires qualification, for many postcolonial theorists have insisted that the concept of modernity, if indispensable, has been cast erroneously as a singular condition, which, having originated in Europe or the West, has progressively expanded to encompass (and homogenize) societies globally.[17] To recognize the specificity of diverse modern contexts, and avoid analyzing them through perpetual reference back to parameters set by European modernity, many scholars have taken up Shmuel Eisenstadt's notion of "multiple modernities," or Arjun Appadurai's and Paul Gilroy's term "alternative modernities."[18] Nonetheless, this book posits global modernity in the singular. This is not to deny the insight, crystallized in these pluralist interventions, that modernity assumes markedly distinct, even mutually oppositional forms as it takes hold in diverse geographical and cultural contexts. My reasoning rather stems from the theory of combined and uneven development, a Marxist analysis of capitalist modernity stemming primarily from Leon Trotsky that I discuss at length in chapter 2 of this book. It would be reductive, this theory suggests, to choose between a singular and plural conception of modernity. By contrast with the multiple-modernities theorist Dilip Parameshwar Gaonkar's claim that "modernity is not one but many," combined and uneven development entails an understanding of modernity that is, in Franco Moretti's words, both "one and unequal."[19] *One* in that the modern world, as precipitated by and constituted through capitalism's expansive tendency toward ever greater accumulation and the global articulation of markets, must be understood as an integrated whole.[20] *Unequal* in that this integration, far from implying homogeneity, is riven by disjuncture, unevenness and diversions. For not only does capitalist modernity play out in diverse ways through various agents, in divergent

cultural and geographical contexts and at different moments of history; it also actively produces inequality and difference, whether by extracting resources and labor from some regions (and classes) to invest it in others, separating sites of production from consumer cultures, or politically dividing laboring classes along ethnic or national lines.[21]

Critical scholarship on mapmaking shows how maps, once established by newly centralized modern states in Japan, China, and parts of Europe in the sixteenth and seventeenth centuries, have proven integral to each of the mutually entailing institutions and phenomena that, together, comprise global modernity.[22] Integral, that is, to colonialism in facilitating the global movement of armies and settlers, displacing preexisting epistemologies, and enframing colonized societies in ways that "underwrote imperial governance and the exercise of colonial power"; to capitalist globalization in enhancing the mobility of commodities, synchronizing world markets, and generalizing cadastral surveys; to secularization in replacing received religious worldviews with empirical measurement and mathematical projection; to the experience of "time-space compression" in conditioning encounters with distant geographies, whether in representation or directly through aiding global mobility; and to urban transformation and bureaucratic administration in enabling the synoptic spatial planning of previously haphazard cities.[23] Recognizing cartography's role in the articulation of global modernity indicates how map art is uniquely placed to explore themes relating to each of these phenomena and raises a number of questions pursued throughout this book. How have map artists grasped the underlying geographical imaginations, as well as the internal disjunctures, that shape global modernity? How have they sought to interrupt, trouble, and reimagine modern constructions of space? Are artistic mapping practices bound to recapitulate the distanced and calculative ontology of modern cartography? Should map art be seen as coextensive with, or distinct from, the broader diversification of mapping practices consequent on digitization? And what does map art add to existing theories of maps and modernity in critical cartography and spatial theory?

In addressing these problematics, this book makes the claim that map art plays out, and puts to the test, some of the central figures, myths, and narratives through which global modernity has been imagined and theorized. This formulation of my argument is deliberately equivocal. For this book is concerned to emphasize how map art, at its most probing, neither simply illustrates nor wholly subverts received understandings of global modernity, but rather complicates and reworks them through concentrated formal experiment. Often map artworks recapitulate the narratives of rupture (spatial as well as temporal) through which global modernity differentiates itself from inherited pasts and surroundings. For example, this book will analyze artworks that proclaim the modernity of the mapped modern globe against the parochialism of received spatialities; hold out the image of totally planned and artificially reconstituted urban worlds; and, using the metaphor of the island, capture the sharply bordered, internally homogenous spatiality through which modern nation states delineate their identity. Yet in the very process of reiterating these founding ruptures, of realizing them concretely in visual form, map art exposes repressed continuities and complexities that haunt—and, when articulated, undermine—the root demarcations that constitute global modernity. Thus, on my analysis, these artworks also show how the mapped modern globe is every bit as constructed and constraining as the metaphysical worldviews it displaced; how modernist city planning actually precipitates the very disorder and ambivalence it strives to extinguish; and how a groundswell of difference and global hybridity persists, unacknowledged, athwart the insular borders delineating modern states.

Map art might undermine the temporal and spatial ruptures that constitute modernity, but the field is not locked perpetually in the mode of critique. Far from it: through critically querying prevailing spatial constructs, map artists come to reimagine mapping practice and with it the spatialities of global modernity. For example, whereas mainstream cartography envelops the earth in a single uniform temporality, I examine artistic mappings in which multiple times and moments of history coexist alongside one another, producing what I call "polychronous cartography."

Here map art's capacity to engage and rework cartography at the level of experimental formal practice is especially vivid. My choice to focus on map art is motivated, in large part, by how artists recapitulate, deconstruct, and reimagine the spatialities of modernity in immanent, concretely instantiated ways. That is not to imply that arts practice is somehow inherently more creative or critical than theoretical engagements, and of course one can point to many uncritical and uncreative instances of map art. Rather, my point is that, unlike critical writing on cartography, which reflects on maps in the medium of written theory, artists "inhabit" the map to better distill, test, and expand its affordances. As Kozloff's ironically exuberant caricature of masculinist and imperialist cartographies indicates, even where map art works to expose and critique mapping's politics, it does so through concretely instantiated artistic (and often cartographic) forms. Formal strategies of art making are of determinate importance in the cumulative image of maps and modernity built through this book, then, but in highly differentiated ways I mean to trace in the case of each artwork I examine. Among many strategies encountered here are practices that accentuate the contradictions immanent to found maps, depict cartographies in social contexts that complicate their significance, collage together seemingly incompatible mappings, or introduce incongruous elements that transform the map from within. Such strategies manifest ways of "reflecting" on cartography, certainly, but in formally incarnate modes that, unlike mapping theory, *embody* mapping's complexities and *enact* its politics. Theorists might call for alternative mapping practices, or new spatial ontologies, but map artists push cartography to theorize and transcend itself.

This capacity to inhabit and practically reconfigure modern cartography has a reverse side, however, and must be carefully parsed. At one level, many of the artworks examined in the book mount strident challenges to modern mapmaking—in fissuring open the bounded form of the nation state, for instance, or enrolling satellite technology to expand mapping beyond the closed domains of institutional cartography. At another level, though, I am concerned to show how these subversions are often undercut by the fact that many map artworks repeat and reify the received ontol-

ogy underlying cartography. Indeed, much of this book turns centrally on questions of ontology—that is, the fundamental "understanding of being" that preconditions possibilities for thought and action within a given historical horizon. In phenomenological philosophy, "ontic" phenomena refer to this or that existing thing, whereas "ontology" signifies the ways in which things exist. Ontology concerns the "being of beings"— the basic modes in which existing things show up and take on meaning.[24] Ontological disclosures, therefore, establish nothing less than "the overall character of the manifest world," preconditioning how particular beings might appear, matter, and relate to each other for certain cultures and at certain moments of history.[25] They set the backdrop of taken-for-granted conceptions of self, society, and world within which various subjects, objects, and practices arise, take on meaning, and play themselves out in a particular age. This book claims that modern cartography performs a specific ontological disclosure of existence, which it casts as measurable, malleable, simultaneous, and uniformly extended. In this modern paradigm, which determines both temporality and spatiality, the world exists independently of the observer, can be represented exactly, and does not admit multiple correct interpretations. Drawing on terminology developed by Stuart Elden, I name this ontological disclosure "the ontology of calculability."[26] Several of the map artworks analyzed in the book denature this ontology, showing how it is, in fact, historically relative to cartography and the modern state and capital's need to render formerly intransigent geographies transparent, measurable, and malleable. Yet in engaging so closely with cartographic form, other map artworks ultimately reproduce and reinforce it. Even as they dispute and strain to leap free from dominant cartographic imaginations, such artworks are ultimately recuperated within the singular, objective, and calculable casting of the world inherited from institutional cartography.

Acknowledging the double-sidedness of map art in this way allows me to clarify its significance against the background of what Jeremy Crampton has called the "undisciplining of cartography" in recent decades.[27] Existing scholarship stresses how map art has combined with digitization and

critical cartography in "taking the map back" from institutional control, thereby reclaiming the mantle of mapmaking for formerly delegitimized lay and artistic practitioners.[28] Having thematized the ontology of calculable extension throughout my analysis of map art, however, I conceive the issue differently. In itself, the recent diffusion of mapping practices to an enlarged social field through digitization, while seeming to explode institutional cartography, often inherits and further entrenches its ontology. Against this backdrop, I claim that the value of experimental map art lies less in how it extends cartography to its excluded others (which is happening regardless of map art) than in the possibility that it might imagine qualitatively different conceptions of mapping and geography.

To demonstrate map art's distinction in this regard, my argument concludes by foregrounding the film that first incited me to write this book: Peter Greenaway's *A Walk Through H* (1978). In unfolding a multiple, fluid, and above all performative conception of mapping, which does not represent but rather enacts rich incalculable geographies, *A Walk Through H* provides an exemplar for how map art might truly contravene institutional cartography. Indeed, whether in the conquering of colonies or administration of states, the globalization of clock-time, or the wholesale planning of cities, the articulation of modernity globally has relied on the cartographic casting of the world as a measurable and malleable extension. In addition to estranging and testing this constitutively modern ontology, the continuing significance of map art consists in how it, in stark contrast to the heightened calculability naturalized through digital mapping, constructs cartographic ontologies as yet unknown.

Having set out the parameters and main arguments of my study of map art, the remainder of this introduction runs as follows. The following section offers a brief genealogy tracing how maps, and especially art and science *in* maps, have been discursively constructed in different ways in modern history. Hence, the genealogy elaborates the reasoning behind my premise that the history of mapmaking is coextensive with that of global modernity, establishes the backdrop against which the import of practices transgressing the art/cartography distinction can be judged, and situates

map art in relation to broader shifts unfolding in contemporary mapping. I then explain the geographically informed methods of cultural analysis through which I interpret map art in this book, before breaking down the six case studies that I examine in depth.

The premise of this book—that map art is especially well placed to explore themes of global modernity because mapmaking itself has been inextricably bound up with the articulation of modern nation states, colonialism, and capitalism—stands at odds with commonly held assumptions about the universality of maps. Writers adhering to what I have termed the "humanist" conception of cartography often adduce "maps" in ancient, even prehistoric societies or across dispersed cultural contexts to present mapping as a "cognitive and cultural universal."[29] My counterassertion of the modernity of mapmaking is grounded in Denis Wood's revisionist survey of map history. In *Rethinking the Power of Maps*, he argues that maps, as they are understood today, "have comparatively shallow roots in human history, almost all of them having been made since 1500."[30] The impression that mapmaking is coextensive with human history, Wood explains, is an effect of contemporary modes of interpretation, which often anachronistically conflate discontinuous artifacts and practices under the generalized label of cartography.[31] Quite unrelated forms of ancient wayfinding, cosmography, and itinerary, which neither influenced one another in a common tradition nor performed equivalent functions, are retrospectively situated as belonging to a shared continuum in the history of cartography, despite the fact that the English words *maps* and *cartography*, much like their equivalents in Spanish, French, Turkish, and Japanese, took on their current meanings only in the early modern period.[32] Wood insists that ancient artifacts and practices now registered in histories of cartography—from Christian *mappamundi* to Peruvian *quipu*, Australian songlines to Babylonian cosmograms—"were not emitted *as maps* by those who made them."[33] Either they performed historical, cosmographical, genealogical, spiritual, or other functions that do not approximate the "heightened spatiality" ascribed to maps today, or else they fused spatial

representation with these other functions in multidimensional objects that precede modern discriminations between geography, history, theology, cosmography, genealogy, and art.[34] "Until modern times," Wood sums up, "no society distinguished—or made—such maps as distinct from religious icons, mandalas, landscape paintings, construction drawings, itineraries and so on."[35]

To insist, in this way, that it is anachronistic to label many pre- and non-modern objects as maps is not to denigrate their significance in relation to mapmaking. To the contrary, it preserves their specificity from reduction to subsequent categories. And, crucially for my study of map art, it also allows one to grasp the history and functions specific to cartography. "Though in 1400 few people used maps," Wood suggests, "by 1600 people around the world found them indispensable. There is a divide here that is impossible to evade."[36] Though he acknowledges that small numbers of maps *do* pre-date 1400, far from seeing these as undermining his periodization, Wood asks why they remained isolated examples, as opposed to mapmaking of the sixteenth century, which "didn't die but rather flourished in the most astonishing fashion."[37] His answer is that mapmaking—though long possible and intermittently practiced—only became necessary with "the needs of the nascent state to take on form and organize its many interests."[38]

For Wood, then, it was the advent of modern state formation, and particularly the establishment of centralized modern states in Japan, China, and parts of Europe in the sixteenth and seventeenth centuries, that first called for the emergence of mapmaking. But maps are not tethered to modern states exclusively, as Wood acknowledges, and accordingly this introduction has already indicated the role of mapmaking in colonialism, uneven capitalist expansion, secularization, and spatial planning. Through these overlapping processes of global modernity, maps have been generalized to such an extent that, today, they seem universal. Significantly for this genealogy, mapmaking's differentiation from among manifold visual practices in the early modern period did not initially entail sharp distinctions between mapmaking and art, or between art and science in mapmaking. Indeed, Svetlana Alpers goes so far as to suggest that in the

Dutch Republic of the seventeenth century, the major commercial center of early modern colonial cartography, "there was perhaps no other time or place such a coincidence between mapping and picturing."[39] Although mapmaking practice was increasingly formalized and framed in terms of scientific method and progress during the nineteenth century, it was only in the mid-twentieth century that mapmaking and art, in Markus Jobst's metaphor, "filed for divorce."[40] In the 1950s mapmakers formulated scientific principles for mapmaking, as part of a wider bid to consolidate cartography as an academic discipline.[41] The influential U.S. geographer Arthur H. Robinson is often cited as the leading figure in this project, which aimed to replace "convention, whim and . . . ill founded judgment" with "principles based on objective visual tests, experience, and logic."[42] In the mid-twentieth century, then, a set of negative associations (with subjectivity, partiality, intuition, and emotion) conjured around "art" came to function as a rhetorical foil or *other* against which cartographic professionals and institutions affirmed their own distinction and "scientific" authority.[43] Thus Edney and Wood suggest that binaries clustered around the art/science dualism have shaped and justified the formation of cartography as a professional discipline, the preserve of trained specialists.[44] And, thus, at a larger scale, Bauman emphasizes how bureaucratic states have secured the social legibility required for effective control by delegitimizing all rival articulations of space as lay or artistic deviations from their own, scientifically established mappings.[45]

Some previous treatments of map art reproduce versions of the art/science distinction by assuming that the "art" in cartography denotes ornamental elements like cartouches or pictorial insets, the aesthetic design of maps more generally or traces of the emotions and individual subjectivity of mapmakers.[46] By contrast, I take the view expressed by Matthew Edney that the opposition of art and science "is a matter for social negotiation and represents no underlying distinction."[47] Designations of art and science in mapmaking are actually performative gestures that distribute authority unevenly among different groups of mapmakers. Two points are crucial for my arguments in this book. First, the stakes of the art/cartography

distinction are in large part *social* in that, however cogent the empirical justifications adduced to sustain it, its ultimate effect is to apportion cartographic legitimacy unequally in society. Second, this social division of authority—whether between scientific cartography and arts practice, or between designations of science and art *in* cartography—is grounded in a set of ontological assumptions about what constitutes space and its mapping. Within the received ontology reproduced by cartography, which I am calling the "ontology of calculability," the world exists objectively, separate from and prior to cartographers' constructions, and is measurable, calculable, and representable. There can be no plurality of equally correct mappings, while only the methodologies labeled "scientific," and founded on supposedly neutral methods of measurement and geometrical projection, offer access to the singular, noncontradictory, and undistorted truth of geography.[48] These two social and ontological aspects of the art/cartography divide are bound up together in that claims to scientific expertise, and thus heightened authority in social discourse, rely on an ontological understanding in which there is only one objective and correct description of reality, graspable only through specialized scientific procedures. Conversely, to allow the plurality, partiality, and creativity attributed to art to infuse one's ontology would undermine the exclusive access to objective truth claimed by cartographic professionals, opening geographical reality up to diverse, equally legitimate mappers.

Map artists have challenged the social effects and ontological basis of the distinction that cartographic institutions have drawn between scientific practice and art in the twentieth century. Although I argue that map art's unique value in relation to the wider culture of contemporary mapping rests in its capacity to envision alternative ontologies, this book remains sensitive to how even ostensibly subversive map artworks often reproduce the ontology of calculability. Irrespective of the underlying ontology, though, where map art queries or blurs the distinction between cartography and art, it also gestures against the received concentration of cartographic legitimacy that it maintains. As such, map art must be situated in relation to the broader process that Jeremy Crampton has called the "undisciplining of cartogra-

phy."[49] "For most of its history," Crampton writes, "mapping has been the practice of powerful elites."[50] However, citing mapping's digitization and the rise of more nuanced conceptions of cartographic truth over the last four decades, he suggests that professional, institutional, and ultimately state control over mapping "is now being challenged by the emergence of a new populist cartography in which the public is gaining (some) access to the means of production of maps."[51]

By contesting the art/science binary that strengthened the institutional monopoly on authoritative mapmaking, map art contributes to this process of "undisciplining" cartography: the idea that institutional cartography, understood as the preserve of trained, often state-sponsored specialists, has given way to a socially expanded and formally diversified field of mapping practices, often taking digital form. Almost unanimously, mapping theorists have narrated the recent history of mapmaking in terms of rupture and transformation, suggesting a transition between residual and emergent mapping paradigms.[52] This notion of a paradigm shift, though expedient, is too neat to capture the varied, halting, and complex processes that, together, are transforming mapping cultures.

The onset of computerization in the 1970s, its widespread expansion in the 1990s, and the miniaturization and networking of digital technologies during the 2000s has given rise to new mapping possibilities.[53] Existing modes of mapmaking, in which static two-dimensional cartographies were hand drawn by dedicated specialists on paper substrates before engraving and dissemination in print, have in large measure been displaced by digital platforms hosting highly flexible, networked, and often user-made mappings. A rich semantics has developed to grapple with various forms and aspects of digital mapping, including geospatial applications, geobrowsers, geolocation software, geovisualization, the geoweb, the geospatial web, locative new media, and map mashups, a common general designation being GIS (geographic information systems). The digital mappings made and circulated under these rubrics remain open to continual renewal, augmentation, and manipulation by diverse mappers. Often, they render geographies in three dimensions, and they exist not as

single, enduring artifacts but rather as codes that can be instanced, used, and modified simultaneously in diverse settings by numerous networked mappers. Even in sketching out these broad contours of cartography's digital transition, it is important to caution against a deterministic reading in which digital technologies unilaterally reshape mapping cultures without friction, unevenness, or remainder. Three points, which I shall unpack more fully below and return to throughout this book, should be emphasized from the outset. First, digitization is only one of several factors reshaping contemporary mapping cultures; second, the development of digital mapping has been (and remains) a fraught, uneven process, contingent on unequal socioeconomic dispensations; and, third, digitalization unfolds in and through existing mapping cultures, whose long ingrained practical procedures and visual codes often inform or otherwise shape digital mapping practices. As I argue at length in chapters 4 and 5, this is especially the case on an ontological level, at which seemingly ruptural mappings often recapitulate a calculable worldview inherited from cartographic institutions.

Still, for many commentators the emergence of flexible, multiple, and collaborative digital mapping practices signal a rupture in the history of cartography every bit as significant as the advent of modernity is for Wood's genealogy of maps. Indeed, Valérie November, Eduardo Camacho-Hubner, and Bruno Latour go so far as to suggest that, henceforth, maps should be dated "BC" and "AC" (before and after computers).[54] GIS has reconfigured the social distribution of mapping, first at the level of consumption, extending the accessibility of maps to a spatial field coextensive with internet coverage, although the quality and consistency of this access diverges drastically around the world.[55] Online mapping platforms have challenged the received sociology of mapmaking more fundamentally, however, in diminishing the distinction between map production and consumption, inviting interaction and creative elaboration from nonprofessional users. Beyond the "geotagging" of additional data within a set structure, platforms with open-source application programming interfaces (APIs) enable substantial annotation, augmentation, and the overlay of external thematic data.

Although the majority of popular open-source mapping applications are owned by large corporations that determine the parameters of user agency, there are democratically organized nonprofit alternatives. OpenStreetMap, the most successful GIS produced and run solely by an online community of volunteer mappers, has proven especially suited to disaster relief; well in advance of established outlets, contributors produced detailed aid maps in response to earthquakes in Haiti in 2010 and Nepal in 2015, as well as the spread of Ebola in West Africa from 2013.[56] The broader diffusion and diversification of digital mapping beyond professional domains, however, largely takes more quotidian forms. Today, mapping is performed less in dedicated sites than in and through an broadened variety of everyday contexts by an expanded body of nonspecialist "produsers."[57] On these grounds, map theorists have taken digitization to have exploded the received concentration of means and legitimacy in mapping. In 2003 Wood declared that "cartography"—which must be understood here not as mapmaking as such but rather mapmaking's institutionalization as a specialized profession—is "dead": "GIS software, particularly once it spread to personal computers and then the Internet, made it possible for anyone with access to a computer to make almost any kind of map, and since the software embodied most of the intellectual capital of academic cartographers as presets and defaults, it all but made Everyman and Everywoman the functional equivalents of professional cartographers . . . The Age of Cartography (RIP) would seem to be over."[58] Where mapping was once claimed as the preserve of state-sponsored specialists, Wood suggests, now it is conducted collaboratively by a networked community of digital mappers.

Other writers caution against overly celebratory and epochal narratives of digital mapping's democratizing influence, whether by reminding us that unofficial mapping practices have long existed alongside mapping institutions or by problematizing digital mapping cultures.[59] In a direct counter to Wood's insistence that "Everyman and Everywoman" are now equivalent to cartographers, rhetorics of expert distinction threaten resurgence in recent attempts to register and license "qualified" GIS experts as

"geospatial engineers."[60] As for the participatory map cultures that have emerged, Jason Farman suggests that the dominant geobrowsers actually contain and co-opt user agency by retaining control over the contexts within which participation occurs.[61] Certainly, user augmentations and maps made with MapQuest, MyMaps, and Bing Maps, the three most prominent open-source mapping applications, are ultimately owned by AOL, Google, and Microsoft, respectively, and it could be argued that digitization has not democratized mapping so much as reconstituted it in the hands of large corporations, which syphon off and monetize data from the commons under the veneer of user volunteerism. Other scholars stress the importance of GIS's military origins, Caren Kaplan arguing that locative media have generalized military rationalities of tracking and targeting through civil society.[62] John Pickles' critique of the "cyber empires" being built through GIS is especially wide ranging.[63] Even as scholars and mappers celebrate the expanded agency brought by GIS, Pickles calls on us to remember "the ways in which these same mapping practices participate in fueling new rounds of capital investment, creative destruction, uneven development, and indeed, at times, the ending of life, wrenching it from its moorings, and destroying it piece by piece, limb by limb."[64]

Accepting these important rejoinders, I am prone to recognize the social extension of mapmaking attendant on digitization. Although the final two chapters of this book criticize GIS and GPS, this is not because they *fail* to open mapping to a broader social field, but rather because they expand mapping beyond professional domains without challenging the received ontology of calculability. Digitization effects only a partial paradigm shift in mapping and stands in need of a supplement that map art is uniquely constituted to deliver: that of reimagining mapping ontologies. I am loath to suggest, however, that map art is alone in challenging prevailing conceptions of mapping, or that the ontology of calculability represents an all-encompassing metaphysical monolith that predetermines all digital mapping practice in advance. As David Pinder as argued, there is a "need to move beyond generalized condemnatory or celebratory accounts" of

contemporary GIS, to explore "multiplicity and diversity against what has often passed as unity" for "existing practices and categories are less constrained than typically acknowledged."[65]

It is important to recognize, therefore, how a remarkable diversity of often contrary and critical digital mappings are possible within the ontology of calculability. As science and technology studies scholars have shown, digital mapping cultures are heterogeneous at several levels.[66] Seemingly singular and uniform mapping applications enroll qualitatively different modes of information, gathered from users that are differently positioned, accessed, and informed.[67] Mapping applications themselves diverge sharply among one another. Focusing on participatory maps of human rights violations in Palestine, Bittner, Glaze, and Turk stress how digital mapping applications are inextricably imbricated in contemporary political struggles, sedimenting and naturalizing some sociopolitical realities, while contesting and marginalizing others.[68] Despite their shared ontology, then, different digital mappings often collide directly in pursuing opposed political agendas. As the example of Palestinian countermapping indicates, many GIS work in explicitly critical or counterhegemonic registers. Besides furthering mapping's general expansion beyond cartographic institutions, these practices "wear their politics on their sleeve" as Alexis Bhagat and Lize Mogel put it, rejecting the veneer of neutrality erected by official cartographies.[69]

Consider three explicitly critical works of GIS, which reflexively play out the partiality, artificiality, and creativity of the spatial visions they set forth: Paula Levine's *The Wall–The World* (2011), a website that superimposes the Israeli West Bank barrier onto cities of browsers' choice; Jeremy Wood's GPS tracings, which, as I show in chapter 5, render seemingly stable GPS coordinates spectral and uncertain; and anthropologist Barbara Glowczewski's *Dream Trackers*, an online project visualizing the songlines through which landscape and mythic narrative fold together in the worldview of the Australian Warlpiri people.[70] Each of these digital works participates in the challenge posed by map art set out in this book. Opening mapped space up to conscious creativity and often political investment without recourse to rhetorics of transparency or correspondence, such works transgress

received distinctions between art and science in cartography and thus implicitly also query the ontology of an objectively calculable space that such distinctions maintain. Still, critical or alternative forms of GIS represent only a peripheral trend in digital mapping today. For the most part, inherited distinctions between artistic partiality and scientific accuracy are only reinforced in the vast majority of digital mapping applications, which incorporate the heterogeneous data generated by ever more users into a view of the world as an regular geometrical extension. For all the changes in procedure and participation precipitated by digitization, this objective, uniformly calculable spatiality remains the dominant ontological horizon of contemporary mapping cultures, which critical forms of GIS and arts practice must strive to contest and transcend from the margins.

Yet the "death" of institutional cartography was never the sole effect of digital technologies, and revisionist philosophies of mapping, which reflect explicitly on cartography's calculative worldview, have also played significant roles in the recent changes unfolding through mapping cultures. Grouped under the heading of "critical cartography," these philosophies have sought to expose and contest the veiled politics of official mapmaking. Practices and theories of critical cartography are united by the insight that "maps make reality as much as they represent it."[71] Spurred on by a controversy in the 1970s, in which the German geographer Arno Peters promulgated a version of the Gall world map in explicit opposition to the (alleged) Eurocentrism of the dominant Mercator projection, politically sharpened perspectives on mapping gained much recognition in the 1980s and 1990s, in large part owing to the seeping influence of postmodern and poststructuralist philosophies asserting the agency of representations and cultural relativity of truths.[72] Claims surrounding neutrality, transparency, and scientific rigor were progressively dislodged in research applying these philosophies, exemplified by J. B. Harley's formative Foucauldian recasting of maps as tools and expressions of social power in 1988. Summarizing the cumulative import of these shifts, John Pickles suggests that "the epistemology of modernist, universalist inquiry . . . has been pretty much laid to rest as a foundation for science."[73] "In its place," he goes on, "we have more

nuanced and multiform understandings of cartographic practice in which the production of geographical images is understood to be a thoroughly social and political project."[74]

Where digitization has broadened the social dispensation of mapping, critical cartography has made considerable headway in displacing cartographic presumptions of scientific neutrality and representational correspondence. Although cartographic theory is still diversifying around new themes, most current humanities and social science scholarship holds maps to organize historically contingent and politically situated propositions about reality, to build social identities and to construct specific relationships between subjects and geographies.[75] This growing appreciation of critical cartography is important in the context of this genealogy. It shows how recent shifts away from the residual formation of cartographic institutions, upheld by discourses of scientific objectivity, is determined not solely by digitization, but rather by an intersection of different developments, of which map art is another. The extent to which critical understandings of mapping have taken hold beyond the academy, however, is uncertain. Indeed, despite their flexibility and interactivity, in chapter 6 I caution that GIS still largely aim at correctness and exact calculation in mapping. In 2013 Google, ignoring decades of critical cartography's insistence on the politics and partiality of mapping, claimed to be assembling a "perfect map of the world," prompting a riposte from Jerry Brotton, author of an enormously popular book asserting the relativity of world maps to different cultural worldviews.[76] If there is a paradigm shift unfolding through contemporary mapping cultures, it seems far from complete.

Alongside digitization and new philosophies of mapping, several fields of popular culture and creative industries have contributed to the emergence of more distributed and diverse contemporary mapping cultures. Through corporate icons; press cartoons; fabric patterning for fashion and furnishing; advertisements on posters, television, and online banners; jewelry; coin design; picture postcards; political campaign imagery; stationary; bumper stickers and animated segues between newsroom broadcasts, cartographic forms have spread through commercial imagery and visual

culture more generally.[77] From map insets that orient play in many kinds of computer games to cartographic sequences introducing popular televisions series like *Game of Thrones* (2011–ongoing) or *The Man in the High Castle* (2015–ongoing), maps of imaged realms and experiments in mapping can be found across media and genre in contemporary popular culture. Although my argument in this book largely focuses on works by artists positioning themselves in the arena of fine-arts practice, there are no essential distinctions between these constructed cultural fields. Engagements with maps in popular culture, then, feed into my analyses of how practices blurring mapping and art not only contest institutional control of cartography, but often query received understandings of mapping. Maps of literary lands, such as those accompanying Madeleine de Scudéry's *Map of Tenderness* (1654) and Robert Louis Stevenson's *Treasure Island* (1883), have received a great deal of critical attention.[78] As I discuss more fully in chapter 4, the fascination of these maps seems to reside in how they endow otherwise intangible geographical fictions with the authority and empirical certitude claimed by, and often associated with, official cartography. In this, literary maps are part of the challenge to institutional cartography I trace in this book: in employing the trappings of cartographic exactitude and empiricism (scales, coordinates, compasses, rhumb lines) to depict nonexistent worlds, literary maps hint at the possibility that official, seemingly passive representational maps are also "imaginary" in that they actively define, codify, and construct their terrains. Maps of literary and imaginary worlds, Ricardo Padrón writes, "work by insisting upon their own similarity" with representational cartographies, leading to the conclusion that "there are no maps of real worlds, only maps of not-so-imaginary worlds that we take for reality."[79] As such, cartographies of fantastic lands in literature and popular culture participate not just in the diffusion of cartographic forms beyond professional domains, but also in the emergence of more plural and performative conceptions of mapping.

In tracing shifting constructions of maps in modernity, this genealogy has established the backdrop of historical breaks and discursive binaries against which the following chapters explore artistic engagements with

mapping. The map, I have emphasized, emerged as a distinct form only with the onset of modern state formation and is specific to the modern need to render geographies as the distanced objects of calculative knowledge and transformative practice. This need intensified during the twentieth century, when professional mapmaking institutions promulgated rhetorics of science and specialism that defined cartography against art in order to bolster official claims to scientific authority. In recent decades, though, uneven digitization has dovetailed with revisionist conceptions of cartographic truth to effect a newly distributed and digital mapping culture, in which the discursive barriers separating sometime producers and consumers begins to erode.

Before providing a detailed breakdown of the six chapters that compose this book, I want to explain the strategies of looking and interpretation through which I engage works of map art and establish the arguments prefaced above. This book employs a geographically informed method of cultural analysis—an "interdisciplinary research practice" associated with literary theorist and art writer Mieke Bal.[80] Cultural analysis attends to the dynamic relations between cultural objects and conceptual theories in close empirical encounters, guided by "a keen awareness of the critic's situatedness in . . . the social and cultural present."[81] As an approach to artworks, cultural analysis differs from protocols received from art history in that it does not subordinate specific engagements with art to questions of "influence, context, iconography, and historical lineage."[82] Instead, cultural analysis turns on the encounter between artwork and researcher, who attends to what art "*is, means,* and *does* in the present time of viewing," and puts artworks in dialogue with prevailing cultural discourses and theories.[83]

This is not to suggest that cultural analysts cannot engage with notions of influence, historical context, and iconography; my analyses often make reference to the social and cultural contexts surrounding map artworks, draw comparisons with other, contemporaneous artists, and establish the iconographical significance of motifs in the images I examine. Cultural analysis differs from established ways of approaching visual objects, rather,

in how it approaches the meaning of artworks. For cultural analysis, significance is neither fixed at the moment of their creation (as in much social history of art), nor encoded within them as an essential content awaiting proper identification (as iconography proposes). Instead, it emerges from the play of relations that surround and include art objects as they pass through various different spatial and conceptual conjunctures, none of which determine their meaning once and for all. There is, for cultural analysis, no single authoritative historical or intellectual frame to which a given object essentially belongs. Exclusive claims to "explain" the forms and meanings of a visual object through reference to its proper context, I claim, conceal the agency of the historian or critic. Such claims not only entail the active selection of the context in which an object is to be interpreted, but presuppose a hierarchy among its various possible contexts, in which one—usually that of its initial production—most befits the artwork and explains its significance. In cutting against these tacit hierarchies, cultural analysis does not propose a "decontextualized" approach to artworks. Rather, it acknowledges the multiplicity of historical and conceptual frames in relation to which the significance of artworks can be explored, and it flattens constructed hierarchies among them, such that one cannot speak of legitimate and illegitimate contexts. Acknowledging this multiplicity of contexts radically opens up the interpretive field, allowing even historically remote cultural objects to resonate beyond past periods and enter into critical dialogue with contemporary debates and concerns. Conversely, persistently referring artworks back to cultural situations or authorial intentions in their originary milieu often effects a form of reverse anachronism, precluding new readings arising from the fact that artworks are reiterated whenever they are confronted anew. Indeed, though generalized claims to historicize or contextualize cultural objects implicitly refer to the circumstances of their production, it should be stressed that the situations through which those objects subsequently circulate, take on new meanings, and produce new effects are no less "historical" and deserving of study.

If cultural analysis's project of relativizing contexts of cultural production, and thus allowing for multiple other historical and conceptual contextu-

alizations, grates against several established visual methodologies, it is worth noting that this maneuver merely realizes the implications of Roland Barthes's argument in his celebrated essay "The Death of the Author." The absence of a literary text's originator in the various sites in which the text is consumed, Barthes suggests, blocks readers and critics from referring to an authorial mindset or intentionality as the ultimate guarantor of the text's meaning. In the absence of a creator's intentions—and, we might add, the social circumstances and cultural codes in which creation took place—the work appears newly obdurate or opaque. It becomes a space "to be ranged over, not pierced"; there is no "secret" authorial or historical essence hidden within, behind, or beneath the text, no inherent or "ultimate meaning," only an encounter between the text and reader.[84] Applying these ideas beyond literature to a variety of different media, cultural analysis affirms the creativity and dynamism inherent in the present-tense encounter between subjects and cultural objects. Interestingly for studies like this book, which are concerned with the relations between art and geography, this approach has a distinctly geographical dimension. Instead of privileging past cultural codes, absent creators, or lines of influence between master artists, cultural analysis emphasizes how cultural objects are situated in contemporary spaces, in which they interact complexly with current cultural discourses. Indeed, the geographical theorist Harriet Hawkins expands upon Bal's work in an explicitly spatial register, arguing that a geographical approach to artworks should turn centrally on the "productive relations between the artwork, world and the various audiences of the work."[85] Hawkins suggests that if received art historical approaches cast artworks as "as standing for something"—an ulterior presence like the creator's mindset, artistic lineages, or some vanished historical zeitgeist—a geographically informed approach would see "art *as* something, something that produces effects" in relation to other entities in proximate sociospatial contexts.[86] Here, artworks are entities encountered in concrete geographical sites, in which they interact with subjects and environments and set off a variety of specific effects.

For this geographical approach to art, which I would describe as a highly spatialized practice of cultural analysis, there are as many appropriate "con-

texts" in which to analyze a given cultural object as there encounters with it. The social circumstances and intellectual culture in which a cultural object was first created; subsequent situations in which it was recoded in terms of a later culture's worldview; philosophies and other discourses derived from times and places with which the object has no direct connection, but resonates in complex ways; and contemporary sites and discourses in and through which critics encounter and theorize artworks, knowingly or otherwise: each of these might be taken as a site or frame in relation to which a given cultural object is analyzed, so long as the critic is mindful that their analyses take shape in and through their engagement with the object in the present. For the cultural analyst, the criterion by which one selects an interpretative context for a particular object or artwork is not that of historical precedence or proximity to the creator's intentions, but rather the dynamism and fecundity of the particular conjuncture in question. The aim is to create a reciprocal, mutually transforming dialogue between object and interpretative context, with the object "participating in the construction of theoretical views."[87] Criticism seeking to one-sidedly "explain" visual objects through reference to historical materials or theoretical discourses renders the images themselves inert, casting them as mere illustrations of periods and metanarratives. Cultural analysis, in contrast, emphasizes the agency of its objects, showing how they actively "speak back" to the situations, discourses, and theories alongside which they are interpreted.[88] Artworks cannot exercise these capacities for theoretical dialogue autonomously of critical practice; extrapolating the ways in which cultural objects interrupt and reconfigure interpretative frames entails the agency of the researcher, who creatively participates in the construction of cultural meanings. This is not to suggest that critics can write whatever they please, but that in selecting interpretative contexts, bringing theoretical insights to bear on artworks, and responding to art through creative forms of writing, researchers might activate and enrich the "event of poesis" through which meaning arises.[89]

In analyzing works of map art in conjunction with spatial theories of global modernity, this book stages a series of cultural analytic encounters

between art objects and theoretical discourses to explore how they mutually illuminate and develop one another. Although I have chosen to engage the field in relation to contemporary spatial theory, I want to underscore how this is one among numerous possible ways of situating map art and analyzing its significance. The advantage of putting map art in dialogue with spatial theories in this way is that it does not approach the field as an inert corpus to be explained or decoded, but allows map artworks to actively interrupt, augment, and reconfigure our theoretical discourses about the spatialities of modernity. My aim in this book, then, is not to ascertain what the artworks mean or meant in an iconographic or historical register, but to open them up to participate in the formation of theory. To this end, I both read map art through the lens of spatial theory and consider how these theories come to be articulated and critically reflected upon in the map artworks, where they accumulate new resonances. The following analyses should therefore be seen as creating and enacting an encounter between map art and spatial theories of global modernity, which unfolds in and through my writing practice.

The sustained, theoretically driven cultural analyses staged in this book differ markedly from existing writing on map art. Admitting for several exceptions, scholars have tended to offer broad outlines or overviews of map art instead of delving into the complexities of focused case studies.[90] Whether in establishing lists and lineages of map artists, classifying different strands of work in the field, or reflecting on its aetiology and cumulative import, these accounts present "aerial surveys" of the field, charting contours that are visible only from high altitudes.[91] My approach can be grasped with the very different geographical metaphor of the core sample. Knowing that map art's larger geography has been extensively surveyed, each chapter in this book drills down—narrowly but deeply—into works by a particular artist, in order to grasp the intricate ways in which map art reflects, tests, and reimagines modern spatialities. The sites from which I extract core samples are few and far between and thus do not represent map art's breadth and variety, which is best ascertained in the surveys cited above. Instead, I have selected case studies that reflect the diverse

facets of global modernity explored by map artists. No limited selection of objects could encompass the full range of problematics entailed in the rubric of global modernity, so I have tried to foreground a variety, focusing on themes that have not yet been studied extensively in writing on map art. Although questions concerning modern colonialism, gender politics, and world markets recur throughout the book, I have not dedicated individual chapters to them, because other scholars have already analyzed the articulation of these themes in map art.[92] In attending to aspects of global modernity that have not received sustained attention in the context of map art, my study broaches the disenchantment of the world; standardization of time; combined and uneven development; utopian social planning; constructions of bordered statehood; the ontology of calculability; rhetorics of objectivity and scientific authority; and digital technologies. Though, admittedly, overviews of map art often mention topics of state bordering and cartography's digital transition, I explore these themes through focused, chapter-length analysis of selected artworks: core samples in a field where synoptic surveys predominate.

This book is structured as follows. In exploring how map art tests and reconfigures received conceptions of global modernity, the first four chapters address artworks that thematize cartographic projections of order onto the times and spaces of a contingent world. Beginning with the disclosure of a measurable and malleable earth through global mapmaking (chapter 1), the book progresses through the cartographic construction of a calculative global temporality (chapter 2); transparent and transformable urban spaces (chapter 3); and insular and homogeneous nation-states (chapter 4). By foregrounding temporal unevenness, social unruliness, and worldly entanglements in modern mapping cultures, map artworks are seen to undermine the myths of objectivity and narratives of rupture that constitute global modernity. These chapters also build a cumulative image of the calculative ontology undergirding modern cartography, on the basis of which the book's final two chapters establish map art's distinct value amid recent shifts in mapping cultures. Although map art joins with

digitization in reclaiming cartography from professional control (chapter 5), I also emphasize how map artworks undertake the more fundamental task of reimagining what mapping is, means, and might become (chapter 6). The detail of the chapters is summarized below.

After this introduction, chapter 1 establishes the book's central problematics by attending to a scenic painting made by the Soviet artist Solomon Nikritin in 1935. *The Old and the New* depicts a bare geographical globe amid figures symbolizing tradition and progress in a nebulous wilderness. In exploring this painting, I draw upon philosopher Peter Sloterdijk's argument that terrestrial globes manifest a post-theological spatiality and arch symbol of modernity. I show how Nikritin imagines the transition, in the context of Soviet modernization, from premodern cosmographies to a modern view of the earth, disclosed as a disenchanted globe. In *The Old and the New*, global cartography has conflicted implications for modern culture: on one side, the mapped globe estranges people from place and supplants traditional worldviews, while, on another, it challenges modern subjects to consciously originate new spatial orders. Thus, on my interpretation, *The Old and the New* foregrounds an abiding modern impulse to map meaning and order onto a disenchanted earth in which neither inhere. This sets the backcloth or bass note against which each of the subsequent case studies explore different (often conflicting) cartographic constructions of time and space in a contingent world.

The first is the uniform temporality built through modern mapping, which I address in chapter 2. My focus is *Forthrights and Meanders*, a series of maps presenting obscure imagined geographies that were printed and drawn on rice paper by the U.S. artist Alison Hildreth from 2009. Whereas cartography is routinely identified first and foremost with space, Hildreth's series foregrounds the cartographic construction of temporality, contesting the universal and calculative apprehension of time that prevails in modernity. Whereas cartography has replaced the overlapping temporalities of traditional societies with globally coordinated clock time, *Forthrights and Meanders* combines elements belonging to radically different moments of history.[93] These polychronous cartographies shatter the singular temporality

reinforced by modern mapping. As such, Hildreth's map art is especially well constituted to grapple with the clashing temporal dynamics of combined and uneven capitalist development, as well as the encroaching ecological disasters it has brought about.

Having explored artistic experiments in cartographic time, my argument turns to artworks in which maps are enrolled to radically reimagine and reconstitute urban space. Chapter 3 attends to a series by the Dutch artist Gert Jan Kocken, named the *Depictions*, in which found maps, made in pursuit of conflicting ideologies during the Second World War, are combined digitally into composite representations of cities such as Amsterdam, Berlin, and Rome. Layering together hundreds of different cartographies, the artworks encapsulate, but also query, the connections among maps, states, and warfare in the practice of modern world-making. I read Kocken's *Depictions* in conjunction with Zygmunt Bauman's conception of the modern state as a "gardener" of society and space, highlighting the transformative potential released in state military mapping, but also unevennesses and dialogic complexities in even apparently totalizing state projects.

In building an image of modernity as a contested garden, in which maps precondition the remolding of a measurable and malleable world, Kocken's *Depictions* constitutes the conceptual core of this book. In further exploring mapping's construction of modern space, chapter 4 thematizes a key cartographic figure through which the modern state has been imagined historically: the geographical island. It attends to *Utopia*, a composite digital cartography made by the Japanese artist Satomi Matoba in 1998. This work brings together two found maps—one presenting Pearl Harbor, Hawaii; the other Hiroshima—to form a single island. I unpack the image in relation to a longer tradition of insular imaginations in modernity, principally Thomas More's treatise *Utopia* of 1516, in which the bounded geographical form of the island serves as the template through which the nascent modern state was envisioned and realized. Matoba undermines this trope of the bordered, internally homogeneous state by bringing together the once distant, politically opposed sites of Hiroshima and Pearl Harbor as one island state. Beyond the naïvely utopian gesture of reconciling twentieth-

century enmities, *Utopia* articulates the repressed global hybridity that persists within and astride even the sharpest delineations of statehood.

If the first four chapters emphasize how cartographic constructions of time and space rest on the ontology of calculability, the final two chapters show how blurring art and cartography challenges this ontology as part of the larger "undisciplining of cartography" described in this introduction. Chapter 5 engages two mapping performances by UK-based walking artist Jeremy Wood. In *My Ghost* (2000–ongoing) and *Meridians* (2005), Wood uses GPS to trace his grounded mobility, turning his moving body into a "geodetic pencil" capable of walking/drawing large-scale mappings. Whereas philosopher Michel de Certeau describes cartography as an elevated visuality, regimenting urban practice from above, my argument stresses how Wood's mappings conflate lived mobility and synoptic cartography. Extending mapping to the street, his practice exemplifies mapping's digital expansion beyond institutional domains. The chapter closes by showing how Wood's art also exposes slippages, dissonance, and pretentions of existential security in digital mapping's worldview of securely calculated locations, which are recast as ghostly projections in a universe without essential orientation. Hence, while *My Ghost* and *Meridians* participate in digital mapping's diffusion beyond powerful institutions, they also indicate how GPS and GIS reproduce the ontology of calculability and indeed accentuate its internal contradictions.

A more meaningful intervention in cartography, I conclude, would not just spread mapping practice to an enlarged social field, but qualitatively reimagine mapping itself. In this project of imagining new cartographic ontologies, map art distinguishes itself from wider shifts in contemporary mapping cultures. Chapter 6 takes up this argument by exploring British painter and director Peter Greenaway's *A Walk Through H*, a 1978 film made up almost entirely of maps. The film narrates an ornithologist's posthumous journey into the afterlife, tracking across ninety-two maps, all of which present imagined terrains. I unpack Greenaway's cinematic cartographies in relation to the quintessentially modern ontology explored throughout this book, in which a meaningless world is rendered measurable

and malleable through cartographic practice. *A Walk Through H* grasps mapped space differently. Here, cartographies do not represent a preexisting measurable reality, but rather performatively manifest and unfold shifting infungible geographies. Beyond merely "taking the map back" from scientific control, *A Walk Through H* transcends the received assumptions about representation and objectivity through which institutions claimed authority over mapmaking in the first place. Released from the ontology of calculability, rich fantastic geographies proliferate in Greenaway's film: mapping beyond measure.

Fig. 3. Solomon Borisovich Nikritin. *The Old and the New. A Group Portrait.* 1935. Oil on canvas, 178.5 x 216 cm. From the collection of the State Museum of Arts of the Republic of Karakalpakstan, named after I.V. Savitsky. Nukus. Karakalpakstan, Uzbekistan.

1 The Shock of the Whole

Phenomenologies of Global Mapping
in Solomon Nikritin's *The Old and the New*

A painting made in the Soviet Union between the world wars offers an intriguing vision of global cartography at work in the social world (fig. 3).[1] Four figures people a wilderness enshrouded by roving mists, which obscure and diffuse the sunlight behind. Two characters at the little group's flanks personify social ills like allegorical figures in a medieval morality play: idolatry, an impassive statue of Venus, and poverty, a maimed and emaciated beggar, who tips an empty tin toward the viewer's charity. By contrast with this outer pair, the central figures embody health and modernity. Unmistakably they belong to the iconography of twentieth-century communism: each a model for their gender type, the two strike purposive postures with muscled bodies clad in clean, practical overalls. Her feet stood wide, the female worker's pointing gesture recalls similarly posed statues of Vladimir Lenin, or even Christopher Columbus, but here aiming to collectivize the east, not colonize the west. She towers above her comrade, whom for sake of ease I shall call "the Bolshevik." He is absorbed in contemplating a pale globe, which he holds, conspicuously, immediately before the female worker's groin. The rock-blue sphere seems undifferentiated at this distance from the picture plane; unmarked by landmass, it could be construed as a blank world to be reimagined, or as exemplifying the obscurity of geographical science in these seemingly primordial surroundings.

The picture has the title *The Old and the New. A Group Portrait,* and was finished early in 1935 by a Ukrainian artist working in Moscow named Solomon Borisovich Nikritin (1898–1965). At six by seven feet, *The Old and the New* is Nikritin's largest composition, in which he combines and

sums up his three longstanding themes of landscape, social contradiction, and global geography. Given the backdrop of Soviet modernization against which Nikritin undertook the work, which was completed in year two of the second Five-Year Plan, its title might be taken to imply a progressive transition from tradition to modernity, with the beggar and Venus belonging to a declining past, and the two Communists to a coming condition of classless plenty. But any apparent progressivism is immediately dispelled by the shroud of ominous fog and claustrophobic proximity of such uncommunicative figures. It is unsurprising, then, that the picture, which Nikritin presented mere months after the strictures of socialist realism were promulgated in August 1934, proved too politically enigmatic for exhibition in the Soviet Union. In April 1935 a committee of artists and critics barred *The Old and the New* from public display. A transcript of their deliberation survives: "After looking at such a work," critic Osip Beskin concluded, "one finds it dreadful to be alive for a month, in spite of all the gaiety of our life."[2] This animus was provoked by the supposed eroticism conjured by the globe's intimate position and the curvaceous worker, as well as the picture's more general idiosyncrasy and ambiguity of intent. These issues were debated in political terms, with the committee linking the artwork's "individualist" and "erotic" tendencies to work by "Italian Fascists."[3] Gloomy, eclectic, and laden with enigmatic symbolism, the painting stood at odds with the emerging political culture defined by uplifting, wholesome, and ideologically transparent socialist realism, its censorship indicating Nikritin's growing marginalization as a "formalist" artist through the 1930s.[4] *The Old and the New* remained in the Nikritin's possession until 1976, when it was acquired by the independent Nukus Museum of Art in Uzbekistan, where it hangs today.[5]

Having gone largely unmentioned in histories of Soviet art, the picture came to my attention thanks to an essay by John E. Bowlt, which provides an illuminating account of Nikritin's painting in the context of Soviet aesthetic and political culture in the 1930s.[6] Although my discussion of *The Old and the New* will return to the shifting politics of Soviet space during that period, this chapter largely draws back from the historical contexts in which

Nikritin worked to explore the picture as an artistic meditation, manifested in painting, on what I term "phenomenologies of global mapping." By this, I mean to grasp the ways that global mapping shapes modern conceptions of space and modes of inhabiting it.[7] What follows is therefore an analysis of the different spatialities produced by global cartography in Nikritin's painting, which I will argue provides a concentrated image of the mutually constitutive connections between maps, modernity, and globalism. Now, it might be cautioned that this construal invests too much in the painted globe, which is so reduced and schematic that were it not for the stand on which the sphere is mounted it might scarcely register as a globe at all. But it is precisely because the globe is depicted modestly that *The Old and the New* sheds light on the phenomenological dimensions of global maps. As a scenic painting depicting a globe as one element embedded and experienced among others within an encompassing context, the picture *emplaces* global mapping, foregrounding the relational work performed by globes on surrounding subjects and their intuitions of space.

To grasp the spatialities unfolded through the globe in the picture, the chapter begins by invoking Peter Sloterdijk's conception of terrestrial globes, which he interprets from a Nietzschean perspective as manifesting a post-theological spatiality and arch-symbol of modernity. Being bound up so closely with the modern condition, terrestrial globalism for Sloterdijk renders humanity insignificant, relative, but also self-sufficient, even empowered; articulating a space without divine plan or natural essence, the modern globe compels people and polities to recognize themselves as the only source of meaning, order, and value. Following a prolegomenon elucidating this account of the modernity of global mapping, the central discussion establishes a close reading of the picture in conjunction with Sloterdijk's theory. Circling the depicted figures to unpack their existential attitudes toward the central globe, my argument demonstrates how the global spatialities depicted in the picture are riven by two countervailing yet indissociable tendencies—one estranging modern subjects from place and meaning, the other empowering them to establish new spatial orders. Regarding the first, I stress global cartography's role in the disenchantment

of the world, arguing that Nikritin's globe inculcates a distanced stance toward locality, while replacing the closed meaningful worlds of traditional cultures with the meaningless facticity of the modern earth. As I move into the second half of the chapter, my focus turns to how these estrangements precondition more creative and affirmative possibilities. The pair stood centrally in the painting are read as modernists who, recognizing themselves as occupants of an earth lacking inner essence or metaphysical plan, stand poised to project their own social visions onto the otherwise formless globe.

Viewed in the round, neither nostalgic estrangement nor modernist empowerment emerges as dominant in the picture. Enlightenment and disenchantment are held tensely in balance. This does not imply that *The Old and the New* is contrary or undecidable as a painting; the dialectic it stages between estrangement and affirmation is rather inherent in modern globality itself. The chapter's final section takes up this dialectic in a historical register. Posing the picture alongside revolutionary global images representing socialist internationalism, as well as the planetary icons through which globalization is articulated today, I show how Nikritin's vision of modern subjects inscribing meaning into an otherwise blank globe has played out concretely in two historical contexts. My closing suggestion, however, is that the picture's bare painted globe returns us to the meaningless facticity of a disenchanted earth, onto which (and in reaction to which) these global rhetorics are projected.

To build this account of the *The Old and the New*, I begin by unpacking Sloterdijk's key statement on the modernity of terrestrial globalism, through which I approach the global fulcrum of Nikritin's painting as a disenchanted earth, held up before unsettled but newly affirmed modern subjects.

The Orb Is Dead: The Modernity of Terrestrial Globalism

Halfway through *Globes*, the second book in *Spheres*, Peter Sloterdijk's three-volume exploration of "manifold universes of existential spatiality," there is an excursus treating the meaning of modern terrestrial globes.[8] Here Sloterdijk restages the famous parable of the madman in Nietzsche's *The Gay Science* in an altered form.[9] Again the lunatic charges into the

marketplace, again he delivers a fraught obituary for divinity, and again the consequences fall on deaf ears. Sloterdijk's retelling differs from Nietzsche's original, however, where the passed godhead is referred to, strangely, as a kind of space. In place of the famous pronouncement on God's death, the madman proclaims: "The Orb is Dead." By "the Orb," Sloterdijk is referring specifically to Christian-Aristotelian cosmography, which conceived of earth as at the center of a firmament of interlocking crystalline spheres. Although a culmination of Christian and Hellenistic thought, this Orb has a larger resonance for Sloterdijk as a synecdoche for religious and metaphysical conceptions of space generally.

In speaking this "unspoken statement," which reimagines the madman's "God" as the Orb, Sloterdijk is inviting readers to consider probably the best known statement on the character and consequences of modernity in spatial terms. For Nietzsche, modernity was the condition that followed the dissolution of social values thought to derive from a transcendent, that is, superhuman and supersensible, rationality. Transcendent imperatives having waned, modernity involves peoples and polities coming to recognize themselves as the origin of the values they esteem. Modern subjects must consciously formulate the ideals and ends that guide their practice without recourse to metaphysical legislation. Redirecting this basic Nietzschean narrative toward questions of spatiality, Sloterdijk insists that the modern crisis of theological and metaphysical regimes implicates received modes of inhabiting space. "God is dead," he writes. "What this actually means is that the Orb is dead, the containing circle has burst, the immune magic of classical ontotheology has lost effect, and our faith in God on high . . . has become powerless, groundless and hopeless."[10] The quotation indicates that for Sloterdijk premodern societies conceived of space ontotheologi-cally (manifesting a theological design or order). For a vivid example, see the thirteenth-century Ebstorf *mappamundi*, in which earth is subtended by the body of Christ, whose head, hands, and feet protrude from the world's extremes. Ontotheological apprehensions of space such as these were imbued with meaning in that beings were conceived as arranged in a created order, in terms of which the world could be known and related to.

Their inhabitants lived in what Clarence J. Glacken has called "the earth as a planned abode for man."[11]

By contrast with the meaning and closure of premodern spatialities, modern subjects undergo the world as an "indifferent machine of becoming that, inaccessible to allocations of meaning, continuously turns within itself."[12] To focus on the existential security lost with ontotheological spatialities, however, is to repeat Nietzsche's madman's fixation with the negative dimensions of modernity, which can be countered by asking instead what *emerges* from the waning of premodern space. In the loss of ontotheological Orbs, Sloterdijk's madman experiences the "birth trauma of the exposed planet," an uneven spheroid moving within a boundless, planless, and indifferent cosmic extension:

> After the destruction of heaven, it was the earth itself that had to take over its function as the last large-scale curvature. This physically real earth, as an irregularly vaulted, unpredictably uneven and grooved body, now had to be circumnavigated and recorded as a whole. Thus the new image of the earth, the terrestrial globe, rose to become the central icon of the modern worldview. Beginning with the Behaim Globe of Nuremberg, made in 1492—the oldest surviving specimen of its kind—and continuing up until NASA's photograms of the earth, the cosmological process of modernity is characterized by the changes of shape and refinements in the earth's image in its diverse technical media.[13]

Hence, the death of holy Orbs is also simultaneously the birth of the terrestrial globe, which can be considered modern, not least in the historical sense that global maps, although constructed on the basis of ancient precedence, were developed in the early modern period and have prevailed since. Beyond chronological correlation, though, the global earth also has intrinsic connections with modernity: having been established by cartographic projection and survey, not religious transmission, terrestrial globes for Sloterdijk figure forth postontotheological space. They manifest an enlightened and disenchanted apprehension of the earth, with a twofold significance. On one level, globes amount, in Nietzsche's words, to a

The Shock of the Whole

"self-belittlement of humankind," which becomes "arbitrary, loitering and dispensable" when human cultures are conceived in their finitude as the transient occupants of an insignificant cosmic body.[14] On another, globes affirm modern subjects, for in a world without transcendent order humans must become their own source of meaning.

Now, Sloterdijk's *Globes* represents but one work in an extensive body of scholarship concerned with the cultural import of global imaginations, from Denis Cosgrove's compendious genealogy of terrestrial imagery to Ursula K. Heise's emphasis on the critical value of planetary knowledge, as opposed to the received localism of much environmental discourse.[15] Though I invoke various insights from this literature, this chapter foregrounds Sloterdijk's excursus because his Nietzschean insistence on an interplay between nostalgic estrangement and modernist empowerment in global spatiality grasps what I see as the core of Nikritin's vision. Before exploring *The Old and the New* in light of Sloterdijk's account, however, I want to qualify my summary of the latter in view of an important counterclaim. Global maps, as Sloterdijk's "macrospherology" amply attests, have long served religious institutions and purposes: clear historical grounds on which to refute terrestrial globalism's connection with disenchantment. But for Sloterdijk modern globalism's emergence also was (and is) a fraught historical process, drawn out over centuries and continually provoking countervailing movements of reenchantment as it unfolded. Faced with the shocking fortuity of the emergent spatial paradigm there arose retrogressive and reparative reactions against modern spatiality: attempts to deny it (Cesare Cremonini refusing to look through Galileo's telescope); to make poetic and intellectual accommodations with it (the lingering conceit of a "music of the spheres"); or to reenchant the desacralized world (the world map sometimes used by DAESH [Islamic State of Iraq and Syria] in their media imagery). Pointing to instances of religious globality ultimately makes little argument with Sloterdijk's understanding of terrestrial globalism as postontotheological, then, for he would understand them as attempts to delay or embellish the facticity of modern space—an impulse to exorcize or "garnish the immeasurable with a colorful array of worlds."[16]

If Sloterdijk's excursus establishes the far-reaching existential conse-
quences of global mapping, which replaced closed worlds of meaning
with a disenchanted earth, Nikritin's *The Old and the New* depicts how
this spatiality plays out in a specific social scene. My reading of the picture
examines the figures' existential attitudes toward the central globe, which,
following Sloterdijk, I take as an articulation of modernity. At once revered
and denied, the globe emerges as simultaneously unsettling and affirming:
a frightening meaning-deficient earth, mapped as a graspable globe over
which modern subjects might exert agency.

Phenomenologies of Global Mapping

I begin with the only figure in Nikritin's picture to examine the globe: the
Bolshevik, whose absorption in the viewing is complete (fig. 4). Spherical
cartographies are especially elusive and enticing, since much of their sur-
face extends over the invisible far side of their curvature. The Bolshevik
submits to this visual appeal. Gripping the stand with his right hand and
revolving the sphere with his left, his gaze falls along its turning equator.
Viewed through the negative moment in Sloterdijk's theory, which holds
global maps to have dissipated the secure existential horizons of traditional
societies, the Bolshevik exemplifies the estrangements attendant upon
modern globalism. In a much-cited essay probing how global figurations
frame human relationships with the environment, Tim Ingold has argued
that "the world imagined as a globe, far from coming into being in and
through a life process . . . figures as an entity that is, as it were, presented
to or confronted by life. The global environment is not a lifeworld, it is a
world apart from life."[17] The global image appears only from afar as "an
object of contemplation," not through lived entanglements with the earth.[18]
This "global ontology of detachment" is for Ingold connected with modern
technology, which requires that the world be "presented as a spectacle" to be
ordered from a disengaged managerial perspective.[19] Thus globes reinforce
a correspondingly distanced form of practice, in which people and places
are engaged with cartographic terms as homogenized and manipulable
points set out in a mapped array.

Fig. 4. Solomon Nikritin. The Bolshevik. Detail of *The Old and the New*.

The figure of the Bolshevik personifies the distanced attitude toward lived space inculcated by global maps on two levels. First, he is external to the representation, which he can survey and even reimagine, but not enter and immerse himself in as a part of its whole. Second, he appears uninterested in, even unaware of, his immediate environment. No longer an inhabitant bound into an encompassing world, the Bolshevik has internalized the global view and relates to his surroundings as they appear through global mapping: insignificant, relative, and distant. He has become what Ingold calls an "exhabitant" of the earth, for whom the world is not a surrounding context in which to dwell but a surface to survey.[20]

The obverse of the Bolshevik's fixation with the spherical cartography before him, then, is his phenomenological and ethical disengagement from the surrounding scene. This lack of social commitment is all the more striking given that Nikritin modeled the figure on a *komsomolets*—a member of the Communist Party's youth wing, the Komsomol, in whose program the youth is hailed as "the vanguard of the proletarian revolution," and as giving "thousands of brave warriors for a better future."[21] As one such warrior, it seems strange that the Bolshevik should allow starvation and tradition to persist around him while attending instead to the globe. Perhaps his preoccupation with geography is only momentary, after which time he will fulfill his vanguardist commitments by filling the beggar's bowl, following his comrade's gesturing hand, or toppling the idolatrous statue back into the swamp. But ultimately the globe is more than a passing curiosity for its enrapt beholder, who chooses not to pursue these outstanding commitments: the globe alone commands his attention and informs his behavior. The Bolshevik's strangely weightless lean compounds the idea that global mappings divorce viewers from their social and spatial context. It makes his alienation literal, as if the globe has induced the Bolshevik to escape the existential scene altogether—a Soviet Apollo transcending gravitation and locality, globe in hand.

This motif is developed more baldly in a watercolor Nikritin made eleven years earlier, with an ironic title, *The Resurrection of the Registration Clerk 2*, suggesting a caricature of Soviet bureaucracy (fig. 5). The picture employs

The Shock of the Whole

a simultaneously Christian and Apollonian imagery of transcendence and light to depict the eponymous functionary as an androgynous nude equipped with globe and abacus, levitating cross-legged in a sunlit sky.[22] This image recalls a broader cast of flying figures in Soviet modernism, from *Over the Town* (1918), Marc Chagall's self-portrait airborne over Vitebsk, to Vasily Kamensky's poetic biography of his spiritual alter-ego, whose "searching Spirit missed . . . the flight of the body under the clouds, the swift discharge into the skies."[23] These alternative imaginations of flight and fliers cut a sharp contrast with the Bolshevik, who neither enjoys Chagall's expansive aerial views, shines like Nikritin's bureaucrat, nor pursues Kamensky's dream of Futurist free flight. Shadowy, unbalanced, and withdrawn into his globe, the Bolshevik's floating precariousness registers less as Apollonian transcendence than as mere alienation—detachment from place.

Recall that for Sloterdijk this unsettled mode of habitation results from a far-reaching historical transition, in which the terrestrial globe displaced closed premodern spatialities. In Nikritin's picture, the globe's historical significance is brought into relief by the statue of Venus, which derives from Hellenistic cultures that attributed spherical form to the cosmos and experienced the globe from within (figs. 6 and 7). Indeed, Sloterdijk contrasts the reified spatiality of modern globalization with that of the ancient Greeks, who had "the privilege of inhabiting a real cosmos . . . a closed and comforting world."[24] The Venus originated from existential spaces oriented toward cosmic order: according to Aristotle, the pre-Socratic thinker Anaxagoras even claimed that life was worth living if only to "apprehend the heavens and the whole order of the universe."[25] Belonging to this older worldview, which conceived of the inhabited world as embedded within a sublime and meaningful universe, the Venus most approximates Sloterdijk's Christian madman. But unlike the madman, who panics at the withdrawal of metaphysical space, the statue seems undaunted by the modern globe. Possessed of a calm solidity, it looks disdainfully past the mapped earth, as if recalling the better (enclosed and meaningful) cosmographies to which she is anachronistically hidebound. If statues could think, she would scorn moderns who manage space cartographically from without; if they

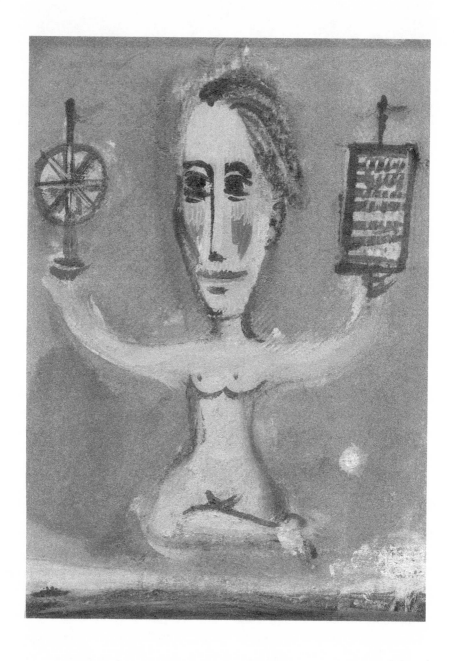

Fig. 5. Solomon Nikritin. *The Resurrection of the Registration Clerk 2*. 1924. Pastel on paper, 9.5 x 13.4 cm. State Museum of Contemporary Art, Thessaloniki. Reproduced by permission of the Costakis collection.

Fig. 6. Solomon Nikritin. Venus. Detail of *The Old and the New*.

Fig. 7. Solomon Nikritin. The Beggar. Detail of *The Old and the New*.

could experience, she would have undergone the loss of existentially secure worldviews in what Max Weber, following Friedrich Schiller, called the "disenchantment of the world." For Weber, premodern societies experienced space as "a great enchanted garden," infused with received stories and figures.[26] In the scene of modernization suggested by *The Old and the New*, such gardens have been overtaken by dense fog, which obscures the meanings once immanent to the Hellenistic and Christian worlds through which the Venus has passed. A lost garden is hinted at pithily by a single yellowed leaf lying dead in the foreground.

The Shock of the Whole

Dismayed by cartographically induced distance and disenchantment, one might search out locality in the picture to counteract the adverse effects of global mapping. Place-based existence continued amid globalism is represented here by the beggar at the composition's right flank (figs. 6 and 7). Of the four figures it is he, who neither examines the globe nor laments lost Orbs, who dwells in place most completely. One might try to construe this occupation romantically as establishing a refuge of authenticity, but there is little in *The Old and the New* to affirm locality. Having lost his lower legs, perhaps in war, the beggar covers his remaining thighs with a board: far from celebrating place, he is condemned to it.[27] This becomes clearer if we compare the figure with a painting Nikritin made in the mid-1920s named *Journey Around the World*.[28] In it, two travelers use a globe as a tool with which to navigate a desert, disregarding centuries in which globes were essentially symbolic objects. Unlike the Bolshevik, who is absorbed in his globe, these figures view theirs in interaction with the landscape. Holding the globe to the sun while riding a miniature automobile, the pair journey around a borderless postrevolutionary world, symbolized by a little red flag flying from the globe. By contrast with the emancipated global movement of these travelers, the beggar's place-based world has little to recommend it. Emaciated and yellow with malnutrition, he is unsheltered and grimly immobile. Even if the beggar dwelt in place willfully, his surroundings are poor compensation for the experiential immediacy foregone by the Bolshevik and the metaphysical meanings mourned by the Venus. He might concur with Sloterdijk's madman's nostalgia for the Christian Orb, for its inhabitants upheld the principle of charity.

The picture does not affirm place against globality, then, despite recognizing distance and disenchantment in global mapping. None of the figures truly inhabits their place: clad for urban labor, the worker and Bolshevik seem misplaced in the wilderness; the beggar's naked torso is unprepared for exposure, while the statue, normally guarded in curated interiors, has been abandoned to the elements. Nor are they responsive to one another; no two gazes meet, not even the young Communists'. In fact, it can be argued that the depicted locality, far from countering globality,

Fig. 8. Solomon Nikritin. Preparatory study for *The Old and the New*. Early 1930s. Pencil and ink on paper, 20 x 15 cm. State Museum of Contemporary Art, Thessaloniki. Reproduced by permission from the Costakis collection.

actually embodies the estrangement and disenchantment produced by globes. This is suggested by one of the many preparatory drawings for *The Old and the New*, which shows the scene boxed into a frame crossed by intersecting ellipsoids and circles (fig. 8). Although this may have been used as a compositional schema through which Nikritin organized the painting, the unnecessarily repetitive global lines, some of which do not even enter the frame, indicate a further significance, especially given the importance accorded globes and discs in Nikritin's theories.[29] The drawing shows existential space not simply containing a globe, but itself caught within the graticular constructions of which globes are made. Place, here, has been circumscribed and pervaded by globality in advance. Following this sketch, it becomes possible to see the locality depicted in *The Old*

and the New as but another expression of the modern (global) spatiality mapped at its center: the watery fog obscures the meanings once immanent to premodern Orbs, and the discordant congregation enacts the estranged sociality induced by the global perspective, while the individual figures take their place within a rigidly rationalized graticular space.

A blank globe stranded in a wasteland among starving beggars, forgotten statues, and estranged moderns: it is little wonder that Bowlt describes the scene as an "apocalyptic limbo."[30] But reactions to the disenchanted earth need not be despairing or nostalgic. Approaching *The Old and the New* through Sloterdijk's Nietzschean moment, we see how the terrestrial globe, while profoundly daunting, might ultimately empower the surrounding subjects, challenging them to assert themselves against the blankness of modern space. This entails taking a self-affirmed attitude to the disenchanted earth, originating modes of inhabiting a desacralized planet that neither bemoan alienation nor long for past cosmic orders, but pursue instead the creative possibilities open to modern subjects.

I begin my discussion of empowered modern meaning-making in Nikritin's painting with Marshall Berman's definition of modernism: the "attempt by modern men and women to become subjects as well as objects of modernization, to get a grip on the modern world and make themselves at home in it."[31] Only one such attempt is discernible, immediately, in *The Old and the New*. Whereas the globe still overawes the Bolshevik, his worker comrade seems to have accepted its disenchanted spatiality and risen to engage her surroundings anew (fig. 9). She rests her right hand assuredly on her hip and extends her left arm outward in a purposive gesture that seems determined to influence the space in which she stands. In confronting the globe's implications and facing her environment thus, the worker meets the challenge, forfeited to her willful design by the passing of metaphysical spatialities, of consciously forging a habitation on a disenchanted earth, presenting a positive counter to the estrangements all around. Construed through her, the globe presents a newly factual and malleable earth as it appears to empowered moderns, ready to revalue and remake the desolate landscape. Unencumbered by metaphysical constructs, such partisans of

The Shock of the Whole

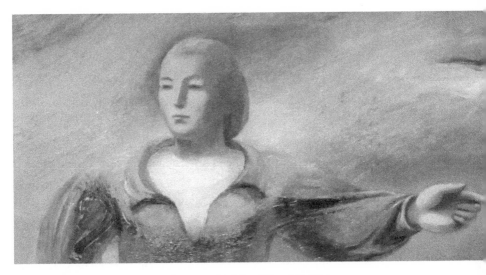

Fig. 9. Solomon Nikritin. The worker. Detail of *The Old and the New*.

modernity recognize themselves as givers of meaning to earthly space, asserting their will over imagined deities or essentialized natures as the origin of existential order hereafter.

The pointing worker can thus be read as embodying the modernist self-assertion resulting from the disintegration of premodern Orbs. In having the globe coincide with her lower abdomen, however, Nikritin's picture indicates a sexual dimension to globalism that went unremarked upon in Sloterdijk's excursus. The coincidence equates globality with gestation and female sexuality, and global viewing with masculine desires and controlling impulses. Yaakov Garb has written about earth imagery from an ecofeminist perspective, which, in a similar manner to *The Old and the New*, proposes "structural resonances between men's violence toward nature and toward women."[32] In the regime of modern globalism, Garb suggests, the earth's experiential realities are fixed by an objectifying visual apparatus; its resources are bared before, and exploited by, modern institutions. As several theorists have emphasized, cartographic visions of the whole earth epitomize a key strategy through which masculinist discourses secure

their authority over other forms of knowledge and practice: what Donna Haraway has famously described as the "God's-eye trick."[33] The trick is that of "seeing everything from nowhere," or rather claiming to do so as a means of having one's own perspective accepted as privileged with respect to others. For Haraway, masculinist visualities articulate partial, situated, and interested representations of the world while rhetorically denying their very partiality, situatedness, and interestedness.[34] The God's-eye trick establishes the authority of official representations by promulgating their supersession of perspectival limitations or bias, while also asserting the subjectivity or partiality of competing visualities. This rhetorical construction of hierarchies can also be seen in the discursive distinctions between art and science in mapmaking that I traced in the introduction. To claim "disembodied scientific objectivity," writes Haraway, supposedly perspective-free masculinist visualities must "distance the knowing subject from everybody and everything in the interests of unfettered power."[35] This entails both a denial of embodiment and the establishment of physical distances, such that the gaze is no longer caught in force field of worldly influences while (seemingly) contextualizing its objects completely. Indeed, Garb argues that phallic images of rockets rising into extraterrestrial space play out male fantasies of disentanglement, disembodiment, and disengagement.[36] Echoing both Ingold and Haraway, he claims this "extraterrestrialism" and the global view to which it gives rise amount to an "escape from participation" in reciprocal ecologies, communal life, and the basic immanence of all perspectives and knowledge itself.[37]

For Garb and Haraway, then, global visuality is inextricably bound up with fantasies of a transcendent, empowered masculine subject. The rhetorical gestures of denying embodiment and distancing the gaze are especially pronounced in modern global cartography and feature centrally in *The Old and the New*. In crossing globe and (female) groin before the Bolshevik's determined male gaze, Nikritin's picture teases out these masculinist impulses to transcendence, authority, and control in modern globalism. Disentangling the gaze from the distorting influences at work on the earth's surface, the modern global view is a perspective that pretends not to be a

perspective: a "conquering gaze from nowhere."[38] The Bolshevik certainly appears to grasp the world in its totality while himself being "above" or outside the worldly contingencies it represents. Denying his bodily emplacement *in* the world, his perspective is ostensibly freed from limited horizons of earthbound situations. Encompassing the mapped globe in a distanced, and thus untainted, view, he strives for that "single privileged viewpoint that gives us the whole picture, the one true representation."[39] If the masculine observer assumes this disembodied, paradoxically unpositioned viewing position, the object of his observation is equated with embodiment and femininity through the earth's visual overlap with the worker's abdomen. Seen in this light, the disenchantment of the world described by Sloterdijk is not simply the passing away of Christian divinity. In Nikritin's gendered iteration of disenchantment, masculinist modern cultures usurp the divine perspective through the God's-eye trick, falsely transcending what was once creation so as to manage and redesign the earth, which is correspondingly reduced to a feminized, exploitable surface.

In this way, *The Old and the New* confirms Garb's and Haraway's feminist critiques of the global view, which is seen to both encapsulate masculinist constructions of a disembodied and disinterested visuality, and to present the whole earth as a passive body for that domineering gaze to conquer, engineer, and control. Still, just as Haraway calls on feminist revisions of visual theory to expose the "radical historical contingency" of the godly gaze epitomized by global cartography, Nikritin is aware that his global vision is but one construction of space and sexuality and can be formulated otherwise.[40] Indeed, in the process of creating *The Old and the New* he also considered neutralizing the masculinist gendering of the earth. In some preparatory studies, the globe does not align with the female worker, while the Bolshevik, still immersed in his proximate environment, is not transported in dreams of extraterrestrial escape and planetary power. One sketch for the figure of the Bolshevik, though, goes further than this, directly reversing the masculinism of the global view (fig. 10). Given the often prudish sexual discourses that prevailed in the Soviet Union in the 1930s, which promoted wholesome and procreative heterosexual relationships,

this drawing is surprisingly erotic. The Bolshevik, whose clearly defined muscles are visible through a tightly fitting vest, leans back languidly with one thigh held open. A far cry from the ideal Stakhanovite producer, he reclines on a pillow that has been incongruously transposed into *The Old and the New*'s outdoor setting. In an alternative gendering of the earth, the globe's stand rests against the Bolshevik's groin. Instead of forgetting his embodiment in contemplation of the earth, he holds the globe closely to himself by the base, as if it were a bodily appendage. Whereas in the final painting Nikritin equates the globe with femininity, here the earth becomes a phallic projection or substitute, while global viewing takes on a reflexive, masturbatory connotation. Even more than *The Old and the New*, this small drawing has no clear import, serving instead to complicate imaginations of gender, global geography, and power. It is undecidable whether the image represents a critique of the global view as the masturbatory self-aggrandizement of scientific knowledge; an expansion of objectification such that reified global surface can be equated with male as well as female body; or a recognition that the global view, despite masculinist rhetorics performing the God's-eye trick, is just as embodied and emplaced as the world it represents. It is clear, though, that this picture deviates from conventional imaginations of the globe as the feminized object of masculinist vision, indicating how relations between the earth, gender, and power remain open to creative experiment and reformation.

Although Nikritin ultimately decided against the alternative gendering of the earth held out in this preparatory sketch for the Bolshevik, the final equation of globe with female abdomen in *The Old and the New* can be construed positively. Philosopher Hans Blumenberg has argued that distanced global imaginations, though existentially disquieting in that they reveal our insignificance in a meaningless universe, ultimately heighten humanity's attachment to the earth. This is because the earth undergoes a double revaluation when represented as a globe. If at first it loses its former value, becoming eccentric matter to be nihilistically remolded at will, when seen against aridity of deep space the earth again becomes precious: a "cosmic oasis . . . this miracle of an exception, our own blue planet in the

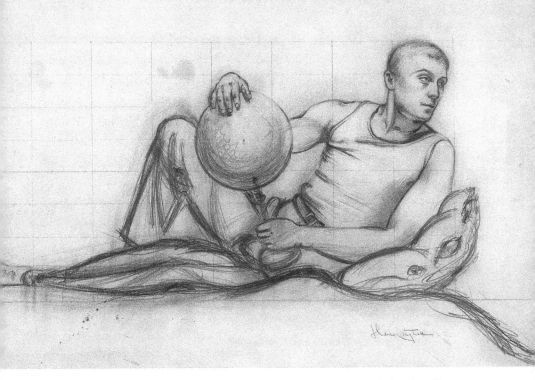

Fig. 10. Solomon Nikritin. *Seated Man with a Globe*. Preparatory study for *The Old and the New*. 1934. Pencil on paper, 49 x 39 cm. State Museum of Contemporary Art, Thessaloniki. Reproduced by permission from the Costakis collection.

midst of the disappointing celestial desert."[41] Through this lens, Nikritin's feminized globe becomes an invaluable womb, while the female worker's expansive gesture seems to acknowledge an earth for which humans are impossibly fortunate. Admittedly this reading, in conceiving the earth in feminized terms of a "womb" or "cradle," perpetuates discourses that reduce women to their reproductive functions.[42] Still, it conceives of the globe in a way that values earthly dwelling over extraterrestrial disengagement. If the Bolshevik seems fated to exemplify modern alienation and masculinist domination through his absorption in the global view, reading the globe through the worker counteracts this "Copernican trauma" by substituting

the estranged globe with an earth conceived as humanity's womb and only viable environment.[43]

Thus the worker enacts a spatiality apparently purged of not only the metaphysical cosmologies declared dead by Sloterdijk, but also the "Copernican" disquiet that followed their withdrawal. Yet even as the worker gestures resolutely over a pliant mapped earth, this ever-equivocal painting casts doubt on her modernist attitude. Might she consolidate the Bolshevik's distanced perspective by acting it out in social practice? Might her commanding point figure an insignificant, even hubristic gesture, destined to disappear into the swirling mists behind? The worker's very modernity seems dubious: her features and complexion resemble those of the Venus personifying tradition to her right, suggesting that "the new" is merely "the old" in modern overalls. And if the worker is distinguished only superficially from tradition, then the globe too might be little different from the premodern geographies it superseded and would share their pathologies and fate.

Mapping Meaning onto the Globe

Notwithstanding these intimations of hubris, for me the worker figure embodies the idea that the unsettling blankness or facticity of global spatiality is, in fact, a precondition of modernist self-assertion. The point is reinforced if we return to the painting's central vignette, depicting the Bolshevik's steely confrontation with the globe. His purposive gaze falls across a nebulous global surface almost inviting the imposition of form. Indeed, it requires no leap of imagination to envisage a pencil in the Bolshevik's left hand, with which he bestows significance on a meaning-deficient world. Building on these moments of empowered, modernist meaning-making in the painting, this final section poses different global imaginations that have prevailed historically alongside *The Old and the New*. First I discuss global images belonging to the contemporary iconography of globalization, then the imagery of socialist internationalism. Exploring the picture's resonances with these very different globalisms, I argue that Nikritin's work focuses a perpetual, constitutively modern impulse to map meaning and

order onto a fortuitous world. I take the blank central globe as my point of departure: an empty space and signifier through which I now engage some of the mappings that have enwrapped the disenchanted globe in constructed significance.

To begin, consider the global rhetorics pervading current visual culture. Unlike Nikritin's three-dimensional globe, today global maps are largely experienced as digital composites that can be instanced and interacted with on screens in countless quotidian settings, or as logos discarding all but the symbolic dimensions of global geography to create instantly consumable icons of corporate identity. Whether branding TNCs, focusing ecological anxieties, or finding a figure for the internet, globe icons tend to elicit cosmopolitan identifications and concerns. Although Nikritin's characters would scarcely recognize these concerns, still less identify with them, *The Old and the New* prefigures the mode of reception in which current global maps and imagery are consumed. My impression is that they are experienced in the backgrounds of lived practice (a browser tab icon, for example, or a clip introducing a newsroom broadcast), and that their efficacy derives from their being both pervasive and inconspicuous. This is confirmed by sociologists Bronislaw Szerzynski and John Urry, who, updating Michael Billig's notion of "banal nationalism," refer to an emergent condition of "banal globalism," in which cosmopolitan consumer-citizens are constructed through daily exposure to media motifs of global belonging.[44] Although such global motifs are rarely submitted to the kind of cerebral scrutiny applied by the Bolshevik, the state of distraction in which contemporary subjects experience them is exemplified by the beggar's spare stare, the Venus's turning away, and the metro worker's attention directed elsewhere. These figures ignore the central globe, but it stands centrally among them, shaping how they conceive and inhabit space all the more effectively for going unnoticed and unremarked. Thus the picture envisions a cultural situation subtly mediated by global mappings, prefiguring the phenomenological conditions through which globalism is constructed today.

Engaging banal globalism through *The Old and the New* also uncovers disquieting aspects of contemporary globality of which prevailing maps

and media motifs give little suggestion. Vittoria Di Palma argues that the mapping application Google Earth "creates the fantasy of an intimate globe," overcoming physical geography to condition an unprecedented accessibility of views and mutual looking across the planet.[45] Posing contemporary global maps and images alongside Nikritin's existentially laden group portrait deflates these fantasies of intimacy. The Bolshevik's intimacy with the globe has its corollary in local distance and disengagement, while mapped visions of world closeness, mutuality, and holism, when set against Nikritin's wilderness, become blindly optimistic rhetorics forcing significance onto a shifting blankness.

It is striking that an interwar Soviet painting should reflect current globalism, since much social theory has presented contemporary globalization as a negation of Eastern Bloc Communism, implicitly positioning the latter outside of globalist discourse. Nevertheless, the globe was one of the most prominent motifs in socialist visual culture. Figured in banners and prints, carried in parades as three-dimensional properties, or reworked by artists as different as the English romantic Walter Crane and the Latvian constructivist Gustav Klutsis, socialist globe imagery provided a concise visual symbol of global solidarity between workers. It emerged in the nineteenth century as part of the larger discourse of socialist internationalism, which sought, in the words of Leon Trotsky, "to put forward and defend the overall interests of the whole proletariat in its totality independent of nationality."[46] These associations are clear in a political poster designed in 1919 by Alexandr Petrovich Apsit entitled *First of May. The Workers of the World Have Nothing to Lose but their Chains, but they Have the Whole World to Gain* (fig. 11).[47] A crowd depicted as representing all world cultures and every trade, though comprised exclusively of men, holds a nighttime revolutionary assembly. The political vision espoused by the central, smock-clad speaker is conjured in the sky: a stark white earth whose nations are steadily merging into the global red of socialism. A scarlet banner declaring "Workers of the World, Unite!" billows around the vision, having been planted, significantly, in Moscow. Imagining Apsit's globe in the blank space of Nikritin's mandates a reinterpretation of *The Old and the New*. The two

youths become advocates of globalizing revolutionary gains in a border-crossing project indicated by the worker's expansionist gesture, while the Venus and beggar come to represent symptoms of residual tradition and morbidity, soon to disappear together with the boundaries that once divided the now united globe. But before long, it becomes apparent that *The Old and the New* undermines the positivity of socialist globalism. In the Apsit, the congregation is a community; though we might query the emergent hierarchy between the speaking individual and the listening crowd, this is a dialogic situation from which a common, indeed universal, project will emerge. The globe reveals a captivating social ideal, towering over a nocturnal scene in which darkness implies not danger but impending daybreak—the coming of a new society. In Nikritin's painting, by contrast, the proximity of the mute figures enacts a claustrophobic isolation, while the globe, far from unfolding a visionary future, belongs to the fallen present fully as much as the dead leaf, dirt ground, or beggar's bowl. Gloom swallows the distinction between night and day.

This mood of doubt and defeat befits the fortunes of socialist globalism in the Soviet Union. Whereas Apsit's poster helped revive revolutionary internationalism after the First World War, by the time Nikritin painted *The Old and the New* the expansionist program of the revolutionary organization known as the Third International or "Comintern" (1919–43) had begun to wane. E. H. Carr has written that in this period the notion of global revolution "no longer occupied a central place in [the Comintern's] agenda.[48] World revolution continued to figure in the perorations of Comintern pronouncements on every solemn occasion; it was no longer thought of as the primary condition of the survival of the Soviet regime." In the 1930s, then, revolutionary internationalism was being gradually hollowed out by a Stalinist drive toward state formation and an accompanying rhetoric of "socialism in one country." This had ramifications for geographical practice: the geodetical geometry in which global cartography is grounded came under criticism for its supposed formalism, and the energies of Soviet cartographers were redirected toward topographical mappings of the Union as a closed territory.[49] Viewed against the backdrop of this ossification

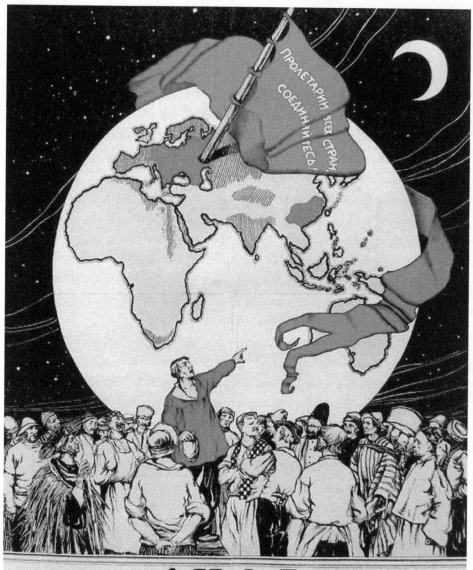

Fig. 11. Alexandr Apsit. *First of May. The Workers of the World Have Nothing to Lose but Their Chains, but They Have the Whole World to Gain.* 1919. Printed poster, 95 x 71 cm. Reproduced by permission of Eric Reznikov.

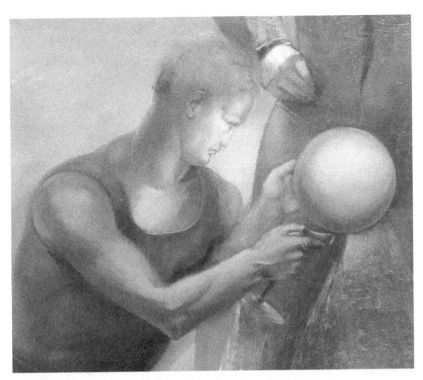

Fig. 12. Solomon Nikritin. The Bolshevik confronts the disenchanted earth. Detail of *The Old and the New.*

of socialist globalism in the Soviet Union, Nikritin's picture takes on the appearance of a pained retrospective restaging of how aspirations toward a globe united under communism played out and came to grief in revolutionary practice. The Bolshevik looks, the worker points, both are in thrall to the global vision, and yet poverty and tradition persist. If Nikritin's is a socialist globe, it was held back from fulfilling its ambitions by the Stalinist assertion of statism, remaining stranded in a landscape it failed to transform and society it failed to unite.

But taking the central sphere in this way as an empty placeholder onto which I have projected different globalisms downplays the fact that, unlike the meaning-saturated global images invoked above, Nikritin's globe offers nothing by way of geographical vision (fig. 12). Resolutely nondiscursive,

it presents a nebulous blank, no less vaporous and uncertain than the mists churning on its peripheries. Remember the extraordinary size of the canvas, confronting spectators with this starkly blank painted globe, larger than many cartographic equivalents, at just eye level. Although it should be said that, viewed up close, the globe does display slight suggestions of form, this only incites viewers to will the existence of a more developed geographical vision that the picture ultimately withholds.

Beyond offering a mute space through which to explore ulterior global discourses, then, Nikritin's globe has its own, specific import. To close, I want to suggest that this bare, rock-blue sphere embodies the meaning-less facticity onto which (and in reaction to which) modern discourses of meaning are projected. Its formal blankness denotes existential blankness, encapsulating the postontotheological spatiality of Sloterdijk's excursus in that it offers neither transcendent meanings nor inherent orders, and certainly no spaces predesignated for human habitation. My reading of *The Old and the New* has also encountered modernist figures who affirm themselves against this blankness by actively originating their own social schemas. The worker stands ready to build upon the tabula rasa of the wasteland; the Bolshevik is poised to inscribe self-made meanings onto a meaningless world. But the bare globe suspended between these two figures subtly undermines their gestures of empowered creativity. Unsettlingly blank, Nikritin's globe sets forth the frightening facticity of the disenchanted earth—a facticity that, though continually papered over with confected significance, haunts the maps made to keep it at bay.

This chapter has explored the spatialities produced through global mapping in Solomon Nikritin's *The Old and the New*. Drawing on Peter Sloterdijk's Nietzschean excursus on terrestrial globes, I have shown how the picture presents globalism as a constitutively modern apprehension of space, riven by two contrary yet inextricable tendencies. On one side, the mapped globe represents a culminating motif in the disenchantment of the world. Clustered around a bare sphere in a murky wasteland, the depicted figures enact an estranged, post-theological spatiality in which humans live upon a globe, not immersively in a world, still less as part

of a meaningfully constructed cosmos. On the other, the disenchanted earth preconditions empowered attitudes to terrestrial space, spurring its inhabitants to generate new spatial orders of their own, reflexive design. Engaging this theme, I have construed the central figures as modernists ready to inscribe new visions of society and space onto a malleable globe, while also connecting Nikritin's picture to global imaginations circulating in Soviet and contemporary culture. In offering a poignant image of socialist internationalism thwarted and in mirroring the phenomenological conditions of banal globalism, the painting brings into focus how modern cultures have enwrapped an unnervingly blank terrestrial globe in constructed significance.

It is eight decades since Nikritin painted *The Old and the New*. In that time the painting has been censored, stored away in the artist's studio, rediscovered by a collector, and taken to Uzbekistan for eventual exhibition. Meanwhile, global imageries and rhetorics have proliferated in cultural discourse, attaining such importance that today the term "globalization" represents perhaps the leading concept through which contemporary society understands itself. What Nikritin's painting returns us to, I have argued, is the meaningless facticity across which these global rhetorics play out. At the Uzbek fringe of a vanished Soviet Union, *The Old and the New* depicts a modern condition in which people and polities consciously project their own meanings onto the fortuitous earth disclosed in their midst. The three following chapters address some of the confected orders that have been mapped onto the times and spaces of the disenchanted modern globe depicted in Nikritin's painting. The next chapter begins by examining a series of map artworks that highlight, and critically reimagine, the global temporality constructed and inculcated by modern mapping.

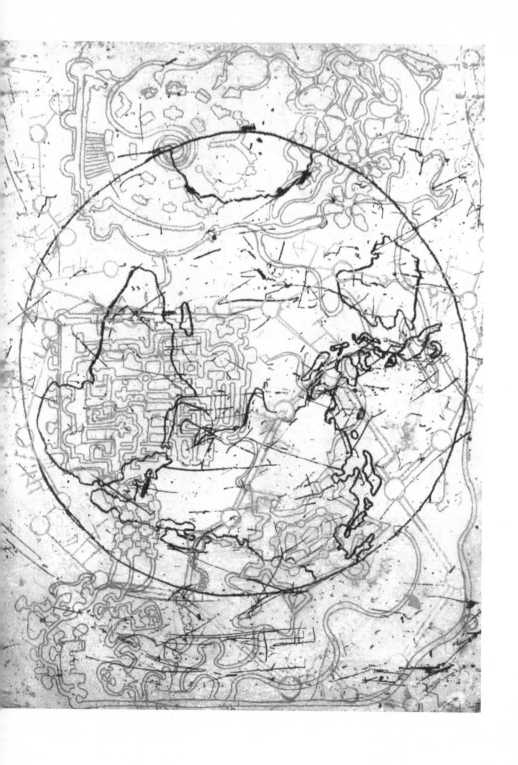

2 Combined and Uneven Cartography

Maps and Time in Alison Hildreth's
Forthrights and Meanders

Cartography and time. The conjuncture has something counterintuitive about it, as if maps were properly at home only in two, occasionally three, spatial dimensions while being excused from any temporal equivalents. Yet despite being routinely identified with space, maps impose temporal as well as spatial orders onto the geographical contingency figured forth in Nikritin's *The Old and the New*.[1] Consider the global maps and icons I discussed in the previous chapter under the rubric of banal globalism. The mapped image of the globe is enrolled in the service of many, often competing actors and interests, from transnational corporations to religious institutions and protest movements.[2] Across this diversity of interests, though, contemporary global images participate in the construction of a common temporality, in which the earth is conceived as forming a simultaneous totality. Different regions certainly have different times in this prevailing imagination of globality, but only according to the carefully calculated zones of a single, globally coordinated temporality.

To explore shifting cartographic constructions of time, this chapter addresses a series of map artworks by Alison Hildreth (b. 1939), a contemporary American artist working in Portland, Maine. Hildreth's mappings stand as an alternative to the uniform temporality that modern mapping cultures have conventionally projected onto the planet. This is intimated by a small etching produced in 2007 entitled *World Fort* (fig. 13). Scat-

Fig. 13. Alison Hildreth. *World Fort*. 2007. Graphite etching, 23 x 30 cm. Reproduced by permission of the artist.

tered with incongruous ruins, geometries, and geomorphologies, onto which the lineaments of an upturned globe are imprinted, this obscure world geography, like Hildreth's wider body of mappings, contains multiple temporal orders, which clash, overlap, and interweave in unpredictable ways. The thirty-seven cartographies that make up the series *Forthrights and Meanders*, in particular, are models of temporal multiplicity and overlap. I approach the series in conjunction with the Marxist theory of combined and uneven development, which stresses how capitalist globalization, far from producing a uniformly developed global dispensation, "survives through uneven geographical development"—indeed "*is* uneven geographical development."[3] In this light, maps and images of a perfectly simultaneous globe must be seen more as embodying the dream of a fully achieved capitalist globalization than as reflecting its reality.[4] Released into a visual culture pervaded by synchronous globes, Hildreth's geographies foreground instead the temporal *gaps*, *differences*, and *disjunctions*—in a word, the unevennesses—with which the modern world is riven.

Centrally at stake in my analysis of Hildreth's mappings, then, is the theme of maps and time. Definitions of maps prioritize space without reference to time: J. B. Harley and David Woodward's widely adopted definition, for example, posits maps as "graphic representations that facilitate a spatial understanding of things, conceptions, conditions, processes, or events in the human world."[5] Yet the absence of the temporality in both cartographic theory and everyday understandings of mapping serves only to underline the originality of Hildreth's obscure mappings, which consistently foreground *time* while geography progressively crumbles and falls away. My argument stresses how Hildreth's map art contravenes cartography's conventional relation to time, giving rise to an experimental form of "polychronous" mapping practice that is especially well constituted to grapple with the temporalities of uneven capitalist development and encroaching environmental disaster.

Monochronous Mapmaking

Maps might be identified first and foremost with space, but it does not follow that time is missing from maps, that maps cannot signify tempo-

rally, or that the act of perceiving a map does not take time. Indeed, Denis Wood insists that "the map *does* encode time, and *to the same degree* that it encodes space," with the qualification that on maps *time has been collapsed into space*."[6] He imagines mapping a walk around the block. The walker's tempo accelerates as the incline drops and slows as obstacles are encountered. Yet when the walk is traced on a map, such temporal variance is flattened out into a line. Its rhythms, lulls, tensions, and revisions become a synchronic shape and can be apprehended instantaneously. The walk's temporality *is* present on the map, Wood maintains, but collapsed into its representation as a spatially inscribed line.

Wood's example illustrates how time pervades cartography in the spatiality of its graphics. Since the temporality of maps has received little attention in the cartographic literature, this section briefly appraises some of the ways that mapmakers have perceived and managed time. Although the temporalities of mapping have varied considerably across history and in different cultural contexts, I stress how the differentiation of maps in modernity gave rise to what I shall call "monochrony" in mapmaking. Viewing Hildreth's mappings against the backdrop of monochronous cartography, I shall gauge the import of their experimental deviations from the received temporality of maps.

Maps have tenses. They might suggest that "this *is*, *was*, or *will be* there," or more ludic temporal propositions: "this *could* or *should have been* there." Tenses are, of course, relative and variable, and maps migrate across different tenses as they and their contexts age and change. Consider, for instance, the declaration appended to John Norden's 1653 map of London: "By the helpe of wich plot they ["cuntrey men"] shall be able to know how farr it is to any street." And yet, for all its proud utility, Norden's "plot" was suddenly rendered less instructive in September 1666, as fire ravaged its sometime referent, transforming the map into a record of London past.

Cartographic tenses are liable to rapid change, then, but they are almost always given as *singular* and *discrete*. That is to say that the majority of maps are presented and perceived as being "monochronous": having one temporality only. They aspire to level all temporal diversity and thereby to achieve

a state in which every part of the geography they set forth is seamlessly simultaneous with every other. However, maps can only pretend to such blanket simultaneity, which remains an impossible but largely unforgoable ideal. *Impossible* because the information given in maps is gathered and organized over periods of time, however small; *unforgoable* because temporal disparity in mapping often diminishes its use value, at least with regard to the navigational purposes with which maps are primarily associated today. This double bind is borne out in the digital mapping application Google Earth. Though users tend to perceive and use this application as though it figured a simultaneous snapshot of the earth at one integral instance, it is actually composed of many thousands of images taken at many thousands of different times. Behind a presentation of monochrony, its virtual globe stitches together colossal temporal diversity into a whole whose seams are rarely smoothed over neatly.

Despite the normativity of monochrony in mapmaking, some contemporary forms of mapping do accommodate temporal variation. These maps represent processual variables within a given spatial dispensation, usually in one of three ways. Some maps present monochronous geographies *successively* (the consecutive climatic maps of a weather bulletin); others present processes *in their successiveness* against a constant geography (incremental territorial gain or loss on a military campaign map); still other, "choropleth" maps represent temporal change in a given variable by area, distinguished by shading or coloration ("between 2009 and 2012," this sort of map might propose, "unemployment dropped by 7 percent in this region—shaded red—but rose by 4 percent in that—shaded green"). Yet although these mapping practices explicitly represent change, they do so only through carefully managed procedures that do not let different times interpenetrate one another, thus preserving the principle of monochrony.

The current preeminence of monochrony in mapmaking, which extends even to specialist maps of changing variables, should not obscure the fact that monochrony has not always been normative in cartography. The temporality of mapping has a history; here I refer to three historical examples to indicate how space became monochronous only in modernity, as

Combined and Uneven Cartography

mapmaking was differentiated as a tool of state organization and capitalist globalization. First consider two geographies that predate cartographic monochrony. *Mappamundi*, medieval Christian worldviews that are often included in histories of cartography, are infused with cosmological and historical narratives: in these world-encompassing geographies, as Daniel K. Connolly has argued, places "were thought to resonate with their own stories or historical significance, and together would, as a cumulative effect, tell the history of creation."[7] The diversity of temporal orders and multiple historical moments can readily be enumerated using the example of the famous *mappamundi* kept in Hereford Cathedral, which was made in the early fourteenth century. Depicted within this single world geography are Alexander the Great's encampment; the saved rising up on the day of judgment while the damned sink into hell; the Minoan labyrinth; Christ both at his crucifixion outside Jerusalem and astride the cosmos after his ascension; Emperor Augustus decreeing that the earth be surveyed; Adam and Eve's ejection from Eden; Apollo's oracle at Delphi; Noah in his arc; and Saint Augustine in his cathedral at Hippo.[8] Here the grand stratum of cosmic or holy time flows in, through and around diverse mythic and human histories.

Temporal disparity and unevenness are hardly specific to the premodern geographies of Christian Europe, though. Jerry Brotton shows how a stone Chinese map named *Yu Ji Tu* ("Map of the Tracks of Yu" or "Footsteps of Yu," 1136), made under the declining Song dynasty, similarly "conflates mystical geography with contemporary place."[9] Brotton argues that, although the map is strikingly modern in that it is fixed into an implacably regular grid, the contemporary geography it sets forth is shot through with a mythic past—"marked by references to the foundational text of the 'Yu Gong' [a chapter from the *Book of Documents*] and its description of a mythical, unified China defined by rivers and mountains."[10] In this map, temporal unevenness is enrolled by the Song authorities in an attempt, as Brotton suggests, to ground its ailing dominion in the authority of a deep, mythic time whose grandeur might be resurrected in the present.

Full monochrony seems to have set in increasingly as mapmaking was differentiated from other, unequivocally *temporal* functions (such as cos-

mogony, eschatology, the narration of national provenance and destiny, history, and royal genealogy), which, as I suggested in the introduction, formerly cohered within single premodern artifacts. This differentiation was especially strong where maps formed part of the administrative organization and functioning of bureaucratic modern states. An early example, to continue with Chinese mapping, is *Yudi Tu* ("Map with Postscript," 1526: a print reproduction of a silk original made fourteen years previously), a map made by Yang Ziqi under the Ming empire.[11] The *Yudi Tu* standardizes imperial geography. Repeated pictograms depict communities ranged right across the empire with unprecedented uniformity; towns lying thousands of miles apart are named in one language; all provinces and prefectures are listed together. In bringing together spectacularly far-flung and various regions in one imperial map, the *Yudi Tu* also encompasses all China under a uniform time. Here the empire is no longer encumbered by the coexistence of figures and geomorphologies belonging to ulterior mythical, historical, or cosmic times in the manner observed in the Hereford *mappamundi* and *Yu Ji Tu*. Ziqi's vision of empire is free from temporal multiplicity and fissure, frozen in the seamlessly monochronous present of 1526.

The transition from polychronous to monochronous mapmaking, though, should not be seen as a formal mutation internal to the history of cartography. Rather, it must be set in relation to broad early modern contexts. Fredric Jameson has observed that "each system—better still, each "mode of production"—produces a temporality that is specific to it."[12] The projection of monochronous time onto the globe is the historical temporality specific to modernity, and it emerged against the backdrop of market globalization, state formation, and colonialism in the early modern period.[13] Conducting operations, coordinating markets, and administering communities at a global scale required not just a unified view of world space, but a synchronized apprehension of time globally. Faced with these tasks, the temporal multiplicity characteristic of earlier worldviews is recast as the epitome of disordered, indeed unworkable disparity. Existing modes of undergoing time were leveled or rendered subordinate to monochrony

Combined and Uneven Cartography

as diverse cultures were colonized, capitalized, or otherwise imbricated in the modern world system.[14]

Walter Benjamin gave an influential account of the monochronous modern temporality as "homogeneous, empty time."[15] For Benjamin, modern cultures represent time as a progressive series of modular, fungible moments following one after another discretely in regular procession. Its units are equal, linear, and do not overlap—"like the beads of a rosary" in his Catholic metaphor.[16] The calculability and manageability of this temporality is paramount: as E. P. Thompson famously argued, standardized "clock time" was instituted at ever-wider scales to better register, coordinate, and discipline laboring subjects' behavior.[17] As monochronous figurations, maps have been significant in manifesting and reinforcing this conception of time, allowing users to deduce times around the world, to centrally coordinate operations, and to establish modern trading and military empires. Indeed, the culminating moment in the globalization of modern temporality was an act of mapping. In 1884 an international committee established Greenwich as the site of the prime meridian—the line running between north and south poles in relation to which distance and time have been determined globally throughout modernity. I shall return to discuss this meridian (and an artistic subversion of the orientation it provides) at length in chapter 5 of this study. My point here is that maps promulgated London, then commercial and colonial capital of the modern world system, as the universal point of reference for measuring space and time.

This section has emphasized how the reigning assumption that maps should appear and aspire to be monochronous, and that any departure from that normative state must be managed through complicated conventions, is not universal. Far from it: the uniform temporality that enfolds the contemporary earth is specific to modernity and modern cartography. Having established the concept and historicity of monochronous mapping, the next section turns to Hildreth's experimental maps, which, I argue, tilt against the monochrony globalized through mapping.

Alison Hildreth and Polychronous Mapping

Hildreth's artworks figure forth what I term "polychronous" geographies, in that different times coexist within them. Elements hailing from multiple historical moments are juxtaposed and coalesce in the common graphic context of these heterogeneous mappings, which thus exist in a state of acute temporal tension, often outright contradiction, with themselves. Hildreth's maps, I contend, are polychronous not just at the level of the geographical subjects they represent, but also in the forms and techniques they enroll to do so. The theoretical provenance and implications of the notion of polychrony are greater than my immediate deployment of it as a formal descriptor would suggest. As I go on to explain, the term "polychrony" represents my modification of Ernst Bloch's concept of "simultaneous non-simultaneity," which in turn derives from the Marxist theory of "combined and uneven development" issuing from Leon Trotsky. Before exploring Hildreth's mappings' special capacity for probing the uneven temporality of capitalist modernity, I mean to establish the manifest fact and character of polychrony in her artworks.

Hildreth has been practicing as artist in Portland, Maine, since the 1970s, predominantly as a maker of drypoint, intaglio, lithograph, and woodcut prints.[18] Some motifs that recur throughout her output are flying beings, whether insects, bats or planes; darkness and creatures that inhabit dark places; stark juxtapositions and admixtures of organic and mechanical forms; and, most important here, a consuming engagement with cartography. This chapter focuses on *Forthrights and Meanders*, a series of dense and mysterious geographies first exhibited at the June Fitzpatrick Gallery in Portland in 2009, in which all of these motifs come together.

The maps that compose *Forthrights and Meanders* are thoroughly heterogeneous, combining features derived from multiple historical moments, social worlds, and visualities, or, rather, "scopic regimes."[19] Though this diversity might be demonstrated by almost any work in the series, I shall take a detail from *Forthrights and Meanders 23* (fig. 14) as my point of departure, since it includes several important elements for my analysis in

Combined and Uneven Cartography

Fig. 14. Alison Hildreth. *A Trace Italienne.* Detail of *Forthrights and Meanders #23.*
2008. Graphic, encaustic and ink wash on rice paper, 91 x 140 cm. Reproduced by
permission of the artist.

this chapter: the characteristic star of a *Trace Italienne* (an angular brand
of early modern fortification to which I will return later) in the top right
corner, protecting and confining the ashen web of a settlement; the warm
orange network of paths that meander vertically down the left side of
the frame; the adjoining yellow line, which traces an inverted and much
simplified continental outline of western Europe through the center of the
figure; the charcoal edge of what purports to be a river running in rings
below the fortress; and a faded pattern of floor or street plans imprinted
discreetly at vertical intervals behind paths down the center of the figure.
These last traces, whose detail lies almost imperceptibly behind paths and
other residues, convey what I see as *Forthrights and Meanders'* basic aes-
thetic: namely, layered historical difference.

Combined and Uneven Cartography

Consider the sheer strangeness of the juxtapositions presented here. Why should a shrunken outline of the European shore lie inverted and strewn between a seventeenth-century fortification and an unknown river? Such incongruities prompt viewers to imaginatively connect disparate elements in the manner of modernist collage. Hildreth's incongruities are distinguished, though, by their unusually temporal character, and by the way they juxtapose elements through layering. Indeed, although Hildreth sometimes sidles contrary objects up parallel to one another (see how the fort abuts the continental outline), more often she presents surprising combinations of substrates over, under, and on top of each other. The aesthetic bears upon time in several senses. Visually, layering elements against an earthen background (*Forthrights and Meanders* often presents brown and gray ink washes over fibrous rice paper) produces a strikingly archeological aesthetic. Hildreth's layering practice mirrors the process of historical sedimentation itself, having been inspired directly by actual historical ruins, as the artist's reflections on a residency she took up in La Napoule in 2009 bear out: "I was and continue to be interested in the layers of civilizations that have occupied the country around La Napoule. I was able to visit Roman ruins in Nice and the archeology museum. One is aware of the many peoples that have inhabited this country for millennia. The bones of these ruins appear as fragments in the work I have done since the residency."[20] Beyond the maps' visual resemblance to archaeological excavation, though, is the actual polychrony between the elements assembled in *Forthrights and Meanders*. Precisely which historical moment or strata a particular cluster of lines, grounding smear, bundle of pterosaur bones, or ghost of a settlement or fort supposedly belongs to can be difficult to pin down. Opacity might plausibly indicate solid grounding in the present: translucency residual, imagined, remembered, or even desired entities mid-passage into ruin, daydream, or realization proper.

One element in *Forthrights and Meanders #23*, though, can be historicized concretely. *Forthrights and Meanders* is littered by a form of defensive architecture known as the *Trace Italienne* (henceforth *Trace*)—aptly named in this context of maps patterned with traces. The visual symmetry of these

Combined and Uneven Cartography

angular, highly rationalized structures—which, viewed in plan, from above, or even obliquely, cannot but evoke a star—is aesthetically unique in the history of fortification. They tend to dominate any map or landscape in which they are situated, even where only the moat remains. Despite their evident formal fascination, the historicity of the *Trace* is centrally important in determining their significance in *Forthrights and Meanders*. The *Trace* was first developed in Italy in the early sixteenth century in response to the introduction of gunpowder into siege warfare.[21] Its "angle bastion," a low-firing platform whose sharp points cast the widest possible field of defensive fire while leaving no blind spots for besiegers to exploit, is widely held to have had a transformative impact on warfare in early modern Europe. Large historical claims have been made for the *Trace*, notably by Geoffrey Parker, who has argued that its emergence precipitated a wider "military revolution," which in turn entailed the rise of absolutist states in western Europe and ultimately conditioned their expansion into colonial empires encompassing much of the globe.[22]

The historical specificity and import of the *Trace* plays out complexly in Hildreth's art. *Elective Affinities (Blue)* (fig. 15), for example, juxtaposes the *Trace*'s starlike ground plan with outlines for older defensive structures: turreted keeps

Fig. 15. Alison Hildreth. Turreted keeps. Detail of *Elective Affinities (Blue)*. 2010. Print on rice paper, 98 x 28 cm. Reproduced by permission of the artist.

that it displaced. *Forthrights and Meanders* goes further, forcing the early modern *Trace* to inhabit common frames with subsequent, mechanical technologies. Planes course over the star forts, which aerial warfare consigned to redundancy in the twentieth century (fig. 16). But the anachronous motifs that populate *Forthrights and Meanders* are not drawn from military or even human history exclusively. Hildreth is interested in forms belonging to what was traditionally understood as "natural history." These include bleached dinosaur bones, like those figured in *Forthrights and Meanders #16* (fig. 17), which incongruously appear alongside either early modern fortifications and twentieth-century aircraft, or continental outlines. Even these basic tectonic templates, which might seem relatively unchanging by contrast with the tumultuous human histories unfolding across them, only contribute to the series' polychrony. Throughout her mappings, Hildreth recapitulates continental outlines; *Forthrights and Meanders #9* contains those of the Russian Far East, western Europe, and eastern Africa (fig. 18). Some such tracings derive from a period after the *Trace* fortifications. The Kamchatka Peninsula (represented in the top right corner of *Forthrights and Meanders #9*), for example, was not mapped in detail until after the Great Northern Expedition under the Russian Empress Anna in the middle of the eighteenth century.[23] Indeed, when the prehistoric creatures whose remains are scattered through the series breathed and predated, the continents did not exist in this form to be represented at all.

Adducing these discontinuities surrounding the motif of the *Trace* demonstrates how the geographies set forth in Hildreth's maps exist in an acute condition of polychrony. Layering up diverse architectures, animal and mechanical forms, and spatial representations, all of which derive from wildly different temporal strata, *Forthrights and Meanders* holds contrary elements together in unities fraught with temporal tension. Hildreth's commitment to polychrony is borne out by what she posits as a prime influence on the series: W. G. Sebald's well-known novel *Austerlitz*.[24] The book narrates European journeys of a Czech-born intellectual named Jacques Austerlitz, who strives to reconstruct his early life before its disruption by Nazism. Its influence is most apparent in the salience of *Trace* in Hildreth's

Combined and Uneven Cartography

Fig. 16. Alison Hildreth. Planes course over the star forts. Detail of *Forthrights and Meanders #21*. Graphic, encaustic and ink wash on rice paper, 2008. 32 x 141 cm. Reproduced by permission of the artist.

Fig. 17. Alison Hildreth. Bleached dinosaur bones. Detail of *Forthrights and Meanders #16*, 2008. Graphite, encaustic and ink wash on paper. 38 x 137 cm. Reproduced by permission of the artist.

art, for these fortifications appear prominently in Austerlitz's itinerary. Yet Sebald's presence in *Forthrights and Meanders* runs deeper. The temporality of Austerlitz's often melancholic reflections, and indeed of the novel as a whole, is characterized by loss, remembrance, and an acute consciousness of the transience of even seemingly stable social worlds. Take the pivotal scene in which Austerlitz suddenly retrieves repressed memories on a lonely platform in Liverpool Street Station, London. Here Sebald imbues architectural space with temporality. First he raises the scene's momen-

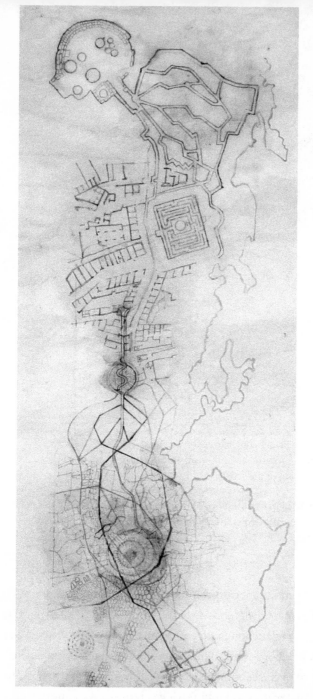

Fig. 18. Alison Hildreth. Continental outlines. Detail of *Forthrights and Meanders #9*. 2008. Graphite, encaustic, and ink wash on paper, 32 x 140 cm. Reproduced by permission of the artist.

tum, dissolving and fragmenting the station's immobility and substance by transforming it into a theater of roving light: "Beams of light followed curious trajectories which violated the laws of physics, departing from the rectilinear and twisting in spirals and eddies before being swallowed up by the wavering shadows. From time to time, and just for a split second, I saw huge halls open up, with rows of pillars and colonnades leading far into the distance, with vaults and brickwork arches bearing on them many-storeyed structures, with flights of stone steps, wooden stairways and ladders, all leading the eye on and on."[25] Sebald progressively grafts time onto this extraordinarily dynamic rendition of architecture, such that it becomes a proxy for the nonlinear temporalities of remembrance. In the flash of halls and flickering vaults a multitude of times become palpable and mobile, laid out like a great chessboard before the protagonist's eyes:

> Memories like this came . . . to me in the disused Ladies' Waiting-Room of Liverpool Street station, memories behind and within which many things much further back in the past seemed to lie, all interlocking like the labyrinthine vaults I saw in the dusty grey light, and which seemed to go on and on for ever. In fact I felt, said Austerlitz, that the waiting-room where I stood as if dazzled contained all the hours of my past life, all the suppressed and extinguished fears and wishes I had ever entertained, as if the black and white diamond pattern of the stone slabs beneath my feet were the board on which the endgame would be played, and it covered the entire plane of time.[26]

Here Austerlitz is able to see across time just as his vision is led into space. Finally he steps into a past hitherto barred to his psyche, and beholds his younger self: "I recognized him by that rucksack of his, and for the first time in as far back as I can remember I recollected myself as a small child, at the moment when I realized that it must have been to this same waiting-room I had come on my arrival in England over half a century ago."[27]

The overall impression of the scene is of alternating temporal disjuncture and identification staged spatially; a lightning storm of time in which polychronous moments interpenetrate and blast apart. The temporally charged

apprehension of space narrated here, I suggest, approximates *Forthrights and Meanders* closely. Beyond cutting against the monochrony assumed in most mapmaking, though, the significance of having different times coexist in single geographies, as is common to Sebald and Hildreth's projects, remains obscure. To develop the theoretical implications of the polychronous mode of mapping practiced by Hildreth, the following section develops the conceptual implications of polychrony for a reading of *Forthrights and Meanders*.

Simultaneous Non-Simultaneity

My concept of polychrony is inspired by the theory of combined and uneven development, a Marxist tradition of thought associated with Leon Trotsky. More specifically, it is inspired by the disjointed, uneven temporalities that this theory ascribes to situations of modernity. For the theory of combined and uneven development, modernizing geographies are host to built forms, political structures, modes of subsistence, and systems of thought that belong to radically different historical orders. This is because, as I suggested in the introduction, it casts modernity as "one and unequal," recognizing capitalist modernity's expansive tendency toward a global scale while simultaneously stressing how this tendency plays out in radically different ways in diverse geographical and social settings. Thus Trotsky points to the "amalgam of archaic with more contemporary forms" attendant on modernization: precapitalist subsistence economies persisting alongside industrial production, for example, or the depletion of some regions while their wealth and labor is invested in developing others.[28] Such contrary coexistences are the visible manifestation of how capitalist modernization compels different modes of production (and their corresponding cultures and lifeworlds) to confront, overlap, and co-opt one another: of how historical modes of production must develop and recede in, through, and around a variety of other social formations.

The Marxist philosopher Ernst Bloch restates the theory of combined and uneven development in explicitly temporal terms. The geography of uneven modernization, for Bloch, is marked by the "*gleichzeitigkeit des ungleichzeitigen*" (simultaneity of the non-simultaneous). "Not all people

Combined and Uneven Cartography

exist in the same Now," he contends. "They do so only externally, by virtue of the fact that they may all be seen today. But that does not mean that are living at the same time with others."[29] Bloch's analysis is developed in relation to the rise of national socialism in interwar Germany, arguing that the movement exploited the German masses' urge to escape the "unbearable Now" of industrial modernity by constructing an idealized past, into which those "out of step with the barren Now retreat."[30] Such rhetorics of anachronism, he argues, intermingle with remainders of traditional lifeways and exist in the same social frame as both the liberal-capitalist present and emergent political futures to produce a landscape riven by simultaneous non-simultaneity. Bloch's analysis might be specific to Germany in the 1930s, but his notion of "simultaneous non-simultaneity" has been brought to bear upon the temporalities of modernity more generally. Indeed, for Fredric Jameson simultaneous non-simultaneity is the defining feature of modernity as such. The "coexistence of distinct moments of history," he argues, is the hallmark not only of modern social conditions, but of cultural modernism too—that is, of artistic production and practice that arises from, represents, or otherwise responds to modern conditions.[31] In the "Secondary Elaborations" appended to his famous essay on postmodernism, Jameson addresses the salience of simultaneous non-simultaneity in modernist culture, adducing "Apollinaire's Paris," which simultaneously contains "both grimy medieval monuments and cramped Renaissance tenements, *and* motorcars and airplanes, telephones, electricity, and the latest fashions in clothing and culture."[32] Polychrony in cultural practice, Jameson contends, is a response to the social realities of uneven development. Modernism, he suggests, grasps a "peculiar overlap of future and past": "the resistance of archaic feudal structures to irresistible modernizing tendencies—of tendential organization and the residual survival of the not yet 'modern.'"[33]

Here, I am not especially concerned with Jameson's wider argument that if simultaneous non-simultaneity is characteristic of modernist culture, postmodernism levels temporal difference.[34] The idea I want to take up instead is how, as an artistic strategy, simultaneous non-simultaneity (for which I use the more concise term polychrony) represents a fertile means of grappling

imaginatively with combined and uneven development. Thus, in juxtaposing elements belonging to different temporal strata within single cartographies, Hildreth's mappings not only break with cartography's received monochrony; they also represent, and reflect on, the contrary temporalities of combined and uneven development that marks capitalist modernity.

Building on the idea of a simultaneous non-simultaneous modernity described by Trotsky, Bloch, and Jameson, the following two sections explore the underlying vision of or attitude toward modern temporality advanced through polychrony in *Forthrights and Meanders*. My approach is to identify and unpack the various forms Hildreth sets in polychronous tension and to examine the meanings that arise from the relationships between them. The meaning of each individual form, or unified cluster of forms, alters upon entering these cartographic fields of temporal tension. Jostling among, communing with, or simply contradicting other elements with different historical origins, each becomes a "being toward" this or that ulterior moment. My argument is that these polychronous relationships build a vision of modernity with two main strands. The first is backward looking: a geographical instance of Romanticism in which the remains of "lost magic kingdoms" contrast sharply with a bellicose modernity. The second unites past and future in a specifically ecological form of the apocalyptic, for which modernity represents a hubristic departure from a natural order that now returns to consume the modern.

Throughout, my analysis signals the potential dangers of these polychronous mappings of modernity. I caution against Hildreth's tendency to slip into either a politically disabling contemporary mode of the *memento mori* tradition, which passively asserts the transience of existing formations, or an eschatological framing of ecology, which would substitute the complexities of a combined and uneven modern ecology with the image of sudden, unavoidable apocalypse.

Lost Magic Kingdoms

Although many of the forms presented in *Forthrights and Meanders* are intelligible, they are often decontextualized, distorted, or otherwise ren-

Combined and Uneven Cartography

dered obscure. Something of this vacillation between clarity and confusion is suggested by the series' title, a quotation lifted from act 3, scene 3 of William Shakespeare's 1611 play *The Tempest*. Stranded on the island inhabited by the sorcerer Prospero, the Milanese King Alonso and his courtiers find themselves simultaneously bewildered and beguiled by its unusual topography. Tired, the royal advisor Gonzalo complains: "My old bones ache: here's a maze trod indeed / Through forth-rights, and meanders!"[35] *Forthrights and Meanders* similarly alternates between the forthright postulation of palpable forms and the meandering obscurity and formal free play that so often overtakes them. I have already indicated several recognizable features, objects, and beings in these geographies; many cartographic conventions, both topographical and projective, are similarly identifiable. Yet everywhere these familiar motifs are rendered opaque or uncanny, whether by being placed in ambiguous or incongruous relationships, or by being blotched, fragmented, and reconfigured in new assemblages. And many of Hildreth's cartographies contain no intelligible referents for either geographical or historical orientation at all. The works that make up *Forthrights and Meanders* often seem to figure the final trace and record of some ancient and otherwise forgotten turmoil, belonging to a time and place absolutely foreign to any plausible lifeworld obtaining today.

This unintelligibility and mysteriousness must be accounted for, not explained away, since it has been actively produced by the absence of toponymy; the lack or aestheticization of cartographic figures (such as compasses, arrows, meridians, and triangulative structures) that would usually assure geographical orientation and meaning; and the prevalence of ancient and prehistorical motifs in the absence of almost any contemporary equivalents. If at key junctures *Forthrights and Meanders* fails to approximate the forms of mapmaking that have been developed, deployed, and globalized by modern bureaucracies, states, and capital, this is because Hildreth's dark, obscure geographies are articulated in opposition to modernity and the maps that made it: because the temporality of *Forthrights and Meanders* is willfully anachronistic, programmatically untimely. In contrast with many of the map artworks examined in this study, which probe the quintessentially

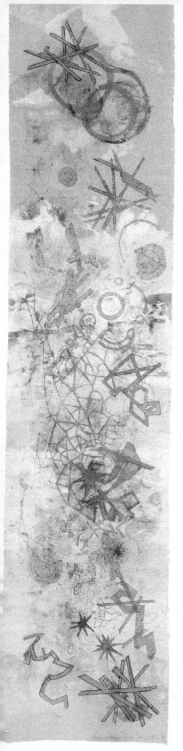

modern drive to planned transformation and the geometrical ontology undergirding cartography, Hildreth's mappings unfold landscapes that evoke, borrowing Eduardo Paolozzi's phrase, "lost magic kingdoms."[36] By this, Paolozzi means (imagined) realms of premodern enchantment, unity, and vitality. *Forthrights and Meanders*, I argue, enacts a kind of melancholic exoticism—a vertigo and fascination that spurns modernity by gazing across the debris of centuries into *tempus incognitus*.

The inverse of this imagination of "lost magic kingdoms" is Hildreth's sparse and unfavorable representation of industrial modernity. This chapter foregrounds three instances of modernity depicted in the series. I have already discussed the *Trace* fortifications. The following section will broach the cartographic geometries interspersed through Hildreth's geographies. In this section I address the frequent depictions of aircraft (often in battle with, or transforming into, insects) and, specifically, the scene of aerial bombardment presented in *Forthrights and Meanders 26* (fig. 19). In the latter scene, the picture plane towers high above what might be concretized as a road network uniting a city, or—considering the work's martial elements—a trench system. In any case, the geography is racked by explosions and now reels under a pall of ash or miasma. Coursing through the altitude separating the viewer from the earth below are several flying machines, apparently dispensing bombs. Here, Hildreth represents modernity through a scene of aerial warfare.

Fig. 19. Alison Hildreth. Aerial bombardment. Detail of *Forthrights and Meanders #26*. 2009. Graphite, encaustic, and ink wash on paper, 32 x 142 cm, 2009. Reproduced by permission of the artist.

Combined and Uneven Cartography

My point here is not just that modern spaces, for Hildreth, are threatened by the possibility of bombing or mechanical warfare more generally. Note how the collections of geometric forms that compose these aircraft are at several points continuous with the grounded lines that surround them. These "flying machines," if they are fully that, are only just differentiated by brown coloration. If one goes by their lineation alone, the forms come to merge into the divided topography behind. This is exemplified by the figure in the picture's bottom right corner (fig. 20), which seems to blend the surrounding warplanes' industrial form with a tangled intersection of several roads such as might exist in the geography below them. Here the ambiguity of such forms, their apparent slippage between mechanical and topographical status, registers as a compaction of the territory and its assailants. As we shall see in the case of helicopters and insects, not to mention spider's webs, cities, and triangular lines, Hildreth frequently forces forms belonging to opposed material, historical, and conceptual orders to coalesce into single figures. In keeping with this, *Forthrights and Meanders 26* shows the bombers emerging out of, or indivisibly bound with, the bombed terrain. The effect is to suggest that modern geographies, in sharp contrast to the lost magic kingdoms imagined in the wider series, somehow imply, perhaps even invite, destructive struggle—that modernity and barbarism, as Josef Früchtl has written, represent "no contradiction in terms. Quite the contrary, in fact: they seem to fit together very well."[37]

As a series of maps crowded with exotic ruins left by mysterious, now vanished peoples, in which the modern world is represented almost solely by destruction beheld and administered from the air, *Forthrights and Meanders*, I argue, presents a characteristically Romantic engagement with cartography, despite its having been produced long after the nineteenth-century terminus traditionally ascribed to Romanticism. Indeed, *Forthrights and Meanders'* polychronous vision, in which projected worlds of premodern vitality exist alongside a destructive modernity, is entirely consonant with the revised and historicized concept of Romanticism elaborated by Michael Löwy and Robert Sayre in their book *Romanticism Against the Tide of Modernity*: "Romanticism represents a critique of modernity, that

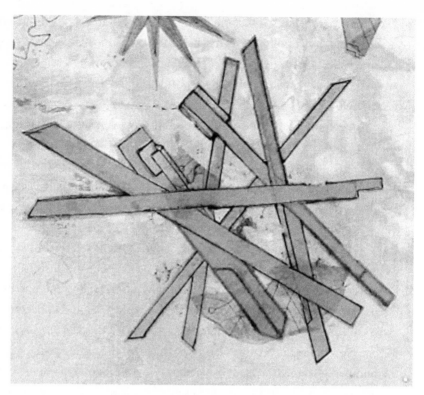

Fig. 20. Alison Hildreth. Mechanical and topographical forms coalesce. Detail of
Forthrights and Meanders #26 (fig. 19).

is, of modern capitalist civilization, in the name of values and ideals drawn
from the past (the precapitalist, premodern past). . . . [This critique is]
characterized by the painful and melancholic conviction that in modern
reality something precious has been lost, at the level of individuals and
humanity at large."[38] This definition of Romanticism serves well to establish
Forthrights and Meanders' connection to contemporary mass culture, with
which its coarse and yellowed aesthetic is so at odds. Löwy and Sayre stress
how Romanticism is not a premodern refutation of the modern, but rather
a specifically "*modern* critique of modernity": "That means that, even as the
Romantics rebel against modernity, they cannot fail to be profoundly shaped
by their time. Thus by reacting emotionally, by reflecting, by writing against

Combined and Uneven Cartography

modernity, they are reacting, reflecting and writing in modern terms. Far from conveying an outsiders' view, far from being a critique rooted in some elsewhere, the Romantic view constitutes modernity's self-criticism."[39] The point, here, is that nothing is so thoroughly modern, so deeply marked by capitalist, industrial, or statist modernity and conditioned by the experience of living through it, as the conscious wish to leave modernity behind. For all their trappings of tradition, attempts to recuperate premodern worlds, like Hildreth's lost magic kingdoms, are profoundly modern.

This second point opens up critical perspectives on *Forthrights and Meanders*. If Romantic artists value traditional worlds (and in this case traditional geographies) on account of their temporal, spatial, and qualitative distance from the banality or maleficence perceived in modernity, the specificity of these premodern worlds is of secondary importance. Consequently, Romantic artists not only tend to collapse differences between diverse premodern cultures, overlooking their mutual tensions as insignificant relative to their current capacity to signify as "enchanted" foils to modern facticity or to disenchantment of the sort figured in Nikritin's *The Old and the New*. Thus Hildreth's mappings mix elements drawn from Christian ecclesiastical architecture with pre-Columbian structures, or Renaissance cosmography with forest forms whose roots sprawl out over the maps. A related critique is how Romantic artists often overlook the presence of alienation or social domination in the premodern worlds they admire. Accordingly, viewers would do well to remember that if *Forthrights and Meanders* presents modernity through the dark prism of mechanized aerial warfare, the "lost magic kingdoms" need not be valorized as pure enchanted counters to modernity. Far from it: the religious architectures depicted throughout the series might just as plausibly indicate the ubiquity of mass deception; the bones of different dinosaurs lying scattered beside one another might signify less bygone worlds of creaturely vitality than the transhistoricality of violence (in this, Hildreth's dinosaurs link up with those in Teligator's book cover described in my opening to this study). Stressing that the prehistoric and premodern elements in Hildreth's polychronous mappings might actually be continuous with her construction of a violent

and deadened modernity serves to undermine the rhetorics of temporal difference on which Romantic nostalgia depends.

Romanticism, stress Löwy and Sayre, is a *modern* rejection of modernity. The more astringent and relentlessly pursued the will to escape modern conditions, the more determined and pervasive the presence of modernity— only negatively so. This Romantic procedure of compensating for the modern present by inverting it is observable in Hildreth's artworks. Her modern rejection of modernity is perhaps clearest not in its explicit themes and motifs, but rather at the level of its medium. Despite the availability of contemporary papers in elaborate gradations of gloss and grammage, and in all conceivable colors, Hildreth's maps are made using a rice paper that is visibly little different than that used fourteen centuries ago. It is similar, to pick one historical equivalent, to the paper of the Dunhuang manuscripts, important Buddhist documents dating from the fifth century, discovered in a set of grottoes in northwestern China. Yet despite being commensurate with these manuscripts in its texture and materiality, the rice paper medium enrolled in *Forthrights and Meanders* has a very different significance. Whereas the Dunhuang manuscripts' paper substrate, which was ready-to-hand at the time of their inscription, belonged to the wider material culture of Tang China, Hildreth can only employ an identical paper in twenty-first-century modernity by positioning herself in retrograde opposition to dominant media, values, and norms. These values and norms still inhabit and determine the significance of the work, but negatively so, in that Hildreth's Romantic mappings variously seek to reject, displace, and transfigure modernity.

This repudiation of modernity has wider interpretative consequences for my account of Hildreth's polychronous cartographies. In figuring forth "lost magic kingdoms," the maps of *Forthrights and Meanders* seem shrouded in mystery. Viewed in Löwy and Sayre's terms as Romantic inversions of a dismal modernity, though, one could argue that the secret driving Hildreth's mappings of enchanted premodern worlds is, in fact, nothing other than *dis*enchantment in the present. The obscure, stained, and auratic geographies figured forth in *Forthrights and Meanders*, I would suggest, can be

Combined and Uneven Cartography

understood as reversals of the reified, uniform geometry of contemporary GIS. The adventitious imperfections (even the crudity and figurative limitations) of the woodcut impression and drypoint relief through which Hildreth's maps are manifested are significant in that they stand deliberately apart from the seamless and instant mass reproducibility achieved in digital visual cultures. The arcane architectures, fragmented perspectives, and multiple semiotic codes unfolded in her maps attempt to counter the properly matched coordinates and uniform scale, systematic projection, and standardized codes that characterize digital mapping applications. The polychrony of Hildreth's *Forthrights and Meanders*, then, reacts against a dull and destructive modernity by counterposing enchanted premodern geographies or "lost magic kingdoms" alongside them. This move is encapsulated in the two epigraphs that introduce her website, which declare: "The path the ancients cleared has closed" (Octavio Paz) and "Soft, dark languages are being silenced" (Margaret Atwood). "The language that is eating the others," Hildreth glosses, "is now our new digital voice."[40]

Before turning in the next section to how *Forthrights and Meanders* imagines modernity's ecological predicament, I want to raise a politically disabling tendency in Hildreth's Romantic geographies, in which past and future combine. I am referring, here, to how images of once-proud realms that have long since lapsed into obscurity come to stand as so many bellwethers of what awaits the modern cultures mapped alongside them. In this, *Forthrights and Meanders* recapitulates the *vanitas* or *memento mori* traditions in Christian culture, which deploy the specter of past demise to issue moral warnings about the future. Take the medieval theme of *The Three Living and the Three Dead*, in which three princes, having gotten lost while hunting, are confronted by three risen cadavers. In Baudouin de Condé's narration of the scene, the dead remind their living counterparts that they too "will be as we are / Behold yourselves betimes in us / Power, honor, riches are nothing / At the hour of death / Only good works count."[41] Significantly, this consciousness of the transience of all things—the idea that "nothing endures"—also permeates Sebald's work.[42] In a secularized *memento mori* mode, Sebald often takes the demise of past projects, people,

and polities as a prompt to reflect on the ephemerality of those present. Overlooking the debris of an abandoned military installation at Orfordness, Sebald's protagonist in *The Rings of Saturn* tells how he "imagined myself amidst the remains of our own civilization after its extinction in some future catastrophe. To me too as for some latter-day stranger ignorant of the nature of our society wandering about among heaps of scrap metal and defunct machinery, the beings who had once lived and worked here were an enigma."[43] Both Sebald's and Hildreth's works can be read in relation to a longer tradition of imagining the present in ruins. Consider, for example, works by the eighteenth-century painter Hubert Robert, who often depicted the same layered ruins surrounding Nîmes that inspired Hildreth during her residency. Robert did not only depict the ruins of *past* historical stages, though, but also "future ruins," imagining contemporaneous societies after their desolation and abandonment.

My suggestion in closing this section is that the "lost magic kingdoms" featured in *Forthrights and Meanders* perform the same function for the modern cultures mapped beside them as the three dead for the three living, the remains of Orfordness for modern civilization in Sebald's itinerant reflections, or the ruins around Nîmes for contemporary architecture in Robert's painterly imagination. The remains of lost premodern worlds lingering on in Hildreth's geographies provide templates, extracted from ancient and perhaps mythic history, for the fate that modern society can expect to befall it. Despite the imaginative temporality constructed in *Forthrights and Meanders*, I find this aspect of the series politically disabling. Allowing images of past ruin to overemphasize the transience of prevailing social formations and to anticipate their future demise suggests the futility of all attempts to act in the present. On the *vanitas* view, all human efforts to direct (or redirect) the dominant order of things are of little wisdom and less significance, for they end, inexorably, in common ruination. As harbingers of disaster to come, the ruins of lost cultures dispersed across *Forthrights and Meanders* also anticipate the theme of ecological crisis and apocalypse discussed in the following section. Yet in implying the transience and futility of all earthly projects, these pessimistic cartographies

undermine the value of constructive attempts to imagine (and practice) modern ecology otherwise. Effectively they naturalize ruin and valorize apathy in the face of unfolding ecological disaster.

Combined and Uneven Ecologies

Moving beyond the nostalgia and retrograde orientation of *Forthrights and Meanders*, this final section shows how Hildreth's polychronous mapping practice also encompasses the overlapping of present and future moments. Whereas the Romantic strand in the series functions by setting a grim modernity in opposition to alluring past worlds, *Forthrights and Meanders* also performs acts of what Roxanne Panchasi has called "cultural anticipation." Inverting the recent scholarly emphasis on the politics of cultural remembrance, Panchasi argues that "the future anticipated at a particular historical moment can tell us a great deal about the cultural assumptions and political perspectives of the *present doing the anticipating*."[44] Accordingly, I focus here on the particular strand of polychrony in Hildreth's cartographies, in which features and figures belonging to emergent futures, or projected ideas about those futures, exist within and come to shape geographies in the present. The specific future anticipated through the uneven overlap of established and emergent elements in *Forthrights and Meanders*, I argue, is that of modernity's ecological ruin following the triumphant resurgence of an avenging natural order. This vision of ruin and resurgence bears directly upon maps. Hildreth presents cartography as laden with hubris, and as confronted, in polychronous fashion, with the catastrophic ecological changes brought on by the modern worlds built through mapping.

I shall begin, then, with the cartographic motifs enrolled in *Forthrights and Meanders*, which are by and large "topographical," meaning they are concerned with observable landforms and structures in the depicted geographies. Consider here the ruined towns and fortifications, many roads, several rivers, ice floes, and standing waters that make up the series' obscure imagined topography. Among these, though, are clusters of forms that, representing no observable landscape or "place world," belong instead to cartography's opposite methodological pole—namely, projective geometry

and geodesy.[45] The geodetical tradition, which is very ancient, establishes positions and distances between terrestrial locations. These were based, initially, on astronomical and later terrestrial measurements.[46] An important seventeenth-century innovation in this tradition, which prevailed well into the twentieth century, was the geometrical triangulation of points in the landscape. By observing and recording the degrees separating two points in a triangle from the vantage point of a third, and then repeating the procedure from one of the other points, one can calculate the distances between all three sites. Although practices of triangulation existed in ancient Greece and Wei China, under the aegis of the Académie des Sciences in seventeenth-century France it became core to cartographic procedure. The astronomer Jean Picard, an important member of the academy, asserted the value of triangulation thus: "For the obtaining of the knowledge of a considerable distance, though less than that of a Degree, 'tis necessary to have recourse to Geometry, to make use of a Chain or succession of Triangles united together, the sides of which are as so many great measures, which passing over the inequalities of the surface of the Earth, give us the measure of a Distance, which it would be impossible to measure otherwise."[47] Vast chains and successions of triangles united together, just as Picard described them, extend across the world of *Forthrights and Meanders*. The visual correspondence between Hildreth's representations and illustrations in Picard's book is striking (figs. 21 and 22). Triangulative mappings constitute one pole in a polychronous relationship. They are historically significant, in that triangulation was not only central to constructing society as the measured object of state administration at a time of newly centralized and absolute monarchical power in Europe; it also established, or else redefined, the shape of modern statehood and was used to measure the extent of numerous modern states beyond France.[48] Thus lines of triangulation, in *Forthrights and Meanders*, stand as synecdoches of a modern epistemological, administrative, and political order.

Yet while the first temporal term in the polychronous relationship under discussion here is grounded firmly in the ascendance of modernity, the second initially seems to span and overflow any periodization I might try

Combined and Uneven Cartography

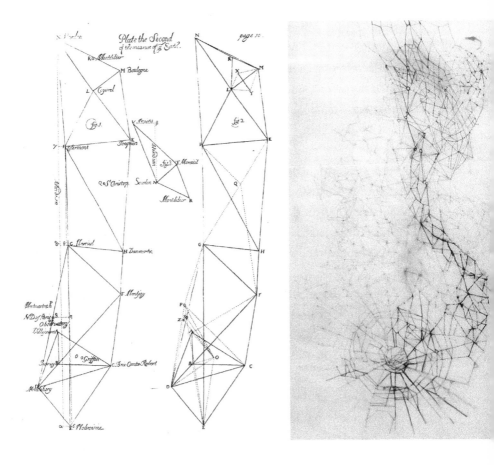

Fig. 21. *Triangulative structure*. Illustration from Jean Picard's *The Measure of the Earth*. 1687. The structure records the measurement by triangulation of the area between Sourdon and Malyoisine. The Huntington Library, San Marino, California. Image published with permission of ProQuest. Further reproduction is prohibited without permission.

Fig. 22. Alison Hildreth. Vast chains of triangles extend across the world. Detail of *Forthrights and Meanders #19*. 2008. Graphite, encaustic, and ink on rice paper, 38 x 137 cm. Reproduced with permission of the artist.

to impose. Most obviously, the set of motifs I am referring to here belongs to another *material* order: that is, the organic, represented in *Forthrights and Meanders* by an army of arthropods that cluster and bustle over and around the diverse landforms before finally overtaking them (fig. 23). Fleets of flies and squadrons of beetles and wasps are shown swarming in an attack upon the human world, sweeping in and over its triangulative forms, and contaminating the windless abstraction of Picard's carefully plotted graphics with their brute quality and substance. Indeed, although these structures are usually taken to exist on a mathematical plane of existence populated by abstract, not to say Platonic ideal forms, Hildreth pictures them as fully physical entities that are liable to rot, smudge, and splinter. In this vision, a renascent organic order contends with and wreaks havoc upon modern civilization, symbolized by its rigid geometries.

Through this spectacle, I claim, Hildreth imagines modernity's encroaching ecological crisis: the fact that "global dependency on the essentially unlimited extraction of natural resources and intensification of pollution due to world-wide commodity production pose ecological threats of heretofore unimaginable magnitude."[49] Hildreth's rendition of ecological disaster imagines the return of, or collapse back into, a state of organic indeterminacy that modernity has striven to rise above, set to rational order, and exploit. *Forthrights and Meanders* anticipates a future in which catastrophe unites the stretch of time preceding the upstart modern world with the age that follows it, consigning modernity to a historical cul-de-sac.

Modern cartography's relation to insects and organic forms in these works, then, is temporal: past and future converge in the ecological conflagration of the modern present. Here, however, polychrony does not occur merely *between* two terms. The relationship is invasive, migrating into, occupying, and transforming the entities doing the relating. Consider a typically melancholic sentence from one of Hildreth's main cultural refer-

Fig. 23. Alison Hildreth. Detail of *Forthrights and Meanders #16*. 2008. Insects range across the entire series, constantly encroaching upon and attacking the human world that surrounds them.

Combined and Uneven Cartography

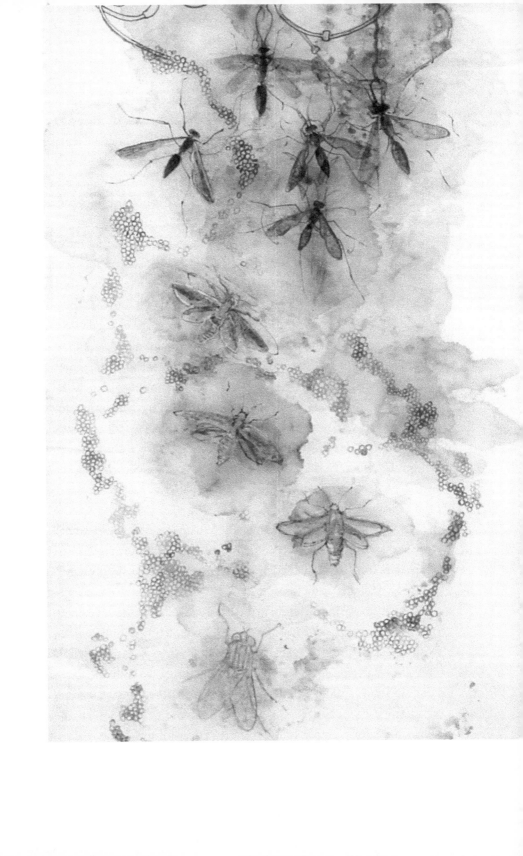

ences, Sebald's *The Rings of Saturn*: "On every new thing there lies already the shadow of annihilation."[50] Here, anticipation of a thing's future demise passes onto the thing itself. In *Forthrights and Meanders* this process is visible in how modern geometry is not presented as faultlessly linear and immaterial. Rather, it appears in the light of its fate: shattered, weighed down by matter, traversed by insects, and cluttered by clinging organic matter. In *Forthrights and Meanders 20* a tower of geometric lines splinters and begins to scatter as the resistance of helicopters and warplanes against the resurgent insects concludes with the machines blending into their arthropod foes (fig. 24). In *Forthrights and Meanders 27* a fortified city no longer stands as a defiant demarcation wresting an ordered habitation from natural disorder (see fig. 25). Now, the city wall provides the outer frame for an elaborate web, fulfilling Alexandre Kojève's prediction that "after the end of History, men would construct their edifices and works of art as birds build their nests and spiders spin their webs."[51] Lastly, in *Forthrights and Meanders 5* mathematical and organic forms are no longer discriminable at all: geometries droop and yellow as the coming organic order darkens their present purity and abstraction (fig. 26). As synecdoches of the modern world they helped bring into being, the cartographic and more generally geometrical forms arrayed through *Forthrights and Meanders* have future ecological demise teleologically latent within them, and beginning to show through.

Through these sullied geometries Hildreth imagines the hubris of modernity and sees cartography as containing, immanently, the seeds of future ruination, from its triangulative revolution onward. The deeply ingrained failing that dooms cartography, it is clear, concerns its fundamental relation to nature. The grim, teeming arthropods that clutter the maps have no place in the rhetorical field of the French Enlightenment under which the Picard-Cassini project of triangulative mapping developed. The choice of insects as emblems in the series is significant: associated with dirt, darkness, and distant evolutionary stages, they are the least recognized sufferers of modernity. The loss of insects following the use of mass insecticides in agriculture, for example, or as an effect of transformed countrysides, not

Combined and Uneven Cartography

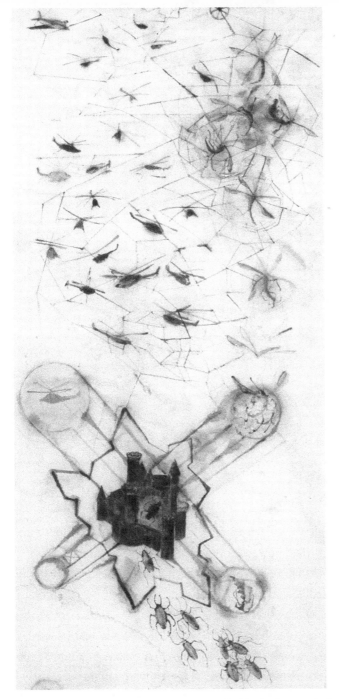

Fig. 24. Alison Hildreth. Flying machines and arthropods. Detail of *Forthrights and Meanders #20*. 2008. Graphite, encaustic, and ink wash on paper. 32 x 141 cm. Reproduced by permission of the artist.

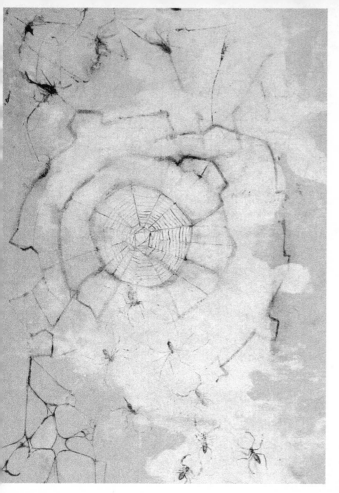

Fig. 25. Alison Hildreth. Spider-web cities. Detail of *Forthrights and Meanders #27*. 2008. 38 x 137 cm. Graphite, encaustic, and ink wash on paper. "After the end of History, men would construct their edifices and works of art as birds build their nests and spiders spin their webs." Reproduced by permission of the artist.

only goes largely unremarked but increases, while modernity's human victims are recorded, however unevenly, in rituals of memorialization.[52] My point here is that if Hildreth's depictions of triangulative cartography register as synecdoches of modern rationalization, the insects represent its unsung victims, whose ascendance in *Forthrights and Meanders* signals the return of a natural order that modernity has schematized, manipulated, and dominated. The two sets of forms are therefore avatars of a more general clash between modernity and nature. The capitulation of the former, which strikes viewers as a prospective catastrophe, represents a triumph for the organic—the denouement concluding the drama of ecological exploitation, in which a renascent nature takes its revenge upon the modern mapping

Combined and Uneven Cartography

Fig. 26. Alison Hildreth. Geometries droop and yellow. Detail of *Forthrights and Meanders #5*. 2008. Graphite, encaustic, and ink wash on paper, 32 x 141 cm. Reproduced by permission of the artist.

cultures that have vied, in the words of Horkheimer and Adorno, to "hold sway over a disenchanted nature."[53]

In closing, however, I want to caution that *Forthrights and Meanders* mystifies the ecological crisis of modernity insofar as it unfolds an *eschatological* vision in which an organic future suddenly overtakes established modernity. This is not to suggest that in engaging with contemporary climate crises, visual art should be limited to providing "accurate" representations— that function most obviously belongs to science or journalism. Still, I would suggest that *Forthrights and Meanders* reproduces a wider narrative framing of ecological disaster, which is imagined as the punctual return of a revenging "nature" conceived as a sentient totality. This narrative

structure often frames contemporary cultural imaginations of climate change. Consider Frank Schätzing's bestselling novel *Der Schwarm*, in which the "yrr"—a ubiquitous but previously undetected species of deep-sea microorganism—begins dismantling modern civilization by destroying its habitats, or M. Night Shyamalan's film *The Happening*, in which plants and trees respond to the same threat, suddenly and in unison, by emitting a toxin that causes humans to commit suicide.[54] In positing an avenging natural order, this narrative structure confabulates and imposes a unity that approximates a sentient personality onto the discontinuous beings and processes commonly totalized as "nature."[55] Furthermore, modernity's ecological predicament only sporadically takes the form of punctual emergencies or "natural disasters" that suddenly suspend and overturn prevailing orders.

In his book *Combined and Uneven Apocalypse*, Evan Calder Williams powerfully critiques essentializing and eschatological anticipations of ecological disaster: "The world is already apocalyptic. Just not all at the same time. . . . To be overcome: the notion of apocalypse as evental, the ground-clearing revelatory trauma that immediately founds a new *nomos* of the earth. In its place: combined and uneven apocalypse."[56] For Williams, a realistic thinking of apocalypse would not fixate on punctual catastrophes, but chart multiple forces and effects as they unfold unevenly through modern ecologies. Now, I would suggest that in pitting modern mapping cultures against a coming organic order, represented as an organized mass of vengeful insects, and showing modernity pass evenly into dereliction, Hildreth's geographies reinforce a seductively dramatic eschatological imagination of contemporary ecology. And yet the new mapping practices through which she does so are hardly bound to this narrative structure. On the contrary, polychronous cartography is uniquely placed to represent what Calder calls "combined and uneven apocalypse." In combing residual geographical formations alongside nascent manifestations of ecological crisis, Hildreth's polychronous mapmaking is able to represent global ecology not as a simultaneous totality, whether stricken or stable, but as "one and unequal." Even as it submits to an apocalyptic

mode of imagining ecology, *Forthrights and Meanders* gestures beyond eschatological thought, in that it instantiates a mapping practice able to grasp modern geographies as wholes riven, unevenly, by unfolding difference. Hildreth's formal innovations in polychronous cartography, then, are perhaps the most significant aspect of her mapping practice. They make possible a temporally sophisticated imagination of ecological crisis. Indeed, if pushed beyond a stark opposition in which the present stability of modernity is overtaken by an emergent revenge of the organic, the polychromic complexities of uneven ecology would eschew eschatology. If not in content then in *form*, Hildreth's mapping practice cuts against the apocalyptic imagination in which ecological disaster will arrive, one fine day, as an "evental" catastrophe precipitated by a coherent, even sentient "nature" and suddenly inaugurate another order.

I have shown how Hildreth's cartographies contravene the monochronous temporality that modern cartography has projected onto the earth. Whereas established cartography aspires to produce simultaneous snapshots of geography, the polychronous mapping practice developed through *Forthrights and Meanders* unfolds fields of temporal tension in which residual, prevailing, and emergent temporal orders coexist, clash, and interweave. Whereas this chapter has explored cartographic orderings of time, the next foregrounds cartographic attempts to render urban space transparent and malleable. Just as *Forthrights and Meanders* both throws the established temporality of mapping into relief and develops a polychronous alternative, the map artworks I turn to now both probe deeply into the cartographic casting of modern space and gesture beyond it through artistic experiment. Gert Jan Kocken's *Depictions* stress the transformative intent, expose the calculative ontology, and accentuate the repressed contradictions of some of the most extreme mapping and planning projects of twentieth-century modernity.

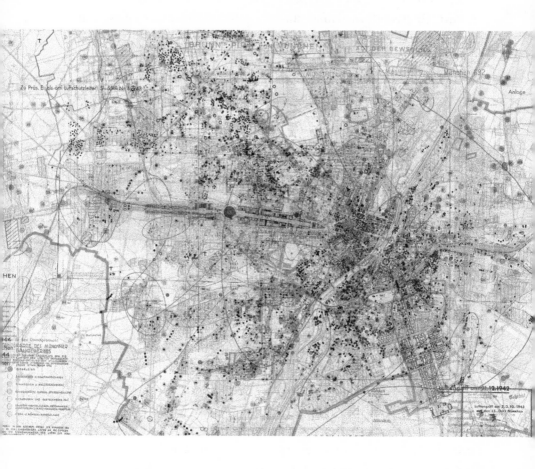

Fig. 27. Gert Jan Kocken. *Depictions of Munich, 1933–1945*. 2014. Digital print, 420 x 300 cm. Reproduced by permission of the artist.

3 Drawing Like a State

Maps, Modernity, and Warfare in
Gert Jan Kocken's *Depictions*

For all their aesthetic fascination, maps are instruments. They figure ulterior realities to facilitate work in and on them. Much of this work has been the molding of the world by modern states, according to projected visions of what an inspired or rational society should look like.[1] That is the message articulated in a series of map-based artworks by the Dutch artist Gert Jan Kocken (b. 1971). Produced between 2011 and the present, the works are titled *Depictions of Amsterdam, 1940–1945; Berlin, 1933–1945; Rome, 1922–1945; Rotterdam, 1940–1945; Munich, 1933–1945;* and *Battle of Berlin, 1945. Depictions of London, Łódź, Stalingrad, Vienna,* and *Warsaw* are in construction. For the sake of expediency, I refer to them collectively as the *Depictions*. Each work is comprised of between twenty-three and one hundred and twenty-four found maps, as well as plans and aerial photographs, which were produced or instrumentalized by belligerent states during the Second World War (though *Depictions of Munich, Berlin,* and *Rome* treat the longer periods of National Socialism in Germany and fascism in Italy). Having been sourced in various archives, this mass of found material has been scanned and painstakingly collaged together in hundreds of digital layers using Photoshop to form six composite wholes. These were then printed for exhibition on walls or mounts stood apart in gallery spaces. *Depictions of Munich* gives an impression of the wider series (figs. 27 and 28). Although all the maps assembled in a particular work figure the same city, they do so from different perspectives, at different times, and for different purposes. There are maps derived from both Axis- and Allied-identified states; maps annotated by statespeople and foot soldiers; maps that project imagined futures and others meant only to figure existing

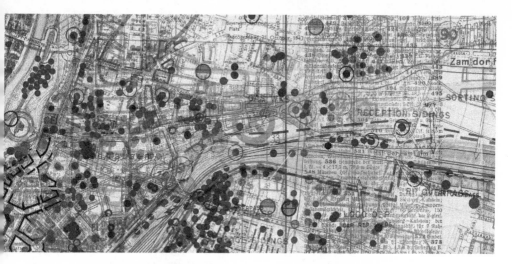

Fig. 28. Gert Jan Kocken. Detail of *Depictions of Munich, 1933–1945*.

situations. There are maps used to plan cities and others to commit acts of urbicide; maps that preceded hostilities and others that outline prospective peace. The documents of which the *Depictions* are comprised are thus disparate, indeed often overtly opposed to one another. All are nonetheless united in presenting the city as an object of state practice, often war.

This chapter explores connections among cartography, modern states, and warfare as they are articulated in Kocken's artistic assemblages of maps. Unlike the many art practices that engage cartography's rhetorical power to enact notions of nationality and statehood, Kocken positions mapping primarily as a practical instrumentation of the state. My argument takes as its point of departure Zygmunt Bauman's metaphorical conception of the modern state as the "gardener" of society: a diagnostician and designer that surveys received conditions and replaces them with planned alternatives. Unpacking Kocken's artworks alongside this theory shows how the *Depictions* present cartography as both an instrument and a record of state struggles to consummate confected designs in social reality. Attending closely to the juxtaposition of state plans and maps in the artworks, the chapter advances several critical understandings of cartography. First, I argue that maps serve

Drawing Like a State

prospective social visions even where they appear narrowly representational. Positioning future plans beside maps in situations of radical transformation, Kocken brings into focus the interventionism implicit in state cartography. Then, drawing from Stuart Elden's work on the calculability of modern space, I show how maps have ontological agency in the artworks, stressing that it is only through mapmaking that these cities emerge as "plannable" at all.

If the *Depictions* crystallize the entwinement of maps with the modern worlds fought for by states, it follows that Kocken's artworks assemble a reflection on modernity through maps, deepening the wider exploration of maps and global modernity built through this study. My analysis of Nikritin's painting *The Old and the New* stressed how maps disclose disenchanted modern geographies that, lacking inherent meaning and order, stand available to inscription and remolding through transformative acts of mapping. Hildreth's *Forthrights and Meanders* shows how this performative power applies as much to the times as the spaces of the disenchanted world, whether in reinforcing the global monochrony that has prevailed in modernity or in imagining a polychronous alternative that is better able to grapple with the realities of uneven development and ecologies. Cartography's capacity not just to project constructed orders onto contingent modern geographies, but to help realize them through rendering the world calculable (and thus more controllable), is still more pronounced in the *Depictions*, which address some of the most extreme modern attempts to remake social space. Accordingly, I unpack how Kocken presents the various functions that constitute transformative state projects. My discussion focuses on his interrelation of different artifacts, drawing on their material histories to show how some rendered existing conditions legible, others projected alternatives, while still others helped realize them. In exploring the latter, I emphasize Kocken's treatment of annotated military maps, suggesting that in the *Depictions* warfare represents a heightened and unfettered mode in which states attempt to realize their designs. By foregrounding extreme moments of war, the *Depictions* articulate inner tendencies of state gardening that are often diluted or restrained in other, nonmilitary contexts, and thus more difficult to perceive and assess.

The artworks figure condensed images of states reshaping human reality in conditions of extremity. Alongside that broad gesture, however, I emphasize that the *Depictions* are constructed through specific, highly differentiated documents. Invoking Michel de Certeau's affirmation of the unruliness of urban practice, I show how the artworks deepen Bauman's theory by exposing frictions and complexity in systematic spatial ordering. Kocken's graphics were reworked for multitudinous purposes by different actors, with the consequence that the *Depictions* foreground unevennesses and dialogic complexities that are lost in the totalizing sweep of Bauman's metaphorics. This nuances the critical understanding of maps and modern world making built up through my analysis of *The Old and the New*, which emphasizes the facticity of the mapped earth, and *Forthrights and Meanders*, which shows how maps project constructed (temporal) orders onto its contingency. The *Depictions* stress how such cartographic orderings of malleable geographies are diffused and diffracted through practice, even in extreme contexts of totalitarianism and total warfare.

The chapter concludes with a brief consideration of how these images, which both monumentalize and complicate state struggles toward modernity, stand in relation to the social present. I argue against the urge to position Kocken's vision in the past as another document of the Second World War. My final suggestion is that the artworks actively defamiliarize the modern condition of reflexive social/spatial gardening, producing a stark image of modern ordering able to resonate not just historically, but also today. Before the *Depictions'* world of warring states and hubristic modern visions, viewers might still experience the vertigo of self-recognition.

Gert Jan Kocken, Map Art, and the State as Gardener of Society

Kocken has been practicing in Amsterdam since the turn of the millennium, largely specializing in photography and readymade objects. His work revisits cultural artifacts in which sociopolitical conflicts were crystallized. A clear example is the series *Defacement* (2005–9), for which he photographed carvings, paintings, and missals that were damaged by iconoclastic violence during the Reformation. Another is a photograph named *Madonna of*

Fig. 29. Gert Jan Kocken. *Ypres, 1914–1918*. 2007. Digital print, 200 x 140 cm. Reproduced by permission of the artist.

Nagasaki, Defacement 9 August 1945 (2007), showing a bust of the Virgin Mary bleached by atomic fire in Nagasaki's Catholic Urakami Cathedral. These presentations of found material exemplify a central thrust of Kocken's practice, which figures forth historical entwinements of political violence and visual culture.

Given the persistent use of politically loaded visual materials in Kocken's practice, it is all but inevitable that one of its major strands should explore cartography. In some works maps are present but peripheral. A magazine issue that Kocken edited is interspersed with readymade maps, lifted from Edward Quin's notoriously ethnocentric *Historical Atlas* (1830).[2] It contains one page from Quin's atlas, in which most of the world is enshrouded in palls of dark cloud, which progressively disperse upon contact with the radiance of Judeo-Christian civilization. Unlike the magazine, *Ypres 1914–1918* (2007) focuses solely on cartography (fig. 29). This stark photograph shows just one of the thirty-five million maps the British Military produced during the First World War.[3] Intensive usage has blackened the map's surface

around the city of Ypres, as if the map's degeneration were talismanically linked to the desolation of the terrain.

Building on these earlier engagements, the *Depictions* represent Kocken's most sustained exploration of cartography and his main contribution to map art. Discussing the *Depictions* in depth alongside Bauman's theory of state "gardening," I show how in Kocken's works maps serve as a practical instrumentation of the modern state. Yet unlike the theories I put in dialogue with the *Depictions*, which engage state practice through conceptual analysis, the artworks are themselves built of maps and plans that were internal to state projects. Using this found material allows Kocken to both present the transformative sweep of state gardening projects and manifest their complexities and uneven effects materially, in the *Depictions'* presence and form. Before exploring these effects, though, I want to discuss Bauman's conceptual metaphor of state gardening.

In the 1987 book *Legislators and Interpreters: On Modernity, Post-Modernity, and Intellectuals*, sociologist Zygmunt Bauman first elaborated a metaphorical conception of modernity premised on the power of states to intervene in and ultimately reshape societies. In the book's fourth chapter, "Gamekeepers Turned Gardeners," Bauman introduces a distinction between "wild" and "garden" cultures.[4] Pre- and nonmodern cultures are wild (or rather "re-evaluated" as wild by modern cultures) because they reproduce themselves of their own accord, without programmatic design and maintenance. The feudal elite that presided over the "wild" culture of premodern Europe, to give Bauman's example, left the diversity of human groups and settlements ranged around them largely to their own devices. Time-tried habits were left untouched. Of course the seigniorial class interacted with society at large and made exacting demands. But it did not dictate a model for how communities should be constituted or life lived. For the premodern mindset, to which the received social order appeared natural and absolute, it was inconceivable that one might.

Against premodern "wilderness," Bauman casts modernity in the resemblance of a garden. Like gardens, modern societies are consciously planned and molded by human endeavor and must be perpetually tended lest they

lapse from the chosen schema. Programmatically redesigning social conditions implies an awareness of their contingency and malleability. For Bauman, this consciousness of contingency fundamentally distinguishes modern societies from premodern communities, which, possessing no knowledge of their own malleability, undertake no self-molding. Modern societies, by contrast, are aware of the "human origin of the human world" and must rise to the task of self-generation.[5] Not having been imagined before modernity, the project of purposefully shaping societies exceeded the capacities of premodern political powers.[6] "A new, more powerful social agent was needed to perform the task," writes Bauman. "That new agent was the state."[7]

In what follows, "state ordering" refers to practices by which state agents instill and maintain a designed social order. Extrapolating from *Legislators and Interpreters*, I propose that state ordering entails the interrelation of three basic functions, each registered in Kocken's artworks: first, the description of received situations, to diagnose their flaws and plot their transformation; second, the articulation of a blueprint to which received situations should ideally correspond; and, third, the variously productive or repressive realization practices through which plans are achieved in social reality. Now, numerous theories of state power might be invoked to offer perspectives on the *Depictions*, not least Michel Foucault's work on discipline and territorial and population control, which has rather overshadowed Bauman's conception of state practice in social theory.[8] Although I will invoke insights from various theorists of state territory, this chapter foregrounds Bauman's modern gardening because, in establishing a clear metaphorical shorthand for both the conscious artificiality and intense spatial focus of state ordering, it grasps what I see as core to the *Depictions'* imaginary. My analysis of Kocken's artworks is therefore grounded in Bauman's theory, through which I stress how modern states fight to impose confected spatial orders on populous cities.

The *Depictions'* cartographic medium makes them especially well placed to grapple with state ordering. It is telling that *Legislators and Interpreters* contains references to draftsmanship and blueprints. Assembling modern societies "demanded a bold, but carefully sketched design," while a "leg-

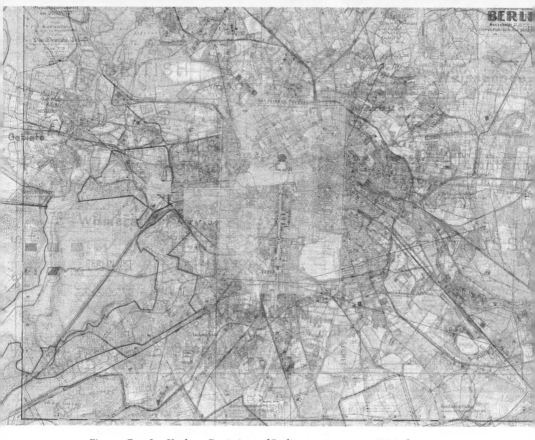

Fig. 30. Gert Jan Kocken. *Depictions of Berlin, 1933–1945*. 2011. Digital print, 430 x 300 cm. Reproduced by permission of the artist.

islator or design-drawing despot were the only frames within which the problem of social order could be envisaged."[9] Though these graphic allusions are not always literal, their importance to state gardening is confirmed by a considerable body of research affirming the indispensability of maps to the formation and reproduction of centralized states.[10] Collaging diverse cartographies, Kocken's *Depictions* manifest a potent reflection on how description, design, and realization dovetail in radical instances of modern states casting the world in the mold of human designs.

An initial point to make about the *Depictions* in connection with state ordering is that several of the graphics they contain are not properly maps at all, but, rather, large urban proposals made to shape the future of the cities they address. This section argues that Kocken's inclusion in his works of both

Drawing Like a State

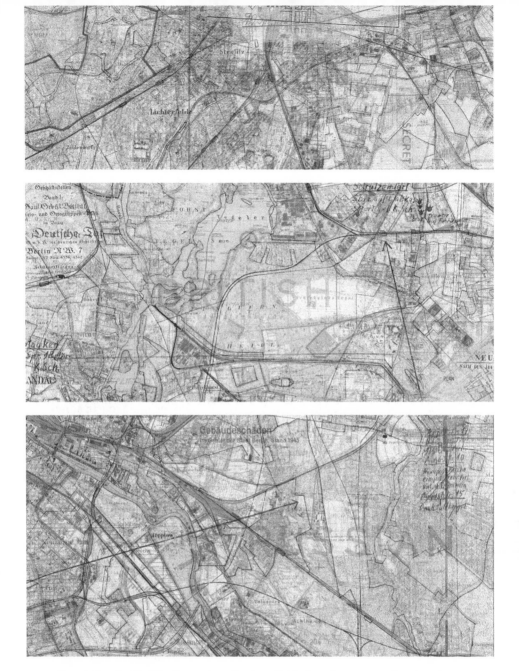

Fig. 31. Gert Jan Kocken. Possessive adjectives divide the urban topography: American. Detail of *Depictions of Berlin, 1933–1945*.

Fig. 32. Gert Jan Kocken. British. Detail of *Depictions of Berlin, 1933–1945*.

Fig. 33. Gert Jan Kocken. Russian. Detail of *Depictions of Berlin, 1933–1945*.

maps and plans—graphic manifestations of description and design—presents mapping and planning as mutually entailing functions in the larger continuum of state ordering. Admitting map and plan alike, so that modest empirical surveys are printed over, above, and flank to flank with transformative programs, the artworks foreground the interventionist core of state mapping.

Although maps and plans share a language of schematic spatial elevations, I assume a functional distinction between them: maps are generally used to advance descriptive arguments about what is, plans to design what might be. Two antagonistic plans assembled in *Depictions of Berlin* exemplify Kocken's presentation of the latter category (fig. 30). First is the plan for Berlin prepared by Allied politicians and commanders at the Yalta Conference in January 1945. These proposals were grafted onto the city in an overprinted map included in *Depictions of Berlin*, which can be recognized by three possessive adjectives dividing the topography: "BRITISH" hanging capitalized between Spandau and Charlottenburg, "RUSSIAN" over Treptow, and "AMERICAN" above Steglitz (figs. 31, 32, and 33). These denote three initially proposed zones of occupation, which were later expanded to include a fourth administered by the French government. Kocken sets this plan for Allied occupation alongside the political vision it displaced: the "Neuplanung Berlin, Nach den Ideen des Führers Ausgearbeitet von A.Speer" (Berlin replanned according to the ideas of the Führer as detailed by A. Speer; figs. 34 and 35). Produced by the office of Albert Speer in 1939–40 at the large scale of 1:4000, the scheme occupies the artwork's center with a spread two and a half meters tall by one meter wide, standing out pale against the jostling colors of surrounding maps. It envisions Berlin's prospective transformation into the "World Capital of Germania" following a Nazi conquest of Eurasia. The centerpiece is a parade boulevard named the Prachtallee (Avenue of Splendors), which was projected to run for five miles from the vast domed Volkshalle (People's Hall) initially sketched by Adolf Hitler himself, to a similarly colossal triumphal arch.[11] Demographic elements that diverged from this imaginary were forcibly displaced. Indeed, *Depictions of Berlin* also presents three ancillary maps to the "Neuplanung Berlin," positioned at intervals south of the Tiergarten. These define *Judenreine* or "Jew-cleansed"

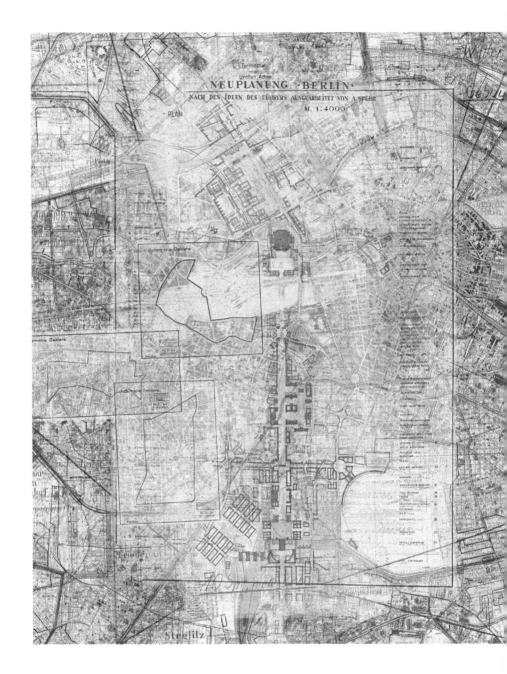

Fig. 34. Gert Jan Kocken. "Berlin replanned according to the ideas of the Führer as detailed by A. Speer." Detail of *Depictions of Berlin, 1933–1945*.

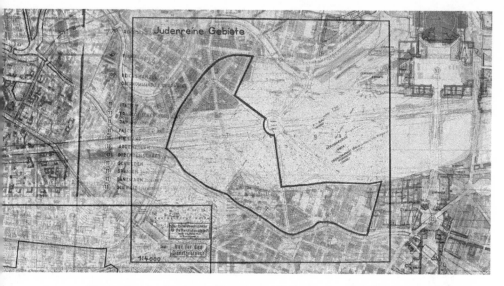

Fig. 35. Gert Jan Kocken. A "Jew-cleansed" district. Detail of *Depictions of Berlin, 1933–1945*.

areas: the culmination of policies aimed at the compulsory eviction of Jews (figs. 34 and 35). In his celebrated work on the modernity of the Holocaust, Bauman argued that, for their executioners, Jewish populations represented weeds infringing on the Nazi garden—blots tainting the desired plan.[12] *Depictions of Berlin* confirms this language of social design and deviation, showing the persecution unfold through urban planning.

These urban designs are surrounded and subtended by documents performing descriptive functions, focused largely on effects of the air war. Some are German, including "Gebäudeschäden im Gebiet der Stadt Berlin" (Building damage to the territory of the city of Berlin) of 1945, with interlocking blocks of red, blue, and green grading the condition of buildings made uninhabitable by Allied bombing with a view to reconstruction (fig. 36). Provocatively, it is presented alongside a "Bomb Damage Plot" used by British Bomber Command to assess and direct their campaign of bombardment. Though these charts describe the creep of urban ruin from two irreconcilable perspectives, both were used as empirical attempts to

Drawing Like a State

Fig. 36. Gert Jan Kocken. "Building damage to the territory of the city of Berlin."
Detail of *Depictions of Berlin, 1933–1945.*

render existing conditions intelligible. These are therefore maps, and they can be differentiated from the plans collaged among them, which projected designed *alternatives* to existing conditions.

Looking at the maps and plans gathered within Kocken's artworks, we are provoked to consider what mandates their combination, and its significance. I connect the combinatory gesture to the "work" performed by cartography on social reality. Positioning maps centrally amid radical attempts to remold societies through urban design, military strategy, and social engineering, the *Depictions* bear directly on the defining theme of critical writing on cartography: the social agency of mapping. Following J. B. Harley's formative Foucauldian analyses of "power/knowledge" in map-

ping, the burgeoning scholarship of critical cartography refutes rhetorics affirming the disinterestedness and representational transparency of maps by foregrounding how they "make reality as much as they represent it."[13] The next section parses two forms of "reality-making" work conducted through cartography that might otherwise be conflated under Bauman's encompassing rubric of gardening: the *instrumentality* of maps in facilitating transformative planning, and cartography's *ontological performativity*, which reveals the world as potentially "orderable" in the first place.

The Instrumentality of Mapping to State Planning

The *Depictions* position maps beside plans in contexts of aggressive state action, suggesting we think of mapping and planning as mutually supportive players in the common scene of state ordering. Theories of how the functions of describing and designing society interrelate in the operation of modern states help develop this idea. James C. Scott's classic study *Seeing Like a State* positions "descriptions" of existing societies as the condition of implementing state "prescriptions" for how they should be.[14] Once the structuration of a given situation has been made transparent to state actors, he argues, its shortcomings can be diagnosed and interventions applied. Here Scott appraises the prospects facing state endeavors undertaken *without* an adequate descriptive apparatus: "If we imagine a state that has no reliable means of enumerating and locating its population, gauging its wealth, and mapping its land, resources, and settlements, we are imagining a state whose interventions in that society are necessarily crude. . . . An illegible society, then, is a hindrance to any effective intervention by the state, whether the purpose of that intervention is plunder or public welfare."[15] The rationale behind descriptive practices is that of making society more amenable to management in accordance with a chosen model. Hence, in our cartographic context, Scott and Bauman would insist that state plans require adequate mappings if they are to be realized effectively, and, conversely, that state cartography's *raison d'être* is to expedite the implementation of designed alternatives.

If mapping and planning entail one another in the operational unity of the state, as these theorists suggest, the interpretative consequence for our

Drawing Like a State

encounter with the *Depictions* is that, though only few of the documents assembled in the artworks present fully fledged future designs, all serve transformative visions—even the apparently empirical maps. This can be brought into relief by identifying Kocken's plans with utopianism, another of Bauman's signal categories. For Bauman, utopianism is inseparable from the gardening mentality: imagining communities that are ideal in relation to received social formations entails a conception of society as relative, mutable, and potentially malleable. Coupled with state power, utopianism might assume "an active historical role," projecting social models and maintaining a climate of transformative potential.[16] Addressing a significant city in twentieth-century modernity, *Depictions of Berlin* fixes a moment when several utopias "entered the historical stage as important members of the cast," depicting fascist, communist, and liberal-capitalist visions of modernity vying for hegemony.[17] The "Neuplanung Berlin" plainly figures a utopian scheme, its scale and neoclassical iconography concentrating the racial-historical mythology of National Socialism in architectural form. The Yalta plan's utopianism, by contrast, is not clear cut. Its proposals seem a practical response to a situation forced upon the Allies, not a positive proposal. Though the plan is itself no utopian scheme, it nonetheless exhibits the pull of utopianism on interstate politics, for the central gesture of polarizing Berlin into distinct spheres of influence stems from the differing social ideals promoted by the occupying states. The projection of utopian social ideals is present here, but at a remove.

Unpacking the sometimes latent, sometimes manifest utopianism of these plans underlines how the surrounding maps, though in themselves descriptive of preexisting conditions, facilitate projects aimed at remaking extant social reality in utopian fashion. A context of social design inheres in the artworks even where maps have been presented *without* the corollary presence of plans. This is confirmed by *Depictions of Amsterdam*, which includes a map Scott uses to demonstrate what cartography makes possible for state power. Viewers will recognize the sheet from among the larger collage by the dense mass of black dots that curve east then south from Amsterdam's central canal belt. The occupiers demanded that the

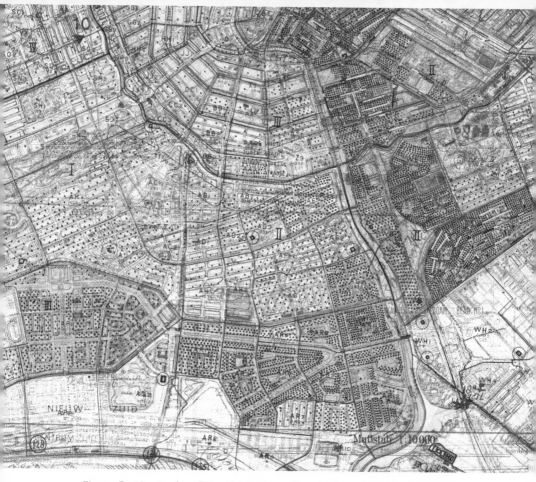

Fig. 37. Gert Jan Kocken. "The distribution of Jews in the municipality." Detail of *Depictions of Amsterdam, 1940–1945*. 2010. Digital print, 380 x 280 cm. Reproduced by permission of the artist.

Amsterdam Municipal Bureau of Statistics make this document in 1941. Titled "The Distribution of Jews in the Municipality" (*Verspreiding van de Joden over de Gemeente*), each dot on its surface figures ten people of that category (fig. 37). The work was completed in nine days, without protest from the functionaries, after which it was used to deport sixty-five thousand people.[18] Scott uses this example to highlight the role played by state descriptions within transformative projects. The occupiers "supplied the murderous purpose," but it was the social legibility encoded in administrative mapmaking that facilitated "its efficient implementation."[19]

Drawing Like a State

Despite the narrowly descriptive content of "The distribution of Jews in the municipality," it was continuous with an Aryanist vision of a Europe stratified and purged by race.

Thus *Depictions of Amsterdam* exhibits the latent influence of a particular social design. That latency would be recognizable in "The Distribution of Jews in the Municipality" irrespective of its inclusion in Kocken's artwork. Making the observation here, however, reinforces one of the series' principal suggestions, which is especially explicit where both maps and plans are present: namely, that maps are instruments of social intervention—they figure to facilitate. Much of what they have facilitated, moreover, amounts to gardening, the ordering of social spaces by states according to confected visions of modernity. Although, as a theoretical metaphor, the concept of gardening applies very widely to situations of modernity and practice of modern states, it is important to emphasize its dehumanizing and genocidal implications in the *Depictions'* context of Nazi social and spatial policy. The metaphor of gardening, in this context, grasps the ways in which racist rhetorics cast Jewish populations as invasive weeds encroaching on the state's carefully plotted garden (social space) and cultivated plants (populations). As Bauman writes, "Visions of society-as-garden define parts of the social habitat as human weeds. Like all other weeds, they must be kept segregated, contained, prevented from spreading, removed and kept outside the society boundaries; if all these means prove insufficient, they must be killed."[20] In "The Distribution of Jews in the Municipality," in which the Jewish population are enumerated, visually isolated, and spatially plotted ahead of the deportations, Bauman's gardening and weeding metaphors are horribly literalized.

A further ramification of Kocken's presentation of maps and plans within the universe of state gardening warrants address here. If the foregoing discussion posits mapping and planning as discrete functions in the continuum of state gardening, their juxtaposition in the *Depictions* could equally be construed as a conflation. Taking Kocken's collages as a refutation or deconstruction of the distinction between descriptive maps and creative plans, I argue, reveals two essential aspects of modern gardening. The first

is implicit in Bauman's theory. It is in the logic of state ordering that plans, in attaining social reality, must cease being prospective or utopian, and thus switch categories to become maps. The point is evident in the Yalta demarcation. Produced in early 1945, when the politics concentrated in the "Neuplanung Berlin" still refused to rescind its claims over Europe, the Allied plan's political hold was initially insecure. After the eventual German surrender in May, however, its delineations accumulated descriptive value as the victorious scheme was imposed on Berlin. Furthermore, the Yalta proposals exceeded the political reality first intended for them, providing the cartographic basis for the Cold War's web of geopolitical tension and proxy conflict. What had been a prospective plan became a map with descriptive purchase for another half-century. The "Neuplanung Berlin," by contrast, did not sediment into being. Although its imminent reality must have seemed assured at the height of Nazi power, when assessed retrospectively from the world prepared for at Yalta, or from today, the plan seems a *merely* utopian scheme, having lost its hold on reality during the war. Presenting differently fated plans together before viewers' inevitably comparative gazes, *Depictions of Berlin* shows how not only the success, but also the very definition of a document depends on the fortunes of the state promoting it.

In the *Depictions*, then, a plan is a map of a prospective social reality that stands as yet-unrealized, or that lost the chance of realization as events turned another way. And the artworks also present the other, crucial possibility that prospective designs might finally become present descriptions. *Plans might become maps.* The modern condition of "gardening" states struggling to consummate their confected visions is predicated on—indeed fundamentally *is*—that possibility.

Understanding the *Depictions* as an artistic conflation of maps and plans illuminates an ontological dimension of modern gardening, unmentioned by Bauman but preconditioning the ordering processes he describes. Querying the divide between cartography and planning draws out performative and productive functions that go largely unrecognized (and are thus all the more effective) in seemingly representational maps. This is worth empha-

sizing, for the foregoing analysis of mapping's instrumentality conjures state ordering as something that *uses* but ultimately lies outside cartography, leaving intact conventional assumptions that maps are "truth documents" describing geography "as it really is."[21] In light of critical cartography's insistence on the creative influence mapping exerts over social reality, I want to show how maps in the *Depictions* are not only instrumental to authority but powerful agents in themselves, "creating and building the world as much as measuring and describing it."[22]

Crucially, I see the artworks as extending this grasp of cartographic agency to an ontological level. Beyond shaping this spatial practice, or that political identification, Kocken's maps enact a prior, more fundamental ontological disclosure of the world that preconditions each particular instance of cartographic instrumentality. Indeed, alongside other technologies, cartography produces a distinctly modern understanding of being without which reflexive sociospatial ordering would be not just impractical, but inconceivable. To give terms and substance to this, consider how Stuart Elden posits the development of "a rejuvenated cartography" from the seventeenth century onward as a leading edge in a wider ontological determination under modernity, premised centrally on the world's "calculability."[23] Calculable space is typified by Cartesian extension, grasped as "measurable, mappable, strictly demarcated, and thereby controllable."[24] Maps focus the calculability, and consequent availability to intervention, of space so determined. Unfolding geographies through gridded visualizations— quantitatively measured, tabulated, divided between classified qualities— the cartographic disclosure of being makes modern ordering possible. For urban plans to be detailed, cities must first be grasped as measurable and malleable fields; for deviance to be isolated, society must be apprehended as classifiable populations; for influence to be apportioned, space must be conceived in divisible, internally coordinated planes. Through cartographic acts of ontological disclosure, modern society becomes susceptible to reflexive ordering—"the object of its own practice."[25]

Kocken's method of collaging found maps reveals how this cartographically constructed ontology of calculability underlies otherwise intractably

opposed political formations. Beneath the apparently irreconcilable ideologies juxtaposed through the *Depictions* looms a common articulation of a potentially orderable world, conditioning all subsequent orderings. Though these cartographies were put to conflicting political purposes, in presuming the world's basic measurability they concord entirely; though these plans advanced antithetical utopias, in their commitment to the perfectibility of a calculable society they parallel exactly. This has complex implications. While the contrary modernities fighting the war all rest, in Elden's words, "on the same view of the world as something orderable, measurable, controllable and ultimately destroyable," this effaces neither the moral nor political differences separating them; for Elden it is not simply *that* the world is calculable that matters, but *how* its calculability is acted upon.[26] This is reflected in my distinction between cartography's instrumentality and ontological performativity in the *Depictions*: the artworks present maps as both instruments offering legibility to specific political designs, and performative graphics that, in disclosing an ontology of calculable extension, precondition the possibility of otherwise very different orderings.

In this analysis, then, the artworks make salient an underlying ontological paradigm in which modern ordering arises. But if state gardening depends on this measurable and malleable ontology, it also requires realization through specific practices. The following section explores the military ordering practices through which the *Depictions* articulates an especially radical vision of modern gardening.

Realization Registered in Military Map Annotations

With a phrase published in 1832 that has since been presented exhaustively as the paradigmatic statement on modern conflict, the Prussian militarist Carl von Clausewitz defined warfare as "a continuation of political intercourse, carried on with other means."[27] Clausewitz's position is more nuanced than this now tired soundbite would suggest; the energy and constraints particular to warfare, he explains, also dialectically shapes the politics it serves. This qualification accepted, the "by other means" formula defines warfare as a political instrumentation of the state, an example of

Drawing Like a State

the third dimension of state ordering extrapolated from Bauman above: namely, realization practices, the variously constructive and destructive means by which states achieve their designs.

This section explores Kocken's presentation of warfare in relation to state ordering. In the *Depictions* warfare is a directly coercive political practice aimed at realizing state visions. The artworks' grasp of state action is therefore particularly accentuated, articulating the latent potential of state ordering through bellicose practices that in peacetime would be diluted and restrained by social institutions. Military realization practices are registered in the *Depictions*, not in the printed documents, but in marks subsequently made upon them. Kocken has gathered diverse cartographies that abound in military annotations, which serve several functions. Often these annotations augment cartographic legibility in response to the "fog" of war—a hurried situational subset of state description. Here, however, I focus on marks made on maps by soldiers and military planners formulating prospective strategies and actions, for these directly advanced realization processes. *Battle of Berlin 1945* is comprised of twenty-three Red Army maps, which figure ground movements planned and executed in the last large battle of the European theater. It brims with speculative marks made by military personnel in sketching out and concretizing plans, weighing up strategies cartographically to imagine their ramifications (fig. 38). Green pincers stab into Berlin's southern edge, marking an offensive by the Third Guards Tank Army. Elsewhere pencil fronts progress along river banks and down streets, raids weave between firing positions stubbed onto the map surface, while arrows of various colors and widths course across urban space—graphic avatars of agreed itineraries or lines of attack.

Seventy years on, it is largely impossible to separate annotations that project impending actions from others that figure existing situations. It seems sensible to imagine that the annotations are sometimes descriptive, marking fluctuating fronts and firing positions, and sometimes anticipatory, unfolding and assessing possible assaults, retreats, and other maneuvers. Concerning their maker's phenomenology, the latter annotations involve moving imaginatively beyond the present situation into the image-space

Fig. 38. Gert Jan Kocken. Pincers stab into Berlin's southern edge. Detail of *Battle of Berlin, 1945*.

of the map, where imminent scenarios can be worked through in advance. It is not anticipatory map annotations in themselves that are at stake here, however, but the significance generated by their assemblage within the *Depictions*. The most striking formal fact of *Battle of Berlin* is aggregation (fig. 39). A profusion of local sketches and mappings, strewn with idio-syncratic marks made by individual actors faced with specific situations, have been grafted onto one another such that a larger picture looms into sight above the confusion of warfare cartographies. Innumerable efforts have accumulated and taken shape across figurations of what was once the existing terrain, and their ultimate purpose takes shape. Thus we see the Yalta proposals for a defeated and occupied Berlin being steadily realized in and through the splintered Red Army annotations gathered in this work.

The *Depictions* are able to set forth the inner tendencies of state ordering because of the extremity of the martial realization practices assembled in them. Military action is extreme because it fundamentally involves physical

Drawing Like a State

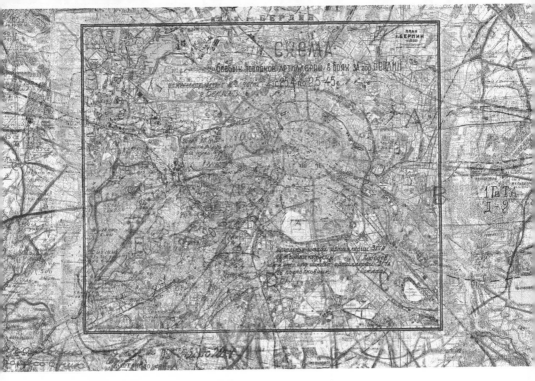

Fig. 39. Gert Jan Kocken. *Battle of Berlin, 1945*. 2011. Digital print, 280 x 380 cm.
Reproduced by permission of the artist.

violence and death. Through direct coercion it imposes political designs
with exceptional thoroughness and speed, and neutralizes impediments to
ordering. Scott identifies three factors that have served to restrain states'
transformative potential: "a private sphere of activity in which the state
and its agencies may not legitimately interfere"; "liberal political economy,"
the complexity of which puts much social activity beyond administration;
and "working, representative institutions through which a resistant society
could make its influence felt."[28] Each factor comes under heavy strain during
wartime; in the contexts of total warfare addressed by Kocken, they were
almost entirely nullified as belligerent societies mobilized at every level.
Under such conditions, which Bauman calls "situations of interregnum and
instability," state ordering projects unfold with their potential unimpeded
by limiting internal pressures.[29]

The *Depictions* therefore embody a moment of radically unfettered
state gardening. Though it is important that the bellicosity of these state

ordering projects not blind us to totalizing gardening in civil contexts (such as the Soviet five-year plans, Point Four Program, or reconstruction of postwar Japan), in the *Depictions* militarism serves to radicalize and distill state ordering to its essential features. Here, total war provided the extreme circumstances through which the basic ordering procedures of description, design, and realization were pursued with a force and fervor that is usually diluted or restrained (though still present) in nonmilitary circumstances. Seldom has the confection of ideal social situations been pursued with the thoroughness with which Albert Speer reconceived his capital; rarely has the plotting of urban space carried such mortal weight as for Red Army soldiers fighting their way across Berlin; scarcely have methods of enforcing prescriptions exceeded the deployment of fleets of bombers over cities. Amid the upheavals arrayed through the *Depictions*, the latent tendencies of state ordering are released and played out in perhaps the strongest conceivable form. Had Kocken presented ordering processes with documents pertaining to a more benign field of state activity, he would not have plumbed such depths of transformative potential.

Unruly Cities

Given the transformative intent behind the graphics collaged into the *Depictions*, not to mention the drastic means enrolled to enforce them, one might expect the city in Kocken's presentation to epitomize deliberately "gardened" environments. So much would be consonant with Bauman's metaphor, which invokes visions of "the perfect city" in writings by Étienne-Gabriel Morelly and Le Corbusier as the ultimate goal modern ordering strives after.[30] But even a cursory viewing makes clear that Kocken's works present cities in a starkly different light. If bureaucratic states envision perfectly uniform urban spaces, those proffered in the *Depictions* are characterized by heterogeneity, contradiction, and spiraling disorder. Far from carefully cultivated gardens, Kocken's geographies amplify moments of unevenness and uncertainty in the historical material, constructing the city as an inscrutable and unruly object of state attention.

Drawing Like a State

As such, the *Depictions* highlight another aspect of modern gardening espied by Bauman and other spatial theorists—namely, the mutual entwinement and complementarity of order and chaos in situations of modernity. This complementarity is necessarily repressed or unrecognized by state actors themselves, appearing only as sporadic tensions or lacunae in their gardening projects. For Bauman, not only are "new areas of chaos . . . generated by ordering activity," which create unforeseen problems to be addressed through further ordering.[31] In addition, chaos and order conceptually presuppose one another. They are "modern twins": "Without the negativity of chaos, there is no positivity of order; without chaos, no order."[32] To explore these torques of order and chaos in the *Depictions*, I shall begin with Michel de Certeau's affirmation of the inventiveness and unruliness of quotidian urban practice, which is widely invoked in accounts of modern cities to counterbalance instances of surveillance and control.[33] From the first volume of *The Practice of Everyday Life*, I take up the well-known argument showing how orders imposed on cities come to be practiced by "ordinary users" in tactical ways that diffract, frustrate, subtly alter, or even subvert them, surreptitiously, from below.[34] This perspective is salutary in relation to the *Depictions* inasmuch as it prompts reflection on the limits encountered and complexities accrued by apparently total state ordering programs as they played out beyond planners' drawing boards. In Kocken's works, emphasis shifts from dominant organizations of space to de Certeau's "second moment of analysis," concerned with how diversions and difference are introduced into these structures through their being realized in practice.[35]

Admittedly, significant points of divergence must be borne in mind when considering the *Depictions* alongside de Certeau's theory. The latter privileges ephemeral walking performed by "ordinary" people, whereas Kocken's artworks engage military operations mapped by combatants unlikely to have belonged to more subaltern ranks. Furthermore, de Certeau takes maps to reify dominant spatial orders, denigrating traced movements as petrified "relics" causing "a way of being in the world to be forgotten."[36]

Subsequent theory, however, no longer thinks of maps as static representations, set apart from lived reality. Emphasis falls instead on diverse reiterations of map artifacts, which, as Kitchin and Dodge express it, "are of-the-moment, brought into being through practices (embodied, social, technical), *always* remade every time they are engaged with . . . maps are transitory and fleeting, being contingent, relational and context-dependent. *Maps are practices*—they are always *mappings*; spatial practices enacted to solve relational problems."[37]

Combining this recasting of fixed cartographies as contextual mappings with de Certeau's theory of unruly urban practice opens another perspective on state ordering in the artworks. In this light, the *Depictions* assemble traces of moments at which even apparently absolute state orderings were diverted and diffracted, altered and appropriated as they ran up against the contingencies of use in varied urban settings. Kocken's method of manipulating historical documents highlights dissonances introduced through usage, for the chosen materials are never only legislative fantasies of unsullied order, but rather *practiced* artifacts, actively involved in historical struggles against received conditions. Amended, augmented, even scarred, Kocken's maps and plans figure material traces of state gardening programs being compelled to negotiate and unfurl in relation to complicating frictions, despite their protestations of power.

This perspective can be sustained through numerous instances in the artworks. First come failed realizations—planned actions gone awry with unplanned consequences. In *Depictions of Amsterdam*, there is the labeling on a 1942 USAF damage assessment photograph, which highlights the distance (around eight kilometers) between the "Aiming Point" of a bombing sortie on a Fokker aircraft factory and two areas it actually damaged, unintentionally killing almost two hundred Dutch civilians.[38] Besides referencing such outright failures of state strategies, the *Depictions* also evidence their subtle adoption apropos de Certeau. Indeed, what the diverse annotations spread though the artworks perform, above all, is the diffraction of purportedly uniform spatial orderings into an agitated multitude of local practices and disparate voices, speaking in a surpris-

Fig. 40. Gert Jan Kocken. Casual red loops. Detail of *Depictions of Munich, 1933–1945*.
Reproduced by permission of the artist.

ingly dialogical space. This is signaled in hundreds of notational codes
and handwriting styles inscribed through Kocken's cities, which offer an
affecting visual demonstration of how diverse combatants compelled to
enact state gardening subtly put their own stamp on the process, through
mappings. Consider the casual red loops and sky blue blocks with which
an RAF damage assessor divided Munich (fig. 40); the scarlet heading
"схема" (plan), stenciled between carefully measured lines on a map of
Berlin by some fastidious Soviet official; or the *Geschutsopstelling* (gun

emplacements) just west of Amsterdam, labeled by the Dutch resistance in watery blue capitals that subsequently bled.

Mindful of other writers' cautions against overstating the political significance of de Certeau's theory, I want to make clear that these traces do not indicate elements of progressive resistance in otherwise oppressive cartographies.[39] Kocken's collages do however accentuate the sheer heterogeneity of actors and interests internal to seemingly monolithic state orderings. Layering together heterogeneous postulations of space, the *Depictions* fragment the apparent cohesiveness of state territory and unitarily planned cities. Complex tangles of informal practices and local actors replace the monochronous blocks through which political cartography has traditionally delineated states. Kocken's recovery of difference within state orderings pertains especially to Berlin, the vital political culture of which the Nazi administration notoriously quelled with the monolithic "Neuplanung Berlin."

In recovering heterogeneity that has been suppressed or expelled by homogeneous spatial orders, the *Depictions* also critically interrupt notions of cartographic objectivity. As Lorraine Daston and Marianne Janack have shown, the largely taken-for-granted concept of objectivity is not only historically contingent but overly monolithic in that it corrals together "a dizzying array of different kinds of virtues, ideals, metaphysical positions and psychological states."[40] Behind its unitary facade teem discrepant ideas of impartiality; value-neutrality; standardized methods; an empirical orientation to the world; factuality; emotional restraint; and the existence of things independently of human cognizance. Daston traces how this "thick layering of oddly matched meanings" accrued historically, arguing that the predominant conception of objectivity today emerged in scientific discourse during the nineteenth century.[41] This specific articulation of objectivity, which Daston terms "aperspectival," is distinct from ontological objectivity, which "pursues the ultimate structure of reality," and mechanical objectivity, which "forbids judgement and interpretation" in scientific inquiry.[42] Having migrated from philosophies promoting moral selflessness in public conduct and the suspension of personal prejudices in

Drawing Like a State

aesthetic judgment, aperspectival objectivity seeks to eliminate individual and collective "idiosyncrasies" from scientific discourse and representation.[43] This objectivity developed in tandem with the idea of an international scientific community, in which influence of personality and placehood in knowledge claims might be recognized and pared down through communication across distant scientific practitioners and institutions.[44] Quantitative methods became increasingly valued in the nineteenth century, for once common standards of measure had been agreed, their results were readily communicable across cultural differences.[45] Such practices imply a conception of the scientist as "an interchangeable and therefore featureless observer—unmarked by nationality . . . or by any other idiosyncrasy" that might disrupt or distort the communication of knowledge.[46] The subject of aperspectival objectivity, in other words, is scarcely a subject at all, for this subject has denied embodiment, emplacement, affects, and affinities so as to inhabit what Thomas Nagel has called the "view from nowhere."[47]

Modern cartography exemplifies aperspectival objectivity in several respects. Maps make the fantasy of an anonymous, comprehensive, and fully detached grasp of the world graphically palpable, allowing viewers to imagine that this geographical knowledge exists above all distorted, place-bound, or ideological viewing positions. Beyond effacing the subjectivity of its practitioners though standardized production procedures, modern maps therefore literalize metaphors of "escaping perspective," "climbing out of our own minds," or actually attaining the "view from nowhere."[48] However: in redefining official cartographies as situationally performed mappings; recovering the heterogeneity of maps and map users in seemingly monolithic state orderings; and foregrounding the radically opposed ideological projects in which maps are enrolled, the *Depictions* shatter rhetorics of aperspectival universality in cartography.

This fragmentation has a double significance. In the first, Kocken's works inscribe the emplacement and interestedness of allegedly aperspectival cartographies. Far from maintaining the appearance of worldless neutrality, purged of all residues of situation and subjectivity, the *Depictions* show how maps are marked by worldly perspectives and concerns. Produced for pal-

pable political ends; annotated by idiosyncratic actors; and often physically damaged in unfolding events, these cartographies belong inextricably to the spaces and struggles that they purport to represent detachedly. In Kocken's works, reputedly aperspectival visions are recognized for what they always were: standpoint representations and situated epistemologies, profoundly at odds with one another in that each is influenced by—and striving to influence—their specific place in the uneven historical unfolding of modernity. This recognition has implications for how we conceive the politics of mapmaking. Whereas modern scientific institutions have propounded the "transcendence of individual viewpoints in deliberation and action" as "a precondition for a just and harmonious society," Daston cautions that, often, in "burying their individual identities in the impersonal collectivity, scientists actually aggrandize rather than surrender their social and intellectual authority."[49] Indeed, feminist theorists have emphasized how official claims to aperspectival objectivity serve to naturalize socially interested, power-laden views.[50] This God's-eye trick, which I have mentioned in reference to modern global visions in chapter 1, invokes a "view from nowhere," above all perspectives, so as to put particular claims and agendas beyond refutation as independently objective. Feminist theorists have countered this discursive strategy by tracing the "contingent histories, social context and relations" that produced epistemologies that purport to be immutable, contextless, and disinterested.[51] Reduced to its core, this critique of claims to aperspectival objectivity argues, as Janack puts it, that "the views of some-people-in-particular has in fact passed as the view of no-one-in-particular."[52] Kocken's works lay bare the contingency and contextualism of supposedly aperspectival mappings in an analogous manner, setting forth the sociospatial engagements that aperspectivalism denies. Each document that the works combine brims with "information too particular to person and place to conform to the strictures of aperspectival objectivity."[53] Hence, in collaging cartographies from the Second World War, the *Depictions* not only charts the damage unleashed by the masculine will-to-violence through total military mobilization. More subtly, by resituating military maps in the world of engaged perspectives, it also contributes to standpoint

theory's critique of masculinist rationality more generally. No longer able to transcend scrutiny through the God's-eye trick, cartographic claims to objectively map race, geography, society, or any other object, irrespectively of mapmakers' and users' subject positions, are seen as legitimizing rhetorics promulgated by ideologically situated historical actors.

In addition to resituating aperspectival mappings, the *Depictions'* fragmentation of cartographic objectivity has a further significance in that it highlights the uneven character of modernity thematized in the preceding chapter. Daston and Janack argue that objectivity, despite being lionized as a modern ideal, does not possess the universality and coherence it is taken to signify, but is rather a "variegated motley" of different virtues, practices and measures.[54] This recognition of different conceptions of objectivity—as well as conflicting measures, units, and practices *within* each variant of objectivity—conjugates with my conceptualization of modernity in the introduction to this book. Rather than positing a homogenous modern condition, which globalization will eventually realize universally, modernity is actually "one and unequal," producing radical social and geographical unevenness as it unfolds. Now, nowhere have modern pretensions to universality been more pronounced than in discourses of scientific objectivity. By eliminating the idiosyncrasies of distinctive mapping cultures, modern cartographic institutions have sought universal, rationally established mapmaking methods whose validity should be accepted as immutable across all cultural contexts.[55] And yet, far from "compelling assent from all rational minds," the modern cartographies presented in Kocken's artworks fracture into a mosaic of discrepant fragments that scarcely add up to a discernible city, let alone achieve the unanimity and universality to which impersonal mapmaking methods aspire.[56] In place of measures that translate across particularist positions, the *Depictions* heighten disparities between incommensurate units, standards, languages, and graphic styles with which state mappers calculated and labeled territories. Into reputedly disinterested urban overviews, the *Depictions* insert plans revealing how state mapmaking always entails interested, interventionist, and ideologically driven transformative projects. The aspiration that objectivity might

produce universally valid maps has broken down so drastically, here, that the *Depictions'* patchwork of viewing positions recalls the sensuous place-based spatialities of premodern cultures—not uniform Platonic grids. Cartographic objectivity, it seems, is just as uneven, multiple, and conflicted as modern globalization itself. Digitally accentuating epistemological differences and conflicting interests among ostensibly objective mappings, the *Depictions* emphasize how objective space is not homogenous and universal, but multiple, internally discordant, and uneven.

Antinomies of Order and Chaos

Given the heterogeneity of urban space in the *Depictions*, I want to qualify my previous suggestion that the enormous *potential* of state ordering finds paradigmatic expression in the *Depictions* with a recognition that its failures, unevennesses, and dialogic complexities are also apparent—all the more starkly given the extremity of the historical moment Kocken addresses. In fact, in addition to indicating complexities in state gardening practices, Kocken's unruly cities enact a further dialectic—or, rather, antinomy—between state ordering and the forms of urban disorder it attempts to regulate and resolve.

Whether in reference to practices of "urban informality" that meet the shortcomings, and occasionally inform the logic, of top-down planning, or the manifold uncertainties that arise from even closely ordered cities, numerous urban theorists have sought to conceptualize how activities of "state-sponsored planning . . . produce the very disorder they were seeking to overcome."[57] Following this reversal, it seems crucial that the complexity, even chaos, manifest in Kocken's cities is not simply ulterior to gardened order. Their unruliness is no holdover of Bauman's "wilderness"—the unplanned cultures that precede and surround modern gardening's "enclaves of order."[58] Rather, the moments of complexity, uncertainty, and disarray Kocken assembles all represent *components or consequences of ordering itself*. From swathes of bombed and burned-out buildings to diverse spatial practices or from one state's truculent counterreaction against another's project to the ever-less-legible cartographies, straining to figure

Drawing Like a State

the shifting variables in play, in these artworks state ordering inadvertently incurs fresh forms of disorder and conditions new ambiguities that must in turn be resolved or succumbed to. Indeed, modern ordering can be said to found the very categories of disorder, uncertainty, and chaos inasmuch as these emerge, through a function of *différance*, as antonyms against which formulations of planning, certainty, and order are articulated. Only when apprehended alongside pristine plans do long-sedimented urban forms become blots inciting intervention; only in light of centralized commands dictating actions do heterogeneous spatial practices become disorderly deviations to be regimented into step; only against rhetorics of scientific certainty invested in cartography do spontaneous tracings of space become subjective statements requiring professional censure. Both conceptually defining and materially precipitating surrounding fields of chaos that tend against the principle of designed, transparent order, the "apparatus of planning" epitomized in Kocken's maps and plans "produces the unplanned and unplannable."[59]

This amounts to arguing, ultimately, that in the *Depictions* the task of replacing premodern wilderness with reflexively ordered social worlds— for Bauman the defining project of modernity—has been eclipsed by a second struggle, endemic within gardening itself, in which order and chaos produce and incite each other in a mutually perpetuating spiral. Unlike ordering once "wild" societies, of which one can scarcely imagine even beleaguered remainders lingering on in Kocken's exhaustively ordered cities, this latter struggle sustains itself without resolution. The more astringent and relentlessly pursued a vision of order, the greater the uncertainty it calls into being and the more intractable the chaotic effects it unwittingly provokes.[60] Conversely, chaos created through ordering induces further ordering; the more extensive the chaos, the more obsessional must be the gardening bent on setting it to order.

The *Depictions* envisage a modern condition constituted between these dynamics. Order and chaos perform no dialectic, which implies an unfolding resolution, but figure instead an antinomy—that is, a self-reinforcing stasis in which spatial order and chaos instigate each other irresolvably.

Far from achieving a utopian settlement, modern ordering continues to ramify and reproduce itself in ever-different forms, which prompts me, in the following analysis, to consider how the *Depictions* connect to the social present.

Presenting State Ordering

The *Depictions*, then, combine found materials into an artistic reflection on aggressive state ordering, which, even in apparently total incarnations, remains fraught with difference and chaos. As such, the works incite reflection not only on the Second World War, but confronts viewers with a stark, defamiliarized image of the gardened modern condition as such, extending to its present manifestations.

This does not necessarily align with the experience of encountering the *Depictions* in their contemporary contexts of display; they can seem incongruous, even anachronistic, in the spaces and places of contemporary art. Take the display of *Battle of Berlin* and *Depictions of Berlin* in 2011 at the Rijksakademie, or State Academy of Fine Art in Amsterdam. In the nineteenth century the building served as a cavalry barracks. Once filled with the ephemera of munitions and messes, the smell and bustle of animals and personnel, the space passed to the academy in the 1980s. Creative labor supplanted military power. Now quiet and whitewashed, the Rijksakademie typifies a historical break with the modern paradigm of warfare involving states and standing armies. Looking at the *Depictions* there meant gazing on a strange world of sublimely massive state action that seemed out of place within the contemplative postmodern atmosphere of the repurposed Rijksakademie. The works framed and mounted seemed like alienated artifacts in a colonial museum. This viewing might lead one to construe bellicose state gardening as a declining remainder of modernist history, belonging to what John Mueller has called the "remnants of war" and destined to be replaced by the more fluid "asymmetrical" conflicts of recent times.[61]

Finally, though, this is not how I conceive the *Depictions'* relation to their sites of encounter. If the *Depictions* appear remote or incongruous, for me this is because they have been actively defamiliarized through artistic

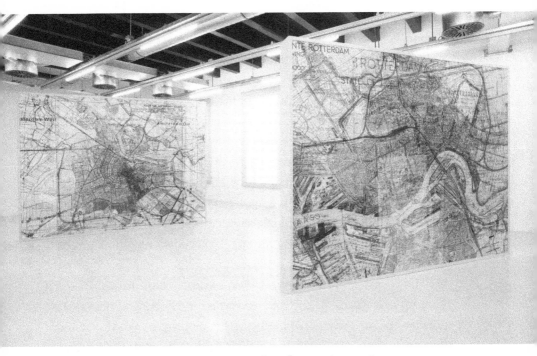

Fig. 41. Installation view of Gert Jan Kocken's *Depictions of Amsterdam, 1940–1945* (2010) and *Depictions of Rotterdam, 1940–1945* (2010). Both digital prints, 380 x 280 cm. Stedelijk Museum Schiedam, 2010. Reproduced by permission of the artist.

manipulation. Estrangement was certainly the dominant impression made by *Depictions of Rotterdam* and *Amsterdam* in the Stedelijk Museum Schiedam in 2010. Each standing at six square meters on mounts positioned centrally in the space, the artworks dwarfed spectators and dominated the exhibition room (fig. 41). Scaling and placing the *Depictions* in this configuration physically confronted viewers, who had just emerged from a passageway hung with watercolors from Hitler's juvenilia. Compare this encounter with more casual engagements with maps, which render realities that exceed embodied perception in a scale and format befitting the limitations of human users. The *Depictions* do not submit to this imperative. Far from offering ready-to-hand geographies on foldable paper or scrollable screens, Kocken configures cartographies as imposing presences

requiring map readers to adapt to the map's dimensions, not the other way around. With no folding, scrolling, or zooming mechanism available, one must step back to view the whole and strain on tiptoes to grasp the part. Cartography is made strange and monumental, its once familiar graphics subtracted from the flow of use and collapsed into reified blocks.

The *Depictions* are therefore unfamiliar because they have been defamiliarized, not because their vision is historically remote. Any impulse to limit their significance to the past is further undercut by Kocken's digital reworking of the individual maps. Concerned that the documents appear less vital because they have yellowed, he has lightened their underlying paper. The removal of sixty years' accumulated discoloration subtly weakens our sense of these graphics' historical embeddedness, presenting state ordering in a way that might resonate beyond the defined episode of the war. These gestures prime viewers to experience not historical distance in Kocken's image of modernity, but the vertigo of self-recognition. What we see estranged and relativized in Kocken's assemblages are the functions of reflexive description, design, and realization that constitute the continuing (and continually faltering) fundamentals of modernity as such.

This chapter has explored the presentation of modernity and state practice through cartography in Kocken's *Depictions*, arguing that the artworks manifest a vision of state action crystalized in Bauman's metaphor of gardening. Drawing maps and plans from extreme situations surrounding the Second World War, the *Depictions* explore how state gardening unfolds in the heightened form of total war. But these are not therefore totalized images. Reworking a differentiated mass of historical material, the *Depictions* foreground the friction and differences with which state ordering projects are fraught, indicating the complexities of Bauman's conceptual metaphorics. The artworks also resonate beyond state conflicts: addressing extreme instances of warfare serves to articulate the transformative inner tendencies of state practice, which are diluted and restrained but still operative in other modern situations. Presenting the modern world as a contested garden, the *Depictions* estrange a long naturalized condition that we continue to practice and undergo.

Together, my analyses of Hildreth's *Forthrights and Meanders* and Kocken's *Depictions* have explored how maps project confected orders onto the times and spaces of the disenchanted world, as revealed in Nikritin's *The Old and the New*. In doing so, I have broached the ontological basis of modern mapping's world-shaping power: the ontology of calculability, which grasps geographical reality as an objective, measurable, and malleable extension. Before I turn, in the final two chapters of this book, to the question of how map artists might subvert and imagine alternatives to this ontology, the following chapter thematizes one last way in which cartography molds and orders contingent geographies. Whereas the *Depictions* stress the indispensability of maps to the state gardening of social space, the map artwork I study next foregrounds the cartographic production of modern statehood itself.

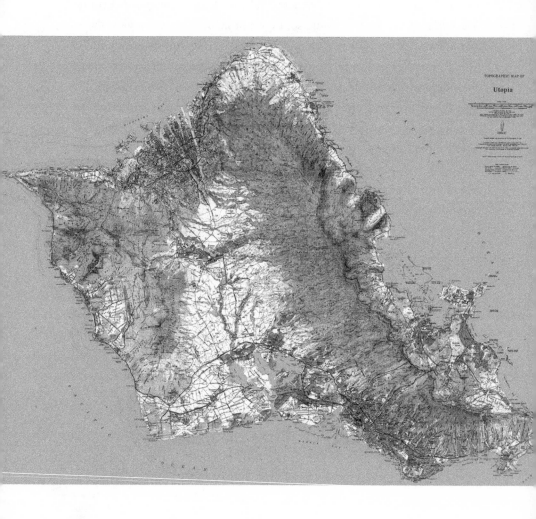

Fig. 42. Satomi Matoba. *Utopia*. 1998. Digital collage, dimensions variable. Reproduced by permission of the artist.

4 Insular Imaginations

Statehood, Islands, and Globalization in Satomi Matoba's *Utopia*

With the notion of "ontological performativity," the previous chapter high-lights cartography's capacity to assert, create, or perform beings that would not otherwise exist, and to unfold understandings of being that would not otherwise obtain. My analysis of the *Depictions* shows how modern mapping performs a fundamental disclosure of geographical reality as a measurable and malleable extension. Each remaining chapter returns to this quintessen-tially modern ontology, stressing how it undergirds and recuperates even some of the most strident artistic attempts to reclaim mapping and imagine it otherwise. The following chapter addresses a dimension of mapping's per-formativity that went unremarked upon in my analysis of Kocken's artworks. Whether in ordering urban geographies or rendering them "orderable" in the first place, maps in the *Depictions* are a practical instrumentation of modern states—a tool through which state legislators and planners pursue variously utopian and bellicose designs. Yet other map artists foreground the cartographic production of nation-states themselves. The bodies, borders, and lexical designations that constitute the mapped image of the state are subverted in works by Luciano Fabro, who strung up and skewered outlines of Italy; Michael Craig-Martin, whose map of Asia substitutes existing national toponyms for European ones; and Francis Alÿs and Alban Biaussat, both of whom walked and reinscribed the infamous "green line" demarca-tion drawn by an Israeli general in 1949 at the end of the Arab-Israeli War. These artworks highlight the materiality and malleability of statehood, which is seen not as a preexisting reality awaiting visual representation, but rather as the contingent product of performative acts of mapping.

To explore how cartographic constructions of statehood have been taken up, subverted, and reimagined in map art, this chapter attends to *Utopia* (fig. 42), a digital collage made in 1998 by the Japanese artist Satomi Matoba (b. 1960). The image conflates maps of two significant sites in the Second World War—Hiroshima and Pearl Harbor—such that they cohere together in an imaginary island state. Although many works of map art foreground the production of statehood and the performativity of borderlines, Matoba's *Utopia* is distinctive in how it imagines the nation-state in the historically significant form of an island. Indeed, my analysis unpacks the artwork in relation to the early modern discourse that concretized the hitherto inconceivable boundedness and internal coherence of the nascent state through recourse to the figure of the island. Especially important in this conjuncture is the historical image to which Matoba's artwork unmistakably alludes: the island republic illustrated on the frontispiece to the Renaissance philosopher Thomas More's famous 1516 tract *On the Best Condition of a Republic and the New Island Utopia* (henceforth *On Utopia*).[1] In casting the state as an island, I claim, Matoba's *Utopia* not only metaphorically encapsulates the state's bordered and integral spatiality, but reaches back to the very visual figure through which mapmakers first conceived statehood and gave it form.

But Matoba's image does not do this to simply recapitulate early modern imaginations of the state. If at first sight the work conforms to normative mapping practice, I would suggest that this conventionalism is a deliberate veil. In a move characteristic of the larger discourse of utopian mapping, *Utopia* takes on the trappings of objectivity and punctilious representationalism in order to present an otherwise outlandish vision as if it were an extant reality. My argument shows how, behind a veneer of humble empiricism, Matoba's *Utopia* unfolds an experimental geographical vision that undermines the bordered cohesion of the nation-state in two ways. The first is utopian in the pejorative sense of naïvely wishing away the complexities of global modernity. Bringing the geopolitically significant sites of Hiroshima and Pearl Harbor together as a utopian island republic, the artwork projects a fantasy in which the nationalist enmities of the

twentieth century are overcome and reconciled through globalization. The second subversion works by accentuating the repressed transcultural hybridity that persists, unacknowledged, athwart national borders and inside national geobodies. Collaging together distant geographies such that they compose parts of a single island, Matoba admits difference into the founding trope of modern statehood, undermining the bordered and homogeneous spatiality on which the nation-state was modeled historically.

In these ways, Matoba troubles the insular geography of modern nation-states as encapsulated in the frontispiece to Thomas More's *On Utopia*. In another respect, however, Matoba's artwork reinforces the incipient spatiality heralded in the 1516 illustration. In presenting her alternative rendition of statehood as a measurable geography laid out before a transformative panoptic gaze, Matoba's *Utopia* remains caught within the paradigm of calculability introduced in the previous chapter. I argue that, even as it contests and counters received constructions of the modern nation-state, Matoba's artwork repeats the underlying ontology on which states depend. In this way, *Utopia* intimates a danger that shadows not just map art, but digital mapping too: that despite rhetorics asserting discontinuities, and even paradigm shifts, unfolding through contemporary mapping, recent attempts to reimagine mapped space often inherit and reiterate cartography's underlying grasp of the world as a measurable and malleable extension.

Satomi Matoba and Utopian Mapping

Born in Hiroshima, Matoba trained as an artist in London, where she lived between 1995 and 2001 before returning to practice in Japan. She gained visibility as a map artist after works from her series *Map of Utopia* (1998–2007) were included in all four incarnations of the group exhibition *The Map Is Not the Territory*, which was first held in London in 2001. There, *Map of Utopia* was hung alongside works by other significant map artists, including Susan Hiller, Michael Druks, Grayson Perry, Kathy Prendergast, and Peter Greenaway, whose cinematic mappings I discuss in chapter 6. Matoba's works are discussed in Denis Cosgrove's survey of map art; figure on the cover and as the opening inspiration to Steve Pile and Nigel Thift's

experimental introduction to urban studies *City A–Z*; and have featured more broadly in map art's remarkable rise in popularity in recent decades through numerous exhibitions worldwide.[2]

Matoba self-consciously relates *Map of Utopia* to themes of cosmopolitan identity and globalization.[3] At the center of the series is the idea that once fixed geographies, and discrete cultures, might fragment and coalesce in new dispensations. This idea is explored formally, through digital collage. Much like Kocken's urban assemblages, the collages that make up *Map of Utopia* are composed of preexisting maps, which Matoba has scanned and digitally rearranged in surprising ways. Many of the geographies Matoba works with are announced in the work's titles: *Pearl Harbor—Hiroshima* (1998), *Genève—Hiroshima* (1998), and *The Japanese British Island* (2001). The series also contains *Shores of a River* (2000), which reworks numerous maps of urban centers and waterways from around the world, such that the world's cities are joined together by a great circular river; *Asian Archipelago* (2007), which collages fifteen cartographies showing Japan's territorial conquests in the 1930s and 1940s into the shape of Japanese islands; and *Utopia* itself, which I describe in depth later in this section.

In presenting unreal geographies, in which distant cities and obdurate geologies are cast in unlikely new ensembles, Matoba's works recall and revisit a rich history of maps presenting fictive, utopian, or otherwise intangible worlds. Writers interested in imaginary mappings often reference Oscar Wilde's famous statement in *The Soul of Man Under Socialism* (1891) that "a map of the world which does not contain utopia is not worth glancing at."[4] Even a work of map art quotes Wilde: a reflective globe created by Ruth Watson has the sentence sandblasted onto its mirrored surface.[5] Yet the distinctive allure of allegorical, fantastic, and utopian maps is much better grasped, I propose, by reversing Wilde's formulation such that it reads "a utopia which has not been mapped is not worth glancing at." Clearly the proposition is questionable (who would want to narrow the variety of utopian expression to visual blueprints?), but it does indicate the specific value of cartographic utopias. Denis Wood argues that maps offer views that are inaccessible to established perception: that they "give

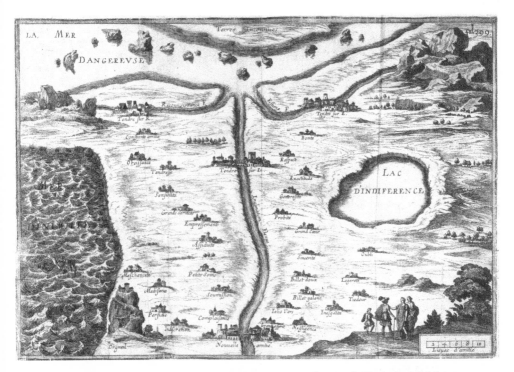

Fig. 43. François Chauveau. Map accompanying *Carte du pays de Tendre* by Madeleine de Scudéry and Collaborators. 1654. Engraving, 31 x 22. Wikimedia Commons.

us . . . a reality that exceeds our reach, our vision, the span of our days, a reality we achieve in no other way."[6] This constitutive ability to render the intangible tangible and the vague precise is particularly enabling for utopian discourse, which is often dismissed as hypothetical or escapist—a juvenile flight from intransigent realities. When utopias are concretized as maps, formerly implausible social visions become tenable concrete geographies. Imagined terrains take on the reality of palpable, fully articulated social worlds, achieving a level of detail and existential plausibility that renders them potentially realizable social propositions, if they are not mistaken for actually existing terrains.

Given their special capacity for articulating fantasies with all the precision of extant geographies, maps have long been used to envision nebulous

inner states, dreams, fictional lands, and utopian designs. There is a long-standing discourse of allegorical mapping, which presents elusive states of consciousness or moral possibilities topographically. Though many examples might be adduced here, the best-known work in this tradition is the *Map of Tenderness* published in Madeleine de Scudéry's 1654 novel *Clelie* (fig. 43).[7] Created collectively in a women's literary salon, this map unfolds what is both a subjective geography and a geography of subjectivity, spatializing erotic affects and possibilities as a landscape of ambling paths, roadside towns, and waterways. As an early experiment in cartography, emotion, and selfhood, the *Map of Tenderness* has subsequently stimulated much alternative mapping practice (not least that of the Situationist International) and has been theorized as a feminist counter to masculinist rhetorics of disinterestedness and disembodiment in cartography.[8] Maps of fictional territories abound in modern literature, whether in synthesizing complex settings, emphasizing the importance of topography to a given narrative, or heightening the fiction's sense of reality with supporting documentation. Two enduringly popular examples accompany Robert Louis Stevenson's *Treasure Island* (1883) and J. R. R. Tolkien's *The Lord of the Rings* (1954), the latter's maps being animated in popular film adaptations between 2001 and 2003. Coming closer to Matoba's *Map of Utopia*, a cursory survey of avowedly utopian cartography would include the engravings illustrating Bartolomeo Del Bene's radial *City of Truth* (1609), Robert Owen's plans and painted prospects for the socialist communities he called *New Harmony* and *New Moral World* in the 1820s and 1830s, and the frontispiece to Thomas More's 1516 *On Utopia*, my key comparison for Matoba's *Utopia* in this chapter. Several writers on fantastic and utopian mapping suggest that in presenting consciously confabulated terrains as objective realities, utopian mapping accentuates the creativity inherent in all mapping, even—if not especially—that of ostensibly official and scientific cartographies.[9] There is no essential difference, on this view, between maps of imagined worlds and established mapmaking; they can be distinguished only in that utopian maps acknowledge and revel in their world-making power, while normative maps conceal their performativity,

Insular Imaginations

and secure the reality of their constructions, through rhetorics of repre-
sentationalism and objectivity.

I shall return to the topic of performativity later, when discussing the
role of mapping—and especially the mapped figure of the island—in con-
stituting the geobody of the early modern nation-state. My purpose at this
juncture is to indicate Matoba's *Utopia*'s relation to a broader discourse of
reflexively utopian and fantastic mapping, from which her formal strate-
gies derive. Like the personal landscape set forth in de Scudéry's *Map of
Tenderness*, Matoba sets out (partly) to map an intangible subjectivity or
identity: "the innerscape of a cosmopolitan" as she puts it.[10] And like the
maps illustrating Tolkien's Middle Earth and More's *On Utopia*, she elab-
orates a fictional world in all the detail of an extant geography. The way in
which Matoba's *Utopia* draws on utopian mapping's distinctive capacity
to fantasize with exactitude and (apparent) empiricism is evident in its
impeccably conventional formal presentation. An unbordered text placed
in the upper right corner of the image introduces the map as though it
showed nothing unusual. All the normal accompaniments of professional
map production are provided: scale, sources, and copyright are presented
beneath a title reading "Topographic Map of Utopia." On first glance, then,
Matoba's map might scarcely register as an artistic, let alone a utopian object
at all: its standardized symbolization and colors, conventional selection
of features, and crisp visual presentation all correspond closely to topo-
graphical maps printed in government departments or commercial map
houses in the late twentieth century, while the geographical space it sets
forth is just as uniform and measurable as that of any other professionally
produced cartography.

Yet despite the outward show of conventionalism, *Utopia* unfolds a car-
tographic vision that defies existing geography so drastically as to rend
even its underlying tectonics. Collaging together two preexisting maps,
the image conflates distant places. The first map shows Oahu, an island
in the Hawaiian archipelago with a lagoon named Wai Momi by Hawaii's
Polynesian cultures, and Pearl Harbor by later U.S. inhabitants. Into the
island's northern shore Matoba has incorporated a fragment from the

second map. This map represents central Hiroshima, which conventionally lies on the southeastern coast of Honshu, the largest of the Japanese islands. The size of the respective map fragments is far from equal: save for the small amount of land ceded from the northern Waialua District, the Oahu map persists almost unchanged in *Utopia*. The map of central Hiroshima, by contrast, is not only cut from its surrounding context in Honshu's Ōta bay, but reoriented—swiveled around one hundred and eighty degrees so that the six fingerlike channels of Hiroshima's delta fray out into the ocean north of Oahu. Matoba does not stress this imbalance: the suture between the two maps is papered over by the close alignment of Hiroshima's road network with Oahu's highways, and the roughly equivalent scaling and detail of the two maps. Only the toponyms in two different languages and writing systems, the variant coloring of urban space (bright red in the Oahuan map, gray in the Japanese), and the unlikelihood that this modestly sized island could support a densely populated city like Hiroshima, betrays the presence of two cartographies in the image.

Matoba selected Hiroshima and Pearl Harbor for the collage on the historical grounds that both sites were strategically (and symbolically) important in the Asia-Pacific War. Pearl Harbor, which has been used by the U.S. Navy as a maritime base since 1899, was attacked by the Imperial Japanese Navy on 7 December 1941; Hiroshima was the first city to be targeted with an atomic bomb on 9 August 1945, through which the United States forced the Japanese to surrender the following month. Together, Hiroshima and Pearl Harbor evoke interstate hostility through what it has laid waste: an island attacked by surprise, and a city of 350,000 inhabitations irradiated by an atomic explosion. Chronologically, the respective destruction of these sites bookmarked the Asia-Pacific conflict (the last major war waged by Matoba's country of birth), inaugurated the era of fission weapons, and precipitated a rise in U.S. military and economic power, which would dominate world geopolitics through the twentieth century.

Although the conjuncture of Hiroshima and Pearl Harbor refers specifically to the interstate struggles of the Asia-Pacific War, I read *Utopia* as a mediation on (and deconstruction of) modern statehood more gener-

ally. To explain why, the following section establishes Matoba's artwork's intertextual resonances with Thomas More's *On Utopia* and presents a short cultural history of the significance of islands in mappings of the state. In positing her utopia as an island, I argue, Matoba reworks the very geographical figure in whose image modern statehood was first envisaged and articulated.

Utopian Allusions

Much of *Utopia*'s interest, to me, lies in how it revisits the famous frontispiece to Thomas More's text, which, like many other early modern literary and cartographic documents, projects the bounded form of the island as an archetype of the emergent territorial nation-state. Although the adjective *utopian* is often appended to contemporary descriptions of afterlives, dreams, religious paradises, and fantasies, the word *utopia* is relatively young, having been coined in 1516 in More's *On Utopia*.[11] Translated from its ancient Greek components, More's neologism becomes "nonplace," though the initial *u* can also be related to *eu* to become "excellent-place."[12] With this title, More concretized an emergent literary genre, which narrated hypothetical or experimental communal possibilities.

On Utopia stages a conversation between a fictionalized version of More himself, his friend Peter Gilles, and the traveler Raphael Hythlodaeus (whose name translates as "speaker of nonsense"), who describes an island society located in the New World. To summarize its history briefly, this society was formerly a peninsula named Abraxa, which was united by a conquering ruler, Utopus, who pacified the previously "rude and uncivilized" peoples living there.[13] He decreed that the isthmus connecting Abraxa to the mainland be severed, ordering a channel fifteen miles long to be dug in order to bring "the sea right round about the land" and thus to create a bounded polity, Utopia. By the time Hythlodaeus visited Utopia, it was settled by fifty-four cities sharing a common design, language, and legal code. Religious diversity and free speech were respected, and representative democracy prevailed, though political discussion outside mandated arenas was a capital offense. The society possessed "bondmen"—internal

criminals and prisoners of war—but these were not held as private slaves: utopia was largely classless, with property held in common.

As a crisply delineated island, presented at the center of a single sheet under the title *Utopia*, Matoba's artwork specifically recalls the illustration on the frontispiece to *On Utopia*, which figures the island Hythlodaeus visited as a landscape drawing, arguably a map (fig. 44).[14] I will return to the protocartographic quality of the image in the final section of this chapter. On the frontispiece, Utopia has the shape of a croissant, curling around a harbor, its mouth overlooked by a fortified tower. Its settlements are arranged symmetrically, with cities represented metonymically by seven towers and other structures sited at regular intervals along a lightly indented coast. Amaurot, the capital, stands in the island's middle, a doorless gate built into its center. The city is separated from most of the other towns by the river Anyrus or "nowater," which emerges from a visible source to harbor's left and runs a circular course parallel with the coastline before flowing back into the harbor from the right.

Numerous scholars have read More's *On Utopia* (and its frontispiece) against the backdrop of the onset of modernity, and specifically modern state formation, in the sixteenth century. Robert Tally, for instance, argues that "utopian theory in the early modern epoch went hand-in-hand with the development of the nation-state form and the radical transformation of social space that accompanied the emergence of market capitalism, which also occasioned a wholesale revision of how the lived and imagined spaces of the world were interpreted."[15] Indeed, in relativizing received social reality as but one possibility among many, and in projecting a new communal order in detail, *On Utopia* relates broadly to the transformative modern mindset. Most importantly for my analysis of Matoba's *Utopia*, though, is how More's text prefigures and imagines modern state formation. King Utopus's deliberate separation of Abraxa from the mainland, I claim, represents a founding rupture that constitutes the modern polity, marking Utopia as a bounded, internally homogeneous social body. The need to dig a ditch also relates to the gardening mentality explored in the previous chapter, insofar as it betrays a neurotic wish to defend a carefully arranged

Insular Imaginations

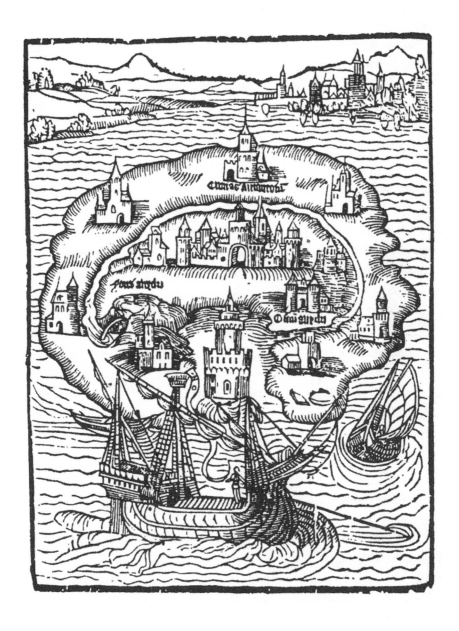

Fig. 44. Frontispiece of Thomas More, *On the Best Condition of a Republic and the New Island Utopia*. 1516. Woodcut engraving. Wikimedia Commons.

social order against contaminating influences outside. Here however I follow Phillip Wegner in focusing on how the ditch performs and constitutes the space of nation-statehood: "What we see suddenly exploding forth in More's work is a radically new and deeply spatialized kind of political, social, and cultural formation—that of the modern nation-state. . . . By digging the trench that creates the insular space . . . Utopus marks a *border* where there has previously existed only an indistinct *frontier* between 'neighboring peoples,' a disjunctive act of territorial inclusion as well as exclusion [that represents] a crucial dimension of the subsequent spatial practices of the modern nation-state."[16] For Wegner, then, the island societies conjured in early utopian discourse were bound up with a wider transformation of how political space was conceived and practiced in early modernity. Benedict Anderson characterizes this shift by contrasting an "older imagining" in which "states were defined as centers, borders were porous and indistinct, and sovereignties faded imperceptibly into one another" with "the modern conception," for which "state sovereignty is fully, flatly, and evenly operative over each square centimeter of a legally demarcated territory."[17] As received premodern spatialities of overlapping realms, fealty obligations, and dynastic affinities waned, English utopian writers began to imagine new forms of community and political space. More's *Utopia* (1516), Bacon's *New Atlantis* (1627), Gabriel Platt's *Macaria* (1641), and Henry Neville's *Isle of Pines* (1668) each take the geographical figure of the island as the model for a sharply enclosed political space, without internal divisions. Inscribing newly unified polities and collective identities through fictions of insularity, utopian discourse pioneered a modern political geography composed of discrete and homogenous nation-states.

The link between these utopian islands and the onset of modern state formation is reinforced by the cultural history of islands in the early modern imagination. Even beyond utopian discourse, as Angus Cameron has demonstrated, the enclosed form of the island provided a "powerful metaphoric figure" through which the radical new spatiality of "the bounded, inward-looking territorial state" was imagined and given substance.[18] Especially revealing, in this connection, is Philip E. Steinberg's work, which

traces the "association of 'islandness' with territorial unity" in Mediterranean portolan charts (early maritime maps) as far back as the fourteenth century.[19] Steinberg argues not only that "the modern, or Westphalian, ideal of the state as territorially bounded, unambiguously governed by a sole authority and culturally homogeneous is a profoundly *insular* vision," but further that cultural representations of islands "inadvertently established a grammar for the imagining and mapping of the territorial state that was to emerge in later years."[20] Telling in this regard are portolan charts on which different realms, like Scotland and England, were depicted as separate islands even where they were known to occupy a continuous landmass (for an example, see fig. 45).[21] Depicting even contiguous nation-states as islands in this manner not only served to naturalize thoroughly conventional demarcations of national territory by giving them the appearance of physical geography (comparable instances exist of mapmakers plotting imaginary mountain ranges along borderlines); it also offered a model through which the then startlingly novel, perhaps even inconceivable form of the modern nation-state could be grasped and disseminated. Imaginations of islands, as Wegner puts it, provide the "conceptual framework or representation of space of "nationness" within which the particularity of each individual nation can then be represented."[22]

My analysis of Matoba's map art takes forward the idea that, historically, insular form did not simply resonate with statehood, nor was it used to represent preexisting states. Rather, the mapped form of islands participated performatively in a far-reaching reconfiguration of political space, providing the template in whose image the emergent modern state was conceived and constructed. But before examining how Matoba reworks the image of the island state, I want to specify the political implications of insular statehood more fully, for it is the politics implied by insular form that *Utopia* contests most centrally.

The forms of political community conditioned by the image of the island come to the fore when considering two mutually entailing formal characteristics of insular mapping: borders and bodies. Mapping's performative capacity to define the shape of statehood is nowhere more evident than

Fig. 45. Battista Agnese. Detail of *Atlas de Battista Agnese*. 1544. In his atlas Battista Agnese represents Scotland and England as two distinct islands, corresponding to the two kingdoms, separated by a channel of water. Parchment sheet, 14 x 20 cm. Courtesy of the National Library of Congress.

in the delineation of national borders. The cartographic drawing of lines, writes John Pickles, represents a performative "spatial and geographical act" in which cultural conceptions of identity and difference are "literally written onto the surface of the earth and coded by layer upon layer of lines drawn on paper."[23] Borderlines figure "a spatial 'not'—a differentiation and/ or negation of all that lies beyond it."[24] This is especially true of national

Insular Imaginations

boundary lines, which designate cohesive interior spaces within which local differences are erased or else eclipsed by exterior distinctions with other homogeneous nation-states. Now, in light of Steinberg's claim that mapped islands held out the model for nascent statehood, coastlines can be retrospectively recast as the prototype of modern national borderlines. The function of mapped coastlines, which signify little but a spatial "not" that differentiates land from water, applies more widely and has been extrapolated to delineate other, more obscure qualities like national cultures.

But performative acts of separation also confer identity onto what they separate. In the case of insular statehood, borderlines produce what Thongchai Winichakul has termed the "geo-body"—that is, the extension of the mapped nation-state.[25] In its ideal form, Winichakul suggests, the national geo-body is discrete and integral. Most obviously, this pertains to questions of sovereignty, which, in the Westphalian paradigm, is exercised by states exclusively within their own territorial jurisdictions and not beyond them. The insularity of geo-bodies also serves to ground otherwise diffuse conceptions of nationhood. To cartographically endow a nation with defined spatial extension or "body" is to perform an act of inclusion and exclusion that conjures a collective identity in space, even where that identity actually exists only in fragments or not at all. Such mappings both enclose once heterogeneous local cultures within the overarching homogeneity of the state and posit a surrounding foreignness in contrast to which the integral identity of the national self is secured.

The external difference and interior unity projected by insular imaginations is clearer still in the physiological connotation of the term "geo-body." Analogical discourses of the body politic, which "conceived of social structure and process through the prism of the human body," prevailed in two major cultural points of reference for Matoba's work: More's England and Showa Japan.[26] This physiological casting of the state prompts the idea that mapped borders figure a kind of skin, assuring the national organism's immunity. The integral spatiality produced by these analogies of geographical insularity and bodily immunity can be summed up by way of reference to a postcard map, which, returning briefly to the historical

context discussed in the previous chapter, displays a Nazi representation of the state (fig. 46). Hitler's photo-collaged portrait is presented as the sovereign head of a national body. But, unlike the best known image of the body politic, Abraham Bosse's frontispiece to Hobbes' *Leviathan*, here the ruler's neck does not connect to an anthropomorphic social body. It has been pasted onto a national *geo*-body: a map of the German state, which is imagined as an island. The cliffs—which, contrary to empirical induction, demarcate the state on all sides—enforce its discrete and unitary spatiality, which is further underlined by the accompanying caption: "ONE PEOPLE/ ONE REALM/ONE LEADER."

Selecting this exaggerated fascist example, I realize, suggests a too completely pessimistic view of nation-states as oppressive, homogenizing, and unaccepting of difference and must be qualified by a recognition of the need to parse different incarnations of nationalism and nation-states, some imperialist and repressive, certainly, but others providing cohesion to anti-imperialist struggle and incubating progressive social projects.[27] I invoke the postcard in closing this section, though, because in combining insular and physiological images of statehood it accentuates the unifying and exclusionary political logic that these models imply and precipitate. For nation-statehood conceived strictly through insular imaginations, any sociocultural formations disposed across the unscalable cliff (or hermetic skin) that defines the geo-body must be repressed, downplayed, or even eliminated. This hermetic logic is ever vulnerable to countertendencies, however, for were affinities to be established *without* the insular geo-body, or differences exposed *within* it, then the nation-state's integrity and insularity would be compromised and might even disintegrate. The next section attends to these possibilities in Matoba's *Utopia*. I explore how the artwork, in revisiting the insular imaginations at the root of modern statehood, deconstructs the received spatiality of the nation-state.

Subverting the National Geo-Body

In *Utopia*, Matoba revisits More's proleptic imagination of insular statehood, which I claim she redirects in support of her own cosmopolitan

Insular Imaginations

13·MÄRZ 1938
EIN VOLK EIN REICH
EIN FÜHRER

Fig. 46. Artist unknown. This postcard map celebrates the "Anschluss," Austria's political union with Germany. 1938. Printed card, 14.5 x 10 cm. Courtesy of the British Museum.

sympathies. Having historically provided the model for "coherent territorial states each inhabited by a separate ethnically and linguistically homogenous population," insular form in *Utopia* is riven by heterogeneity.[28] Indeed, despite its isolation and closure, Matoba's island state manifests a space of adjoining differences, even interculturality, in that the people and places associated with the three distinct cultures of Japan, the United States, and Polynesian Hawaii coexist within it. Collaging difference into the insular state, *Utopia* fragments the integrity and boundedness projected in received imaginations of statehood. This subversion, I suggest, can be construed in two ways: first, as naïvely celebrating the integrative effects of globalization, and, second, as indicating forms of hybridity and difference that, though repressed, have inhabited insular statehood all along.

I begin with the first interpretation, in which Matoba's work projects a vision of how globalization fragments the cohesion and blurs the boundedness of insular statehood. On this view, Matoba conjoins distant geographical referents to represent globalization's supposed softening of territorial distinctions, intermingling of cultures, and, most important in *Utopia*, mollification of international aggressions. Hiroshima and Oahu may be presented without any visual reference to the damage they sustained historically, but the selection of geographies here clearly derives from their significance in the Pacific War. In the absence of the kinds of cartographic figures associated with warfare seen in Kocken's *Depictions* (front lines or arrows of maneuver), their meeting here suggests a peaceful state of reconciliation and cultural encounter following the Second World War. Indeed, viewed as part of Matoba's larger body of map art, Hiroshima's and Pearl Harbor's newfound geographical proximity comes to symbolize how the nationalist enmities between their polities have similarly diminished, owing to a broad reconfiguration of cultural space through globalization.

It is necessary, then, to set *Utopia* in relation to Matoba's wider imagination of a globalized world geography, in which national distinctions give way to cosmopolitan connections. Although I subsequently emphasize how Matoba projects a rather naïve image of global cultural communion,

Fig. 47. Satomi Matoba. *Shores of a River*. 2000. Digital collage, dimensions variable.
Reproduced by permission of the artist.

which overlooks globalization's inequalities and violent undersides, and courts the common critique of utopianism as impractical or fanciful, first I want to reconstruct this imagination of globalization through reference to the most ambitious work in the series, *Map of Utopia: Shores of a River* (2000). Another digital map collage of variable dimensions, *Shores of a River* reimagines world geography as a vast plain (fig. 47). The expanse is broken by a river, which, defying existing examples and definitions of rivers, runs back around on itself to form a great circle in a manner comparable with the river Anyrus or "nowater" in More's *On Utopia*, which is almost circular. An improbably dense selection of world cities clusters along its banks, including Yokohama, Brazzaville, Kinshasa, La Havana, Kyoto, Al-Qahirah, Jersey City, Saigon, Budapest, Rome, Shanghai, Niagara, Caracas, Tehrān, Johannesburg, Djakarta, Calcutta, and Beijing: here Matoba gathers a globally representative sample of urban geographies, cutting across constructed geopolitical divisions between East and West, North and South, or First, Second, and Third Worlds. The river is pasted together out of numerous existing waterways (I have highlighted its course in fig. 48). Its length relative to the surrounding cities is difficult to judge, for the river swerves frequently between orientations and suddenly opens out into improbable lakes. The body of water to the upper left of the image is Tokyo Bay, in the midst of which rests Manhattan Island's distinctive outline. London visually dominates what the image's orientation suggests is the river's most southerly segment. To the west, it flows through Vienna and Seoul, bypassing Delhi, which, confounding easy equation of globalization with cites, is presented along with a wider context of smaller rural towns and villages. To the east, it breaks around a complex of islets and islands (one of which hosts the city of Montreal) before coursing north through Al-Qahirah (Cairo), toward Calcutta. As the Seine it curls through Paris; as the Neva it flows into a lake-centered subsystem, whose banks display a remarkable amalgam of cultural difference: Soviet Leningrad, Congolese Brazzaville and Kinshasa, and Cuban la Havana, with Pulau Ujong, Singapore's main island, lying in the lake's middle.

Fig. 48. Satomi Matoba. *Shores of a River*, with alterations by the author. The course of the eponymous river is indicated by a line. Reproduced by permission of the artist.

Matoba's presentation of cities from around the planet in a uniform space, language, and graphic style, all without reference to regional histories and culture, might be taken to illustrate globalization, as it is often conceived, as "the worldwide Americanization or standardization of culture, the destruction of local differences, the massification of all the peoples on the planet."[29] But this impression of homogenization, I would suggest, is only the formal byproduct of a more hopeful vision of globalization articulated in *Shores of a River*, which, in imagining the intermingling of once nationalistically divided cultures, provides one way to interpret Matoba's reworking of the state in *Utopia*. The world-encircling river, on my reading, stands as a metaphor for how globalization connects and blurs cultures, providing a figure through which to envisage a cosmopolitan political geography. River imagery is certainly rich with metaphorical associations with globalization. Most obviously, Matoba's river literalizes Manuel Castells' influential claim that today's society "is constructed around flows: flows of capital, flows of information, flows of technology, flows of organizational interaction, flows of images, sounds, and symbols."[30] The river, then, can be taken to stand for the sublime magnitude of data flows composing the internet: insignificant daily transfers and online interactions feeding into a massive cumulative totality, like the brooks streaming into Matoba's great river. Standing for economic flows, the river as a fertilizing force, which, in threatening to periodically dry up or change course, reflects contemporary desires and fears surrounding the mobility of finance capital, which city legislators compete to court and retain. Add to this how the artwork reorganizes once-remote cities such that they now lie improbably close to one another, flouting existing terrestrial space. Indeed, *Shores of a River* takes seriously what Frances Carincross calls the "death of distances" under the pressure of a new round of transport and telecommunications technologies, which supposedly "loosens the grip of geography," eventually "killing location" as a significant factor in social practice.[31] Unfolding the world as a great plain on which formerly distant cities are rendered proximate or otherwise interconnected through a circling river, *Shores of a River* envisions

a supremely developed, globalized world in which former intuitions of distance no longer obtain.[32]

Beyond these technical and economic resonances, though, it is *Shores of a River*'s lack of geopolitical borderlines, even among such diverse cultures and distant geographies, that indicates the series' politics. *Map of Utopia*, Matoba writes, "is a metaphorical landscape of the postmodern global world of pluralism, or the innerscape of a cosmopolitan."[33] Although the content of this cosmopolitanism remains unspecific (perhaps Matoba means it to be suggestively vague), its underlying hope seems to be that the interconnectedness of cultures across global geography, as has come to the fore through recent globalization discourse, diminishes nationalist hostility and the exclusionary principle of place-bound identities. "When we think of our own brutality which enables us to do anything against people with whom we have nothing in common," Matoba writes, "we find the importance of interdependence and mutual reliance."[34] She relates this idea specifically to *Utopia* by asking: "If these two places had been closely located, could such brutal crimes [as these sites endured in the Pacific War] have been committed?"[35]

Hence, the geography Matoba sets out in *Shores of a River*, and indeed *Map of Utopia* at large, is meant as a cosmopolitan counter to parochial identities and nationalist aggression. It posits an interconnected world geography, marked not by international partitions and fixed distances but rather by plural encounters and transcultural flows, which the artist imagines as heralding a similarly inclusive and plural politics. But if *Shores of a River* indicates Matoba's politics in *Utopia*, this should not obscure key differences in how that politics is realized in the two works. In *Shores of a River* the global river replaces national borderlines as the organizing figure of political geography, substituting partitioned nation-states with an undifferentiated space of flows. Unlike *Shores of a River*, *Utopia* does not simply purge geography of nation-states; the insular form of modern statehood persists, as do the national differences evident in Pearl Harbor's and Hiroshima's local toponyms and profiles. *Utopia* might be antinationa*list*

then, but does not postulate a nationless and stateless geography. Whereas *Shores of Rivers* fractures open the exclusivity of insular statehood by imagining external connections and reciprocal flows among cultures globally, *Utopia* undermines the homogeneity of the national geo-body from within.

Collaging plural cultural referents into the supposedly sealed and integral insular state, *Utopia* cuts against what Paul Gilroy describes as the "unthinking assumption that cultures always flow into patterns congruent with the borders of essentially homogeneous nation states."[36] Here, the once geopolitically opposed cultures of Japan and the United States coexist within the state-as-island, whose coastal border thus no longer serves to secure the unity, and therefore exclusivity, of the cultural formation within. Thus *Utopia* formally articulates Matoba's wish that global connections might "make the distinction between insider and outsider invalid."[37] *Utopia* imagines the "inside" space of the island—archetype of contained self-identity—inhabited, rendered multiple, but not shattered, by the "outside" represented by remote cultural spaces against which it was once sharply delineated.

It must be noted, however, that Matoba's insistence on transcultural peace and cultural conviviality through globalization, while entirely appropriate to an overtly utopian set of map artworks, has an ideological dimension. For in extrapolating the utopian promise of a cosmopolitan world order from the realities of globalization, it overlooks the complexities of globalizing processes, papering over the exploitation, forced migration, and violence that they often entail. If globalization jettisons some subjects into the excitements of global mobility and encounter, it pins others to the factory floor; it establishes transcultural peace and toleration on one continent only to unleash new rounds of "primitive accumulation" and sectarian divisions elsewhere; and it develops extraordinary new urban infrastructures at nodes in the global economy, while stripping minerals and labor from its peripheries.[38] Yet it would be remiss, in making this critique, to pass over the one dimension of *Utopia* and *Shores of a River* that taints Matoba's otherwise idealized view of globalization, which stems from the incongruity of river and island imagery with contemporary imag-

inations of globalization. Posed in connection with the new technologies, economic structures, and consumer cultures associated with globalization, earthen banks, lapping tides, floodplains, and water fauna seem rustic, even retrograde. This choice of metaphor is revealing: one strand in the globalization literature draws attention to how the frenetic speeds and encompassing reach with which spatial interactions occur in advanced modernity can produce existential anxiety, overexposure, and insecurity in the subjects that undergo them.[39] Digital media streams images of distant disasters into the lifeworld; individual lives are determined by economic forces exceeding not only political control through representative states but perhaps even cognition itself; the temporality of labor and sociality not only accelerates but loses predictable routine or rhythmicity.[40] Against this backdrop, Matoba's choice to depict a circular river and self-contained island seems symptomatic. These closed spaces betray an impulse to establish worlds of existential closure, immunity, orientation, and security amid the disorienting data flows and overbearing infrastructures endemic to liquid modernity: to reduce these unsurveyable totalities to contained, safely mappable terrains and still instantaneous global reciprocities to the pastoral pace of a streaming river or lapping tide.

The very geographical figures with which Matoba ostensibly celebrates postwar globalization as utopian, in other words, also suggest a will to closure and comfort where the vicissitudes of global flux can be withstood, or perhaps at last enjoyed. But one does not have to overemphasize this to construe *Utopia* without idealizing globalization. On my first interpretation, directed by Matoba's explicit statements and wider imagination of world geography in *Shores of a River*, *Utopia* sets forth a condition that comes *after* the geopolitical divisions and strife of twentieth-century modernity, which the work imagines transcended by the transcultural flows of globalization. Yet the utopianism of this vision implies that nation-states were once stable constructs. Another perspective on the image, then, suggests that *Utopia* does not imagine a condition following the age of exclusive national cultures, but rather foregrounds the plurality that has always existed within nation-states, long-repressed by prevailing discourses asserting the

insularity and integrity of national cultures within state borders. Admittedly this interpretation has to ignore the artist's own stress on postwar globalization, not to mention the reference to the Second World War conjured by Hiroshima and Pearl Harbor. It has the value, though, of not sanitizing the politics of globalization, and of undermining insular constructions of statehood in a deeper, uncanny way.

If conventionally political mapping reinforces imaginations of ethnic cohesion and stability within exactly drawn borders, as though national cultures were autochthonous outgrowths of the regions they inhabit, this second reading of *Utopia* enjoins that national cultures are actually reifications of diverse peoples and mobile practices, which, issuing from no fixed point of origin, are always already unmoored and traversal.[41] This perspective is recommended by the work of James Clifford, who argued for the reorientation of anthropological study such that researchers, rather than attempting to excavate the foundational "roots" of cultural formations, would attend instead to the contingent "routes" through which cultural forms are sedimented. Critiquing conceptions of national cultures as insular blocks (that might later be blurred through globalization), Clifford stresses how "discrete regions and territories, do not exist prior to [transregional] contacts, but are sustained through them, appropriating and disciplining the restless movements of people and things."[42] Viewed from this vantage point, the disparate cultural formations that coexist on Matoba's vision of Oahu need not be conceived as part of the deterritorializing sweep of postwar transnationalism. They might just as well be taken to signify those manifold pre- and subnational mobilities that, under conditions of modern state formation, have been subsequently frozen as supposedly integral national cultures. Oahu is the point of confluence for at least three population movements. Polynesian Hawaiians, though often naturalized as "native" in the discourse of subsequent colonizers, crossed much of the Pacific Ocean to settle the island. The Hawaiian Islands were annexed to the United States in 1893, only attaining federated statehood in 1959, violently facilitating colonial settlement from the east. This demographic diversity, and the several global migrations it implies, is only accentuated

by the artist's collaging in of a Japanese cultural presence in the form of Hiroshima. To those unfamiliar with Hawaiian history, this insertion may seem forced. But it makes sense in light of the sustained Japanese migration to the islands before the Asian Exclusion Act of 1924, with Japanese migrants and their descendants composing a full 46 percent of Hawaii's population in 1930.[43]

I take the inclusion of this East Asian referent, combined with the Polynesian and U.S. migrations implied in the image, to signal the manifold cultural currents that, following Clifford, precede, transgress, and move within the bordered spaces staked out by states. Oahu, here, is crossed by disparate cultural trajectories, some colonizing, others migratory. In hosting these nomadic cultural flows, *Utopia* offers a peculiarly haunted revision of the island state as depicted in frontispiece to More's *On Utopia*. I have discussed how early modern states, by adopting the bounded and integral form beheld previously only in geographical islands, sought to carve overarching national territories away from the force field of local and cross-cultural attachments; so much is imagined in the symmetrical uniform cities and insular closure depicted on the frontispiece. Yet in Matoba's reworking of the image, the coastline delineating the shape, and thus constituting the identity, of the nation-state comes to be shadowed by unregimented forms of difference and hybridity that do not align with its profile. Unlike in *Shores of a River*, this groundswell of transcultural multiplicity has not overcome and transcended insular statehood under the banner of globalization. The image offered in *Utopia*, rather, is of cultural hybridity and mobility persisting, forgotten, unacknowledged, or disavowed, athwart and within the insular templates imposed by modern states.

In this way, *Utopia* renders the founding model of modern statehood profoundly uncanny. Whereas conventional political mapping posits state borders and geo-bodies as secure, evident, and exclusive, in Matoba's artwork the imagination of enclosed self-identity they enact is seen as a mirage or rhetorical construct, projected onto a field of restless cultural interchange that states can never fully fence in, homogenize, or otherwise discipline.

The Continuity of Calculable Space

Many writers have argued that globalization erodes or else reconfigures nation-states, and many have emphasized the repressed mobility and difference at play beneath and behind sharply delineated national cultures. Matoba's *Utopia*, however, articulates these challenges to the nation-state's coherence in and through the founding archetype of modern statehood: the bounded geographical island. Reading Matoba's image alongside the frontispiece to *On Utopia*, my analysis has stressed how *Utopia* diverges from received imaginations of insular statehood. Whether in appropriating insular form for a cosmopolitan political vision or showing how state borderlines are haunted by a groundswell of mobile hybridity, I have argued that *Utopia* reworks and undermines its early modern referent.

In closing, however, I want to indicate how, in reaching back to how Thomas More and his illustrator imagined the emergent spatial paradigm of modern statehood, Matoba's *Utopia* inadvertently foregrounds basic *continuities* in how modern space is conceived and practiced—continuities that persist beneath the proliferation of global flows and porous borders that Matoba hails as utopian. Although it undermines the aggressive geopolitics of state geo-bodies, *Utopia*, like the other works in its series, is conspicuously conventional in that it reproduces a synoptic, calculating, and potentially controlling stance toward the represented terrain. Indeed, *Map of Utopia* might project peace between human polities, but it only confirms the cartographer's mastery over its geographical objects, which, just as in normative mapmaking, have been set within grids and reduced to expertly codified semiotics.

The continuities between *On Utopia* and *Utopia* can be brought into focus by relating Matoba's artwork to the "ontology of calculability," which I discussed in the previous chapter in reference to the work of Stuart Elden. On the basis of his analysis of the cartographic disclosure of the world as a measurable and malleable extension, Elden intervenes in debates over the status of *territory* under conditions of globalization. If a territory is understood as the bounded dominion of a particular power, we might

take *Utopia*, which exposes difference inside the geo-body, or *Shores of a River*, which does away with national geo-bodies altogether, to have transcended the territorial condition. Yet for Elden territory does not equate with bordered space, as epitomized by insular statehood. Instead, he argues that borders are a "secondary aspect" of territory, building on the prior, more basic ontology of calculability, which, as I have already discussed in both the introduction and my analysis of Kocken's *Depictions*, "sees beings as calculable, as quantitatively measurable, as extended."[44] Rather than territory being constituted through bordering practices, then, it is the cartographic apprehension of territory as a measurable and divisible field that makes modern borders possible.[45] Elden picks out the treaties of Tordesillas, Westphalia, and the Pyrenees as important examples of political demarcation that each depended on the prior grasp of geography as calculable extension.[46] Territory, in Elden's presentation, is therefore "a rendering of the emergent [modern] concept of 'space' as a political category: owned, distributed, mapped, calculated, bordered, and controlled."[47]

Having established territory's basis in the calculable ontology of modernity, Elden writes against ruptural theories of globalization claiming that the contemporary moment is characterized by deterritorialization, understood as a progressive diminution of the importance of geography in social affairs.[48] Although Elden agrees that the existing configuration of sovereign states is undergoing a complex contestation and renegotiation, these changes are not seen as affecting the underlying ontology for which space is something legible, calculable, and quantitatively known, and thus susceptible to political apportion and intervention.[49] This ontology made possible state bordering and geo-bodies, certainly, but "this is not to say that territory is inherently tied to the state."[50] Hence, the sub-, non-, and trans-state spaces ascribed to globalizing processes, far from altering the underlying grasp of modern calculable space, represent "a continuation of Cartesian thought by other means."[51] "Rather than initiating a radical break," Elden writes, "capitalism extends the mathematical, calculative understanding of territory to the entire globe, instead of merely a single state. The flows of information, the digital 'revolution,' the Internet, global capital, and

international deregulation are little more than the old ideas writ large [in that they each depend on that calculative apprehension of space]."[52] The emergence of new digital mapping applications that I described in the introduction, with Google Earth as their apogee, illustrates the continuity, not to say expansion, of calculable space under the auspices of contemporary globalization. Matoba's *Utopia* is fully able to depict unfolding fissures in the received dispensation of insular statehood, then, while simultaneously indicating the continuity of calculable space as "the overriding geographical determination of our world."[53]

With respect to the ontology of calculability theorized by Elden, *Utopia* is essentially a repetition of its early modern template. This point can be substantiated by returning, briefly, to the comparison between Matoba's utopian island and the geographical illustration of More's *On Utopia*. Whereas my earlier discussion of the frontispiece stressed how the island's artificial separation from the mainland performatively constituted modern statehood, Elden's account of the calculability of modern space brings other aspects to the fore. The woodcut is remarkable, at least to a modern eye trained in pictures with a single organizing viewpoint, in that two differing perspectives coexist within it. Utopia is envisioned vertically, as on a schematic map, allowing its regular design to be surveyed and its inhabitants to be surveilled, while, inland, the landscape and towns from which it was severed are pictured horizontally. Spires, forests, and hills appear from a grounded perspective (fig. 49), as do the ships patrolling the foreground. Assessed in conjunction with the notion of calculable space, this can be taken to suggest that the two societies inhabit qualitatively different ways of seeing and being in space. Presented, in More's text, as traditional, indeed taken-for-granted organic constructs, the settlements onshore are depicted as they appear in lived experience, without the need arising to map, measure, or plan their inner order. The utopian polity, by contrast, presents a quintessentially modern spatial field in that it has been deliberately "gardened," and so is offered up as a semischematic object before a calculating and interventionist protocartographic gaze. Although, admittedly, the woodcut does not contain the now recognizable apparatus

Fig. 49. Detail of the frontispiece to Thomas More's *On Utopia*.

of cartographic measurability (scale, tabulated grid, and coordinates), one should note that, as published in 1516, it pre-dates the explosion of early modern mapmaking that I described in the introduction, adopting the perspective of an emergent mode of synoptic rationality and social planning before many graphic technologies of calculability developed. "It's early," as Denis Wood writes of this woodcut specifically, "but clearly moving toward the map."[54]

In Matoba's reworking of the image to reflect the concerns and circumstances of latter-day globalization, this transition "toward the map" has long been achieved. *Utopia*, like the wider series, meets the formal expectations of conventional topographic maps made by dedicated institutions in the mid-to-late twentieth century. The frontispiece was cut as mapmaking was beginning to emerge as a differentiated practice and so contains elements (the far landscape profile and proximate galleys) that belong more to lineages of painting than to cartography. No traces of alternative genre linger in Matoba's *Utopia*, by contrast. It establishes a quantified space that dispels ambivalence and is measurable in every dimension, purportedly on the basis of empirically surveyed data, organized around a mathematically constructed scalar projection.

Utopia and the frontispiece therefore sit at opposite chronological ends of the same conception of space as mappable, measurable, and malleable. Respecting this fundamental ontological disclosure of modern geography, the relation of the two images is one of continuity or repetition. True, the

Insular Imaginations

repetition introduces numerous differences. In the woodcut, the regularity of settlements is inexact, differing forms of land use are indicated only vaguely, and the toponyms are very partial; Matoba's *Utopia*, on the other hand, is highly consistent, sharply delineating agricultural, residential, forested, rocky, and watery space and comprehensively labeling the island's places. But from the perspective provided by Elden we understand that these differences occur within the same continuum or paradigm of calculable modern territory, such that Matoba's *Utopia* stands as a mature realization of the kind of mapped and measurable space that is pioneered in the frontispiece's tentative imagination of a synoptic space of social design. The commensurability of Matoba's series *Map of Utopia* with the ontology of calculability under construction in More's time is clearer still in *Shores of a River*, which, notwithstanding Matoba's comprehensive reconfiguration of world geography, is divided up by a linear grid imposed over an otherwise turbulent space of flows. Intersecting at entirely regular points across the represented territory, the thin blue lines of this grid indicate how, despite the map's seismic rearrangement of global spaces and places, the underlying ontology of calculation and control prevails just as completely as ever.

Directed by the utopianism announced in Matoba's titles, this chapter has emphasized the ways in which *Utopia*, and more briefly *Shores of a River*, reimagines political space beyond insular (exclusive and homogenous) constructions of statehood. My analysis has warned against Matoba's overly optimistic view that globalization is an unambiguously utopian force, reconciling nationalist enmities and incubating cosmopolitanism around the world. However, I also interpret *Utopia* as showing how restless cultural hybridity and difference have always subtended and beset insular nation-states—haunting and relativizing the bounded partitions of modern political geography.

By appraising Matoba's détournements of insular statehood in relation to the ontology of calculability introduced in the previous chapter, my analysis of *Utopia* anticipates the problematic addressed centrally in the remainder of this book. *Utopia* and *Shores of a River* undermine the long-dominant national paradigm, certainly, and conjure a newly multiple, flowing and

interconnected world. But by articulating a utopian politics through maps that remain conventional at the level of their form, Matoba prompts the rejoinder that her transformations of political space, though ostensibly extensive, depend on and reinforce the underlying ontology of calculability and control. This reversal applies far more widely than *Map of Utopia*; in the following chapter I argue that both digital mapping applications and many other works of map art, while seeming to reimagine political geography or to reclaim mapping from institutional control, often repeat and further expand its inherited ontology. Following my closing insistence that *Utopia*'s subversion of modern statehood remains caught with the paradigm of calculability, the remainder of this study asks whether map art might trouble the received casting of the world as a measurable and malleable extension, or even enact geographical ontologies as yet unknown.

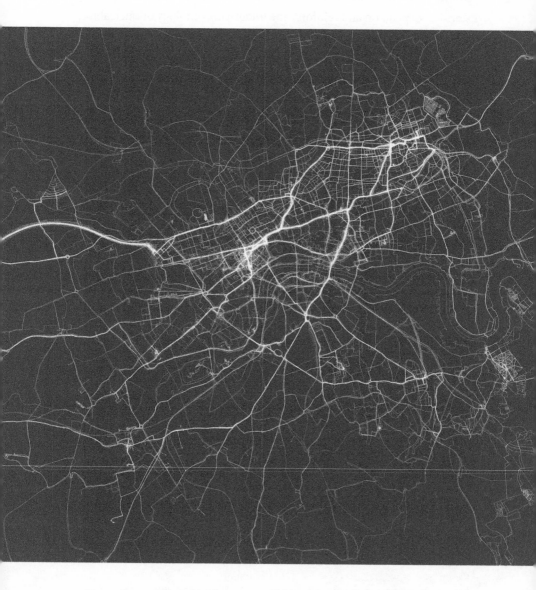

Fig. 50. Jeremy Wood. *My Ghost*. 2009. Giclée print, 31 x 33 cm. Reproduced by permission of the artist.

5 Cartography at Ground Level

Spectrality and Streets in Jeremy Wood's
My Ghost and *Meridians*

An implicit model of map art runs throughout the previous chapters. I have treated cartography as a theme explored in four artistic projects, which manifest meditations on the modernity of mapping but are not primarily instances of mapmaking in themselves. One way of putting this is that I have privileged "mapping *in* art." Nikritin's *The Old and the New*, in which a global map is but one object among others represented in a scenic painting, is the clearest illustration of this. And yet from the beginning the question of how cartography is presented and reflected upon in artworks has been shadowed by an alternative formulation of what constitutes map art—"art *as* mapping."[1] Indeed, in exploring cartography thematically, several of the projects I have looked at also undertake forms of mapmaking in their own right. This pertains especially to Hildreth's series *Forthrights and Meanders*, which develops a polychronous mode of cartography, and Matoba's *Utopia*, which reworks formerly closed insular mappings for a counternational political imagination. By no means do I want to downplay the extent to which these works engage and enrich mapmaking practice. Nevertheless, my analyses of Hildreth's and Matoba's interventions in mapping have focused first and foremost on the theoretical reflections they perform or provoke, specifically regarding how maps generate temporalities and spatialize identities.

In the final two chapters of this study, then, I want to bring the subordinate conjugation of map art—"art *as* mapping"—to the fore. Doing this means posing directly questions that, though present in previous chapters, have been largely subordinated to my overarching thematic and

theoretical concerns. What are the implications of artists transgressing the received distinction between cartography and art? To which alternative formations of mapmaking and mapped space do such transgressions give rise? And how do they intersect with the central theme I have been exploring—namely, mapping's constitutively modern, world-molding powers? Logically, the import of projects aimed at blurring art with mapmaking can be grasped only with respect to how the two fields have been held apart historically. To address these questions, therefore, it is necessary to cast back to the introduction to this book, in which I provided a brief genealogy of the discourses through which cartographic and artistic practice have been constructed in relation to one another. There, I took the view that designations of "art" and "science" in cartography, despite their ostensibly descriptive intent, are best understood as performative gestures that invest and distribute authority unevenly among different groups engaged in mapping. I stressed the social and ontological aspects of the art/science distinction that came to prevail in modernity, especially in the mid-twentieth century. The art/science distinction is *social* in that it performs a distinction between laypeople and mapmaking experts. It elevates professional claims and representations to the status of disinterested and universally binding facts, while other mappings and spatial imaginations circulating in society are recast, through a function of *différance*, as nonspecialist, subjective, parochial, interested, lay, amateur, and artistic. The art/science distinction also implies a specific *ontology*, which justifies and maintains this unequal dispensation of authority among mapmakers. This is what I have described throughout this book as the "ontology of calculability," which articulates the world as a measurable and monochronous extension that precedes and exists independently of cartographers' constructions. This ontology provides the basis for institutional and professional authority in mapmaking in that claims to represent geographies scientifically and correctly rest on presumptions that the world is singular and objective, can only be represented accurately through "neutral" procedures of survey and projection, and does not admit a plurality of equally correct mappings.

Cartography at Ground Level

Having grasped the historically instituted threshold separating cartography from art, or mapmaking's supposedly scientific core from its artistic superficialities, it becomes possible to address the implications of artistic incursions across it. In view of the simultaneously social and ontological import of the art/cartography distinction, the final two chapters of this book argue that the practices that transgress this boundary unfold correspondingly social and ontological challenges to established cartography. This chapter addresses the first of these challenges. It explores the social implications of "art as mapping," showing how map art might cut against the received concentration of cartographic means and legitimacy in professional domains and thereby "take back the map" from institutional control.[2]

To do this, I focus on map-based practices by U.S.-born walking artist Jeremy Wood (b. 1976). Given my emphasis on the social concentration of cartographic authority through rhetorics of science and specialism, I am especially interested in how Wood's artworks reconfigure the relations among mapping, everyday walking, and streets through the experimental use of Global Positioning Systems (GPS). Tracing his movements with GPS technology to create personal cartographies, Wood transforms his walking body into what he calls a "geodetic pencil," inscribing urban landscapes as it traverses them. In many of these mapping performances, Wood willfully directs his walking so as to trace images, words, and street patternings before the solar eye conjured by mapping; others track the ostensibly unmodified movements that make up his daily life. Of the latter, one image in particular encapsulates my concerns: *My Ghost*, a map presenting accumulated GPS tracks of Wood's daily mobility through London over seventeen years (2000–17) (for an image of the work in 2009, see fig. 50). *My Ghost* and other works accentuate the social challenge posed by "art as mapping" in an especially strong form. Not only do they transgress the distinction separating supposedly scientific cartography from art; in figuring everyday walking as a medium of mapmaking, they also diminish the distance between expert cartography and lay practice more generally. My analysis shows how Wood's works, which conflate formerly discrete practices of cartography, art, and pedestrianism, embody key problems and possibilities

thrown up by the recent diffusion and diversification of mapping beyond institutional domains. I am also concerned to stress how, in enrolling geospatial technologies to do so, Wood's art encapsulates connections between map art and digital mapping platforms that have arisen in recent decades. The fields converge, here, in contributing toward the emergence of a more distributed and multiple mapping culture than that which has prevailed under institutional cartography.

Characteristically for a walking-cum-mapping artist, Wood articulates the social expansion of cartographic means and legitimacy in an acutely spatial manner. Accordingly, my discussion foregrounds the shifting status of *the street* in his artworks. The first half of the chapter contrasts Wood's artistic vision of cartography at ground level with the received relationship between mapping and streets. In the spaces and places produced by modern urbanism, I argue, the street has been figured largely as a subordinate social site to be ordered by elevated cartographers and planners. Wood's itinerant mappings, in contrast, take the street and its users as the site and agents of cartographic practice. As such, the works empower pedestrianism: far from being caught in an imposed urban grillwork, walking becomes the reiterative making and remaking of streets through performative acts of mapping.

The second half of the chapter shifts focus from the social to the ontological dimensions of the art/cartography distinction. On this second point, Wood's mappings are not celebrated uncritically. I have suggested how professional cartography's unequal apportioning of authority rests on the "ontology of calculability," which presupposes the world's basic measurability through exact, objective procedures. In expanding mapping practices to the formerly excluded cluster of people and places conjured by "the street," does Wood's work displace the transparent, uniform, and objective casting of space inherited from institutional cartography? Or does it entrench this ontology through an enlarged social field? Although Wood's mappings offer no alternative articulation of mapped space, I invoke the metaphor of spectrality in *My Ghost* to show how *Meridians* (2005), another of Wood's itinerant mappings, playfully exposes the slippages and pretensions of

existential security in the GPS worldview of calculated locations. Wood's art, I conclude, is poised astride shifting mapping paradigms: in reclaiming mapping for its social others, *My Ghost* and *Meridians* simultaneously rely upon and undermine the inherited cartographic ontology of calculability.

These conclusions lead into the final chapter, which makes a pair with this one in that both foreground the social and ontological significance of overcoming the art/cartography divide. There, I consider how map art might transcend the ontology of calculability by turning to a film made thirty seven years before *My Ghost*: Peter Greenaway's *A Walk Through H* (1978). This film, I will go on to argue, unfolds a peculiar casting of geography that deviates radically from the forms of measurable and monochronous extension examined throughout this book. Taken together, my analyses of Wood's and Greenaway's mappings emphasize the far-reaching implications of challenging art's separation from cartography. More than simply heightening the aesthetic considerations of mapmaking, these chapters show how these practices of "art as mapping" not only burst cartography from institutional sequestration, but also displace the ontological assumptions that have rationalized professional control over mapping for much of modern history. Released from the singular and purportedly objective ontology of calculability, diverse mappers might build rich fantastic geographies, beyond received projections of science and art.

Jeremy Wood and the Project of a Personal Cartography

Born in San Francisco and raised in Berlin, Wood currently works in and around Oxfordshire in England. His art encompasses different media, from photography and digital drawing to walking performances, yet thematically it coheres closely around the personal geographies enacted in and through his life. Wood charts these geographies through the experimental use of satellite tracking technology. At the core of his practice, then, are Global Positioning Systems, which allow users to establish longitude, latitude, and altitude quickly within a standard global framework. GPS can be simplified to three constituent elements: first, a constellation of (at present) thirty satellites orbiting the earth, established by the U.S. Department of Defense

and NATO in 1993; second, the World Geodetic System 1984 (WGS84), an internally coordinated graticular map produced by the U.S. Defense Mapping Agency to represent the earth; and, third, innumerable receivers that detect and triangulate the signals emitted by at least three satellites so as to calculate the device's position within the WGS84.[3]

The mobility of these receivers, which are often produced as small handheld units or embedded in smartphones, is especially important in Wood's practice, which explores the limits and possibilities of the GPS infrastructure through the mobile methods of walking art. The impetus behind the burgeoning cultural interest in walking, suggests David Pinder, is to "leave behind fixed or elevated viewpoints in favor of mobile, grounded, and partial perspectives."[4] In exploring subjective spatialities, the political channeling of mobility and the fortuitous simultaneities to which urban modernity gives rise, Wood's practice broaches some of the quintessential themes of walking art as it has developed from the early twentieth-century avant-gardes through to the "expanded field" of art today. He is unusual among walking artists, though, in that instead of invoking the partiality and mobility of embodied walking to counter the omniscience perceived in cartography, his practice combines and even conflates the two impulses of walking and mapping such that they no longer represent contraries. By recording his own mobility as GPS "trackpoint data," Wood transforms walking into a tool of cartographic drawing. The resultant information is then modeled on specially designed software named GPSography, which figures the lines made by Wood's movement into "sculptural objects" that can be superimposed over maps or aerial photographs.[5] In this configuration, the artist's traversal of a landscape constitutes both part of the medium through which his maps are made and the subject matter they represent. Constantly plotting his mobility, Wood's walking body becomes a "geodetical pencil," as Lauriault puts it.[6] This formulation concentrates what I see as a central gesture of his practice: namely, the merging of grounded mobility with synoptic mapping.

Wood's works of walking/mapping fall under two broad categories. First come pieces in which the artist directs his mobility willfully so as to write shapely new streets, images, and words into existence. Consider, in this

Cartography at Ground Level

connection, *Brighton Boat* (2001–2), in which Wood walked the GPS image of a ship through the city of Brighton. Or *Meridians* (2005), a long walk through London whose vagaries write out a sentence spoken by Ishmael in Melville's *Moby Dick* to describe Rokovoko, the island home of the harpooner Queequeg: "It is not down in any map; true places never are."[7] I will return to discuss *Meridians* and reflect on this anticartographic note later in the chapter. The works in the first category take the landscape as a jotting pad or drawing board. Unlike the pristine blankness of these stationer's equivalents, however, the English landscapes that form the basis for the majority of Wood's peripatetic jottings are strewn with impediments accumulated over millennia of history. The images are, consequently, humble and dialogic examples of draftsmanship, for in "taking a line for a walk" (Paul Klee's phrase) across such cluttered countryside canvases, Wood's somatic pencil must negotiate and respond creatively to the multiple physical features and human relations that surround his mobile self.[8] This aspect of the artworks comes across strongly in Tracey P. Lauriault's reflections on Wood's GPS art, which, she argues, include "land, water, air and the engineered environment of places" as "protagonists" of the spatial stories told in the works.[9] To show how environments and events altered the walking/drawing of *Meridians*, Lauriault recounts how Wood had to dodge golf balls and misshape words due to the unforeseen erecting of circus tents on the planned route.[10] While carefully treading the Greenwich Meridian line, he was also almost thrown off course by a boisterous Labrador.[11]

The compromises entailed in walking a line through the landscape, in calling attention to the reciprocity of people, environments, and animals in quotidian geographies, compare favorably with the forms of modernist street planning discussed in the following section, which take existing settings as empty pages on which to inscribe synoptic street patternings. The contrast with modern urbanism is stronger still in the second category of Wood's artworks, in which Wood's mobility is ostensibly unmodified by being recorded cartographically. Mapped lines unfurl with apparently no regard to the proverbial cartographic "eye in the sky," turning the function of GPS tracking from that of spectating deliberately staged geographical

performances to documenting the spatialities and rhythms enacted in the course of Wood's everyday activity.

Such tracings make up what Wood calls his "cartographic journals": a publicly visible bank of personal images that record the spatial unfolding of his life and trigger memories of past mobility. Some journal entries recount a single stroll (walking the dog); others narrate more elaborate walks (exploring a maze). Only one of Wood's GPS tracings, though, boasts a durational stretch of seventeen years. *My Ghost* concentrates this remarkably protracted accumulation of trackpoint data recording the artist's movements in, through, over, and under central London, whether on foot or by car, bicycle, tube, or plane. The title registers the uncanniness Wood felt on seeing the routes taken by his former selves objectified, visually, before him. This chapter discusses *My Ghost* in detail because its conflation of synoptic cartography with the vagaries and banality of quotidian mobility embodies the blurring of hierarchies in contemporary mapping cultures.

My Ghost presents a stark monochromatic map comprised of brilliant white lines strung out across a black space. Being digital, the work's dimensions and scale are variable, though Wood has exhibited different prints of 3.3 by 3.1 meters and, more recently, 2.1 by 1.3 meters. On my own estimate, this latter configuration makes a scale of roughly 1:9000. This is relatively large, allowing viewers to follow closely the meanderings of individual paths, while still combining many particulars into a synoptic whole. Even without resort to the explanatory notes that accompany the map both online and in the gallery, it is recognizably London. Recognition is not instantaneous, however. By contrast with the cartographic *gestalt* that centuries of mapmaking have established for the old imperial metropole, Wood's map is decidedly off kilter. The usually dominant curls of the river Thames (which appear as a blank between Wood's clustered paths) figure as but a feint sideshow to a long tangle of intersecting paths extending out over the image. Drawn together into two, perhaps three key nodes north of the river, the pathways shine forth in concentrated white threads.

It is important that the lines traced across *My Ghost* are not laid over an aerial photograph of the region traversed, as they are in other works,

but stand isolated against an inexpressive black background. Abstraction from the terrain releases the pathways from immediate referral back to their origins in geographical mobility, allowing viewers to engage them as pure forms or Rorschachian prompts to association. Loosened up to diverse resonances in this way, the image suggests several visual analogies: a dot-to-dot illustration of some as-yet-unamed constellation; satellite photographs of nocturnal regions in which white indicates densely lit urban nodes, tapering off into a dark surrounding rurality; the rudiments of capillaries visible in radiographic images; or Lichtenberg figures, scientific images in which electrified dust is discharged through metals, plastics, or wood to create branching luminescent structures that resemble lightning.[12] In view of this uncanny phosphorescence, combined with the work's phantasmal title, the analogy of ectoplasm also comes to mind. The spirit given shape by the substance, in this case, would belong not to an individual, but a city: the febrile pneuma of London as it is fetishized in Peter Ackroyd's "biography" of the city, for instance.[13]

I will pick up on the artwork's susceptibility to association and analogy, and especially this last theme of spectral geographies, later in the chapter, which considers the ways in which Wood's works complicate the GPS ontology of fixed location. The idea to take onboard here is that *My Ghost* offers an imaginative vision of how everyday mobility and cartographic drawing coalesce in the increasingly distributed culture of digital mapping. Indeed, though the map can be read simply as a visual record of Wood's personal geographies, this straightforward representational function is complicated by the fact that the artist's mobility is not just the object or subject matter of *My Ghost*, but also the medium and agency through which the map was made. Wood's GPS mappings fold closely together the formerly discrete (and I will suggest hierarchically opposed) domains of panoptic mapping and quotidian mobility—so closely, in fact, as to make walking synonymous with mapping.

To explore the implications of this conflation, the following sections set *My Ghost* in contrast with cartography's relationship to the street as it has been inherited from modern urbanism. Discussing Michel de Certeau's

account of how elevated cartographers and planners have imposed urban orderings on the street brings into focus the social significance of Wood's blurring of synoptic mapping with urban walking.

Setting the Street to Order

For much of modern urban history the relationship between cartography and the street has been determined by the imperatives of state-backed planning and the (utopian) ideal of a fully calculable and controllable city. In streets received from preindustrial settlement, planners often saw chaotic meeting places of contrary purposes and moribund remainders of premodern indeterminacy. Viewed as impediments hindering the construction of optimally designed urban machines, the street elicited antipathy and ordering zeal. Baron von Haussmann's pseudomedical discourse on the necessity of clearing "clogged arteries" in the medieval city, alongside Le Corbusier's famous moratorium on the street in *The Radiant City* (1935), stand as paradigmatic statements of this animus.[14] To the modernizing mind, Zygmunt Bauman writes, old streets become an "incoherent and contingent by-product of uncoordinated and desynchronized building history," obstructing the "platonic sublimity, mathematical orderliness" and seamless functional division that urban modernity—so it was hoped— would usher in.[15] Bustling premodern streets were to be mapped out, street practices to be disentangled and set to rational order.

Despite the modernist aggressivity toward it, there is something irreducible and intransigent about street sociality. Multiform thoroughfares might be split into discrete communicative modes; street commerce and culture removed to dedicated sites, but no sociospatial planning project will entirely do away with friction and informality at the thresholds between functional domains. Streets therefore present urban planning with a special difficulty, in that they simultaneously incite and elude ordering energies. City administrations have often navigated this double bind by remaking the street after the pristine legibility admired in maps. Cartographic rationalities of naming, numbering, tabulating, coloring, and demarcating space through conventionally agreed codifications have presented a

model for the ordered modern street.[16] Consequently, formerly irregular, informal, and inscrutable streets, the shifting complexity of which has so often confounded cartographic attempts to establish transparency, have been rearranged or rebuilt entirely.[17]

In the received practices of modern urbanism, then, cartographers and planners have taken the street as an object of not just surveillance and representation, but planned reformation too. One way to summarize this is to say that modern cartography manifests an elevated view in relation to the street. This recalls the prolegomenon to Michel de Certeau's often excerpted chapter "Walking in the City," in which the author looks down on Manhattan's streets from the height of the World Trade Center, then ten years old.[18] Though this analysis is well known, I want to rehearse the key opposition driving de Certeau's account because it is precisely this binary that Wood's mappings collapse. Distance and ocular objectification are leading motifs in de Certeau's analysis, in which cartography and elevated views more generally are positioned as foils against which to celebrate transitory practices performed in the streets. Elevation, he writes, "transforms [the subject] into a voyeur. It transforms the bewitching world by which one was "possessed" into a text that lies before one's eyes. It allows one to read it, to be a solar Eye, looking down like a god."[19] Here, the panoptic visuality that surveils the city is epitomized by cartography in the practical sense of establishing distance and legibility. Maps disentangle their users from the sensuous complexity of "grounded" practices, allowing one to grasp urban geographies without being caught up in them. They reduce streets and urban spaces to transparently readable "texts" that allow for rationalized interventions from afar.

Significantly, de Certeau's characterization misunderstands cartography insofar as an important distinction obtains between cartography and aerial or heightened perspectives. To think that the visions built through mapping could be attained in embodied experience, however elevated, would be to conceive maps as transparent windows, not culturally relative and politically invested visions.[20] Yet the elevation de Certeau ascribes to cartography describes more than the practical illusion of verticality constructed

by maps; cartography is also elevated in another, metaphorical sense of belonging to a dominant position in the field of social relations. In speaking of the all-seeing reader of the urban text, he has in mind the "the space planner urbanist, city planner or cartographer."[21] Here, elevation denotes the ruling position enjoyed by legislators and state actors, who, as I have argued in chapter 3, survey received spaces and populations to "garden" them in accordance with a chosen model, often as executors of corporate rationality. *The map* and *the street* represent not just physical spaces and practices, then, but also metaphorical sites denoting diametrically opposed positions within a symbolic topology of social power.

Cartographers grasp space "from above" in the sense of occupying a socially dominant position; subjects traversing streets practice space creatively "from below" in that they act from a site of ostensible weakness. This schema is, I realize, inescapably binary, as well as vitiated by the "denigration of vision" that suffused de Certeau's intellectual milieu.[22] Yet his identification of cartography with dominant social agents is borne out, to a degree, by the discursive construction of cartography through modernity, especially in the twentieth century. Through what Donna Haraway has described as the "God's-eye trick," which I discussed in chapter 1, cartographic legitimacy was increasingly claimed as the preserve of mapping professionals and legislative institutions, who presented their representations as transcending the fray of partial perspectives.[23] Such rhetorics of scientific objectivity and expert distinction, argues Harley, "enabled cartographers to build a wall around their citadel of the 'true' map," beyond which "there was a 'not cartography' land where lurked an army of inaccurate, heretical, subjective, valuative, and ideologically distorted images."[24] This image of a cartographer's "citadel" conjugates with de Certeau's skyscraper in that both represent elevated social sites and symbols of panoptic power, raised above the supposedly partial, myopic, or distorted spatialities practiced by noncartographers in the city streets below. I cite these vignettes of elevation and enclosure to stress how discourses of objectivity and professional specialism perform an unequal distribution of cartographic legitimacy among social groups engaged in mapping. Maps produced by dedicated professional institutions

Cartography at Ground Level

are set apart from, indeed above, competing articulations of geography, which, though not condemned to outright illegality, are denigrated as lay and artistic deviations from professional procedures.

In the dispensation inherited from modern urbanism, then, cartographers and planners look down on earthbound streets from heights both practical and social. *Practical* in that they enroll maps' distanced legibility to mold street spaces and subjects; *social* in that discourses of science and specialism have confined cartographic authority to delimited institutional domains while withholding it from the populace at large.

Descending into the Street

Having built an image of how, in modern urbanism, cartography and streets are locked into an asymmetrical antinomy that is played out through city spaces, I want to examine how these relations are reconfigured in Wood's itinerant mappings. The artworks' central gesture, I have suggested, is to conflate grounded mobility with synoptic mapping. It is only now, in light of the strategies through which institutional cartography has proclaimed itself apart from transient spatial practices, that the larger significance of this conflation becomes clear. My claim is that, in blending mapping with walking, Wood collapses the binaries driving de Certeau's account of urban practice and cuts against cartography's elevation in relation to the street. In *My Ghost*, walking *is* mapping, while cartographic inscription, far from signaling distanced ordering, *is* lived mobility. Mapping thus blurs into the fleeting street-level performances against which it was formerly defined.

Just as institutional cartography's elevation above the street is both a practical effect of maps' distanced legibility and the metaphorical expression of dominative social relations, so Wood's intervention has both technical and social aspects. Enrolling the mobility of geospatial devices as a drawing method, *My Ghost* brings to focus key developments in cartography's digital transition. Where print mapmaking was essentially a sedentary undertaking done in dedicated sites (though requiring prior surveys), digital mapping is increasingly peripatetic. Performed on smartphones by diverse users, mapping takes place *in* and *through* varied street spaces, with which maps

interact in complex reciprocal ways.[25] Technically, the function of inscribing Wood's movements through GPS might seem underwhelming by contrast with increasingly sophisticated smartphone-based mapping applications. Yet for me the simplicity of making street-level mobility over into mapmaking distills the *social* import of shifts toward distributed digital mapping. Indeed, in merging mapping with quotidian practice Wood accentuates what Jeremy Crampton has called the "undisciplining of cartography": the process through which mapmaking, under prevailing technological and epistemological pressures, is "slipping from the control of the powerful elites that have exercised dominance over it for several hundred years."[26] *My Ghost* presents a spatial imagination of this "undisciplining," in which the once excluded and subordinate people and places evoked by "the street" become sites and subjects through which mapping is performed.

As such, *My Ghost* transgresses the historically instituted distinctions that set institutional cartography above not only everyday articulations of space, but artistic practice too. In modernity, cartographic professionals came to enact their own scientific authority by defining their practice against the subjectivism, partiality, and creativity perceived in art.[27] Sometimes cartography as a whole has been positioned in opposition to arts practice; more often, though, the binary runs through cartography, with art being "accorded a cosmetic rather than a central role in cartographic communication."[28] Made by an itinerant artist with no official accreditation in cartography, *My Ghost* pays no heed to the art/science opposition. If legitimacy in mapmaking has traditionally been claimed by the delimited "citadel" of cartography, whose palisades define scientific cartographers from the lay and artistic mappers ranged without, *My Ghost* emblematizes artistic attempts to "take back the map" from institutional control.[29]

What distinguishes *My Ghost* both within Wood's own body of work, and the field of map-based art at large, though, is how it also extends mapping to quotidian practice more generally. Unlike *Meridians*, which "takes back the map" to articulate a carefully executed artistic rendering of space, in *My Ghost* the artist's routes are not dictated by the need to perform words and images before a satellite gaze. The lines unfold according to the move-

ments and rhythms of daily life. It may be naive to imagine that Wood's mobility continued unaltered by being tracked (Lauriault notes how the image does not "tell us when he journeyed with the GPS turned off"), yet *My Ghost* is not a preconceived artistic vision. It is an accumulation of the kind of commonplace spatial practices that de Certeau valorized for their subaltern creativity.[30] For him, the transient performances through which bodies negotiate cities, requiring neither official training nor dedicated sites, manifested an ineradicable foil to panoptic ordering. What could incarnate unofficial, nonprofessional, indeed "ordinary" practice more fully than moving through the city? In grounding cartographic inscription in daily meanderings, *My Ghost* embodies the challenge posed to professional cartography by distributed digital mapping, which intersperses everyday lives with quotidian acts of mapping and makes potential mappers of non-specialist users. Mapping descends into the street, empowering Wood's pedestrianism, which writes/walks out new shapes and street patternings that are registered, but no longer determined from on high, by cartography.

In stressing how Wood appropriates mapping for the quotidian and artistic fields of practice against which institutional cartography has traditionally asserted its own distinction, I have already presented this descent in terms of democratization. This would accord with more optimistic valuations of cartography's digital transition, which draw attention to how current shifts in mapping "blur the traditional boundaries between map user and map maker, the trained professional the map amateur."[31] Yet if Wood's practice brings into focus the recent expansion of cartographic means and legitimacy beyond institutional domains, it also embodies more disquieting aspects of digital mapping. Indeed, Wood's GPS-driven conflation of walking with mapping might be linked to the (largely voluntary) proffering of once private geographies through mobile phone signals as commercially and governmentally exploitable data sets; the surveillance of convicts through networked anklets and the potential for "geoslavery" it suggests; or to the diffusion of military tracking and targeting rationalities into commercial, governmental, and ultimately personal practices through the generalization of GPS technology.[32] Adducing these developments serves to dampen

celebratory narrations of cartography's digital transition, balancing my image of mapping's democratizing descent into the street with the sobering realities of how digital mapping regimes are "fueling new rounds of capital investment, creative destruction, uneven development, and indeed, at times, the ending of life."[33] A fuller appraisal of Wood's itinerant mappings than is possible within the frame of this chapter would connect the artworks with the exploitation of personal geometrics, whether by policy makers, surveillance agencies, state militaries, or profit-driven geobrowsers.

Another critique might focus on how Wood's highly individual project of tracing a cartographic journal offers a rather depoliticized vision of the newly distributed digital mapping cultures. Unlike comparable works of map art, like Esther Polak and Jeroen Kee's *Amsterdam RealTime* (2002), which combine GPS traces from a variety of different users, in *My Ghost* Wood abstracts his own mobility from the broader social process.[34] I would emphasize, however, that the "undisciplining of cartography" turns centrally not on an opposition of individual versus collective mapping practices, but rather on the usurpation of professional cartography—defined by rhetorics of science and specialism—by untrained, non-official mapping practices. What is more, the individualism of Wood's cartographic works indicates a tension that runs through contemporary digital mapping practices. On one side, digitization indeed makes possible new forms of collectively producing and continually augmenting online maps. On another, though, dominant corporate mapping platforms channel these collective practices through interfaces that individualize users. By linking user-generated reviews, photography, and announcements on social media to cartographic locations; filtering (or rather targeting) cartographic information according to users' preferences and search histories; and presenting online maps as just one in a suite of interconnected personal applications, these platforms infuse the use of digital maps with a sense of one's unique subjectivity. Hence, in his account of the application Google Earth, Mark Dorrian notes how "at the same time as Google gives you the world, it also gives you 'yourself,' an effect not unconnected with the company's infamous user profiling techniques and storage of search histories."[35] Google Maps and Google

Earth are participatory, then, but we participate as individuals. Wood's cartographic works recapitulate this problematic. In conflating cartographic inscription with quotidian spatial practice, *My Ghost* also conflates self and geography in ways that mirror the personalization of space in leading digital mapping platforms.

The critical perspective on Wood's works I want to explore here, though, focuses on the ontological underpinnings of contemporary mapping and GPS. Artistic interventions in mapping like Wood's are of little import if they simply expand mapmaking to a larger social field without also challenging the underlying conceptions of mapping and space promulgated by institutional cartography. Professional and scientific claims to possessing privileged access to geographical truth, and therefore superiority over lay and artistic mapping, rest on a particular casting of the world as a calculable, uniformly extended space that exists independently of the observer, can be measured and represented exactly, and does not admit multiple correct interpretations.[36] While unfolding shifts in cartography present a quantitive proliferation of mapping practices, qualitative ontological assumptions about what mapped space fundamentally *is* have persisted untransformed. Mainstream GIS and GPS reproduce values and aims inherited from institutional mapmaking—values like objectivity, accuracy, and uniformity; aims like establishing calculability and control. Despite the prevailing rhetorics of discontinuity, it may be that current shifts toward an expanded culture of digital mapping only resubmit understandings of geography more completely to the cartographic ontology of calculable extension, all behind the smokescreen of democratization.

Against this backdrop, it seems to me that the value of artistic interventions in contemporary mapping like Wood's, beyond "taking back the map" for nonprofessional mappers (which is in any case occurring, albeit unevenly, through cartography's digital transition), lies in how they might counter this ontology with qualitatively different, experimental, and original visions of mapped space. I will suggest that though Wood's mappings hold out no alternative to the coordinated and measurable determination of the world articulated in most digital cartographies, neither do they simply

repeat and reinforce this ontology; indeed, they playfully undermine the GPS worldview of securely established locations. To show this, the next section takes up the metaphor of haunting in *My Ghost* to focus on how *Meridians* renders ostensibly secure GPS locations and measures as spectral, groundless projections.

Spectral Geographies

My Ghost may have been produced using GPS technology, but in exhibition it accumulates affective and metaphorical resonances that exceed the coordinated ontology unfolded through digital mapping. Strikingly, the artwork delineates Wood's mobility against a black background, contravening the convention that maps should postulate a uniformly illuminated, indeed shadowless world. Besides making for a visually distinctive map (the inverted version of *My Ghost* that Wood finished in 2012, which traces dark lines over a white substrate, loses much of its aesthetic impact), Wood's choice of a dominant dark backcloth releases his pathways from referral back to the traversed geography and opens them up to diverse associations. Given the work's title, the darkness invests the image with an ominous tone that colors these resonances: as I noted in my initial description, to me *My Ghost* suggests ectoplasm incarnating the city's *genius loci*. Wood's performance of urban spectrality repays further discussion here, for the figure of the ghost—or, rather, of ghostly geographies—calls into question the certainty and fixity surrounding notions of locatedness in current mapping platforms.

Concepts around haunting and spectrality have come into increasing prominence in cultural theory in recent decades. This has been associated, in large part, with Jacques Derrida's notion of "hauntology," which counters reductions of existence to full and saturated *presence* with an ontology shot through with *spectrality*.[37] Theories of spectrality do not refer to "literal" ghostly visitations, but invoke spectrality metaphorically to draw attention to phenomena that flicker between absence and presence from particular discursive viewpoints.[38] Three basic conditions brought to light by spectrality are: "the persistence of the past in the present"; "present

194 Cartography at Ground Level

absence" (encompassing a more spatial register); and the unrecognized alterity that contaminates all seemingly distilled essences.[39] All three are variously at play in *My Ghost*. The possessive title suggests that the spectrality in question resides in Wood's pathways, which figure forth past selves in the present and disperse his singular subjectivity across distant streets. Here, the image connects with another Derridean term that overlaps with spectrality: "the trace," which, in marking something absent, ruptures the immanence and plenitude of presence ascribed to existence in received metaphysical discourse.[40]

To suggest how this artwork queries the cartographic ontology of extended calculable space, I want to go beyond the idea that Wood's traces haunt the city. Instead, I will consider how the city haunts the map, before progressing, in the following section, to show how cartographies haunt the city. Urban streets might be said to be inherently spectral in that they consist of vacant spaces between buildings, which take on their own positive identity and form, like plaster filling gaps in a mold. *My Ghost* extends this hovering between being and nonbeing to the city at large. Far from presenting an urban texture of obdurate solidities, London figures as a spectral presence in that it comes to visibility only epiphenomenally, implied by the snaking shapes of Wood's isolated pathways. Indeed, though Wood's movements ostensibly constitute the map's sole subject matter, they are shadowed by the noticeable absence of the traversed city. Here, it is the manifold spaces and places of the city, in all their excess variety and unprocessed (unprocessable) specificity, that haunt the digital grids and data trails traced over them.

"The key conceptual feature of GPS," writes William Rankin, "is that it replaces lumpy, historical, human space with a globally uniform mathematical system."[41] This system, the WGS84 mentioned above, constitutes the *a priori* ground of much digital mapping, including the dominant Google applications. On one level, the metaphorics and aesthetic of spectrality in *My Ghost* might be taken to envision how calculable GPS are shadowed by manifold unregistered and unverified geographies they neither locate nor coordinate. As digital mapping applications entrench the ontology

of calculability through lifeworlds globally, it becomes shadowed by ever more geographical complexities that linger unregistered within its platonic graticular grid. In this way, *My Ghost* brings into focus the latency of what Deborah Dixon calls "extra-geographies"—those "other words that arise beyond the survey and the map."[42] Interpreting the image as a demonstration of how the WGS84 is haunted by unprocessed geographical excess suggests one way in which Wood's practices query GPS's representational powers.

The analysis of *Meridians* that follows reverses this formulation. In it, I want to stress not how the city haunts the map, but how locative media are themselves uncanny assemblages that shadow social reality. Locative media, as Ned Prutzer has argued, are uncanny in that they displace objects to an incongruous digital dimension; fail to firmly place signals, despite the appearance of accuracy; and shape lived geographies while scarcely being visible within them.[43] This identification of spectrality is especially challenging, since it undermines the orientation and existential security offered by GPS, which enrolls an infrastructure costing billions of dollars, as well as the rhetorics of mathematical, atomically-timed precision designed to reassure users as to where they are amid the otherwise disorienting, even frightening, forces of globalization. Martin and Rosello espy a "huge paradox" in a postmodern culture simultaneously riven by disorientation and uncertainty, and enthralled by the "hyper-orientation" realized through satellite visuality.[44] Much of the appeal of GPS and GIS derives, perhaps, from how they assuage the existential anxieties endemic to liquid modernity; this links up with my argument in chapter 1 that global cartographies establish meaning and order partly to cover over the frightening facticity of the disenchanted earth.

But what if the locating structures projected by digital mapping were perceived not as offering a reassuring grasp of geographical reality, but as themselves spectral? Present insofar as they are communicated and acted upon, sometimes even instantiated concretely, yet for all that largely notable for their absence in the offline world? What if the standards of reference through which spatialities are now pervasively determined were recognized as phantasmal projections that suffuse and direct social practice

Cartography at Ground Level

without ever being fully *there?* Wood's *Meridians* shows how adopting such a perspective would have a profoundly disorienting and dislocating effect. Turning a noun into a verb, I will argue that the image "ghosts" seemingly secure locative frameworks—that it loosens their appearance of saturated reality and renders them spectral by playing two discrepant geographical standards off against one another.

Meridians is a walking artwork performed discontinuously in central London over forty-four miles and three months in early 2005, the GPS trails of which have been matched with an aerial photograph of the area and exhibited as a long rectangular print (fig. 51).[45] Examining this image entails another (lesser) journey on the part of the viewer, who must travel along its 8.5-meter breadth to follow the artist's path. As I have noted, Wood's walk traces a quotation from *Moby Dick* on the landscape. Absorbed in the visual "noise" of the aerial photograph—arterial rail junctions, broccoli trees, shadows cast by inscrutable structures—or in picking out Melville's sentence from the disconnected sites of walking/writing, it is easy to overlook two millimeter-thin lines that run almost parallel to one another across the breadth of the image. And yet, for calculable cartographic space, these lines, the eponymous *Meridians*, have a significance that far outweighs the geographical complexities that surround and overshadow them.

Meridians are vertical "lines of longitude" in a graticular structure representing the earth; they intersect with horizontal "parallels" or "lines of latitude" to form a global grid. The lines figured in Wood's artwork are especially significant; each represents a *prime* meridian—that is, the one vertical chosen as the key standard in reference to which longitude (temporal and spatial distance to the east and west) is measured within a particular terrestrial model. A prime meridian marks 0° in a system comprising 360°. The higher of the pair in the artwork is the Greenwich Meridian posited in the Airy ellipsoid, the graticule constructed by the astronomer George Airy and internationally recognized by dominant states as the prime meridian at an 1884 conference in Washington DC. The institution of this meridian as prime represents a well-known instance of how political economy and imperial power impinge on the history of

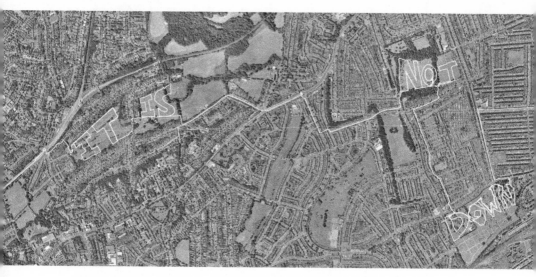

Fig. 51. Jeremy Wood. *Meridians*. 2005. Cotton print, 859 x 140 cm. Reproduced by permission of the artist. .

cartography, in that figurations of the earth were henceforth centered on the capital of the British Empire. The second, lower prime meridian in the image was established one hundred years after the Washington conference for the WGS84 reference system used in GPS.

These lines are the most important vectors in two mathematical globes that differ slightly but significantly from one another. Established after satellite geodesy replaced astronomically established longitudes in the twentieth century, the WGS84 belongs to a larger ellipsoid projection of the uneven terrestrial surface.[46] The result is an unnerving incongruity between points of reference that are widely assumed to coincide and often referred to interchangeably: GPS readings taken astride the Greenwich Meridian locate the user not at the great limen between East and West, but one hundred meters inside the Eastern hemisphere. This divergence is too small to make the different systems obvious, while still generating slippages, blind spots and dis- or unlocated places in an otherwise calculable geography.

Cartography at Ground Level

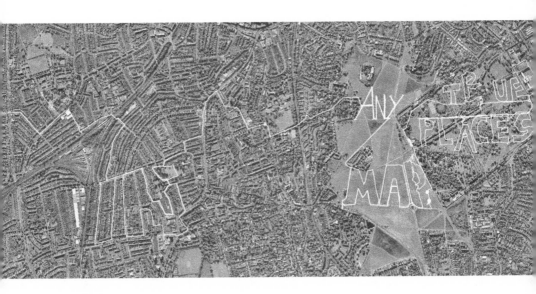

I argue that *Meridians* builds an unsettling image of how the funda-
mental standards that ground pervasive assumptions of locatedness are, in
fact, phantasmal projections masking our vulnerability amid globalization
and the world's basic contingency. To show how, my discussion will move
through the horizontality, doubling, and visual faintness of prime merid-
ians in the artwork, arguing that these gestures complicate the ontology
of calculability. Although my stress on mapping's ghostliness cuts against
the prevailing assumption that calculable space corresponds fully with
reality as such, I do not mean to imply that locative frameworks are merely
illusory deviations from reality proper. To be spectral is not to be unreal
or fanciful, but to hover at constructed thresholds separating absence and
presence, fact and fiction, life and death, visibility and invisibility. In keep-
ing with my wider argument about cartography's world-building power,
then, I want to insist, as Roberts has written, that "the ghost 'makes things
happen': it transforms."[47] Ultimately, the spectrality of the cartographic
ontology of calculability derives from how it pervades and determines

social practice while seeming to exist as a geometrical realm beyond messy lived geographies.

Meridians' first intervention in smoothly calculable space concerns the orientation of the two lines, the identity of which may surprise viewers who know that meridians are vertical: like gaps separating the pieces of an orange, they gore the globe before meeting at its poles. And yet Wood's lines run not top to bottom, but horizontally through the image. Although the whole artwork is oriented such that its topmost edge faces west, this would scarcely be noticeable in a large-scale aerial photograph did it not contradict the verticality basic to meridians. This orientation was probably chosen pragmatically, to ease the viewing of such an elongated print and allow space to walk the long quotation from Melville, but it has interpretive consequences. In contradicting maps' normative northward orientation, Wood's horizontal meridians are existentially disorienting. North is not upward; moreover, the very notion that there is an "upward" is exposed as a figment of the cultural imagination.

The contingency of longitude lines and other conventions on which digital calculable space is built is further emphasized by the doubling of

prime meridians in Wood's artwork. Primality denotes indivisibility and preeminence; to posit a *pair* of prime meridians within a single reference system is oxymoronic. In having two prime meridians bisecting London's landscape, *Meridians* dramatizes the plurality of mutually contradictory frames of reference and their common groundlessness. Both systems evoked in the artwork hold up their prime meridian as an absolute standard in space-time, and yet they unwittingly indicate, by their nonconvergence, the confected and contingent character of such standards. The two lines relativize one another.

This doubling and relativizing of cartographic standards fissures open an uncanny space in the otherwise uniformly coded global surface. "The two meridian lines," Wood writes, "are the edges of maps that don't meet up; between them are places that don't exist. Within this area of adjustment, the east-west hemispheres cannot be straddled."[48] Beyond juxtaposing discrepant standards to expose their common contingency, Wood also explores the physical sites of their divergence on foot. Traversing this crepuscular zone of contradictory placements, in which things are not where they are located, he exploits the incongruence between calculative frameworks. Here, people, places, and objects might subtly elude codings imposed by one locative system by identifying with the other, or even take on a renewed specificity as the two geodetic ellipsoids cancel each other out. This groundswell of geographical difference is prominent in *Meridians*, where the contradictory lines are overwhelmed visually by the photographed geographies. And, in a final turn of the screw, Wood writes/walks Ishmael's statement on cartography's essential falsity in this ontologically fraught gap between paradigms.

Given my stress on cartography's world-shaping agency throughout this book, I find the distinction between maps and extant places expressed in the quotation from Melville dubious—not to mention its rhetoric of authenticity. That said, the point I want to make here is that, by highlighting incongruences among different cartographic standards and between maps and the walkable world, *Meridians* opens up a zone riven by a spectrality of two distinct sorts. Ghostliness attaches, first, to the aforementioned

geographical specificities, which, though prominent in the aerial photograph, are filtered out by the quantitative calculative grids projected over them. Second, ghostliness attends the meridians themselves, which I take as synecdoches of calculative extension more generally. Here, locative frameworks are characterized by "noticeable absence": existent insofar as they are incessantly communicated and practiced, yet scarcely observable in the landscape they claim to grasp so exactly.[49]

The spectrality of cartographic standards and projections is reinforced, finally, in Wood's graphic presentation of the longitude lines, which are so easily missed on first viewing the artwork. Instead, the gaze is immediately drawn along Wood's meandering course into the alluring complexities of the aerial photograph. It is unsettling, then, to suddenly become aware that the landscape has been lanced through by implacably straight lines, which little belong to the city's uneven accretion below. Amid so much messy specificity, their Platonic rigidity suggests the unseen influence of a homogeneous geometry working beneath or behind this otherwise heterogeneous geography. The meridians are inconspicuous because of their minute width and coloration. Whereas Wood has chosen a slightly thicker white line to pick his pathways out from the surrounding landscape, the meridians are figured in pale green, as if for camouflage against the abundant foliage and river murk behind. The continuing sociohistorical importance of prime meridians, to which questions of "Where are we?" and "When are we?" are referred globally, goes unregistered in this lackluster presentation, where they command less attention than the wastelands or warehouses ranged around them. Indeed, while Wood's walking occasionally aligns itself with the meridians ("TRUE PLACES" has been traced above and below them as if guided by ruled paper), at others he simply writes across them, disregarding their bearing (fig. 52). So barely perceptible are the meridians as to set their being in doubt, especially against an aerial photograph that conjures the authority of indexical realism, however dubiously. Here, prime meridians are not the taken-for-granted universals of mainstream mapping, but phantasmal projections: flickering between absence and presence, their spectral grillwork encapsulates both the modern need to

Cartography at Ground Level

Fig. 52. Jeremy Wood. Detail of *Meridians*.

realize calculability and orientation amid contingency, and the arbitrariness of confected notions of locatedness.

Nigel Thrift asserts that the generalization of locative media has entrenched calculable forms of "address" so pervasively as to constitute a new "technological unconscious."[50] I have argued that *Meridians* "ghosts" the cartographic frames that are precognitively identified with reality. The three gestures of presenting traditionally vertical longitude lines horizontally, having two equally absolute prime meridians relativize one another, and reducing reference lines to faint tracings that are alien to lived geographies all combine to render the GPS ontology of calculable extension spectral and strange. Thus, the artwork not only queries the extent to which our being-in-space coincides with the global positions attributed to it in locative media. More fundamentally, *Meridians* asserts the arbitrariness of all such articulations of location, which play out as specters over a disjointed terrestrial surface in which they scarcely inhere.

Cartography at Ground Level

As social reality is rendered ever more calculable, Thrift argues that "getting lost will increasingly become a challenging and difficult task."[51] *Meridians* upends the terms of this statement, building an unsettling vision of how the framings and orientations articulated through locative media, though apparently certain, are ultimately groundless. Social existence may feel ubiquitously coded and channeled by locative media, yet we are adrift nonetheless—all the more completely for submitting ourselves to geospatial devices. Weaving between discrepant standards, Wood calls upon us not to rest securely in the phantom security of digital mapping. As Lauriault puts it, "We believe the instruments while really we are lost in space."[52]

This chapter has explored shifting relations among mapping, the street, and pedestrianism in Wood's mapping performances, contrasting them with the binary opposition between synoptic cartography and subversive walking in de Certeau's account of modern urbanism. I have argued that, in blurring cartographic drawing with grounded mobility, Wood expands formerly elevated and esoteric mapping practices to the people and places conjured by "the street." Blurring received hierarchies among maps and mappers, *My Ghost* accentuates how map art connects with contemporary shifts toward a distributed digital mapping culture and contributes to the "undisciplining of cartography."

Yet I have also cautioned that opening mapping to an enlarged socio-spatial field might further entrench the ontology of calculability inherited from institutional cartography. While Wood's mappings hold out no alternative to the GIS worldview of securely calculated locations, they do query and complicate it. In *Meridians*, seemingly solid and secure coordinated structures are rendered ghostly; despite prevailing rhetorics of precision and objectivity, figures of location and orientation are exposed as stray projections in a universe without essential bearings. Performing the absence and arbitrariness of locative grids in the midst of a culture that automatically assumes their reality, Wood's mappings provoke disorientation, even vertigo.

In the context of this book, *My Ghost* and *Meridians* rest on a knife's edge between expanding mapping to a broader social site, repeating an inherited ontology of coordinated global positions, and exposing slippages and

Cartography at Ground Level

pretensions in this ontology. In effect, Wood's work stands poised *between* mapping paradigms. A fuller transformation of established cartography would not only quantitatively expand and query its assumptions, but unfold a qualitatively different determination of geography. To provide a counterpoint to the expansion of mapping to the street and the "ghosting" of calculable space seen in Wood, in the final chapter I turn to Greenaway's *A Walk Through H*. This film, I argue, goes beyond querying calculable space to articulate a wholly ulterior determination of geography in its own right.

Fig. 53. Peter Greenaway. Antilipe. Detail of *A Walk Through H*. 1978.

6 Another *Chorein*

Alternative Ontologies in
Peter Greenaway's *A Walk Through H*

Each chapter of this study has thematized aspects of what I have termed the "ontology of calculability." This constitutively modern casting of geography grasps the world as a singular, measurable, and monochronous extension, allowing diverse terrains to be quantified, rendered legible, and thereby purposefully remade. Through an analysis of Jeremy Wood's artistic GPS mappings, the previous chapter explored how cartography's excluded social others are "taking back the map" from professional institutions under the conditions of contemporary digitization. I also stressed, however, how the emergence of a more distributed digital mapping culture does not displace the ontological presumptions that have long underpinned rhetorics of science and specialism in cartography. In this concluding chapter, then, I want to both reflect back on the vision of modern calculable space built up over previous case studies and gesture beyond it. Specifically, I want to suggest how map art, beyond reclaiming mapping practice from institutional control, might also transcend the ontology of calculability and articulate geographical reality in fundamentally different ways.

To explore these ontological ramifications of map art, I shall return to the film that first piqued my interest in the field, drew me to see its director perform as a video jockey, remixing and projecting his footage live, in the Netherlands (where I now live), and incited me to write this study. *A Walk Through H: The Reincarnation of an Ornithologist* was written and directed by the British artist and filmmaker Peter Greenaway. The film is forty-one minutes long, was funded by the British Film Institute, and released in 1978. Its narrative relates the posthumous travels and travails of an unnamed orni-

thologist on his journey into the afterlife, which is represented in ninety-two maps. Almost all of the film's footage focuses on these cartographies, which depict diverse imagined worlds. Before describing *A Walk Through H* in detail, I want to convey why I was so taken by the film. Drawn into the fantastic terrains Greenaway sets forth, I was struck by the sheer strangeness of this mapping practice in relation to cartography as I had known it. Through the film's fluid, rich, and explicitly creative cartographies, I came to reflect on how prevailing conceptions of geographical space, despite their being taken for granted in contemporary culture, are neither natural nor neutral. *A Walk Through H*, in other words, relativized my sense of geography's ontology. I do not mean by this that Greenaway imagines specific spaces that differed radically from those familiar to me (though he does)—ontology, after all, refers not to what exists but instead to *how* what exists exists. It indicates the general mode in and through which particular beings become present and intelligible. What the obscure mapping practice presented in the film brought home for me, then, was how the underlying grasp of "space" through which modern cultures apprehend specific sites is a contingent construction, one of many historically and culturally relative ways in which the world has been grasped, represented, and related to. Other, very different castings of geography became possible. And mapping—that practice through which cultural worldviews are concentrated, codified, and articulated graphically—seemed the place to search these "other ontologies" out.

For me, the constructedness and relativity of geographical ontologies remains the most challenging and fertile idea explored by map artists. Although this theme has been taken up in geographical theory, approaching the topic through map art brings into focus how historical ontologies are not transcendent abstractions, but constructed and contested aesthetically, through concrete forms and mediations.[1] Through writing this study, I have found that cartography has been bound up historically with one geographical ontology in particular—the ontology of calculability. In disclosing the world as a measurable, malleable, and monochronous extension without inherent meaning, this casting of existence encapsulates what is meant by "modernity" or "modern conditions." Previous chapters have focused on map artworks

Another *Chorein*

that explore (and critically contest) aspects of this ontology—namely, its disenchantment, legibility, simultaneity, divisibility, and objectivity. Notwithstanding this sustained emphasis on cartography's historical entwinement with modern calculable space, mapping is not bound essentially to this one delineation of being. Indeed, this chapter concludes my study of map art with Greenaway's film *A Walk Through H* because it gestures toward an alternative ontology: a shifting, multiple, and performative casting of geography that cuts against reigning conceptions of calculable space.

In demonstrating this, I will take up the argument begun in the previous chapter, in which Wood's walking performances are presented as enacting cartography's expansion beyond scientific and institutional domains, but without quite transcending the coordinated space assumed by GPS. *A Walk Through H* can be seen as going beyond Wood's challenge to institutional cartography in that, beyond reclaiming mapping from disciplinary control, it also displaces the ontological assumptions that legitimated that control in the first place. Presenting Greenaway's 1978 film as furthering Wood's contemporary mapping projects, I realize, entails breaking with linear chronology. Tracking three decades back from Wood's *My Ghost* and *Meridians* to explore *A Walk Through H* in this way has several advantages. By putting otherwise disparate map artists in dialogue with one another, returning to Greenaway's film underlines how alternative mapping practices neither reduce to, nor depend on, cartography's digital transition.

To show how *A Walk Through H* unfolds an alternative grasp of geography to that disclosed through the ontology of calculability, the remainder of the chapter is structured as follows. After describing the aesthetic and narrative complexities of Greenaway's film, my discussion invokes the ancient Greek word *chora*, or, rather, Bernhard Siegert's contemporary reworking of it as a verb, *chorein*. *Chorein* denotes the articulation of historical ontologies in specific technical media, including maps. It is the manifestation, in concrete objects and practices, of a particular culture's grasp of what geography is and means. The term's contemporary significance lies in how it gets away from the pervasive, taken-for-granted concept of "space." In writing this, I recognize that numerous geographical studies have drawn attention to counter-

hegemonic spaces and spatialities, and I do not mean to contest their value. I would suggest, however, that where these analyses point to conceptions of geography that differ fundamentally from the dominant modern notion of "space"—which, for me, implies objectivity, uniformity, and calculability—then these conceptions warrant their own distinct terms, thus avoiding their reduction to prevailing categories. The notion of chorein opens up the possibility of alternative geographical vocabularies, beyond or ulterior to "space" and its associations with objectivity and calculability. Through a close analysis of *A Walk Through H*, I describe how the chorein performed in Greenaway's film deviates markedly from the ontology of calculability—not least because the latter is premised on separating supposedly scientific cartographies from the plurality, partiality, and creativity attributed to art. Whereas the prevailing ontology assumes the world's singularity, objective existence, and uniform calculability, I show how Greenaway's chorein sets up shifting infungible geographies, whose multiplicity cannot be brought under a common measure. Crucially for my argument, *A Walk Through H* develops an eminently performative understanding of mapping. If historically maps have largely been conceived of as epiphenomenal representations meant to correspond with a singular reality that preexists them, in Greenaway's film they are progressively seen to produce and perform multiple geographies. This displacement of representational correspondence as cartography's essential function, I claim, annuls the ontological basis upon which institutional cartography has claimed special authority in mapping.

In emphasizing the ontological performativity at the core of the film's chorein, I do not mean to present Greenaway as a singular genius who, through concentrated individual imagination, leaps free of the inherited ontological assumptions in which cultural discourses at large remain enmeshed. Many other map artists also deviated from extended measurable space, whether through heterogeneous graphic procedures (think of Qiu Zhijie's multiform globes and landscapes) or place-based experiential encounters (think of Philip Hughes's layered landscapes). What is more, *A Walk Through H* also participates in a much wider critical reconsideration of cartography, as my close discussion of the film will show. Greenaway does

Another *Chorein*

not conjure a new ontology out of the ether, then, but focuses accumulating artistic and theoretical reconsiderations of cartography into a sustained alternative imagination of what mapping is, means, and might become. This is what warrants my extended analysis of the film in concluding this study. For in projecting "another chorein"—an articulation of the world in which essentialized distinctions between art and science, reality and representation, have no purchase—*A Walk Through H* throws into relief the ontology of calculable extension that Nikritin, Hildreth, Kocken, Matoba, and Wood have each explored and tested in different ways.

Journeying through Maps

A Walk Through H: The Reincarnation of an Ornithologist is comprised almost exclusively of maps of imagined terrains painted and collaged by Greenaway himself, who was trained in visual art and has long exhibited painting alongside his filmmaking activity. Nearly every shot shows the camera crabbing or booming closely across the surface of map after map, some drawn in pencil and pastel, others in pen and ink; some laid out straightly with a ruler, others built up out of blotched fabrics or encrusted paint; some framed totalities, others fragments imprinted on the unlikely substrates of a shirt collar, sandpaper, or letters. The maps are neither geometrically arranged and consistently realized cartographies nor do they result from simple formal free play. The overall impression is of rationalistically conceived graphics that have ramified outward into vibrant new geographies, or else decomposed back into some pre- or nongeometrical cauldron of elements that consumes their previous purity. Greenaway elaborates on geometrical cartographies in fantastic digressions; mechanically reproducible graphics are rendered unique through tears or stains (even bloodstains, in one case), while the rigorous clarity of scientific mappings has been sullied by incongruous decontextualizations or unanticipated layers of lettering and pigment, which relativize and multiply meanings through adventitious additions.

The ninety-two maps presented in the film could stand in their own right as a body of conventionally static artworks. Many have been exhibited as

such, notably in a 2003 show named *The Map is Not the Territory iii*, in which Greenaway's maps hung alongside Matoba's *Shores of a River* and *Utopia*, examined in chapter 4. Indeed, the film opens with the maps displayed in a small, apparently first-floor gallery, the camera tracking along walls on which the maps are framed and numbered. But although they are self-sufficient as visual artworks, in *A Walk Through H* the maps immediately become involved in a first-person narrative conveyed through a voiceover. Read in deadpan, faux documentary style by actor Colin Cantlie, it relates the largely posthumous travels and travails of an unnamed ornithologist, who has succumbed to an unspecified sickness. Having "finally left" for the afterlife "on the Tuesday morning early at about a quarter to two" the ornithologist travels toward "H," his ambiguous destination. In interviews, Greenaway has suggested that H might signal heaven or hell, although the titular reference to reincarnation implies that H might also represent a new life.[2] The narration tells of how the ornithologist's journey is hindered by a rival, Van Hoyten the bird counter, and guided by Tulse Luper, a map collector and the ornithologist's arcane mentor, who counsels him that "the time to decide what H stood for was at the end of the journey, and by that time it scarcely mattered." The route passes through numerous fictional waypoints, cities, and landscapes, which increasingly deviate from what, conventionally, would be designated geography. To get a sense of these varied terrains, the strangeness of which is rendered humorous by Cantlie's flat narration, consider some of what the protagonist encounters: Hestergard, the "first measuring place," after which it is "impossible to go back"; Canterlupis; Hesgadin, a city "in two parts, both of them silent"; Manephia; Balladrome; Dormis, "a sedate place"; two unnamed cities, one of which "reminded me of a seaport, though it was far from the sea"; Antilipe (fig. 53), as distinct from the Syrian town of the same name; Contorpis; not Anascol (which the narrator discovers does not exist); a path traced in the blood—"type A"—of a woman who "said her name was Correlegiano"; a "playing field marked out for an abandoned game and scattered with obstacles that made the game unplayable"; the "Owl Gate," which passes into the Amsterdam Map; a maze, drawn by an inspector of mazes; a territory inscribed on yel-

low hospital paper by a radiologist "suffering from too much exposure to the X-ray machine"; "a lonely road"; "the floor plan of a gallery"; southeast Australia; "the plumage of a Red-legged Partridge"; several dry riverbeds; and, lastly, as the ornithologist approaches H, a series of paths taken first by sheep, the wind, and finally the routes of shadows made by flying birds.

This geographical voyage from deathbed to H is complexly entwined with two other narrative threads. One is the protagonist's struggle in life to gather the maps required for his upcoming passage beyond it. Tracking over diverse mappings, we hear how the ornithologist bought, stole, inherited, traded, or simply stumbled across the necessary cartographies, receiving some as presents, others anonymously—all under the often cajoling, sometimes stern steersmanship of Tulse Luper. This plot, which gathers momentum as the ornithologist's "last illness" sets in, spills into a third narrative strand: the antagonism between the ornithologist and Van Hoyten. The two never meet face to face, yet they persistently obstruct one another's projects, the ornithologist sabotaging Van Hoyten's bird counting by clouding the sky with wood fires, Van Hoyten usurping the ornithologist's position as keeper of the owls at the Amsterdam Zoo. Yet it is in Van Hoyten's office that the ornithologist discovers—and purloins—"perhaps the most significant map" for his journey: the Amsterdam Map, which I discuss below.

The configuration of time built through these interlocking plots is shifting and multiple: these too are polychronous mappings. The vagaries of gathering maps and the battle with Van Hoyten would seem to occur during the ornithologist's lifetime, while the voyage with and through the maps appears to commence only with his death. Nevertheless, as the film progresses, temporal linearity—in which map collection precedes map use and life precedes death—is replaced by the overlapping of mutually shaping temporal orders. Interleaving three narrative strands, the film suggests that the ornithologist's conflict with Van Hoyten seems to impact his journey through the maps, while the fraught process of tracing and pilfering obscure cartographies directly expands and forecloses the terrains available to the posthumous itinerant. Despite this rhizomatic polychrony, the walk through (or is it to?) H increasingly becomes the predominant narrative

thread. However frustrated the ornithologist's journey, whether because of Van Hoyten's schemes or stranger interruptions, like the maps' tendency to fade upon traversal, the momentum of travel builds implacably through the film's final third. In large part, this is down to the musical score, which was written by Michael Nyman (an important minimalist composer who was Greenaway's close collaborator until 1991, when they parted ways during the production of *Prospero's Books*) and performed by the Campiello Band. Greenaway has long argued that the predominance of dramatic narrative in conventional cinema subordinates film's potentialities to those inherited from literature, proposing music as an alternative means of structuring film. Music plays a leading role in *A Walk Through H*, then: a rare example of a soundtrack devised specifically to accompany map reading. In rapid structural repetitions, which occasionally break off into wavering, sometimes discordant digressions, the music cues speedy travel or marks out adversity and disoriented wandering, before returning to the shunting repetitions that hurtle the ornithologist through barer and barer maps on the approach to H.[3] Finally, the ornithologist reaches his destination: "I had arrived. It was Tuesday morning early at about a quarter to two." This is exactly when he departed—the journey through H, though arduous and thick with incident, has occupied no time at all in the living world.

Two prominent aspects of the film warrant attention here. First is the allegory of birds and flight. Accompanied by the ornithologist's outlandish but internally consistent narrative, Greenaway's distinctive cartographies would form a sealed totality—a universe unto itself—were it not that the film has been intercut with footage of various birds—from owls to ostriches. Beyond relieving the closure of the maps, these shots connect with the characters' ornithological pursuits, as do numerous other references to avian flight, the film's core metaphor. Here, Greenaway's biography is relevant: his father, an amateur ornithologist, died shortly before *A Walk Through H* was made. On this basis, the birds and their migration can be understood as surrogates for spiritual travel through and beyond life. This reading is supported by the fact that, once the ornithologist has reached H, the camera pulls back from the final map and settles on a copy of Tulse Luper's book. Its cover

Another *Chorein*

Fig. 54. Peter Greenaway. Windmills or signposts. Detail of *A Walk Through H.* 1978.

displays a title, *Some Migratory Birds of the Northern Hemisphere*, and boasts 92 maps and 1,418 birds in color (matching the narrator's tally of 1,418 miles covered in reaching H), leaving the audience with a closing image of the ornithologist's spiritual journey into heaven or hell as an avian migration through diverse cartographies. Crucial in grasping the film's thematic unity, the idea that maps and migrating birds stand in for the soul's traversal of an obscure hereafter also becomes important in my argument—not for its biographical or theological substance, but because exploring the "undiscovered country" of the afterlife allows Greenaway to imaginatively map a parallel reality with a logic and spatiality all its own. For the insistently atheist Greenaway, notions of the hereafter have no mandated content (its indeterminacy is emphasized by the abbreviation "H"). The afterlife, H, is a blankness or nonentity on which his film projects an imagined spatiality: a metaphysical *terra incognita* to be mapped in ways that need not conform to the calculable world articulated in most cartographies.

Another *Chorein* 215

Second is a recurrent visual motif: a vertical line intersected by two crossed slats (fig. 54). The narrator first draws attention to this sign in a map inherited from his aunt, which faded, leaving only "a mark that could have been a signpost or the skeleton of a windmill." These signs appear throughout the film—one sector of The Amsterdam Map is littered with them. Following this reference to Amsterdam, the windmill-cipher seems bound up with Greenaway's more general fascination with Dutch culture and painting.[4] The more obvious interpretation, though, follows the suggestion that this is a signpost directing the ornithological wayfarer through H. Indeed, as the narrator nears H, the maps increasingly distill into faint scraps and traces punctuated by this motif of a signpost. Construed through my concern with differing ontologies in this chapter, however, the ciphers can also be taken to signal a deviant spatiality to that unfolded through the maps in which they are embedded. As erect signposts or windmills they recall another film that Greenaway made in the same year, the satirical *Vertical Features Remake* (1978), in which the fictional Institute of Reclamation and Restoration strives to capture the essence of the English landscape cinematically by attending to its vertical features. Viewed as an emblem for the embodied spatiality of landscape experience, in which viewers stand amid surrounding verticals, these windmills or signposts obliquely counter the elevated gaze built through maps, which collapse verticals into a legible text laid out below the viewer.

This plurality of spatialities in the maps is significant in exploring how *A Walk Through H* unfolds an ontology that diverges from calculable cartographic extension. Before reading this theme closely through the film, though, I will situate *A Walk Through H* within the theoretical reflections on truth and representation offered in Greenaway's wider work, which will feed into the ontological reading staged in this chapter.

Greenaway, Modern Ocularcentrism, and Cartography's Chorein

Many critical accounts position Greenaway's *oeuvre* as exemplary of postmodern cinema, if not postmodern culture more generally.[5] Certainly, many themes and strategies associated with postmodernism can be traced through

his work, in the skepticism and irony he directs toward modernist asser-
tions of truth as correctness or essence; his persistent restaging of historical
cultural forms, especially from the seventeenth century, in the present; his
merging of influences derived from both "high" and "low" cultural fields;
and his omnivorous intertextual poaching. Although Greenaway's films
came to prominence at a time when modernist and postmodernist positions
were often distinguished quite sharply, these divisions have since largely
evaporated and been replaced by more nuanced theories submitting to
neither modernist certainty nor postmodern relativity.

Yet Greenaway's typically postmodernist preoccupations remain signif-
icant for this chapter, for they give rise to his intensely skeptical attitude
toward the positivist ontology of calculability. Indeed, in line with what I
have argued throughout this study, cartography is important in the context
of Greenaway's "fundamentally postmodern sensibility" in that it figures
a totalizing device through which modern cultures have sought to grasp
and remake geographical reality. Maps exemplify a wider cluster of tools
and techniques of the modern ocularcentrism that Greenaway's films per-
sistently thematize, parody, but also celebrate.[6] The maps of *A Walk Through
H* should be understood, then, in tandem with the perspectival framing
apparatus enrolled in *The Draughtsman's Contract* (1982); the grids and
cameras through which the twin zoologists of *A Zed & Two Noughts* (1985)
measure organic decay; and the twenty four encyclopedic volumes that
allow the Baconian conjurer of *Prospero's Books* (1991) to comprehensively
grasp and control his world; not to mention the lists, tables, and charts that
populate Greenaway's early films. *A Walk Through H*'s cartographies can
therefore be positioned as part of a wider exploration of the visual drive to
discern order, dispel illusion, and establish meaning in a contingent uni-
verse. In their quixotic impulse to "fix a path made by the wind, or a path
made across the grass by the shadow of flying birds," the maps evoke, as
Elliott and Purdy eloquently put it, "the pathos of human failure to contain
and circumscribe the natural world in cultural codes and scientific systems."[7]

This stress on the relativity and hubris of modern knowledge systems is
echoed in most critical writing on the film. Human attempts to establish

meaning and order, writes Alan Woods, are "always linked to absurdity and human vanity" in Greenaway's work, which foregrounds "their arbitrary and whimsical nature."[8] In mimicking the procedures, exaggerating the inner logic, and forcing the contradictions of modern knowledge techniques, suggest Paula Willoquet-Maricondi and Mary Aleman-Galway, Greenaway "puts all constructions of reality into question."[9] Undeniably, these statements capture a dominant thematic strand in Greenaway's work, and an important aspect of *A Walk Through H* in particular. This is borne out by the artist's own comments on the film: "Maps and catalogues and systems fascinate me," he writes. "They are all attempts to classify chaos. They try to demonstrate that there is an order and an objectivity in the world. . . . My starting idea for *A Walk Through H* came when I found a collection of Ordnance Survey maps that had mistakes . . . Here we are, it seemed, trying to define and circumscribe nature, and it's as if nature were sabotaging or satirising our attempts."[10] Yet despite Greenaway's explicit focus on the arbitrariness of modern truth constructions, as embodied in maps, I do not think that this is where the originality of *A Walk Through H* lies. The reason I turn to the film here is not because it foregrounds the partiality and artificiality of cartographic visions; I have explored that theme throughout this study, from the inscrutable, unyielding facticity of Nikritin's bare globe to the clashing double standards of Wood's *Meridians*. More significantly, in stressing the limitations and hubris of cartographically representing an ungraspable "nature," Greenaway's ostensibly postmodernist film scarcely deviates from the epistemology of modern mapping practice. Stressing cartography's failure to match up with its geographical objects, even interminably so, subtly perpetuates the inherited conception of cartography as a representation distanced from a surrounding reality that it struggles to capture graphically. This strand of the film, in other words, amounts to little more than a pessimistic recasting of modernist representationalism, in which the map fails to grasp the territories with regard to which it is still little more than an epiphenomenal mimetic construction.

Instead, my argument espies a more challenging approach to mapping in *A Walk Through H*, which both coexists with Greenaway's pessimistic

Another *Chorein*

representationalism and gestures beyond it. This aspect of the film, I argue, reverses the assumed relations between maps and geographies, setting forth an imaginative ontology in which rich realities are performed through mapping practices that are neither hierarchized as "artistic" or "scientific," nor separated out as mere representations of objective, preexisting realities. Instead, categories of art and science merge in the common project of building fantastic cultural worlds. In presenting this vision, *A Walk Through H* not only anticipates several subsequent developments in mapping theory. Crucially for my claims in closing this study, it also holds out a reimagined cartographic ontology—a determination of how geography *is*, and of mapping's role in articulating this mode of existence—that breaks away from prevailing notions of objective calculable space. Indeed, notwithstanding the apparent marginality of *A Walk Through H*, which Greenaway counts among his "juvenilia," when assessed with respect to the historical continuity of modern calculable space the film takes on a greater significance. I argue that Greenaway's mappings construct an alternative ontology to that which has prevailed in modernity, thereby fulfilling a transition between paradigms that was enacted only incompletely in Wood's *My Ghost* and *Meridians*.

How to capture the vivid, fluid, and multiple ontology unfolded through *A Walk Through H*? Certainly not through reference to "space," however experimentally conceived, for my argument is precisely that Greenaway's film diverges from the identification of the world with objectively measurable extension. This distance from established notions of space indicates a peculiar difficulty in grasping Greenaway's alternative ontology, in that any new or other articulation of reality, cartographic or otherwise, necessarily falls outside the vocabulary available to describe it within the prevailing horizon of intelligibility. To avoid reducing Greenaway's obscure and peripheral ontology to received understandings of space, the terminology I use to explore it here is correspondingly oblique. I am referring to the term *chora* (also spelled *khôra*). Originally an ancient Greek noun (χώρα), which has been translated as the "land surrounding" a *polis*, chora has been taken up by numerous modern philosophers, not least Martin Heidegger and

Jacques Derrida, for whom it signaled the ontological spacing or disclosure within which particular beings "take place." In doing so, they build on Plato's *Timaeus*, in which chora is defined as that which "provides a fixed site for all things that come to be."[11] Chora offers a suitably unfamiliar foil to taken-for-granted conceptions of "space," since, as Heidegger makes clear: "The Greeks had no word for "space." This is no accident, for they experienced the spatial on the basis not of place (*topos*); they experienced it as chora, which signifies neither space nor place but that which is occupied by what stands there. The place belongs to the thing itself."[12] Understood, in this way, as the situated disclosure within which particular beings come to presence, chora has the value of relativizing long-naturalized intuitions of space as objective extension, independent of the beings that pass through it. This is perhaps most explicit in Julia Kristeva's argument that the chora, as an "essentially mobile and extremely provisional" articulation of the world, precedes "a disposition that already depends on representation, lends itself to phenomenological, spatial intuition, and gives rise to geometry."[13]

However, this in itself is insufficient to grasp the ontological dimensions of *A Walk Through H*. Heidegger, like Foucault after him, argues that empirical knowledge of particular beings, such as the geographies represented by maps, constitute "ontic" knowledge (Foucault calls this *connaissance*), whereas the "ontological" signals the more fundamental ways in which particular beings are able to appear within a particular historical horizon of intelligibility (*savoir* in Foucault). Put reductively, the ontic refers to the "what" of existence—specific entities and their attributes—while the ontological denotes the "how" of existence—the culturally plural modes in which it is possible for things to exist, preconditioning particular "ontic" experiences. Greek chora belongs to this second, ontological category, in that it discloses possible ways in which things can be present and intelligible. However, I find the distinction between the ontic and the ontological that lies behind Heidegger's thinking of chora problematic when considering cartography, since it positions maps as all-too-specific objects and tracings that are secondary to a prior, ultimately mysterious ontological revelation of Being that precedes and conditions them.[14] Moreover, returning to an

ancient Greek concept for an alternative to the modern determination of space risks building a characteristically "Western" genealogy of historical ontologies, of which Greenaway's film contains little suggestion.

The media theorist Bernhard Siegert has negotiated both of these reservations. Elaborating a theory of pervasive "cultural techniques" through which reality is articulated, Siegert collapses Heidegger's division between ontology and the ontic: "The concept of cultural techniques clearly and unequivocally repudiates the ontology of philosophical concepts. Humans *as such* do not exist independently of cultural techniques of hominization, time *as such* does not exist independently of cultural techniques of time measurement, and space *as such* does not exist independently of cultural techniques of spatial control. This does not mean that the theory of cultural techniques is anti-ontological; rather, it moves ontology into the domain of ontic operations."[15] In this revision of ontological thought, the ontology through which a culture grasps existence is instantiated in and through ostensibly ontic practices, including forms of mapping. Against this backdrop, Siegert invokes the chora. He begins with Sophocles's *Antigone*, in which chora figures as chorein, the verb form, meaning "to make place," "give room," and "traverse successfully." Building on the polyvalent Greek, Siegert defines *chorein* as an "act of setting up space [*sic*], which precedes place and founds the capability-to-be-at-a-place."[16] Though I would qualify this definition by insisting that *space* as extension—as Siegert himself recognizes—represents but one possible casting of geography, it has several methodological merits.[17] Not only does it ground the disclosure of otherwise portentous and mysterious ontologies in specific, "ontic" mediations like maps, with traceable media histories; it also extrapolates creatively from the Greek, opening the notion of chorein up for use in other historical moments. Rather than referring various ontologies back to some foundational Hellenistic chora, the obscurity and contested legacies of which have been emphasized by Stuart Elden, Siegert wields the term widely, tracking the technical determination of geographies in diverse contexts, beyond constructed lineages leading back to Greek roots.[18] As his central example of chorein thus defined, Siegert foregrounds the particular grasp

of "the sea" that emerged in the United Provinces of the Netherlands as it fought for independence and built a global trading empire in the seventeenth century. Through the spread of representational techniques such as annotated water-level coast panoramas in print pamphlets, maritime space was increasingly articulated as a navigable and open space of commercial enterprise and imperial possibility.[19]

This version of chorein conjugates closely with what I termed mapping's "ontological performativity" in chapter 3, yet the phonetic obscurity of the Greek has the further value, in this chapter, of relativizing "space" as only one among many ways of naming (and conceiving) geography. It is in terms of this methodological rethinking of chorein that I see Greenaway's film as moving beyond the previous case studies discussed in this book. Phrased in Siegert's terms, each of the artworks I have examined has explored and challenged the prevailing cartographic chorein of calculability, through which world has been articulated as a measurable, monochronous, and malleable extension. *A Walk Through H* offers a counter- or alternative chorein, unfolded in and through the technical media of painted maps, moving film cameras, and recorded narration. This chorein differs from the received ontology of calculability in three crucial respects. First, the separation of maps from the geographies they are conventionally taken to represent is annulled: in the world of *A Walk Through H*, maps do not reflect or represent geographical reality, but make it. This is bound up, second, with a dissolution of the art/science distinction, which no longer divides mappings as more or less "correct" or "incorrect" representations. Third, these two facets condition a profoundly performative ontology, in which rich fantastic geographies are enacted through multiple mapping performances, none of which are isolated as scientifically authoritative and objectively binding.

The following sections undertake a detailed analysis of key moments in Greenaway's cinematic mappings, focusing on how these three gestures combine to form a chorein in which maps no longer mimetically measure a reality that preexists them, but rather build and perform a rich multiplicity of geographies.

Another *Chorein*

Creating Territories as You Walk Through Them

A key theoretical statement on the nature of cartography in *A Walk Through H* comes in a single sentence, which asserts the performative agency of mapping significantly in advance of critical scholarship: "Perhaps the country only existed in its maps, in which case the traveller created the territory as he walked through it." In suggesting the theoretical importance of this line for the film's alternative vision of mapping, however, I do not mean to overlook Siegert's crucial emphasis on how a chorein should specifically *not* be understood as an abstract, theoretical casting of existence that precedes specific encounters with and mediations of the world. As I have explained, in Siegert's theory chorein rather means the articulation of a historical ontology in specific cultural mediations. Accordingly, it is worth indicating now that the next section will go on to examine how Greenaway's performative grasp of mapping is manifested aesthetically through the medium of film. If the film's chorein is encapsulated verbally in the sentence I unpack here, it is primarily articulated in and through the ninety-two filmed maps, which differ qualitatively from the chorein of calculable and representational cartography.

Over the course of *A Walk Through H*, the maps used by the narrator in his eccentric expedition into the afterlife become progressively less representational and more performative. There are statements, especially toward the beginning of the film, that suggest the cartographies are being used conventionally to navigate external terrains. At one point the itinerant ornithologist says he "left the territory it [a map] represented without regret. It smelled of guano." At another, he becomes lost and slowly meanders as narrative momentum dips, implying that his map fails to adequately depict an effective path: "On the map I continued to follow what I thought might be a sensible route. If there had been cardinal points I was walking North, South, East, and West indiscriminately, and I kept coming across the same places and the same events. I slowed my pace, knowing that I was lost." Nothing here contradicts the conventional notion that maps represent a geography that precedes them, and in this case eludes their mimetic grasp.

Yet the reasons for the ornithologist's disorientation become increasingly peculiar. Although all maps eventually become redundant in relation to the geographies they figure forth, this process is accelerated metaphysically in the universe of *A Walk Through H*, in which maps fade rapidly during use, leaving only ambiguous traces. One map "began to fade before I had crossed two thirds on the territory it represented," as a result of which the ornithologist "hurried till I was sure that I had reached the territory of the next map." Although the narrator rushes, here, to navigate terrains before his guiding representation fades, this seems less and less the cause for his flight. Notice how, when running through the next fading map, the traveler refers not to crossing the terrain it represents, but only to "a third of its territory," as if the land is bound up directly in the figuration. The next map fades "as I reached its furthest edge." By this point, reference to a represented terrain has dropped away entirely, replaced by the bordered graphic space manifested by the maps themselves. Indeed, the film presents the viewer with footage of neither the terrains being traversed, nor scenes of map reading: only map after fading map appears. The camera's travel along the maps replaces the ornithologist's travel through the terrain, steadily building the impression that no represented geography exists outside these cartographies, only the worlds that they themselves materialize and unfold.

This is confirmed by the ornithologist's own dawning suspicion that not only are his maps and the terrain one and the same thing, but that maps (or rather using maps) actively make reality: "Perhaps it was not impossible that other travelers had different maps of this territory, simpler and more straightforward maps. Perhaps the country only existed in its maps, in which case the traveler created the territory as he walked through it. If he should stand still, so would the landscape." Here, the narrator suggests the performativity of mapping: the idea that maps are not just epiphenomenal representations of reality, but shape and even constitute it. Admittedly, this thought remains undeveloped in the film, and the narrative swiftly resumes ("I kept moving" is the very next line). Yet the idea that maps make or indeed *are* the terrains they appear to represent encapsulates, theoretically, the larger vision unfurled aesthetically in *A Walk Through H*, in which

mappings manifest rich worlds that do not seem to exist independently of them. The film is pervaded by a sense of the world as a map that has been enacted and materialized, and of the map as a basis or paradigm for not only a cultural worldview, but physical geography itself. The idea that a terrain exists only in and through maps not only sums up the character of Greenaway's chorein; as I will show at the end of this section, it also fundamentally contradicts the ontology that has justified rhetorics of objectivity and professionalism in cartography.

Before doing this, though, I want to frame the ornithologist's idea that geographies exist only in maps in relation to two contemporaneous writings, which help to situate, unpack, and underline the significance of its view of mapping. The first is by the Argentinian writer Jorges Luis Borges, the second by the French philosopher Jean Baudrillard. Greenaway has repeatedly named Borges as an intellectual influence, especially on his early filmmaking. Borges turns to the theme of mapping in several writings and is frequently cited in discussions around cartography in cultural theory, not to mention in several accounts of map art. Notably, there is the vertiginous map-within-a-map staged in the essay "Partial Magic in the Quixote," and—most pertinent in this discussion—the maps made at increasingly large scales in the short story "On Exactitude in Science."[20] Although first written in 1948, this fiction was published in English in 1970 as part of the collection *A Universal History of Infamy*, as Greenaway's independent filmmaking was gathering pace. In its faux factual presentation, concern with obscure systems of reference and representation, arcane ironies, and playful blurring of fiction with reality, the tone of *A Walk Through H* is thoroughly Borgesian. The ornithologist's remark that "the country only existed in its maps" chimes with "On Exactitude in Science" especially closely. Borges's story, which is introduced as the fragment of an early modern travelogue, parodies notions of representational correctness and correspondence. One might call it a fable illustrating the folly of giving mimesis free rein. The fragment reports on an Empire in which mapmaking became so developed, and maps so large and meticulous, as to produce a cartography coextensive with the Empire it was made to depict. This vision resembles Greenaway's in that it brings map and

territory closely together, which Borges does to parody the self-defeating impulse toward complete representation.[21] However, the story does not take the further step of conflating or switching the two categories. The map "coincided point for point" with the territory, but map and territory remain distinct. The secondariness of Borges's quixotic cartography is underlined by the fact that it is abandoned by the next political generation, which little values cartography: "In the Deserts of the West, still today, there are Tattered Ruins of that Map, inhabited by Animals and Beggars."

As is well known, the philosopher Jean Baudrillard repurposes "On Exactitude in Science" for his own ends in *Simulation and Simulacra*. The book opens by recapitulating Borges's story as a beautiful but quaint fable parodying the "discrete charm" of representation—quaint because, for Baudrillard, the reality/representation distinction has been progressively collapsed as pervasive representations reconstitute reality. A fundamental revision is therefore proposed:

> The territory no longer precedes the map, nor does it survive it. It is nevertheless the map that precedes the territory—precession of simulacra—that engenders the territory, and if one must return to the fable, today it is the territory whose shreds slowly rot across the extent of the map. It is the real, and not the map, whose vestiges persist here and there in the deserts that are no longer those of the Empire, but ours. . . . But it is no longer a question of either maps or territories. Something has disappeared: the sovereign difference, between one and the other, that constituted the charm of abstraction. Because it is difference that constitutes the poetry of the map and the charm of the territory, the magic of the concept and the charm of the real. This imaginary of representation, which simultaneously culminates in and is engulfed by the cartographers' mad project of the ideal coextensivity of map and territory, disappears in the simulation whose operation is nuclear and genetic, no longer at all specular or discursive.[22]

This formulation of the relations between maps and territories approximates Greenaway's statement much more closely than "On Exactitude in

Another *Chorein*

Science" in its unrevised form, which remains bound within what Baudrillard calls the "imaginary of representation," however critically. Although toward the end of the next section I will tease out the differences between Baudrillard's and Greenaway's conceptions of mapping, here Baudrillard's reversal of the assumed relationship between reality and representation brings the peculiarities of *A Walk Through H*'s chorein into focus. Both diverge from the conception of maps as epiphenomenal representations implied in prevailing discourses of accuracy, science, and measurement in mapping. Like Baudrillard, Greenaway's narrator entertains the idea that maps shape and generate geographies ("the traveler created the territory as he walked through it"), and that the "sovereign difference" between them might be overcome (such that "the country only existed in its maps"). Indeed, as the next section demonstrates concretely through close visual analysis, Greenaway's chorein unfolds a vision that transcends the binary between map and territory.

These passages from Borges and Baudrillard have been much debated in critical scholarship, as has their import for map studies.[23] Citing them here serves, first, to expound the theoretical implications of this passage in Greenaway's narration, showing how it tilts against the representationalist view of mapping; second, to situate *A Walk Through H* in a larger critical lineage that queries received norms in cartography; and, third, to assert the farsightedness of Greenaway's performative vision of maps. Indeed, his artistic rendition of how cartographies constitute territories not only preceded Baudrillard's philosophical discussion of the theme by three years, but anticipated fundamental revisions that have subsequently come to define critical mapping theory, which now holds "that maps *make* reality as much as they represent it."[24] I highlight the film's prescience here not just to establish Greenaway's originality in this (constructed) intellectual lineage. More important, I want to show how map art can not only contribute to theoretical debates on mapping, but attain critical insights into mapping that would predominate in scholarship only later, and then against much resistance.

The performative casting of mapping projected in Greenaway's chorein links up with my analysis of Jeremy Wood's walking art in the previous chapter in that it further undermines the authority of institutional cartography. In the introduction I suggested that professional cartographic institutions have constructed their distinction in relation to lay and artistic mapping by projecting a notional ability to represent geographies with a disinterestedness unattainable by other mappers. A grasp of the world as not only representable, but so singular and objective that there is only one (scientific) way it may be mapped, is therefore indispensable to received separations between professional and lay mapmaking, between correct and incorrect cartographies, and between science and art in mapping. In shifting from a representational to a performative casting of mapping, Greenaway's chorein removes the basis of these divisions. In the world constructed in the film, essentialized distinctions between art and science in cartography fall away in the face of multiple mapping performances. These mappings enact and build rich fantastic geographies; cannot be divided between art and science; and cannot be assessed as either incorrect or objective. In this way Greenaway's film can be seen as complementing or even completing Wood's social expansion of mapping practices: whereas *My Ghost* and *Meridians* extend cartographic practice to formerly excluded people and places, *A Walk Through H* displaces the ontological assumptions that justified their exclusion in the first place.

Having unpacked the narrator's key statement on the performativity of mapping, situated it in relation to contemporaneous cultural ideas about maps, and asserted its implications for received distinctions in cartography, in the next section I turn to Greenaway's maps themselves. Following Siegert's rethinking of chorein, which insists that historical ontologies, far from being ethereal abstractions, are articulated materially through mediations, I explore how the film's performative ontology is manifested aesthetically. Attending to the rich geographies unfolded through Greenaway's practice of "art as mapping," I stress how *A Walk Through H* transcends many (though not all) of the constraints of the measurable and malleable modern space I have studied so far.

Another *Chorein*

Fig. 55. Peter Greenaway. The owl gate. Detail of *A Walk Through H*. 1978.

Midway through his journey into H, the ornithologist approaches a gate—
"Tulse Luper called it the owl gate." In fact, the gate has long since broken
and been removed, leaving only two austere gateposts jutting into the
map's blank border (fig. 55). Through the gate, we enter the Amsterdam
Map, which is significant for the film's narrative, its aesthetic, and my
argument in this chapter—for the narrative, because in stealing this map
the ornithologist scores a triumph over Van Hoyten and learns to look for
maps in ever new places. For the film's aesthetic, because these liberated
collecting habits lead to the film's construction of increasingly eccentric
terrains and because the map is among the most elaborate of Greenaway's
cartographies, drawing together many of their notable styles and motifs.
For my argument, because its flaccid geometrical structure, multiple focal-
izations, and plural graphic strategies combine to parody and counter the
measurable extension projected in cartographic practices at large. Indeed,

Another *Chorein* 229

the contrast between Greenaway's chorein and the received ontology of mapping I am setting up here is only heightened by the work's allusion to the city of Amsterdam, which, as a historical center of map production, was key to the development of modern calculable space.

For the moment, I will explore the Amsterdam Map (figs. 56 and 57) in isolation from its narrative and visual framing in the film, treating it as an autonomous artwork, which it also is. The image has the dimensions of a rectangular portrait. Numerous paths are gridded together to make up a rectangle of lines, which roughly align with the picture edge. In seven columns by twelve rows, these paths divide up a plane that, though shadowy, teems with complexity. The darkness enshrouding this terrain is a deep indigo that glitters with a meteorite blue, not to mention the white and turquoise paths that cross through it. The schematized image of a signpost or windmill is repeated throughout the image, whether as isolated icons, small groupings lined up soldier-like along a path as if for inspection, or the large cluster that takes up around six fields in the center-left of the image.

In the ontology of calculable extension, the grid represents a quintessential device of measurement and a symbol of uniformity and structure. Greenaway's rectangle of pathways, in contrast, deforms and even satirizes the rational grid, which it renders incalculable and turns to aesthetic, not functional ends. Consider the horizontal lines linking the topmost edge of Greenaway's block of pathways: unlike most connecting grid lines, which assure regular distances between the points they unite, these paths veer into asymmetrical curves between each column, making seven differently sized arches. The third semicircle from the left glows orange, making an incongruous sunset against which five signposts or windmills stand silhouetted. This suggestion of a crepuscular horizon ruptures the totalized vertical space conjured by cartographic grids—the perspective through which, as previous chapters have stressed, modern legislators have surveyed and ordered social space. Paths are drawn loosely throughout the image, apparently without a straight edge. Dividing a formerly continuous terrain, they produce irregular and idiosyncratic bounded zones. Indeed, these quirky enclosures are each qualitatively distinct in both their shape and graphic

Another *Chorein*

Fig. 56. Peter Greenaway. *The Amsterdam Map*, overview and detail from *A Walk Through H*, 1978. Courtesy of the BFI National Archive.

Fig. 57. Peter Greenaway. Windmills lined up soldier-like along a path as if for inspection. Detail of *The Amsterdam Map*.

media: far from being fungible block-filled units, they are manifested in a variety of different hatchings and washes done in pencil, ink, pastel, and other materials. Even the signposts or windmills, the number and graphic simplicity of which might first suggest a standardized icon, scorn regularity: many vary in size and proportion, lots have different colors to neighboring signs, and some contain several colors faded together. Given the unique rendition of each signpost, I hesitate to call them map icons. Each could potentially stand alone as a tall object seen against the horizon, in which case these too would break up the unified focal "view from above" evoked by the grid. This plurality of viewpoints is epitomized in another map, this one made up of ink washes on fabric, named *Whither Shall I Wander* (fig. 58).[25] Two different views are made to cohere within a common frame: the lower two-thirds of the central geography are clearly cartographic: fields interlock without the foreshortening that would suggest a grounded perspective. The higher third, though, is seen horizontally, with humped hills, or perhaps rather islands, silhouetted against a white sky behind.

Although these individual maps deviate from the ontology of calculability, it is important not to lose sight of their place within the flow of *A Walk Through H*. The incalculable and performative character of Greenaway's cartographies derives not just from the narrator's speculations on cartography and the formal presentation of individual maps, but also from the fact that these are moving, partial images, unfolding according to a temporality co-constructed by the camera's mobility, editing, and accompanying soundtrack. Conventionally, modern mapping attempts to schematize shifting variables and offer synoptic overviews of otherwise ungraspable terrains. As the single film explored in this study, though, *A Walk Through H* is especially well placed to contravene the impulse to stasis and totalization. Only rarely in *A Walk Through H* do we see a map statically and as a whole: for the most part, the camera rather tracks along the course of a path, or offers a vignette of this or that topographical feature. Thus the film's mapping out of an alternative chorein should be seen as stemming, in part, from its media specificity.

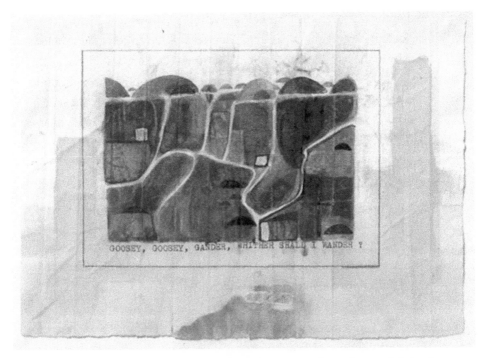

Fig. 58. Peter Greenaway. *Whither Shall I Wander*: cartographic and grounded visuali-
ties combine. Detail of *A Walk Through H*. Courtesy of the BFI National Archive.

The aggregated moments of disparity, irregularity, and flow I have
described all combine to produce an incalculable geography. Along his
journey the ornithologist tries to time the fading of the maps, calculate
the proper walking pace, and establish distances, whether those between
cities or that to his final destination. However, this impulse to establish
regularity and control, presumably nurtured by a lifetime lived within the
horizon of calculability, is confounded by the geographies of H. Around
halfway through the film the narrator feels he has "discovered the correct
walking pace" to avoid the fading terrain, and he takes comfort from his
impression, but this could well be down to some chance or fiat of the maps
and not his calculative procedures, which seem not only anal-retentive but
ultimately futile when projected onto the shifting terrain. Indeed, by the

Another *Chorein*

end of the film even the ornithologist admits that the "usual intentions of cartography were now collapsing." Much of this has to do with the heterogeneity of the terrain. Measurability presumes the comparability of all that must be measured: if a geography cannot be expressed or brought under common terms and standards, it slips beyond calculation. Any terrain with a composition as plural as *Whither Shall I Wander* or the Amsterdam Map therefore eludes the total calculability striven for by modern mapping, and thus also the sociospatial interventions calculability makes possible. This is brought home by comparing the map with Kocken's *Depictions of Amsterdam*, in which the projection of uniform calculable frameworks onto the city conditioned numerous ordering projects, from military campaigns to racial purges. No such gardening could arise from the chorein unfolded by Greenaway's mappings, nor could the single, totalized global temporality that Hildreth deconstructed in *Forthrights and Meanders*. Indeed, in the Amsterdam Map, no distances are so regular as to allow the synchronization of times among its different parts. No prime meridian exists for all determinations of time to refer to—not even the white path running centrally down the Amsterdam Map could provide such a standard, since it weaves far too irregularly. The world of *A Walk Through H*, then, consists of infungible, even clashing graphics, shapes, and spaces; by unrepeatable improvisations and intermingled colors that cannot be separated out into a tabulated key or legend. That the very grid supposedly organizing the map is multicolored, irregular, and built up in disparate materials signals that incalculability has taken root even in the paradigmatic instrument of measurement itself.

If these maps do not figure geographies in terms of the uniformity that marks cartographic space as it has developed in modernity, it is important to remember that this uniformity is bound up with the project of representation. Once geography is conceived as a regular and therefore calculable extension, its measurements can be converted and plotted into graphics. Greenaway's chorein differs from the ontology of modern mapping most fundamentally, then, in its reversal of the presumption that maps represent geographies, as discussed in the previous section. To show how the

Another *Chorein*

film's shift from a representational to a performative casting of mapping is manifested aesthetically in its maps, I now turn to some of the stranger cartographies presented in *A Walk Through H*. When the narrator wonders whether he is creating the terrain as he walks through it, he is using the Amsterdam Map, which could still plausibly be taken to represent a prior geography (perhaps a Dutch landscape scattered with windmills and split into *polders*). The performativity entertained by the narrator is rather more evident as the maps become progressively more unusual through the film. The path curling around a speckled eggshell is one example, the map drawn on an illustration to a book of French history another. Still another shows "a journey on the plumage of a Red-legged Partridge," a path extending along the bird's left breast and into an eye (figs. 59 and 60). There are no physical geographies to which these maps might plausibly correspond. Rather, these odd images themselves become the terrains that the ornithologist traverses. This capacity to function as material landscapes unites these otherwise disparate images, many of which do not approximate conventional notions of maps at all (in fact, the narrator refers to many of them as drawings). Yet the eggshell, book illustration, and partridge, much like the plan for a flying machine and musical score, become geographies through their being collected and traveled over by the ornithologist in his journey through H. No longer judged by whether they correspond with an external territory (according to received definitions of mapping), all these images are taken as so many terrains—their different graphic forms serving not to classify them as maps or otherwise, but as manifesting varied geomorphologies. Understood this way, the maps (or, rather, drawings) recall George Perec's essay "Species of Spaces," which opens by describing how a written page does not stand in for some other space it describes, but itself constitutes an existential space: "I write: I inhabit my sheet of paper, I invest it, I travel across it."[26]

The idea that maps and other documents do not depict but rather constitute spaces stands at odds with the representationalist conception of maps as transparencies, in which mediating graphics disappear into the viewer's imagination of the terrain. In *A Walk Through H*, however, the materiality of the maps becomes increasingly prominent. Material marks—

like the obscure numbers and dotted lines scattered across the partridge, "details of French history" on the book illustration, and "Figure 58" printed below the speckled egg—substitute for nothing, represent nothing; all simply make up part of the graphic terrain. This is taken to extremes in several of Greenaway's maps, one of which proclaims its materiality in its name: *Sandpaper*. These maps make no pretense of representational transparency—they glory in their own opacity, which can be traversed as landscapes themselves. Abrasions and annotations, coordinates and contours, not to mention stranger graphic forms, become elements in a geomorphology all their own. It is therefore appropriate to approach these ninety-two maps as physical geographies. Some are remarkably vivid. Fig. 61, for instance, presents a many colored world, framed against a containing black background in an image resembling a Polaroid photograph. Numerous paths cross and jar with one another, some almost completely erased, others standing out over them, freshly in white. The site is a palimpsest, worn in by old routes. This, like the ninety-one other geographies, belongs to a chorein in which maps manifest worlds, rather than represent them from a distance. They produce effects; they create and embody realities; they are the terrains that they purport to describe.

Maps and Modernity

This theme of performative world-making complicates my comparison of Greenaway's chorein with the calculable cartographic space explored through this study. The film might confound the measurability and representationalism of established cartographic space; as regards the *modernity* of mapping, however, *A Walk Through H* is continuous with much received practice. Previous case studies have built a definition of modernity as denoting conditions in which social formations and environments are

Fig. 59. Peter Greenaway. The ornithologist navigates obscure avian terrains: a path curls around a speckled eggshell. Detail of *A Walk Through H.*

Fig. 60. Peter Greenaway. A journal on the plumage of a red-legged partridge. Detail of *A Walk Through H.*

Another *Chorein*

Figure 58

Fig. 61. Peter Greenaway. A palimpsest, worn in by old routes. Detail of *A Walk Through H*. Courtesy of the BFI National Archive.

grasped not as constants whose character unfolds from some essential or metaphysical order, but as contingent and thus malleable. Cartography is modern, I have proposed, in that it lays out a disenchanted earth that is amenable to fundamental reconstitution through willful practice. This argument is encapsulated by Nikritin's *The Old and the New*, in which a blank globe is surrounded by moderns who variously confront the Nietzschean task of projecting value and order onto a meaningless world.

At one level, this view of modern world-making pertains equally to the chorein articulated in *A Walk Through H*. Indeed, in overcoming repre-

Another *Chorein*

sentationalism and calculable space, the film hardly imagines a return to some absolute and unchangeable pre- or nonmodern ontology. To the contrary: like the modern ontology of calculability, it defies any assumption that geographies manifest essential or metaphysical identities. Like the ontology of calculable extension, it too presupposes the world's basic malleability through mapping practice. Yet the two ontologies differ in *how* they imagine the world's transformation through cartography. Previous chapters have shown that, in the received ontology of cartography, mapping provides the legibility and knowledge on the basis of which society and space are transformed programmatically.[27] It is therefore the *instrumentality* of cartography that matters in most projects of modern ordering. In contrast to this, Greenaway's chorein emphasizes not how cartographic legibility is *used* in transformative projects, but rather the *performativity* immanent to maps themselves. The power of maps in the film is similar to the performativity explored by Matoba's *Utopia*, which I analyzed in chapter 4. There, I stressed how otherwise abstract imaginations of community have not only taken form, but have been realized socially and ultimately physically through performative acts of mapping. This is clear in Matoba's treatment of the geographical figure of the island, which historically provided the model through with the modern nation-state was imagined, enacted, and concretely instantiated. Matoba remaps the social space of the island, affirming its internal difference: her *Utopia* performs a pluralist polity, no longer cartographically enclosed against others outside as an insular community.

Matoba's performative conception of cartography comes close to Greenaway's grasp of mapping in *A Walk Through H*. It must be noted, though, that the film's vision of cartographic performativity is amplified to the point of being almost outlandish. Maps can be treated as terrains in their own right—they even unfold cultural geographies that users inhabit mentally. But they do not spontaneously produce physical geographies from themselves as they seem to in Greenaway's artistic vision. As my framing of Matoba's insular mappings in chapter 4 explains, maps rather create specific *conceptions of* and *relations to* existing physical and social geographies,

inciting viewers to practice in and manage those terrains in certain ways that ultimately alter them physically.[28] This accounts for the lag in Baudrillard's description of how representations reconstitute reality: since simulations are realized incrementally and unevenly through practice, it takes time for maps to supplant the real, which rots across the map only slowly. Here it becomes possible to pinpoint the divergences between Greenaway's chorein and Baudrillard's theory. For the philosopher, maps precede and provide a template for the territory, eventually forcing the disappearance of pregiven "realities" as cultural and physical geographies are reconstituted through the proliferation of maps and mapping. The map reconstitutes the real only gradually, through successive stages. In the film, by contrast, the distinction between maps and territories is annulled immediately. True, the narrator's suggestion that "the traveler created the territory as he walked through it" certainly hints at a more drawn out process, in which maps make worlds through shaping conceptions. For the most part, however, Greenaway's cartographies unfold territories *without* the intermediary stages expressed metaphorically by the gradual rotting of the real across the map in Baudrillard's revision of Borges's fable. In *A Walk Through H*, there is no process of substitution.

Foregrounding cartography's constitution of worlds in this especially direct way, *A Walk Through H* both ties back into the mutually constitutive connections between maps and modern world-making explored through previous chapters and pushes them to an extreme. These maps do not present the legibility through which existing conditions are consciously transformed (Bauman's concept of sociospatial "gardening"), nor do they unfold underlying conceptions of the world that are steadily realized through social practice (what I have called mapping's "ontological performativity"). Rather, Greenaway's mapping practice radicalizes these instrumental and performative conceptions of cartography's capacity to shape and build realities. *A Walk Through H* imagines the agency of mapping in perhaps the most unfettered manner conceivable, presenting a vision in which cartography directly manifests new worlds, which exist nowhere save in the maps themselves.

Another *Chorein*

A Walk Through H should therefore be seen as simultaneously negating and consummating the connections between maps and modernity explored in previous chapters. *As negating them*, in that Greenaway's mapping practice is so oblique in relation to the ontology of calculability as to justify its designation as performing a separate chorein. Indeed, I have argued that this chorein discloses irregular and infungible geographies that cannot be brought under a common measure; that it displaces representation as cartography's essential function, annulling received distinctions between professional and lay mapping, cartography and art, and science and art in mapping; and that this affirms a radically performative conception in which maps manifest rich and multiple worlds. *As consummating them*, because while Greenaway's chorein denies the calculability and representationalism of modern space, this extrapolated imagination of cartographic performativity realizes the essence of modern world-making in a distilled form unseen in previous case studies. Neither in the total instrumentality portrayed in Kocken's *Depictions*, in which mapping strives to render societies wholly legible for transformative intervention, nor in the performative construction of insularity in Matoba's *Utopia*, in which maps project alternative imaginations of social space, does cartography unfold and constitute worlds so directly.

In Greenaway's intensified grasp of the agency of mapping, maps do not represent ulterior realities, but manifest rich geographies in their own presence and form—so much so that, in the universe of the film, there is no reality save for the worlds set forth in maps (admitting the infrequent shots of birds). Inherited notions of art and science, representation and reality, collapse into this practice of unfolding diverse worlds through mapping. Between Antilipe and the Owl Gate, as terrains fade with their maps and winds trace a path toward heaven or hell, *A Walk Through H* affirms cartography's constitutively modern power to make geographies. Although on every other count Greenaway's chorein stands at odds with the modern ontology of calculability, this impulse to found the world anew through mapping does not negate, but rather distills and radicalizes modernity.

Envoi
Artists Astride Shifting Mapping Paradigms

In the introduction I invoked the metaphor of the core sample to grasp the distinctive procedures of looking and writing that I bring to bear on map art in this book. The foregoing chapters might be conceived, therefore, as a row of six cores that, having been extracted from diverse sites in the larger terrain of map art, allow us to glimpse an underlying stratigraphy. Though narrow, these samples are formally and conceptually rich. Individual works of map art, I hope to have shown, repay the strategies of concentrated, geographically informed cultural analysis signaled here by the image of the core drill, through which more and more of their layered complexity is brought up to the surface. Whether in concretizing, complicating, or outright refuting geographical theories, querying prevailing spatial constructs, or reimagining cartographic space altogether, the map artworks I have studied present multiple strata of significance and perform many forms of work on the objects, concepts, and contexts that I pose alongside them. Just as actual core samples offer clues to a wider geology, the visual, conceptual, and performative complexity encountered in these case studies indicates the complexity of map art at large.

The metaphor of core samples, drawn from distant points on the earth's crust, raises the question of whether the map artworks I have explored extend down toward a common conceptual center or, rather, attest to the specificity of their own, local geologies. Although a cumulative vision of maps and global modernity has built up over the course of this study, it would be remiss to gloss over the points of dissonance at which the six case studies reflect back critically on another. Nikritin's *The Old and the New* intimates how modernity is haunted by the earth's lack of inherent order,

meaning, and orientation, yet Kocken's *Depictions* expose modern culture's presumption of geography's essential singularity, uniformity, and measurability; Wood's *My Ghost* enacts the possibility of an undisciplined mapping practice, in which everyday walking is a form of cartography, whereas in Greenaway's *A Walk Through H* this project is eclipsed by the task of overturning the received ontology that has traditionally governed mapmaking.

Nonetheless, across the varicolored layers compacted in my row of cores, common structures loom into view. Together, my studies of map artworks present two major arguments. The first four chapters focus on the ways that map artists have explored the confected visions of modernity that maps project onto the times and spaces of a disenchanted world. Nikritin's painting *The Old and the New* shows how the mapped globe unsettles but also emboldens modern cultures, disclosing a meaningless and malleable earth to be remade by empowered modern subjects. The heterogeneous geographies of Hildreth's *Forthrights and Meanders* throw into relief the uniform temporality that conventional maps have inculcated globally; the *Depictions*, Kocken's series of digital collages, stress the centrality of maps in projecting and realizing some of the most extreme urban and social designs of the twentieth century, while *Utopia*, Matoba's revision of the state-as-island motif, attests to cartography's performative power in constituting the spatial form of modern polities. My first main argument is that map art, even in recapitulating these modern orderings of geography, interrupts, undermines, and redirects the founding figures and narratives of rupture that constitute global modernity. Thus Nikritin's painting suggests that the ostensibly disenchanted globe is just as constructed, and certainly as constraining, as the premodern worldviews it displaced; Hildreth's mappings revel in the forms of polychrony and unevenness that are repressed in mapping's conventionally synchronized temporality; the *Depictions* accentuate unruly spatial practices that teem in the cracks of even the most centralized urban designs; and *Utopia* foregrounds the persistence of unfixed and hybrid transcultural flows that persist, though disavowed, athwart the borders and inside the geobodies of ostensibly homogenous nation-states.

Whether in reiterating, troubling, or reimagining modern constructions of space, each of the map artists I have analyzed feeds into a cumulative picture of cartography's fundamental grasp of the world—its ontology. This "ontology of calculability," I suggest, discloses geographical reality as a contingent, simultaneous, and measurable extension that is amenable to programmatic intervention, redesign, and political apportion. On this basis, the final two chapters of the study argue for a specific view of map art's significance against the backdrop of the recent "undisciplining of cartography," through which mapping is "slipping from the control of the powerful elites that have exercised dominance over it for several hundred years," and thus opened up to an expanded field of consumers and producers.[1] I reiterate my argument, here, in relation to Denis Wood and John Krygier's stirring survey of map art's politics, the clarity and stridence of which warrants quotation at length:

> Art maps contest not only the authority of professional mapmaking institutions—government, business, and science—to reliably map the world, but they also reject the world such institutions bring into being. Art maps are always pointing toward worlds other than those mapped by professional mapmakers. In doing so, art maps draw attention to the world-making power of professional mapmaking. What is at stake, art maps insist, is the nature of the world we want to live in. . . . Map artists do not reject maps. They reject the authority claimed by professional cartography uniquely to portray reality as it is. In place of such professional values as accuracy and precision, art maps assert values of imagination, social justice, dreams, and myths; and in the maps they make hurl these values as critiques of the maps made by professionals and the world professional maps have brought into being. Artists insist that their maps chart social and cultural worlds every bit as 'real' as those mapped by professional cartographers. . . . The project of art mapping is nothing less than the remaking of the world.[2]

My chapters bear out many of the gestures that Wood and Krygier espy here, especially how map art highlights the performativity of mapping, privileges the role of imagination as much as representation in mapmak-

ing, and challenges institutional cartography's monopoly on authority in mapping. Overall, though, this study has taken a view of map art's import that is rather more differentiated and equivocal than Wood and Krygier's celebratory appraisal of the field. My analyses draw attention to tensions and dangers that attend map art, as well as its critical visions and liberatory gestures. Chief among the dangers is how many works of map art, even as they subvert, reclaim, or otherwise reimagine received constructions of space, reproduce the underlying ontology of calculability. This study furnishes two examples of such recuperation. Matoba's *Utopia* undermines the received political geography of nation-states and Wood's *My Ghost* takes mapping back from institutional cartography for the formerly excluded people and places signaled by "the street." Yet both works remain contained within the determination of geography as a uniformly measurable extension—signaling the risk that, even when imagining new political spatialities and reclaiming mapping for a broadened social field, map art might ultimately further extend and entrench conventional cartographic modes, as well as received apprehensions of space.

My second main argument, therefore, is that map art's significance does not stem from artists' capacity to socially expand mapmaking beyond institutional domains (which is already being realized, unevenly, through mapping's digitization). Rather, map art's unique value in relation to contemporary mapping cultures lies in how it might denaturalize, challenge, and push beyond the ontology of calculable extension, through which institutional control over cartography was rationalized in the first place. This value is demonstrated in my analysis of Wood's *Meridians*, which, beyond reclaiming mapping for its excluded social others, exposes slippages and contradictions in digital mapping's undergirding ontology. If Wood renders the securely coordinated GPS geode spectral and strange, Greenaway's film *A Walk Through H* goes still further, displacing the cartographic disclosure of geography as extended measurable "space" altogether. The film offers what I have called "another chorein": a fundamental casting of geography that leaps free from the prevailing paradigm of calculable extension. Greenaway's maps neither calculate nor represent a singular preexisting

reality. Instead, according to the film's dynamic chorein, mapping enacts and manifests multiple geographies that exist beyond synoptic calculation and control. In unfolding reimagined geographical ontologies, map art's project truly is "nothing less than the remaking of the world."

With its posthumous protagonist speculating elaborately on the unusual affordances of the maps he collected when alive, Greenaway's film is exceptionally reflexive in imagining another conception of mapping. Yet it must be understood as a single sample, lifted from a terrain rich with promising uncored sites. Myriad other forms of experimental mapmaking remain to be theorized in relation to the reigning ontology of calculability. The more digital mapping perpetuates and entrenches the inherited grasp of the earth as a singular calculable geode, the more important it becomes to explore map art's capacity to perform alternative chorein. As writing on not just map art, but also geography's broader visual culture accumulates and diversifies, it will encounter numerous past and peripheral ontologies, which, in holding out alternatives to the measurable and malleable modern geode, come up as resources through which to imagine geography otherwise.

Notes

Introduction

1. On the ideological significance of global cartography in Soviet culture, see Baron, "Scales of Ambition" and "World Revolution and Cartography."

2. For a survey of Kozloff's engagement with themes of mapping, masculinism, and militarism, see Earenfight, *Joyce Kozloff*.

3. On the dominative propensities of the "vertical angle," see Kress and van Leeuwen, *Reading Images*, 140–8, following a reference in Rose, *Visual Methodologies*, 70. On the masculinism of this perspective, see Nash, "Reclaiming Vision."

4. To my knowledge, the term "map art" was first used by Denis Wood in a 2006 special issue of *Cartographic Perspectives* dedicated to the topic (Wood, "Map Art," 5).

5. Curnow, "Mapping and the Expanded Field of Contemporary Art," 255; Watson, "Mapping and Contemporary Art," 297; and Harmon, *The Map As Art*, 10.

6. Thrift, "Remembering the Technological Unconscious."

7. Wood, "Map Art," 10; see also Cosgrove, "Maps, Mapping, Modernity"; Hawkins, *For Creative Geographies*, 37–60; and Pinder, "Subverting Cartography."

8. Jameson, *Postmodernism*, 54. Jameson's concept of cognitive mapping is posed in relation to map art in Watson, "Mapping and Contemporary Art," 295; Holmes, *Escape the Overcode*; O'Rourke, *Walking and Mapping*, xvii; and Toscano and Kinkle, *Cartographies of the Absolute*, 1–26. For a discussion of cognitive mapping in spatial theory, see Tally, *Spatiality*, 67–74.

9. O'Rourke, *Walking and Mapping*; and Pinder, "Subverting Cartography" and "Errant Paths."

10. Pinder, "Errant Paths," 674.

11. Harmon, *You Are Here*, 10.

12. Harmon, *You Are Here*, 11.

13. Harmon, *You Are Here*, 11.

14. Helgerson, "The Folly of Maps and Modernity," 241.

15. A trenchant statement of this periodization can be found in Martin Albrow's book *The Global Age*, which counterposes "the Modern Age" (that "passing historical episode") against "the Global Age" as two constitutively different periods, the latter negating the former "between 1945 and 1989." See Albrow, *The Global Age*, 11 and 96.

16. Dirlik, "Global Modernity?," 276.

17. For just one example of this critique, see Ang, "European Reluctance," 78.

18. Eisenstadt, "Multiple Modernities"; Appadurai, *Modernity at Large*, 49–50; and Gilroy, *The Black Atlantic*, 1–40.

19. Gaonkar, "On Alternative Modernities," 23; Moretti, "Conjectures on World Literature," 55.

20. On the need to conceive capitalism as an integrated totality, see Lazarus, "Vivek Chibber," 95–96.

21. For a discussion of these overlapping processes, see Harvey, *Spaces of Neoliberalization*, 71–114. In addition, the Warwick Research Collective (wREC) provides an excellent overview of how the concept of a "combined and uneven" modernity fulfils two imperatives: that of thinking capitalist modernity holistically, as an interlocking globality whose parts cannot be understood without reference to the greater structure, while simultaneously stressing the diversity of its regional incarnations and internal contradictions, the disparate social and political formations that arise in response to it and the inequality inherent to capitalist development. See wREC, *Combined and Uneven Development*, 10–15.

22. On the establishment of mapmaking in and through the rise of the modern state, see Wood, *Rethinking the Power of Maps*, 27–33, and Biggs, "Putting the State on the Map."

23. Ramaswamy, *Terrestrial Lessons*, xvii. On the ways in which cartography has bound up historically with colonialism see Appadurai, *Modernity at Large*, 121–6, Arias and Mélendez, "Spaces and the Rhetorics of Power in Colonial Spanish America," and Jazeel, "Subaltern Geographies"; with capitalist globalisation, see Brotton, *Trading Territories*, and Domosh, "Geoeconomic Imaginations and Economic Geography in the Early Twentieth Century"; with the secularisation religious cosmographies, see Woodward, "Maps and the Rationalisation of Geographic Space," 84–85, and Sloterdijk, *Globes*, 765–818; with time-space compression, see Massey "A Global Sense of Place"; Warf, *Time-Space Compression*, 40–77; and with urban planning, see Scott, *Seeing Like a State*, 103–46.

24. On culturally and historically contingent ontologies or understandings of being, see Dreyfus, "Heidegger's Ontology of Art." Most discussions of ontology take their bearings from the German philosopher Martin Heidegger, whose writings focus insistently on the "being of beings." George Steiner explains that, for Heidegger, ontology "keeps its distance from every particular and individual object, phenomenon, presence; from every this and every that." Instead, it seeks to grasp what unites all particular beings: namely that they *are*. As Heidegger's thought developed, the ways in which beings exist—the "mode of *being* of a being"—was increasingly seen as plural and historically variable. His later work stretches out a grand "history of being," over the course of which beings have manifested themselves intelligibly in

numerous, mutually incompatible ways. Steiner, *Heidegger*, 39; Heidegger "Being and Time: Introduction," 47.

25. Young, *Heidegger's Philosophy of Art*, 138.

26. See Elden, "Missing the Point," and "National Socialism and the Politics of Calculation." For fuller descriptions of this ontology, see Harley, *The New Nature of Maps*, 154; and Pickles, *A History of Spaces*, 80–86. In addition to the calculability of modern geography, Elden also broaches the calculative apprehension of time as a progression of discrete fungible units. He describes how, in modernity, time "is rendered the same, each moment a point on a time-series, with these moments increasingly close together in an acceleration of speeds." Elden, "Missing the Point," 16. On how the acceleration of culture under globalization rests on this "calculative understanding of time," see Elden, "The War of Races and the Constitution of the State," 151. A further discussion of the rationalization of time in modernity can be found in Harvey, *The Condition of Postmodernity*, 252.

27. Crampton, *Mapping*, 40.

28. Wood, *Rethinking the Power of Maps*, 156.

29. Varanka, "Interpreting Map Art," 15. For an example, see Norman Thrower's claim "that map making arose independently in isolated societies attests to its universality." *Maps and Civilization*, 10.

30. See Wood, *Rethinking the Power of Maps*, 19–35. On Wood's qualified definition, maps are "more or less permanent, more or less graphic artefacts that support the descriptive function in human discourse that links territory to other things, advancing in this way the interests of those making (or controlling the making) of the maps": *Rethinking the Power of Maps*, 20.

31. Wood, *Rethinking the Power of Maps*, 26–27.

32. Wood, *Rethinking the Power of Maps*, 27.

33. Wood, *Rethinking the Power of Maps*, 26.

34. Wood, *Rethinking the Power of Maps*, 24.

35. Wood, *Rethinking the Power of Maps*, 26.

36. Wood, *Rethinking the Power of Maps*, 27.

37. Wood, *Rethinking the Power of Maps*, 23.

38. Wood, *Rethinking the Power of Maps*, 38. On cartography's centrality to the modern state formation, see Biggs, "Putting the State on the Map."

39. Alpers, *The Art of Describing*, 119. For a more encompassing study of the connections between mapmaking and art in the early modern period, see Rees, "Historical Links between Cartography and Art."

40. Jobst, "Marriage and Divorce," 4.

41. See McMaster and McMaster, "A History of Twentieth-Century American Academic Cartography"; Edney, "Putting 'Cartography' into the History of Cartography," 713; Wood, *Rethinking the Power of Maps*, 121–25; and Crampton, *Mapping*, 50–61.

42. Quoted in Edney, "Putting 'Cartography' into the History of Cartography," 17.

43. Cosgrove, "Maps, Mapping, Modernity," 36; Krygier and Varanka, "Art and Cartography in the Twentieth Century," 78.

44. Edney, "Cartography Without 'Progress,'" 56; Wood, *Rethinking the Power of Maps*, 120–26.

45. The "elusive goal" of modern state formation, writes Bauman, "was the subordination of social space to one and only one, officially approved and state-sponsored map—an effort coupled with and supported by the disqualification of all other, competitive maps or interpretations of space, as well as the dismantling or disabling of all cartographic institutions and endeavors other than the state-established, state-endowed or state-licensed": Bauman, *Globalisation: The Human Consequences*, 31.

46. The decorative aesthetics of cartography are discussed in Welu, "The Sources and Development of Cartographic Ornamentation in the Netherlands"; the aesthetics of map design in Woodward, "Introduction," 1–9 (though, for a critique, see Cosgrove, "Maps, Mapping, Modernity," 37); and aesthetic expression of cartographers' subjectivities are addressed in Fairbairn, "Rejecting Illusionism."

47. Edney, "Cartography Without 'Progress,'" 75.

48. My presentation here is informed by Edney's analysis of how official cartography "proclaims that there is one world which can be progressively described and known, and that the survey map is that description": "Cartography Without 'Progress,'" 64, and by J. B. Harley's summary of the assumptions preconditioning established cartography, which is worth quoting at length: "[Official cartography's] assumptions are that the objects in the world to be mapped are real and objective, and that they enjoy an existence independent of the cartographer; that their reality can be expressed in mathematical terms; that systematic observation and measurement offer the only route to cartographic truth; and that this truth can be independently verified": *The New Nature of Maps*, 154.

49. Crampton, *Mapping*, 40.

50. Crampton, *Mapping*, 25–26.

51. Crampton, *Mapping*, 26.

52. Dora, "A World of Slipping Maps"; Pickles, *A History of Spaces*; Crampton, *Mappings*.

53. Pickles, *A History of Spaces*, 149.

54. November, Camacho-Hubner and Latour, "Entering a Risky Territory," 582–84.

55. On the differential access to GIS consequent upon the uneven development and integration of Internet infrastructures, see Laituri, "Equity and Access to GIS for Marginal Communities" and Mark Dorrain's discussion of Google Earth's "politics of resolution": "On Google Earth," 301.

56. On the participatory mapping of these disasters, see Poiani, Rocha, Degrossi, and de Albuquerque, "Potential of Collaborative Mapping for Disaster Relief," and Zook,

Graham, Shelton, and Gorman, "Volunteered Geographic Information and Crowd-sourcing Disaster Relief."

57. This neologism is discussed in Coleman, Georgiaidou, and Labor, "Volunteered Geographic Information."

58. Wood, *Rethinking the Power of Maps*, 126.

59. David Pinder, for example, qualifies ruptural accounts of cartography's digital transition by recalling longstanding traditions of autonomous mapping practices: Pinder, "Cartographies Unbound," 41.

60. On these attempts to license GIS, see Crampton, *Mapping*, 41.

61. Farman, "Mapping the Digital Empire." Ultimately, however, Farman argues beyond this, suggesting that users might query dominant frames of representation from within.

62. Kaplan, "Precision Targets."

63. Pickles, *A History of Spaces*, 147–75.

64. Pickles, *A History of Spaces*, 152.

65. See Pinder, "Dis-locative Arts," 522 and 526.

66. For a overview of emphases and approaches in science and technology studies (STS), see Bijker, Hughes, and Pinch, *The Social Construction of Technological Systems*.

67. Bittner, "Diversity in Volunteered Geographic Information."

68. Bittner, Glaze, and Turk, "Tracing Contingencies," especially 939. For an excellent study of contested mapping practices in Israel and Palestine from a science and technology studies perspective, see Bier, *Mapping Israel, Mapping Palestine*.

69. Mogel and Bhagat, "Introduction," 6.

70. Glowczewski's *Dream Trackers* and Levine's *The Wall-The World* are discussed in O'Rourke, *Walking and Mapping*, 117–22 and 180–83. For the anthropological research from which *Dream Trackers* sprung, see Glowczewski, *Desert Dreamers*.

71. Crampton, *Mapping*, 18.

72. On the Arno Peters controversy, see Black, *Maps and Politics*, 33–36.

73. Pickles, *A History of Spaces*, 145.

74. Pickles, *A History of Spaces*, 145.

75. For a discussion of developing themes in critical map studies, see Dodge, Kitchin, and Perkins, "Thinking About Maps."

76. Brotton, "Google, there's no such thing as a perfect map of the world." *Guardian*, May 16, 2013, https://www.theguardian.com/commentisfree/2013/may/16/google-no-such-thing-as-perfect-map (accessed February 27, 2017).

77. For examples of maps in picture postcards, posters, press cartoons, and coins, see Bryars and Harper, *A History of the Twentieth Century in 100 Maps*, 184–85, 166–67, 46–49, and 154–55. Maps tattooed or worn as identity markers on the human body are discussed in Jacob, *The Sovereign Map*, 48. For a discussion of how global cartographic imagery has been reworked and "dematerialized" in corporate visual

design, such that global maps represent "the *idea* of 'being global'" rather than an extant geographical dispensation, see Cosgrove, *Apollo's Eye*, 263–65.

78. For an excellent overview of maps of literary and other imagined worlds, see Padrón, "Mapping Imaginary Worlds." For an interesting discussion of escapist fantasy mapping in Britain following the Great War, see Bryars and Harper, *A History of the Twentieth Century in 100 Maps*, 58–59.

79. Padrón, "Mapping Imaginary Worlds," 286.

80. Aydemir, "A Reaction to the Früchtl/Bal Debate," 38.

81. Bal, "Introduction," 1.

82. Bal, *Louise Bourgeois' Spider*, xi.

83. Bal, *Louise Bourgeois' Spider*, xii.

84. Barthes, "The Death of the Author," 147.

85. See Hawkins, *For Creative Geographies*, 15. These interdisciplinary connections are discussed further in my "Review of *For Creative Geographies*," 3–4.

86. See Hawkins, *For Creative Geographies*, 10.

87. Bal, "Introduction," 12.

88. Bal, "Close-ups and Mirrors," 138.

89. Hawkins, *For Creatives Geographies*, 13.

90. Against the critical tendency towards surveys of the field, some close analyses of map art can be found in Crampton, *Mapping*, 169–72; Hawkins, *For Creative Geographies*, 37–60; Nash, "Reclaiming Vision"; Parsons, "Mapping the Globe"; and Wood, *Rethinking the Power of Maps*, 189–90 and 218–30.

91. See Watson, "Mapping and Contemporary Art," 293–302; Curnow, "Mapping and the Expanded Field of Contemporary Art," 255–60; D'ignazio, "Art and Cartography," 190–91; and Wood, *Rethinking the Power of Maps*, 214–18.

92. Cóilín Parsons has analyzed "the depredations of colonialism and its legacies of violence" in the map art of Gulam Mohammed Sheikh ("Mapping the Globe," 185); Catherine Nash attends to the formal strategies through which Kathy Prendergast and other map artists counter masculinist rhetorics of disinterestedness in geography ("Reclaiming Vision"; "Mapping Emotion"); and Jeremy Crampton reflects on the geographies of finance as articulated in map art of Deirdre Kelly (*Mapping*, 169–72).

93. On T. J. Clark's summary, the temporality of premodern cultures is characterized by "the past living on (most often monstrously) in the detail of everyday life": "For a Left With No Future," 70.

1. The Shock of the Whole

1. A version of this chapter has been published as a journal article in *GeoHumanities: Space, Place, and the Humanities*. See my "The Shock of the Whole."

2. Transcript published in London, "The Seven Soviet Arts," 382.

3. Transcript published in London, "The Seven Soviet Arts," 382.

4. Smirnov, *Sound in Z*, 127. For further discussion of the picture's censure, see Bowlt, "Solomon Nikritin," 160–65.

5. Bowlt, "Solomon Nikritin," 157.

6. Bowlt, "Solomon Nikritin," 153–68.

7. A distinction obtains between "pure" phenomenology, which studies how the world is apprehended by a transhistorical subject, undiluted by context, and a historicizing "existential" phenomenology, for which existence is disclosed to human consciousness in radically different ways in different cultures and moments of history. For a discussion of this distinction, see Cerbone *Understanding Phenomenology*, 37.

8. Sloterdijk,"Nearness and Da-sein," 40.

9. For Nietzsche's parable, see *The Gay Science*, 119–20.

10. Sloterdijk, *Globes*, 559.

11. Glacken, *Traces on the Rhodian Shore*, 176.

12. Sloterdijk, *Globes*, 630.

13. Sloterdijk, *Globes*, 558, 773–74.

14. Sloterdijk, *Globes*, 342.

15. See Cosgrove, *Apollo's Eye*, and Heise, *Sense of Place and Sense of Planet*.

16. Sloterdijk, *Globes*, 558.

17. Ingold, "Globes and Spheres," 463.

18. Ingold, "Globes and Spheres," 462.

19. Ingold, "Globes and Spheres," 468.

20. Ingold, *Being Alive*, 112.

21. Quoted in Tirado, "Nietzschean Motifs in the Komsomol's Vanguardism," 236.

22. Cosgrove, *Apollo's Eye*, 1 and 57.

23. Kamensky, *Ego-moia Biographiia Velikogo Futurista*, 109, quoted and translated in Vujosevic, "The Flying Proletarian," 85.

24. Sloterdijk, "Forward to the Theory of Spheres," 223.

25. Aristotle, *Eudemian Ethics*, 5.

26. Weber, *Sociology of Religion*, 270.

27. Bowlt, "Solomon Nikritin," 160.

28. *Journey Around the World* is reproduced in Bowlt, "Solomon Nikritin," 156, and Adaskina, Bowlt, Misler, and Tsantsanoglou, *Spheres of Light*, 270.

29. On global forms in Nikritin's theories, see Bowlt, "Solomon Nikritin," 166.

30. Bowlt, "Solomon Nikritin," 168

31. Berman, *All That Is Solid Melts into Air*, 5.

32. Garb links the modern global view with pornographic visualities. "Perspective or Escape?," 269. However, this perspective should be weighed against Nash, "Reclaiming Vision," and Rose "Distance, Surface, Elsewhere," which uncover complexities and alternative tendencies in the patriarchal cartographic gaze.

33. See, for example, Bonneuil and Fressoz, who write that the global view "extends a view of objectivity as the 'view from nowhere' . . . according to which true knowledge is that produced by abstraction from the system observed." *The Shock of the Anthropocene*, 62–63.

34. Haraway, "Situated Knowledges," 581.

35. Haraway, "Situated Knowledges," 576 and 581.

36. Garb, "Perspective or Escape?," 271–75.

37. Garb, "Perspective or Escape?," 278.

38. Haraway, "Situated Knowledges," 581.

39. Garb, "Perspective or Escape?," 278.

40. Haraway, "Situated Knowledges," 579.

41. Blumenberg, *The Genesis of the Copernican World*, 685, following Lazier's discussion, in "Earthrise," 619.

42. On cultural discourses in which nature is "allegorized as a powerful maternal force, the womb of all human production," see Soper, *What is Nature?*, 103, 102–7.

43. Blumenberg, *The Genesis of the Copernican World*, 678.

44. Szerszynski and Urry, "Cultures of Cosmopolitanism," 466–68; Billig, *Banal Nationalism*.

45. Di Palma, "Zoom: Google Earth and Global Intimacy," 264.

46. Trotsky, "The First Five Years of the Communist International."

47. I chose this example following Baron, "Scales of Ambition," 2.

48. Carr, *The Twilight of the Comintern*, 9.

49. See Baron, "Scales of Ambition."

2. Combined and Uneven Cartography

1. Although space is prioritized over time in both everyday mapping practices and critical writing on cartography, it is worth noting that there are mapmaking traditions—albeit marginal ones—that build temporal dimensions into cartography. Especially influential in this regard, was work on "time-geography" by Torsten Hägerstrand, whose time diagrams plotted the mobility of defined demographics over a given duration. Hägerstrand's methods have been taken up and reconfigured in contemporary critical GIS by Mei-Po Kwan. For a discussion and critique of time-geography, see Rose, *Feminism and Geography*, 21–34. For Mei-Po Kwan's critical "re-envisioning" of time-geography, see her "Feminist Visualization," 653–54.

2. On the historical variety of images of the global earth, see Cosgrove, *Apollo's Eye*.

3. Harvey, *Spaces of Global Capitalism*, 115.

4. Smith, *Millennial Dreams*, 11–14.

5. Harley and Woodward, "Preface," xvi.

6. Wood, *Rethinking the Power of Maps*, 95.

7. Connolly, *The Maps of Matthew Paris*, 93.

8. For a synoptic account of the Hereford *mappamundi,* see Harvey, *Mappa Mundi.* On the organization of time in the artifact, see McKenzie, "The Westward Progression of History on Medieval Mappaemundi."

9. Brotton, *A History of the World in Twelve Maps,* 134.

10. Brotton, *A History of the World in Twelve Maps,* 134.

11. The Map with Postscript is reproduced in Fuke and Guoqing, *China in Ancient and Modern Maps,* 96–97.

12. Jameson, *The Seeds of Time,* 16.

13. Berger, "Into the Woods," following up on a reference in Fensterstock, "Untitled Essay."

14. On the globalization of modern "TimeSpace," see Wallerstein, "The Inventions of TimeSpace Realities."

15. Benjamin, *Illuminations,* 252.

16. Benjamin, *Illuminations,* 255.

17. Thompson, "Time, Work-Discipline, and Industrial Capitalism." On "the calculative understanding of time," see Elden, "The War of Races and the Constitution of the State," 151.

18. For a discussion of Hildreth's printmaking, see my "On the Untimeliness of Alison Hildreth's Printmaking 1974–2014."

19. Jay, "Scopic Regimes of Modernity."

20. Quoted by Hildreth's assistant Alina Gallo in a personal communication, 25 October 2012.

21. Duffy, *Siege Warfare.*

22. Parker, *The Military Revolution.*

23. I acknowledge, though, that basic maps of Kamchatka were made by Semen Remezov in the mid-seventeenth century. See Kivelson, *Cartographies of Tsardom,* 133–46.

24. Hildreth, "Interview with the Artist for the Thousand Words Project."

25. Sebald, *Austerlitz,* 193–94.

26. Sebald, *Austerlitz,* 193.

27. Sebald, *Austerlitz,* 193.

28. Trotsky, History of the Russian Revolution, 5, following a reference in the Warwick Research Collective's *Combined and Uneven Development,* 6.

29. Bloch, "Nonsynchronism and the Obligation to Its Dialectics," 22.

30. Bloch, "Nonsynchronism and the Obligation to Its Dialectics," 22.

31. Jameson, *Postmodernism,* 307.

32. Jameson, *Postmodernism,* 297–417 and 311, following Lazarus, *The Postcolonial Unconscious,* 109.

33. Jameson, *Postmodernism,* 309. In foregrounding theories of simultaneous nonsimultaneity, I have emphasized the cultural manifestations combined and uneven development, for these resonate strongly with Hildreth's polychronous cartographies.

Still, it is worth noting that this is just one of several overlapping strands of reflection on combined and uneven development in Marxist theory. In a broadly economic register, Neil Smith influentially argued that "uneven development is the systematic geographical expression of the contradictions inherent in the very constitution and structure of captial"; in a political vein, Michel Löwy has emphasized the revolutionary potential latent in situations of unevenness characteristic of "peripheral capitalist countries"; and, in a more cultural register, Bloch and Jameson emphasize how the process of uneven capitalist development gives rise to internally heterogeneous temporalities, as registered and articulated in cultural practice. See Smith, *Uneven Development*, 4; and Löwy, *The Politics of Combined and Uneven Development*, 110.

34. For a critical discussion of Jameson's account of the leveling of temporal difference in postmodern culture, see Lazarus, *The Postcolonial Unconscious*, 109–11.

35. Shakespeare, *The Tempest*, 110.

36. Paolozzi, *Lost Magic Kingdoms*.

37. Früchtl, *Our Enlightened Barbarian Modernity*, 6.

38. Löwy and Sayre, *Romanticism against the Tide of Modernity*, 17 and 21. The periodization that follows from this conceptualization is especially challenging for existing definitions of Romanticism as a historical period. The Romantic "worldview," Löwy and Sayre argue, is "coextensive with capitalism itself," a basic reaction to the modern world system that migrates and develops along with and against it. As such, "the romantic fire *is* still burning." "The Fire is Still Burning," 90.

39. Löwy and Sayre, *Romanticism against the Tide of Modernity*, 21. The Retort Collective makes a similar conceptual move, though in a rather different context, in suggesting that revolutionary Islam, in pursuing what they call its "will-to-go-back" (that is, to restitute a premodern social order), is "a modern phenomenon—even, *especially*, in its wish not to be." See *Afflicted Powers*, 184.

40. These quotations are drawn from a short artist statement on the June Fitzpatrick Gallery's website, which I accessed on February 11, 2013. Since then, the gallery has closed and the website is no longer available.

41. Quoted in Cohen, *Metamorphosis of a Death Symbol*, 34.

42. Sebald, *The Rings of Saturn*, 23.

43. Sebald, *The Rings of Saturn*, 247.

44. Panchasi, *Future Tense*, 4.

45. On the notion of place-world, see Casey, *Getting Back into Place*, iv–xv.

46. See Aujac, Harley, and Woodward, "The Foundations of Theoretical Cartography in Archaic and Ancient Greece."

47. Jean Picard, *The Measure of the Earth*, 3.

48. On mapping in the practice of the absolutist state in seventeenth-century France, see Petto, *When France Was King of Cartography*, especially 57–98. On the history of absolutism more generally, see Anderson, *Lineages of the Absolutist State*.

49. Jorgenson and Kick, "Introduction," 3.

50. Sebald, *The Rings of Saturn*, 23.

51. Kojève, *Introduction of the Reading of Hegel*, 159–60.

52. On the suffering of insects in modernity, see Edgerton, *The Shock of the Old*, 160–83.

53. Horkheimer and Adorno, *Dialectic of Enlightenment*, 4.

54. Schätzing, *The Swarm*.

55. For a critical account of the concept of "nature" in relation to political ecology, see Soper, *What is Nature?* especially 149–79, and Žižek, *Living in the End Times*, 349–52.

56. Williams, *Combined and Uneven Apocalypse*, 149.

3. Drawing Like a State

1. A version of this chapter has been published as a journal article in *Environment and Planning D: Society and Space*. See my "Drawing Like a State." For more images of the *Depictions* than are reproduced here, Kocken has a book forthcoming with Roma.

2. Kocken, *The World According to Gert Jan Kocken*, and Quin, *Historical Atlas*. The magazine series *The World According To . . .* asks artists to become editors, assembling visual materials that reference the concerns and worldview that informs their work.

3. Black, *Maps and Politics*, 154.

4. Bauman, *Legislators and Interpreters*, 51–53.

5. Bauman, *Legislators and Interpreters*, 52.

6. Bauman, *Legislators and Interpreters*, 52.

7. Bauman, *Legislators and Interpreters*, 52.

8. Foucault, *Security, Territory, Population*. For an account of how Bauman's work related to Foucault, see Beilharz, "The Worlds We Create."

9. Bauman, *Legislators and Interpreters*, 28 and 54.

10. Denis Wood gives a remarkable discussion of this literature, arguing that maps fulfilled the "needs of the nascent state to take on form and organize its many interests." *Rethinking the Power of Maps*, 27–35 and 38.

11. Speer, *Inside the Third Reich*.

12. Bauman, *Modernity and the Holocaust*.

13. Harley, "Maps, Knowledge, and Power"; Crampton, *Mapping*, 18.

14. Scott, *Seeing Like a State*, 91.

15. Scott, *Seeing Like a State*, 77.

16. Bauman, *Socialism*, 11.

17. Bauman, *Socialism*, 18.

18. Scott, *Seeing Like a State*, 78.

19. Scott, *Seeing Like a State*, 78.

20. Bauman, *Modernity and the Holocaust*, 92.

21. Kitchen, Perkins, and Dodge, "Thinking About Maps," 4.

22. Corner, "The Agency of Mapping," 213.

23. Elden, "Missing the Point," 14.

24. Elden, *The Birth of Territory*, 291.

25. Bauman, *Legislators and Interpreters*, 67.

26. Elden, "National Socialism and the Politics of Calculation," 764 and 763.

27. Clausewitz, *On War*, 28.

28. Scott, *Seeing Like a State*, 101–2.

29. Bauman, *Modernity and the Holocaust*, 111.

30. Bauman, *Globalisation*, 35–45. On cities in contemporary "liquid modernity," see Bauman, *City of Fears, City of Hopes*, 15–27.

31. Bauman, *Modernity and Ambivalence*, 14. For a discussion of this aspect of Bauman's metaphorics of modernity, see Pinder, *Visions of the City*, 85–86.

32. Bauman, *Modernity and Ambivalence*, 7.

33. As noted in Pinder, *Errant Paths*, 678.

34. de Certeau, *The Practice of Everyday Life*, v.

35. de Certeau, *The Practice of Everyday Life*, 116.

36. de Certeau, *The Practice of Everyday Life*, 84.

37. Kitchin and Dodge, "Rethinking Maps," 335, emphasis in text. On the reiterative character of mapping practices, see also Casino and Hanna, "Beyond the Binaries."

38. Klinkert, "Crossing Borders," 572.

39. The resistive dimension of pedestrianism is qualified in Tonkiss, *Space, the City, and Social Theory*, 132, and Pinder, "Errant Paths," 678.

40. Janack, "Dilemmas of Objectivity," 275.

41. Daston, "Objectivity and the Escape from Perspective," 598.

42. Daston, "Objectivity and the Escape from Perspective," 599.

43. Daston, "Objectivity and the Escape from Perspective," 598.

44. See Daston, "Objectivity and the Escape from Perspective," 607–9.

45. Daston, "Objectivity and the Escape from Perspective," 609.

46. Daston, "Objectivity and the Escape from Perspective," 609.

47. Nagel, *The View from Nowhere*.

48. Daston, "Objectivity and the Escape from Perspective," 599.

49. Daston, "Objectivity and the Escape from Perspective," 607 and 614.

50. See, for example, Haraway, "Situated Knowledges"; Kukla, "Naturalizing Objectivity"; and Wylie, "Feminist Philosophy of Science."

51. Wylie, "Feminist Philosophy of Science," 61. See also Haraway, "Situated Knowledges."

52. Janack, "Dilemmas of Objectivity," 273.

53. Daston, "Objectivity and the Escape from Perspective," 612.

54. Janack, "Dilemmas of Objectivity," 277.

55. For a historical overview of the rationalization of geographical imaginations in modernity, see Harvey, *The Condition of Postmodernity*, 245–54.

56. Daston, "Objectivity and the Escape from Perspective," 598.

57. See AlSayyad and Roy, *Urban Informality*; on urban uncertainties see Zeiderman, Kaker, Silver, and Wood, "Uncertainty and Urban Life"; and on the production of urban disorder, see Mooney, "Urban 'Disorders,'" 65.

58. Bauman and May, *Thinking Sociologically*, 124.

59. Roy, "Urban Informality," 156.

60. Though I acknowledge scholarship that nuances the binary of order and chaos through the third term of complexity (see Hayles, *Chaos and Order*), the totalizing gardening mentalities treated in the *Depictions* require my theorizing their antinomy.

61. Mueller, *The Remnants of War*.

4. Insular Imaginations

1. As translated from the Latin: *Libellus vere aureus, nec minus salutaris quam festivus, de optimo rei publicae statu, deque nova insula Utopia*. Although most scholars abbreviate the title of More's treatise to *Utopia*, I distinguish this work from Matoba's artwork of the same name by referring to it as *On Utopia*.

2. Cosgrove, "Maps, Mapping, Modernity," and Pile and Thrift, *City A–Z: Urban Fragments*.

3. Matoba, "Map of Utopia," xvi.

4. For a discussion of Wilde's statement, see Tally, *Utopia in the Age of Globalization*, 2, and Tuan, "Maps and Art," 19.

5. Watson's artwork is reproduced in Harmon, *The Map as Art*, 45.

6. Wood, *Rethinking the Power of Maps*, 15.

7. A wider range of examples are compiled in Harmon, *You Are Here*, 44–59.

8. On the novel's influence on the Situationist International, see Wark, *The Beach Beneath the Street*, 76. For an analysis of *Map of Tenderness* as a feminist geography, see Bruno, *Atlas of Emotion*, 223–27.

9. Ricardo Padrón, for instance, has argued that "all maps are, in some sense, maps of imaginary worlds." "Mapping Imaginary Worlds," 284.

10. Matoba, "Map of Utopia," xvi.

11. Robert Tally distinguishes modern utopian discourse from classical and premodern antecedents by observing that Plato's *Republic* and Augustine's *City of God* presented "abstract ideals . . . located outside of both space and time," whereas modern utopianism locates its visions in geographical space, such that they might plausibly exist, however distantly. Tally, *Utopia in the Age of Globalization*, 3.

12. Eco, *The Book of Legendary Lands*, 305.

13. More, *Utopia*, 50.

14. Denis Wood remarks that "It's not a quite a map, but it's not quite not a map either." *Rethinking the Power of Maps*, 37.

15. Tally, *Utopia in the Age of Globalization*, 3.

16. Wegner, "Here or Nowhere," 120.

17. Anderson, *Imagined Communities*, 19. On mapping's role in effecting this transition, see Biggs, "Putting the State on the Map."

18. Cameron, "Splendid Isolation," 743, 742. On the role of insular imaginations in historical constructions of statehood, see Balasopoulos, "Nesologies," and Beer, "Island Bounds."

19. Steinberg, "Insularity, Sovereignty and Statehood," 261.

20. Steinberg, "Insularity, Sovereignty and Statehood," 255, 258, emphasis in text.

21. Steinberg, "Insularity, Sovereignty and Statehood," 261.

22. Wegner, "Here or Nowhere," 55.

23. Pickles, *A History of Spaces*, 3 and 5.

24. Cameron, "Ground Zero," 418.

25. Winichakul discusses the concept in *Siam Mapped*, 16–18 and 129–31.

26. Harris, *Foreign Bodies and the Body Politic*, 1.

27. On these distinctions, see Lazarus, *Nationalism and Cultural Practice*, 68–143.

28. Hobsbawm, *Nations and Nationalism*, 133.

29. Jameson, "Notes on Globalization as a Philosophical Issue," 57.

30. Castells, *Rise of the Network Society*, 411.

31. Carincross, *The Death of Distances*, 2 and 5.

32. Building on the "death of distance" thesis, Jeremy Brotton develops a counterintuitive account of the spatialities of globalization. Brotton stresses the significance of "real-time" digital telecommunication technologies, which he takes to compress the terrestrial distances figured forth in global mapping so radically as to render them redundant. On this basis, Brotton argues that at the very moment in which "globalism becomes central to contemporary cultural politics, its geographical referent, the image of the terrestrial globe, becomes a residual signifier." Brotton, "Terrestrial Globalism," 71.

33. Matoba, "Map of Utopia," xvi.

34. Matoba, "Map of Utopia," xvi.

35. Matoba, "Map of Utopia," xv.

36. Gilroy, *The Black Atlantic*, 5.

37. Matoba, "Map of Utopia," xvi.

38. Retort Collective, *Afflicted Powers*, 186.

39. On these anxieties, see Beck, *Risk Society*; Virilio, *The Lost Dimension*; and Bauman, *Liquid Modernity*.

40. On the disorientation brought on by capitalist globalization, see Jameson, *Postmodernism*, 51; on the irregularization of contemporary life and labor, see Bauman, *Liquid Life*, 116–28.

41. For a discussion of ancient myths of autochthony ("the idea that men sprung up fully formed, born of the earth"), see Elden, *The Birth of Territory*, 22–26.

42. Clifford, *Routes*, 3.

43. Okihiro, *Cane Fires*, 185.

44. Elden, "Missing the Point," 11 and 15.

45. Modern borders, for Elden, entail "more than a simple line staked out on the ground." *The Birth of Territory*, 325. Indeed, he asserts more generally that "territory in the modern sense requires a level of cartographic ability that was simply lacking in earlier periods." Elden, "Missing the Point," 15.

46. Elden describes how the Treaty of Tordesillas (1494) divided the globe "from pole to pole" between Spanish and Portuguese claims to colonial possession; the agreements conflated as the treaties of Westphalia (1648) affirmed the authority of subsidiary rulers in the Holy Roman Empire within their territories; and the Treaty of the Pyrenees (1659) delineated exactly the border between France and Spain. Elden, *The Birth of Territory* 241, 309–14, and 325.

47. Elden, "Governmentality, Calculation, Territory," 578.

48. Specifically, Elden cites Paul Virilio's work on the overcoming of space under conditions of globalization. Deleuze and Guattari's casting of the concept, Elden recognizes, is more complex than this. "Missing the Point," 9. For a discussion of theories of contemporary deterritorialization, see Heise, *Sense of Place and Sense of Planet*, 51–58.

49. For Elden's analysis of recent contestation over the prevailing dispensation of territory, see *Terror and Territory*.

50. Elden, "Missing the Point," 8.

51. Elden, "Missing the Point," 16.

52. Elden, "The War of Races and the Constitution of the State," 151.

53. Elden, "Missing the Point," 16.

54. Wood, *Rethinking the Power of Maps*, 37.

5. Cartography at Ground Level

1. Although these formulations are my own, similar distinctions figure in David Woodward's relatively early appraisal of relations between art and cartography, in which he discusses "Art in Maps," "Art as Maps," "Maps in Art," and "Maps as Art"; "Introduction," 3–5. Also recall Denis Wood's definition of map art as "*art* made *as, with,* or *about* maps," *Rethinking the Power of Maps*, 172.

2. Wood, *Rethinking the Power of Maps*, 156.

3. For a clear history and analysis of GPS, see Rankin, "Global Positioning System (GPS)."

4. Pinder, *Errant Paths*, 674.

5. Wood, "Can't Be Elsewhere When GPS Drawing," 268–69.

6. Lauriault, "GPS Tracings," 360.

7. Melville, *Moby Dick*, 56.

8. Klee, *Notebooks*, 105.

9. Lauriault, "GPS Tracings," 360.

10. Lauriault, "GPS Tracings," 361.

11. Wood, "Can't Be Elsewhere When GPS Drawing," 275.

12. Elkins, *On Pictures and the Words that Fail Them*, 273–77.

13. Ackroyd, *London*; for a critique, see Buckhurst, "The Contemporary London Gothic and the Limits of the 'Spectral Turn.'"

14. On von Haussmann's physiological urban metaphors, see Ellin, "Shelter from the Storm or Form Follows Fear and Vice Versa," 18; and Le Corbusier, *La Ville Radieuse*.

15. Bauman, *Globalisation*, 42.

16. For discussions of the power and politics of house and street numbering, see Rose-Redwood, "Indexing the Great Ledger of the Community"; of street naming, see Palonen, "Reading Street Names Politically," and Rose-Redwood, Alderman, and Azaryahu, "Geographies of Toponymic Inscription"; and of urban semiotics, see Jaworksi and Thurlow, *Semiotic Landscapes*.

17. On projects of material reformation aimed at establishing sociospatial transparency, see Scott, *Seeing Like a State*.

18. de Certeau, *The Practice of Everyday Life*, 91–110.

19. de Certeau, *The Practice of Everyday Life*, 92.

20. Turchi, *Maps of the Imagination*, 85.

21. de Certeau, *The Practice of Everyday Life*, 93.

22. Jay, *Downcast Eyes*, subtitle.

23. See Haraway, "Situated Knowledges," especially 581.

24. Harley, *The New Nature of Maps*, 155.

25. Verhoeff, *Mobile Screens*.

26. Crampton, *Mapping*, 40–41.

27. On this hierarchical construction of art and science in cartography, see Cartwright, Gartner, and Lehn, "Maps and Mapping in the Eyes of Artists and Cartographies," 3, and Krygier and Varanka, "Art and Cartography in the Twentieth Century," 78.

28. Harley, *The New Natures of Maps*, 154; for an example of art being allowed a superficial role in cartographic practice, see Robinson, "Cartography as an Art."

29. Wood, *Rethinking the Power of Maps*, 156.

30. Lauriault, "GPS Tracings," 365.

31. Della Dora, "A World of Slippery Maps."

32. On the exploitation of private data, see Michael and Clarke, "Location and Tracking of Mobile Devices"; on networked anklets, see Crampton, *The Political Mapping on Cyberspace*, 130; on the notion of geoslavery, see Fisher and Dobson, "Panopticon's Changing Geography"; and on the spread of targeting rationalities through civilian domains, see Kaplan, "Precision Targets"; for a critique of Kaplan, see Rankin, "Global Positioning System (GPS)," 556.

33. Pickles, *A History of Spaces*, 152.

34. For a discussion of Amsterdam RealTime, see O'Rourke, *Walking and Mapping*, 138–41, and Pinder, "Dis-locative Arts," 527. (I also discuss the work in my review of O'Rourke's book; see Ferdinand, "Review of 'Walking and Mapping,'" 338.)

35. Dorrain, "On Google Earth," 293–94.

36. For fuller descriptions of this ontology, see Harley, *The New Nature of Maps*, 154; Pickles, *A History of Spaces*, 80–86; and Elden, "Missing the Point," 15–16.

37. Derrida, *Specters of Marx*.

38. Peeren, *The Spectral Metaphor*, 3.

39. Peeren, *The Spectral Metaphor*, 10.

40. Derrida, *Of Grammatology*, 75–77.

41. Rankin, "Global Positioning System (GPS)," 557.

42. Dixon, "A Benevolent and Sceptical Inquiry," 204.

43. Prutzer, "Examining Amsterdam RealTime."

44. Martin and Rosello, "Disorientation: An Introduction," 9.

45. Wood, "Can't Be Elsewhere When GPS Mapping," 274–75. An abundance of green in the photography indicates that it was not taken in the season Wood walked the same area.

46. See Malys et al., "Why the Greenwich Meridian Moved."

47. Roberts, "Geography and the Visual Image," 8.

48. Wood, "Can't Be Elsewhere When GPS Mapping," 274.

49. Roberts, "Geography and the Visual Image," 2.

50. Thrift, "Remembering the Technical Unconscious."

51. Thrift, "Remembering the Technical Unconscious," 188.

52. Lauriault, "GPS Tracings," 363.

6. Another *Chorein*

1. Elden takes up these issues in *Mapping the Present*.

2. Gras and Gras, *Peter Greenaway*, 103.

3. Alongside this structuring function, music also figures visually in the cartographies themselves, one of which was "made by an exiled pianist as a directive to the members of his band." "As a cartographer," the narrator goes on, "he was not appreciated in his own country." Inscribed into a musical score sheet, this map recalls drawings by the schizophrenic Swiss artist Adolf Wölfli, in that both collapse the discrete "countries" of geography and musical notation. For discussions of Wölfli and mapping, see Harmon, *You Are Here*, 42–43, and Park, Simpson-Housely, and de Man, "To the Infinite Spaces of Creation."

4. See Pascoe, "Greenaway, the Netherlands, and the Conspiracy of History." Van Hoyten appears as a Dutch landscape designer in Greenaway's next film, *The Draughtsman's Contract* (1982), "waving his arms about" as if "homesick for windmills," as one character puts it.

5. Willoquet-Maricondi and Aleman-Galway write that Greenaway is "one of the most challenging dissident postmodernists of our time"; "Introduction," xxiv. Elliot and Purdy claim that his art constitutes a "postmodern *Gesamtkunstwerk.*" *Peter Greenaway,* 7.

6. Lawrence, *The Films of Peter Greenaway,* 4. On the preeminence of visuality in modernity, see Jay, "Scopic Regimes of Modernity."

7. Elliott and Purdy, *Peter Greenaway,* 270.

8. Woods, *Being Naked Playing Dead,* 22.

9. Willoquet-Maricondi and Aleman-Galway, "Introduction," xv.

10. Quoted in Andrews, "A Walk Through Greenaway," 4.

11. Quoted in Siegert, *Cultural Techniques,* 69.

12. Quoted in Siegert, "The *Chorein* of the Pirate," 8.

13. Quoted in West-Pavlov, *Space in Theory,* 44. In Kristeva's work, *chora* is also connected to an early stage of psychological development, which is tactile, presemiotic, and essentially maternal. For a discussion, see West-Pavlov, *Space in Theory,* 37–61, and Silverman, *The Acoustic Mirror,* 102–5.

14. In translations of Heidegger's work and scholarship on Heidegger, Being (capitalized) signals not ontic beings, but an ontological disclosure.

15. Siegert, "Cultural Techniques," 57.

16. Siegert, "The *Chorein* of the Pirate," 8.

17. Siegert, *Cultural Techniques,* 70.

18. Elden, *The Birth of Territory,* 39.

19. Siegert, "The *Chorein* of the Pirate," 8.

20. For an extended discussion of cartographic metaphors in Borges, see Peters, "Resemblance Made Absolutely Exact."

21. In this, Borges is following Lewis Carroll's precedent in "Sylvie and Bruno Concluded," in which a cartographer boasts of having made a map at a scale of 1:1: "It has never been spread out, yet . . . the farmers objected: they said it would cover the whole country, and shut out the sunlight! So we now use the country itself, as its own map, and I assure you it does nearly as well." Carroll, "Sylvie and Bruno Concluded," 727.

22. Baudrillard, *Simulacra and Simulation,* 2.

23. For a discussion of Borges and Baudrillard's presence in cartographic theory, see Pickles, *A History of Spaces,* 94–96.

24. Crampton, *Mapping,* 18. This point is underscored by the fact that in 1999 Corner was still arguing that map studies had yet to fully come to terms with Baudrillard's suggestion that maps generate geographies two decades after Greenaway's film was released; "The Agency of Mapping," 222.

25. This title refers to the English children's song "goosey, goosey, gander, whither shall I wander?," which is printed below the pictured landscape. The maps' titles often cite bird lore, developing the film's central metaphor of spiritual migration.

26. Perec, *Species of Spaces and Other Pieces*, 11.
27. Although chapter 3 stresses that, in doing so, maps also performatively disclose geographies as extended measurable spaces, this is rarely recognized. Indeed, I have argued that the established conception of space *must* see maps as transparent representations, for to admit their performativity would undermine the authority of official cartography.
28. Henri Lefebvre stresses the coexistence of both mental and material production in his account of the production of social space. For a discussion, see Elden, *Understanding Henri Lefebvre*, 181–85.

Envoi

1. Crampton, *Mapping*, 40.
2. Wood and Krygier, "Critical Cartography," 344.

Bibliography

Ackroyd, Peter. *London: A Biography*. London: Chatto & Windus, 2000.

Adaskina, Natalia, John E. Bowlt, Nicoletta Misler, and Maria Tsantsanoglou, eds. *Spheres of Light—Stations of Darkness: The Art of Solomon Nikritin*. Thessaloniki: State Museum of Contemporary Art, 2004.

Adorno, Theodor W., and Max Horkheimer. *Dialectic of Enlightenment*. Translated by John Cumming. New York: Continuum, 2002.

Albrow, Martin. *The Global Age: State and Society Beyond Modernity*. Stanford CA: Stanford University Press, 1997.

Alpers, Svetlana. *The Art of Describing: Dutch Art in the Seventeenth Century*. Chicago: University of Chicago Press, 1983.

AlSayyad, Nezar, and Ananya Roy, eds. *Urban Informality: Transnational Perspectives from the Middle East, Latin America, and South Asia*. Lanham MD: Lexington, 2004.

Anderson, Benedict. *Imagined Communities: Reflections on the Origin and Spread of Nationalism*. Rev. ed. London: Verso, 2006.

Anderson, Perry. *Lineages of the Absolutist State*. London: New Left, 1974.

Andrews, Nigel. "A Walk Through Greenaway." In *Peter Greenaway: Interviews*, edited by Marguerite Gras and Vernon Gras, 3–5. Jackson: University Press of Mississippi, 2000.

Ang, Ien. "European Reluctance: Notes for a Cultural Studies of the 'New Europe.'" In *Trajectories: Inter-Asia Cultural Studies*, edited by Kuan-Hsing, 76–94. New York: Routledge, 1998.

Appadurai, Arjen. *Modernity at Large: Cultural Dimensions of Globalization*. Public Worlds. Minneapolis: University of Minnesota Press, 1996.

Arias, Santa, and Mariselle Mélendez. "Spaces and the Rhetorics of Power in Colonial Spanish America." In *Mapping Colonial Spanish America: Places and Commonplaces of Identity, Culture, and Experience*, edited by Santa Arias and Mariselle Mélendez, 13–23. Lewisburg PA: Bucknell University Press, 2002.

Aristotle. *Eudemian Ethics*. Books 1, 2, and 8. Translated by Michael Woods. 2nd ed. Clarendon Aristotle Series. Oxford: Oxford University Press, 2005.

Aujac, Germaine, J. B. Harley, and David Woodward. "The Foundations of Theoretical Cartography in Archaic and Ancient Greece." In *History of Cartography, Volume One: Cartography in Pre-historic, Ancient, and Medieval Europe and the Mediterranean*,

edited by J. B. Harley and David Woodward, 130–47. Chicago: University of Chicago Press, 1987.

Aydemir, Murat. "A Reaction to the Früchtl/Bal Debate." *Krisis: Journal for Contemporary Philosophy* 2 (2008): 37–39.

Bakhtin, M. M. *The Dialogic Imagination.* Edited by Michael Holquist. Translated by Caryl Emerson and Michael Holquist. Austin: University of Texas Press, 1990.

Bal, Mieke. "Close-ups and Mirrors: The Return of Close Reading, with a Difference." In *The Practice of Cultural Analysis: Exposing Interdisciplinary Interpretation*, edited by Mieke Bal and Bryan Gonzales, 137–42. Stanford CA: Stanford University Press, 1999.

———. "Introduction." In *The Practice of Cultural Analysis: Exposing Interdisciplinary Interpretation*, edited by Mieke Bal and Bryan Gonzales, 1–14. Stanford CA: Stanford University Press, 1999.

———. *Louise Bourgeois' Spider: The Architecture of Art Writing.* Chicago: University of Chicago Press, 2001.

Balasopoulos, Antonis. "Nesologies: Island Form and Postcolonial Geopoetics." *Postcolonial Studies* 11, no. 1 (2008): 9–26.

Baron, Nick. "Scales of Ambition: The Rise and Fall of Internationalism in Soviet Cartographic Cultural and Practice, from Lenin to Stalin," 1–10. Unpublished paper presented at the Royal Geographical Society and Institute of British Geographers Annual International Conference, London, August 27–30, 2013.

———. "World Revolution and Cartography." In *The History of Cartography, Volume 6: Cartography in the Twentieth Century*, edited by Mark Monmonier, 1766–70. Chicago: University of Chicago Press, 2015.

Barthes, Roland. "The Death of the Author." In *Image Music Text*, translated by Stephen Heath, 142–49. London: Fontana, 1977.

Baudrillard, Jean. *Simulacra and Simulation.* Translated by Sheila Glaser. Michigan: University of Michigan Press, 1981.

Bauman, Zygmunt. *City of Fears, City of Hopes.* London: Goldsmiths College, 2003.

———. *Globalisation: The Human Consequences.* Cambridge: Polity, 2012.

———. *Legislators and Interpreters: On Modernity, Post-Modernity, and Intellectuals.* Cambridge: Polity, 1987.

———. *Liquid Life.* Cambridge: Polity, 2005.

———. *Liquid Modernity.* Cambridge: Polity, 2013.

———. *Modernity and Ambivalence.* Cambridge: Polity, 1993.

———. *Modernity and the Holocaust.* New York: Cornell University Press, 1989.

———. *Socialism: The Active Utopia.* London: George Allen & Unwin, 1976.

Bauman, Zygmunt, and Tim May. *Thinking Sociologically.* Oxford: Blackwell, 2014.

Beck, Ulrich. *Risk Society: Towards a New Modernity.* Translated by Mark Ritter. London: Sage, 1992.

Beer, Gillian. "Island Bounds." In *Islands in History and Representation*, edited by Edmond Smith, 32–42. London: Routledge, 2003.

Beilharz, Peter. "The Worlds We Create: Bauman Meets Foucault, and Some Others." *Budhi: A Journal of Ideas and Culture* 8, no. 1 (2004): 245–62.

Beisha, Han, Qiu Fuke, and Sun Guoqing. *China in Ancient and Modern Maps*. London: Philip Wilson, 1998.

Benjamin, Walter. *Illuminations*. Translated by Harry Zorn. London: Pimlico, 1999.

Berger, John. "Into the Woods." In *The Sublime: Documents of Contemporary Art*, edited by Simon Morley, 125–27. Cambridge MA: MIT Press, 2010.

Berman, Marshall. *All That Is Solid Melts into Air: The Experience of Modernity*. New York: Simon & Schuster, 1982.

Bier, Jess. *Mapping Israel, Mapping Palestine: How Occupied Landscapes Shape Scientific Knowledge*. Cambridge MA: MIT Press, 2017.

Biggs, Micheal. "Putting the State on the Map: Cartography, Territory, and European State Formation." *Comparative Studies in Society and History* 41, no. 2 (1999): 374–411.

Bijker, Wiebe E., Thomas P. Hughes, and Trevor Pinch, eds. *The Social Construction of Technological Systems: New Directions in the Sociology and History of Technology*. Cambridge MA: MIT Press, 2012.

Billig, Micheal. *Banal Nationalism*. London: Sage, 1995.

Bittner, Christian. "Diversity in Volunteered Geographic Information: Comparing Open-StreetMap and Wikimapia in Jerusalem." *GeoJournal* 82 (2017): 887–906.

Bittner, Christian, Georg Glasze, and Cate Turk. "Tracing Contingencies: Analysing the Political in Assemblages of Web 2.0 Cartographies." *GeoJournal* 78 (2013): 935–48.

Black, Jeremy. *Maps and Politics*. Chicago: University of Chicago Press, 1998.

Bloch, Ernst. "Nonsynchronism and the Obligation to Its Dialectics." *New German Critique* 11 (Spring 1977): 22–38.

Blumenberg, Hans. *The Genesis of the Copernican World*. Translated by Robert M. Wallace. Cambridge MA: MIT Press, 1987.

Bonneuil, Christophe, and Jean-Baptise Fressoz. *The Shock of the Anthropocene*. Translated by David Fernbach. London: Verso, 2017.

Borges, Jorges Luis. "On Exactitude in Science." In *A Universal History of Infamy*, translated by Norman Thomas di Giovanni, 131. New York: E. P. Dutton, 1970.

Bowlt, John. E. "Solomon Nikritin: The Old and the New." In *Utopian Reality: Reconstructing Culture in Revolutionary Russia and Beyond*, edited by Christina Lodder, Maria Kokkeri, and Maria Mileeva, 153–68. Boston: Brill, 2013.

Brotton, Jerry. "Google, There's No Such Thing as a Perfect Map of the World." *Guardian*, May 16, 2013. https://www.theguardian.com/commentisfree/2013/may/16/google-no-such-thing-as-perfect-map.

———. *A History of the World in Twelve Maps*. London: Allen Lane, 2012.

———. "Terrestrial Globalism: Mapping the Globe in Early Modern Europe." In *Mappings*, edited by Denis Cosgrove, 71–89. London: Reaktion, 1999.

———. *Trading Territories: Mapping the Early Modern World*. London: Reaktion, 2004.

Bryars, Tim, and Tom Harper. *A History of the Twentieth Century in 100 Maps*. London: British Library, 2014.

Cairncross, Frances. *The Death of Distances: How the Communications Revolution Is Changing Our Lives*. London: Texere, 2001.

Cameron, Angus. "Ground Zero—The Semiotics of the Boundary Line." *Social Semiotics* 21, no. 3 (2011): 417–34.

———. "Splendid Isolation: 'Philosopher's Islands' and the Reimagination of Space." *Geoforum* 43, no. 4 (2012): 741–49.

Carr, Edward Hallett. *The Twilight of the Comintern, 1930–1935*. London: Macmillan, 1982.

Carroll, Lewis. "Sylvie and Bruno Concluded." In *The Complete Illustrated Works of Lewis Carroll*. London: Chancellor, 1982.

Cartwright, William, Georg Gartner, and Antje Lehn. "Maps and Mapping in the Eyes of Artists and Cartographers—Experiences from the International Symposium on Cartography and Art." In *Cartography and Art*, edited by William Cartwright, Georg Gartner, and Antje Lehn, 3–8. Lecture Notes in Geoinformation and Cartography. Berlin: Springer, 2009.

Casey, Edward S. *Getting Back into Place: Towards a Renewed Understanding of the Place-World*. Bloomington: Indiana University Press, 1993.

Casino, Vincent J. del, and Stephen P. Hanna. "Beyond the Binaries: A Methodological Intervention for Interrogating Maps as Representational Practices." *ACME: An International Journal for Critical Geographies* 4, no. 1 (2005): 34–56.

Castells, Manuel. *The Rise of the Network Society*. Malden MA: Blackwell, 1996.

Cerbone, David R. *Understanding Phenomenology*. New York: Routledge, 2014.

Certeau, Michel de. *The Practice of Everyday Life*. Berkeley: University of California Press, 1984.

Clark, T. J. "For a Left with No Future." *New Left Review* 74 (March 2012): 53–75.

Clausewitz, Carl von. *On War*. Translated by Michael Howard and Peter Paret. Oxford: Oxford University Press, 2007.

Clifford, James. *Routes: Travel and Translation in the Late Twentieth Century*. Cambridge MA: Harvard University Press, 1997.

Cohen, Kathleen. *Metamorphosis of a Death Symbol: The Transi Tomb in the Late Middle Ages and the Renaissance*. Berkeley: University of California Press, 1973.

Coleman, David J., Yola Georgiaidou, and Jeff Labor. "Volunteered Geographic Information: The Nature and Motivation of Producers." *International Journal of Spatial Data Infrastructures Research* 4 (2009): 332–58.

Connolly, Daniel K. *The Maps of Matthew Paris: Medieval Journeys through Space, Time, and Liturgy*. Woodbridge UK: Boydell, 2009.

Corner, James. "The Agency of Mapping: Speculation, Critique, and Invention." In *Mappings*, edited by Denis Cosgrove, 213–300. London: Reaktion, 1999.

Cosgrove, Denis. *Apollo's Eye: A Cartographic Genealogy of the Earth in the Western Imagination.* Baltimore: John Hopkins University Press, 2001.

———. "Maps, Mapping, Modernity: Art and Cartography in the Twentieth Century." *Imago Mundi* 57, no. 1 (2005): 35–54.

Cosgrove, Denis, and Veronica della Dora. "Mapping Global War: Los Angeles, the Pacific, and Charles Owens's Pictorial Cartography." *Annals of the Association of American Geographers* 95, no. 2 (2005): 373–90.

Crampton, Jeremy W. *Mapping: A Critical Introduction to Cartography and GIS.* Oxford: Blackwell, 2010.

———. *The Political Mapping of Cyberspace.* Chicago: University of Chicago Press, 2003.

Curnow, Wystan. "Mapping and the Expanded Field of Contemporary Art." In *Mappings*, edited by Denis Cosgrove, 253–68. London: Reaktion, 1999.

Daston, Lorraine. "Objectivity and the Escape from Perspective." *Social Studies of Science* 22, no. 4 (1992): 597–618.

Derrida, Jacques. *Of Grammatology.* Translated by Gyatri Chakravorty Spivak. Baltimore: Johns Hopkins University Press, 2016.

———. *Specters of Marx: The State of the Debt, the Work of Mourning, and the New International.* Translated by Peggy Kamuf. New York: Routledge, 1994.

Dexter, Helen. "New War, Good War, and the War on Terror: Explaining, Excusing, and Creating Western Neo-interventionism." *Development and Change* 38, no. 6 (2007): 1055–71.

D'Ignazio, Catherine. "Art and Cartography." In *International Encyclopaedia of Human Geography*, edited by Rob Kitchin and Nigel Thrift, 190–206. Oxford: Elsevier, 2009.

Dirlik, Arif. "Global Modernity? Modernity in an Age of Global Capitalism." *European Journal of Social Theory* 6, no. 3 (2003): 275–92.

Dixon, Deborah. "A Benevolent and Sceptical Inquiry: Exploring 'Fortean Geographies' with the Mothman." *Cultural Geographies* 14, no. 2 (2007): 189–210.

Dobson Jerome E., and Peter F. Fisher. "Panopticon's Changing Geography." *Geographical Review* 97, no. 3 (2007): 307–23.

Dodge, Martin, Chris Perkins, and Robert Kitchen. "Thinking About Maps." In *Rethinking Maps*, edited by Martin Dodge, Chris Perkins, and Robert Kitchen, 16–23. London: Routledge, 2009.

Domosh, Mona. "Geoeconomic Imaginations and Economic Geography in the Early Twentieth Century." *Annals of the Association of American Geographers* 103, no. 4 (2013): 944–66.

Dora, Veronica della. "A World of Slippy Maps: Google Earth, Global Visions, and Topographies of Memory." *Transatlantica* 2 (2012). https://journals.openedition.org/transatlantica/6156#quotation.

Dorrain, Mark. "On Google Earth." In *Seeing From Above: The Aerial View in Visual Culture*, edited by Mark Dorrian and Frédéric Pousin, 290–308. London: I. B. Tauris, 2013.

Dreyfus, Hubert L. "Heidegger's Ontology of Art." In *A Companion to Heidegger*, edited by Hubert L. Dreyfus and Mark A. Wrathall, 407–19. Oxford: Blackwell, 2005.

Duffy, Christopher. *Siege Warfare: The Fortress in the Early Modern World, 1494–1660*. London: Taylor & Francis, 1979.

Earenfight, Phillip, ed. *Joyce Kozloff: Co+ordinates*. Carlisle PA: Trout Gallery, 2008.

Eco, Umberto. *The Book of Legendary Lands*. Translated by Alisdair McEwen. New York: Rizzoli Ex Libris, 2013.

Edgerton, David. *The Shock of the Old: Technology and Global History Since 1900*. London: Profile, 2008.

Edney, Matthew H. "Cartography Without 'Progress': Reinterpreting the Nature and Historical Development of Mapmaking." *Cartographica* 30, no. 2 (1993): 54–68.

———. "Putting 'Cartography' into the History of Cartography: Arthur H. Robinson, David Woodward, and the Creation of a Discipline." *Cartographic Perspectives* 51 (Spring 2005): 14–29.

Eisenstadt, Shmuel N. "Multiple Modernities." *Daedalus* 129, no. 1 (2000): 1–29.

Elden, Stuart. *The Birth of Territory*. Chicago: University of Chicago Press, 2013.

———. "Governmentality, Calculation, Territory." *Environment and Planning D: Society and Space* 25, no. 3 (2006): 562–80.

———. *Mapping the Present: Heidegger, Foucault, and the Project of a Spatial History*. London: Continuum, 2001.

———. "Missing the Point: Globalization, Deterritorialization, and the Space of the World." *Transactions of the Institute of British Geographers* 30, no. 1 (2005): 8–19.

———. "National Socialism and the Politics of Calculation." *Social and Cultural Geography* 7, no. 5 (2006): 753–69.

———. *Terror and Territory: The Spatial Extent of Sovereignty*. Minneapolis: University of Minnesota Press, 2009.

———. *Understanding Henri Lefebvre: Theory and the Possible*. London: Continuum, 2004.

———. "The War of Races and the Constitution of the State: Foucault's 'Il faut défendre la société' and the Politics of Calculation." *Boundary 2* 29 (2002): 125–51.

Elkins, James. *On Pictures and the Words that Fail Them*. Cambridge: Cambridge University Press, 1998.

Ellin, Nan. "Shelter from the Storm or Form Follows Fear and Vice Versa." In *Architecture and Fear*, edited by Nan Ellin, 13–46. New York: Princeton Architectural Press, 1997.

Elliott, Bridget, and Anthony Purdy. *Peter Greenaway: Architecture and Allegory*. Chichester UK: Academy Editions, 1997.

———. "A Walk Through Heterotopia: Peter Greenaway's Landscapes by Numbers." In *Landscape and Cinema*, edited by Martin Lefebvre, 267–90. New York: Routledge, 2006.

Fairbairn, David. "Rejecting Illusionism: Transforming Space into Maps and into Art." In *Cartography and Art*, edited by William Cartwright, Georg Gartner, and Antje Lehn, 23–33. Lecture Notes in Geoinformation and Cartography. Berlin: Springer, 2009.

Farman, Jason. "Mapping the Digital Empire: Google Earth and the Process of Postmodern Cartography." *New Media & Society* 12, no. 6 (2010): 869–88.

Fensterstock, Lauren. "untitled essay." In *The Feathered Hand: Installation, Drawings, and Prints by Alison Hildreth*. Portland ME: University of New England, 2011.

Ferdinand, Simon. "Drawing Like a State: Maps, Modernity, and Warfare in the Art of Gert Jan Kocken." *Environment and Planning D: Society and Space* 35, no. 2 (2017): 319–38.

———. "On the Untimeliness of Alison Hildreth's Printmaking, 1974–2014." In *Alison Hildreth's Printmaking 1974–2014*, 6–13. Berkeley: Edition One, 2016.

———. "Review of 'For Creative Geographies.'" AntipodeFoundation.org. Accessed January 18, 2017. https://radicalantipode.files.wordpress.com/2014/06/book-review_ferdinand-on-hawkins.pdf.

———. Review of *Walking and Mapping: Artists as Cartographers.* *Cartographica* 48, no. 4 (2013): 337–38.

———. "The Shock of the Whole: Phenomenologies of Global Mapping in Solomon Nikritin's *The Old and the New.*" *GeoHumanities* 2, no. 1 (2016): 220–37.

Foucault, Michel. "Of Other Spaces." Translated by Jay Miskowiec. *Diacritics* 16 (1986): 22–27.

———. *Security, Territory, Population: Lectures at the Collège de France 1977–78.* Translated by Graham Burchell. New York: Palgrave Macmillan, 2009.

Früchtl, Josef. *Our Enlightened Barbarian Modernity and the Project of a Critical Theory of Culture.* Amsterdam: Vossiuspers UVA, 2007.

Gaonkar, Dilip Parameshwar. "On Alternative Modernities." In *Alternative Modernities*, edited by Dilip Parameshwar Gaonkar, 1–23. Durham NC: Duke University Press, 2001.

Garb, Yaakov. "Perspective or Escape? Ecofeminist Musings on Contemporary Earth Imagery." In *Reweaving the World: The Emergence of Ecofeminism*, edited by Irene Diamond and Gloria F. Orenstein, 264–78. San Francisco: Sierra Club, 1990.

Gilroy, Paul. *The Black Atlantic: Modernity and Double Consciousness.* Cambridge MA: Harvard University Press, 1993.

Glacken, Clarence. J. *Traces on the Rhodian Shore: Nature and Culture in Western Thought from Ancient Times to the End of the Eighteenth Century.* Berkeley: University of California Press, 1976.

Glowczewski, Barbara. *Desert Dreamers: With the Warlpiri People of Australia.* Translated by Paul Buck and Catherine Petit. Minneapolis: Univocal, 2016.

Gras, Marguerite, and Vernon Gras, eds. *Peter Greenaway: Interviews.* Jackson: University Press of Mississippi, 2000.

Haraway, Donna. "Situated Knowledges: The Science Question in Feminism and the Privilege of Partial Perspective." *Feminist Studies* 14, no. 3 (Autumn 1988): 575–99.

Harley, John Brian. "Maps, Knowledge, and Power." In *The Iconography of Landscape: Essays on the Symbolic Representation, Design, and Use of Past Environments*, edited by Denis Cosgrove and Stephen Daniels, 277–312. Cambridge: Cambridge University Press, 1988.

———. *The New Nature of Maps: Essays in the History of Cartography*. Baltimore: Johns Hopkins University Press, 2002.

Harley, John Brian, and David Woodward. "Preface." In *History of Cartography. Volume One: Cartography in Pre-historic, Ancient, and Medieval Europe and the Mediterranean*, edited by J. B. Harley and David Woodward, xv–xi. Chicago: University of Chicago Press, 1987.

Harmon, Katherine, ed. *You Are Here: Personal Geographies and Other Maps of the Imagination*. Princeton: Princeton Architectural Press, 2004.

———. *The Map as Art: Contemporary Artists Explore Cartography*. Princeton: Princeton University Press, 2009.

Harris, Jonathan Gil. *Foreign Bodies and the Body Politic: Discourses of Social Pathology in Early Modern England*. Cambridge: Cambridge University Press, 1998.

Harvey, David. *The Condition of Postmodernity: An Enquiry Into the Origins of Cultural Change*. Oxford: Blackwell, 1989.

———. *Spaces of Global Capitalism: Towards a Theory of Uneven Geographical Development*. New York: Verso, 2006.

———. *Spaces of Neoliberalization: Towards a Theory of Uneven Geographical Development*. Edited by Hans Gebhardt, Michael Hoyler, and Peter Meusburger. Hettner-Lectures. Vol. 8. Stuttgart: Franz Steiner Verlag, 2005.

Harvey, P. D. A. *Mappa Mundi: The Hereford World Map*. London: British Library, 1996.

Hawkins, Harriet. *For Creative Geographies: Geography, Visual Arts, and the Making of Worlds*. New York: Routledge, 2013.

Hayles, Katherine, ed. *Chaos and Order: Complex Dynamics in Literature and Science*. Chicago: University of Chicago Press, 1991.

Heidegger, Martin. "The Age of the World Picture." In *Off the Beaten Track*, edited and translated by Julian Young and Kenneth Haynes. Cambridge: Cambridge University Press, 2002.

———. "Being and Time: Introduction." In *Basic Writings*, edited by David Farrell Krell. Translated by Joan Stambaugh with J. Glenn Gray and David Farrell Krell, 37–78. San Francisco: HarperCollins, 1993.

Heise, Ursula K. *Sense of Place and Sense of Planet: The Environmental Imagination of the Global*. Oxford: Oxford University Press, 2008.

Helgerson, Richard. "The Folly of Maps and Modernity." In *Literature, Mapping, and the Politics of Early Modern Britain*, edited by Andrew Gordon and Bernhard Klein, 241–62. Cambridge: Cambridge University Press, 2001.

Bibliography

Hildreth, Alison. "Interview with the Artist for the Thousand Words Project." *Vimeo*. Accessed November 29, 2010. http://vimeo.com/17295269.

Hobsbawm, Eric. *Nations and Nationalism Since 1780: Programme, Myth, Reality*. 2nd ed. Cambridge: Cambridge University Press, 2012.

Holmes, Brian. *Escape the Overcode: Activist Art in the Control Society*. Zabreb: WHW; Eindhoven: Van Abbemuseum, 2009.

Ingold, Tim. *Being Alive: Essays on Movement, Knowledge and Description*. New York: Routledge, 2011.

———. "Globes and Spheres: The Topology of Environmentalism." In *Environmental Anthropology: A Historical Reader*, edited by Michael R. Dove and Carol Carpenter, 462–69. Oxford: Blackwell, 2008.

Jacob, Christian. *The Sovereign Map: Theoretical Approaches in Cartography Throughout History*. Edited by Edward H. Dahl. Translated by Tom Conley. Chicago: University of Chicago Press, 2006.

Jameson, Fredric. "Notes on Globalization as a Philosophical Issue." In *The Cultures of Globalization*, edited by Fredric Jameson and Masao Miyoshi, 54–77. Durham NC: Duke University Press, 1998.

———. *Postmodernism, or, The Cultural Logic of Late Capitalism*. Durham NC: Duke University Press, 1991.

———. *The Seeds of Time*. New York: Columbia University Press, 1994.

Janack, Marianne. "Dilemmas of Objectivity." *Social Epistemology* 16, no. 3 (2002): 267–81.

Jaworksi, Adam, and Crispin Thurlow, eds. *Semiotic Landscapes: Language, Image, Space*. New York: Continuum, 2010.

Jay, Martin. *Downcast Eyes: The Denigration of Vision in Twentieth-Century Thought*. Berkeley: University of California Press, 1993.

———. "Scopic Regimes of Modernity." In *Vision and Visuality*, edited by Hal Foster, 3–23. Seattle: Bay, 1988.

Jazeel, Tariq. "Subaltern Geographies: Geographical Knowledge and Postcolonial Strategy." *Singapore Journal of Tropic Geography* 35, no. 1 (2014): 88–103.

Jobst, Markus. "Marriage and Divorce: Is the Evolution of Landscape Paintings Ending in the Fields of Topographic Cartography and Graphic Design?" In *Cartography and Art*, edited by William Cartwright, Georg Gartner, and Antje Lehn, 43–54. Lecture Notes in Geoinformation and Cartography. Berlin: Springer, 2009.

Jorgenson, Andrew, and Edward Kick. "Introduction." In *Globalization and the Environment*, edited by Andrew Jorgenson and Edward Kick, 13–22. New York: Brill, 2006.

Kamensky, Vassily. *Ego-moia Biographiia Velikogo Futurista*. Moscow: Kitovras, 1918.

Kaplan, Caren. "Precision Targets: GPS and the Militarization of US Consumer Identity." *American Quarterly* 58, no. 3 (2006): 693–714.

Kitchin, Robert, and Martin Dodge. "Rethinking Maps." *Progress in Human Geography* 31, no. 3 (2007): 331–44.

Kitchen, Robert, Chris Perkins, and Martin Dodge. "Thinking about Maps." In *Rethinking Maps*, edited by Robert Kitchen, Chris Perkins, and Martin Dodge, 1–25. London: Routledge, 2009.

Kivelson, Valerie. *Cartographies of Tsardom*. Ithaca NY: Cornell University Press, 2006.

Klee, Paul. *Notebooks*. 3 vols. Edited by Jürg Spiller. London: Lund Humphries, 1961.

Klinkert, Wim. "Crossing Borders: Americans and the Liberation of the Netherlands." In *Four Centuries of Dutch-American Relations: 1609–2009*, edited by Hans Krabbendam, Cornelis A. van Minnen, and Giles Scott-Smith, 565–75. New York: SUNY Press, 2009.

Kocken, Gert Jan, ed. *The World According to Gert Jan Kocken*. Berlin: Argobooks, 2012.

Kojève, Alexandre. *Introduction to the Reading of Hegel*. Edited by Allan Bloom. Translated by James Nichols. New York: Basic, 1968.

Kress, R. Gunther, and Theo van Leeuwen. *Reading Images: The Grammar of Visual Design*. London: Routledge, 2006.

Krygier, John B., and Dalia Varanka. "Art and Cartography in the 20th Century." In *The History of Cartography, Volume Six: Cartography in the Twentieth Century*, edited by Mark Monmonier, 78–84. Chicago: University of Chicago Press, 2015.

Kukla, Rebecca. "Natualizing Objectivity." *Perspectives on Science* 16, no. 3 (2008): 285–302.

Kwan, Mei-Po. "Feminist Visualization: Re-envisioning GIS as a Method in Feminist Geographic Research." *Annals of the Association of American Geographers* 29, no. 4 (2000): 645–61.

Laituri, Melinda. "Equity and Access to GIS for Marginal Communities." In *Community Participation and Geographic Systems*, edited by William J.Craig, Trevor M. Harris, and Daniel Weiner, 270–82. New York: Taylor & Francis, 2002.

Lauriault, Tracy P. "GPS Tracings: Personal Cartographies." *Cartographic Journal* 46, no. 4 (2009): 360–65.

Lawrence, Amy. *The Films of Peter Greenaway*. Cambridge: Cambridge University Press, 1997.

Lazarus, Neil. *Nationalism and Cultural Practice in the Postcolonial World*. Cambridge: Cambridge University Press, 1999.

———. *The Postcolonial Unconscious*. Cambridge: Cambridge University Press, 2011.

———. "Vivek Chibber and the Spectre of Postcolonial Theory." *Race & Class* 57, no. 3 (2016): 88–106.

Lazier, Benjamin. "Earthrise; or, the Globalization of the World Picture." *American Historical Review* 116, no. 3 (2011): 602–30.

Le Corbusier. *La Ville Radieuse*. Boulogne: Editions de l'Architecture d'Aujourd'hui, 1935.

London, Kurt. "The Seven Soviet Arts" [1937, extract]. In *Spheres of Light—Stations of Darkness: The Art of Solomon Nikritin*, edited by Natalia Adaskina, John E. Bowlt, Nicoletta Misler, and Maria Tsantsanoglou, 381–84. Thessaloniki: State Museum of Contemporary Art, 2004.

Löwy, Michael. *The Politics of Combined and Uneven Development: The Theory of Permanent Revolution*. Chicago: Haymarket, 2010.

Löwy, Michael, and Robert Sayre. "The Fire Is Still Burning: A Response to Michael Ferber." In *Spirits of Fire: English Romantic Writers and Contemporary Historical Methods*, edited by G. A. Rosso and Daniel P. Watkins, 85–91. London: Associated University Presses, 1990.

———. *Romanticism against the Tide of Modernity*. Translated by Catherine Porter. Durham NC: Duke University Press, 2001.

Luckhurst, Roger. "The Contemporary London Gothic and the Limits of the 'Spectral Turn.'" *Textual Practice* 16, no. 3 (2002): 527–46.

Malys, Stephen, John H. Seago, Nikolaos K. Pavlis, P. Kenneth Seidelmann, and George H. Kaplan. "Why the Greenwich Meridian Moved." *Journal of Geodesy* 89, no. 12 (2015): 1263–72.

Martin, Niall, and Mireille Rosello. "Disorientation: An Introduction." *Culture, Theory, and Critique* 57, no. 1 (2016): 1–16.

Massey, Doreen. "A Global Sense of Place." *Marxism Today* 38 (1991): 24–29.

Matoba, Satomi. "Map of Utopia." In *City A–Z: Urban Fragments*, edited by Steve Pile and Nigel Thrift, xv–xvi. New York: Routledge, 2000.

McKenzie, Stephen. "The Westward Progression of History on Medieval Mappaemundi: An Investigation of the Evidence." In *The Hereford World Map: Medieval World Maps and Their Context*, edited by P. D. A. Harvey, 335–44. London: British Library, 2006.

McMaster, Robert, and Susanna McMaster. "A History of Twentieth-Century American Academic Cartography." *Cartography and Geographic Information Science* 29, no. 3 (2002): 305–21.

Melville, Herman. *Moby Dick*. Ware: Wordsworth Editions, 1992.

Michael, Katina, and Roger Clarke. "Location and Tracking of Mobile Devices: Überveillances Stalks the Streets." *Computer Law & Security Review* 29, no. 3 (2013): 216–28.

Mogel, Lize, and Alexis Bhagat. "Introduction." In *An Atlas of Radical Cartography*, edited by Lize Mogel and Alexis Bhagat, n.p. Los Angeles: Journal of Aesthetics and Protest, 2007.

Mooney, Gerry. "Urban 'Disorders.'" In *Unruly Cities? Order/Disorder*, edited by Steve Pile, Chris Brook, and Gerry Mooney, 49–95. London: Routledge, 2005.

More, Thomas. *Utopia*. In *Three Early Modern Utopias*, edited by Susan Bruce and translated by Ralph Robinson, 1–148. Oxford: Oxford University Press, 2008.

Moretti, Franco. "Conjectures on World Literature." *New Left Review* 1 (January 2000): 54–68.

Mueller, John. *The Remnants of War*. Ithaca NY: Cornell University Press, 2004.

Nagel, Thomas. *The View from Nowhere*. Oxford: Oxford University Press, 1986.

Nash, Catherine. "Mapping Emotion: Longing and Location in the Work of Kathy Prendergast." In *Essays on Irish and Scottish Art and Visual Culture*, edited by Fintan Cullen and John Morrison, 225–53. Aldershot UK: Ashgate, 2005.

———. "Reclaiming Vision: Looking at Landscape and the Body." *Gender, Place & Culture: A Journal of Feminist Geography* 3, no. 2 (1996): 149–69.

Nietzsche, Friedrich. *Beyond Good and Evil/On the Genealogy of Morality*. Translated by Adrian Del Caro. The Complete Works of Friedrich Nietzsche. Vol. 8. Stanford CA: Stanford University Press, 2014.

———. *The Gay Science*. Translated by Josefine Nauckhoff and Adrian Del Caro. Cambridge Texts in the History of Philosophy. Cambridge: Cambridge University Press, 2001.

Norden, John. *Sepculum Britainniæ: An Historical and Chorographical Description of Middlesex and Hartfordshire*. London: Eliot's Court, 1653.

November, Valérie, Eduardo Camacho-Hubner, and Bruno Latour. "Entering a Risky Territory: Space in the Age of Digital Navigation." *Environment and Planning D: Society and Space* 28 (2010): 581–99.

Okihiro, Gary. *Cane Fires: The Anti-Japanese Movement in Hawaii, 1865–1945*. Philadelphia: Temple University Press, 1992.

O'Rourke, Karen. *Walking and Mapping: Artists as Cartographers*. Cambridge MA: MIT Press, 2013.

Padrón, Ricardo. "Mapping Imaginary Worlds." In *Maps: Finding Our Place in the World*, edited by James R. Ackerman and Robert W. Karrow Jr., 255–87. Chicago: University of Chicago Press, 2007.

Palma, Vittoria Di. "Zoom: Google Earth and Global Intimacy." In *Intimate Metropolis: Urban Subjects in the Modern City*, edited by Vittoria Di Palma, Diana Periton, and Marina Lathouri, 239–70. London: Routledge, 2009.

Palonen, Kari. "Reading Street Names Politically." In *Reading the Political: Exploring the Margins of Politics*, edited by Kari Palonen and Tuija Parvikko, 103–21. Tampere: Finnish Political Science Association, 1993.

Panchasi, Roxanne. *Future Tense: The Culture of Anticipation in France between the Wars*. Ithaca NY: Cornell University Press, 2009.

Paolozzi, Eduardo. *Lost Magic Kingdoms and Six Paper Moons from Nahuatl*. London: British Museum, 1985.

Park, Deborah Carter, Paul Simpson-Housley, and Anton de Man. "To the 'Infinite Spaces of Creation': The Interior landscape of a Schizophrenic Artist." *Annals of the Association of American Geographers* 84, no. 2 (1994): 192–209.

Parker, Geoffrey. *The Military Revolution: Military Innovation and the Rise of the West, 1500–1800*. Cambridge: Cambridge University Press, 1988.

Parsons, Cóilín. "Mapping the Globe: Gulam Mohammed Sheikh's Postcolonial Mappae Mundi." *English Language Notes* 52, no. 2 (2014): 185–94.

Pascoe, David. "Greenaway, the Netherlands, and the Conspiracy of History." In *Peter Greenaway's Postmodern/Poststructuralist Cinema*, edited by Paula Willoquet-Maricondi and Mary Aleman-Galway. Lanham MD: Scarecrow, 2008.

Peeren, Esther. *The Spectral Metaphor: Living Ghosts and the Agency of Invisibility*. Basingstoke UK: Palgrave, 2014.

Perec, George. *Species of Spaces and Other Pieces*. Translated by John Sturrock. London: Penguin, 1997.

Peters, John Durham. "Resemblance Made Absolutely Exact: Borges and Royce on Maps and Media." *Variaciones Borges* 25 (2008): 1–21.

Petto, Christine Marie. *When France Was King of Cartography*. Plymouth UK: Lexington, 2007.

Picard, Jean. *The Measure of the Earth: Being an Account of Several Observations Made for That Purpose by Diverse Members of the Royal Academy of Science at Paris*. Translated by Richard Waller. London: R. Roberts, 1687.

Pickles, John. *A History of Spaces: Cartographic Reason, Mapping, and the Geo-coded World*. London: Routledge, 2004.

Pinder, David. "Cartographies Unbound." *Cultural Geographies* 14, no. 3 (2007): 1–10.

———. "Dis-locative Arts: Mobile Media and the Politics of Global Positioning." *Continuum: Journal of Media & Cultural Studies* 27, no. 4 (2013): 523–41.

———. "Errant Paths: The Poetics and Politics of Walking." *Environment and Planning D: Society and Space* 29, no. 4 (2011): 672–92.

———. "Subverting Cartography: the Situationist and Maps of the City." *Environment and Planning A* 28, no. 3 (1996): 405–28.

———. *Visions of the City: Utopianism, Power, and Politics in Twentieth-Century Urbanism*. New York: Routledge, 2005.

Poiani, Thiago Henrique, Roberto Dos Santos Rocha, Castro Livia Degrossi, and Joao Porto de Albuquerque. "Potenital of Collaborative Mapping for Disaster Relief: A Case Study of OpenStreetMap in the Nepal Earthquake 2015." In *49 Hawaii International Conference on System Sciences*, edited by Jay F. Nunamaker Jr. and Robert O. Briggs, 188–97. Hawaii: IEEE Conference, 2016.

Prutzer, Ned. "Examining Amsterdam RealTime: Blueprints, the Cartographic Imaginary and the Locative Uncanny." *InVisible Culture: An Electric Journal for Visual Culture* 23 (2015). http://ivc.lib.rochester.edu/examining-amsterdam-realtime-blueprints-the-cartographic-imaginary-and-the-locative-uncanny/.

Quin, Edward. *Historical Atlas, from the Creation to AD*. London: Seeley Burnside, 1830.

Ramaswamy, Sumathi. *Terrestrial Lessons: The Conquest of the World as Globe*. Chicago: University of Chicago Press, 2017.

Rankin, William. "Global Positioning System (GPS)." In *The History of Cartography, Volume Six: Cartography in the Twentieth Century*, edited by Mark Monmonier, 551–58. Chicago: University of Chicago Press, 2015.

Rees, Ronald. "Historical Links between Cartography and Art." *Geographical Review* 70, no. 2 (1980): 60–78.

Retort Collective. *Afflicted Powers: Capital and Spectacle in a New Age of War.* Rev. ed. New York: Verso, 2006.

Roberts, Elisabeth. "Geography and the Visual Image: A Hauntological Approach." *Progress in Human Geography* 37, no. 3 (2012): 386–402.

Robinson, Arthur H. "Cartography as an Art." In *Cartography Past, Present, and Future: A Festschrift for F. J. Ormeling,* edited by David Rhind, David Ruxton, and Fraser Taylor, 91–102. London: Elsevier Applied Science, 1989.

Rose, Gillian. "Distance, Surface, Elsewhere: A Feminist Critique of the Space of Phallocentric Self/knowledge." *Environment and Planning D: Society and Space* 13, no. 6 (1995): 761–81.

——. *Feminism and Geography: The Limits of Geographical Knowledge.* Oxford: Polity, 1993.

Rose-Redwood, Ruben. "Indexing the Great Ledger of the Community: Urban House Numbering, City Directories, and the Production of Spatial Legibility." *Journal of Historical Geography* 34, no. 2 (2008): 286–310.

Rose-Redwood, Ruben, Derek Alderman, and Maoz Azaryahu. "Geographies of Toponymic Inscription: New Directions in Critical Place-Name Studies." *Progress in Human Geography* 34, no. 4 (2010): 453–70.

Roy, Ananya. "Urban Informality: Toward an Epistemology of Planning." *Journal of the American Planning Association* 71, no. 2 (2005): 147–58.

Schätzing, Frank. *The Swarm: A Novel of the Deep.* Translated by Sally-Ann Spencer. London: Hodder & Stroughton, 2004.

Scott, James C. *Seeing Like a State: How Certain Schemes to Improve the Human Condition Have Failed.* New Haven CT: Yale University Press, 1998.

Sebald, W. G. *Austerlitz.* Translated by Anthea Bell. London: Penguin, 2002.

——. *The Rings of Saturn.* Translated by Michael Hulse. London: Vintage, 2002.

Shakespeare, William. *The Tempest* [1611]. London: Penguin, 1968.

Siegert, Bernhard. "The *Chorein* of the Pirate: On the Origin of the Dutch Seascape." *Grey Room* 57 (2014): 6–23.

——. *Cultural Techniques: Grids, Filters, Doors, and Other Articulations of the Real.* Translated by by Geoffrey Winthrop-Young. New York: Fordham University Press, 2015.

——. "Cultural Techniques: Or the End of the Intellectual Postwar Era in German Media Theory." *Theory, Culture & Society* 30, no. 6 (2013): 48–65.

Silverman, Kaja. *The Acoustic Mirror: The Female Voice in Psychoanalysis and Cinema.* Bloomington: Indiana University Press, 1988.

Sloterdijk, Peter. "Forward to the Theory of Spheres." In *Cosmograms,* edited by Melik Ohanian and Jean-Christophe Royoux, 223-40. New York: Lukas & Sternberg, 2005.

———. *Globes: Macrospherology*. Translated by Wieland Hoban. *Spheres*. Vol. 2. Foreign Agents. South Pasadena CA: Semiotext(e), 2014.

———. "Nearness and *Da-sein*: The Spatiality of Being and Time." Translated by Peer Illner. *Theory, Culture and Society* 29, no. 4 (2012): 36–42.

Smirnov, Andrey. *Sound in Z: Experiments in Sound and Electronic Music in Early Twentieth-Century Russia*. Berlin: Koenig, 2013.

Smith, Neil. *Uneven Development: Nature, Capital, and the Production of Space*. Athens: University of Georgia Press, 2010.

Smith, Paul. *Millennial Dreams: Contemporary Culture and Capital in the North*. New York: Verso, 1997.

Soper, Kate. *What Is Nature?* Oxford: Blackwell, 2000.

Speer, Albert. *Inside the Third Reich: Memoirs by Albert Speer*. Translated by Clara Winston and Richard Winston. New York: Macmillan, 1970.

Steinberg, Philip E. "Insularity, Sovereignty, and Statehood: The Representation of Islands on Portolan Charts and the Construction of the Territorial State." *Geografiska Annaler: Series B, Human Geography* 87, no. 4 (2005): 253–65.

Steiner, George. *Heidegger*. Glasgow: Fontana, 1982.

Szerszynski, Bronislaw, and John Urry. "Cultures of Consumption." *Sociological Review* 50, no. 4 (2002): 466–68.

Tally, Robert T., Jr. *Spatiality*. New York: Routledge, 2013.

———. *Utopia in the Age of Globalization: Space, Representation, and the World System*. New York: Palgrave Macmillan, 2013.

Thompson, E. P. "Time, Work-Discipline, and Industrial Capitalism." *Past & Present* 38 (1967): 56–97.

Thrift, Nigel. "Remembering the Technological Unconscious by Foregrounding Knowledges of Position." *Environment and Planning D. Society and Space* 22, no. 1 (2004): 175–90.

Thrower, Norman J. *Maps and Civilization: Cartography in Culture and Society*. Chicago: University of Chicago Press, 2008.

Tirado, Isabel A. "Nietzschean Motifs in the Komsomol's Vanguardism." In *Nietzsche and Soviet Culture: Ally and Adversary*, edited by Bernice Glatzer Rosenthal, 235–55. Cambridge: Cambridge University Press, 1994.

Tonkiss, Fran. *Space, the City, and Social Theory: Social Relations and Urban Forms*. Oxford: Polity, 2005.

Toscano, Alberto, and Jeff Kinkle. *Cartographies of the Absolute*. Alresford UK: Zero, 2015.

Trotsky, Leon. "The First Five Years of the Communist International Volume 1: May Day and the International." Trotsky Internet Archive. Accessed October 23, 2013. https://goo.gl/KCTX87.

———. *History of the Russian Revolution*. Translated by Max Eastman. Chicago: Haymarket, 2008.

Tuan, Yi-Fu. "Maps and Art: Identity and Utopia." In *World Views: Maps and Art*, edited by Robert Silberman, 10–25. Minneapolis: University of Minnesota Press, 2000.

Turchi, Peter. *Maps of the Imagination: The Writer as Cartographer*. San Antonio: Trinity University Press, 2004.

Varanka, Dalia. "Interpreting Map Art with a Perspective Learned from J. M. Blaut." *Cartographic Perspectives* 53 (Winter 2006): 15–23.

Verhoeff, Nanna. *Mobile Screens: The Visual Regime of Navigation*. Amsterdam: Amsterdam University Press, 2012.

Virilio, Paul. *The Lost Dimension*. Translated by Daniel Moshenberg. New York: Semiotext(e), 1991.

Vujosevic, Tijana. "The Flying Proletarian: Soviet Citizens at the Thresholds of Utopia." *Grey Room* 59 (2015): 78–101.

Wallerstein, Immanuel. "The Inventions of TimeSpace Realities: Towards an Understanding of Our Historical Systems." *Geography* 73, no. 4 (1988): 289–97.

Warf, Barney. *Time-Space Compression: Historical Geographies*. London: Routledge, 2008.

Wark, McKenzie. *The Beach beneath the Street: The Everyday Life and Glorious Times of the Situationist International*. New York: Verso, 2011.

Watson, Ruth. "Mapping and Contemporary Art." *Cartographic Journal* 46 (2009): 293–307.

Weber, Max. *Sociology of Religion*. Translated by Ephraim Fischoff. Boston: Beacon, 1963.

Wegner, Phillip E. "Here or Nowhere: Utopia, Modernity, and Totality." In *Utopia Method Vision: The Use Value of Social Dreaming*, edited by Tom Moylan and Raffaella Baccolini, 113–29. Bern: Peter Lang, 2007.

West-Pavlov, Russell. *Space in Theory: Kristeva, Foucault, Deleuze*. Amsterdam: Rodopi, 2009.

Williams, Evan Caldor. *Combined and Uneven Apocalypse: Luciferian Marxism*. Ropley UK: Zero, 2011.

Willoquet-Maricondi, Paula, and Mary Aleman-Galway. "Introduction: A Postmodern/Poststructuralist Cinema." In *Peter Greenaway's Postmodern/Poststructuralist Cinema*, edited by Paula Willoquet-Maricondi and Mary Aleman-Galway, xiii–xxv. Lanham MD: Scarecrow, 2008.

Winichakul, Thongchai. *Siam Mapped: A History of the Geo-Body of a Nation*. Honolulu: University of Hawaii Press, 1994.

Wood, Denis. "Cartography is Dead (Thank God!)." *Cartographic Perspectives* 45 (Spring 2003): 4–7.

———. "Map Art." *Cartographic Perspectives* 53 (Winter 2006): 5–14.

———. *Rethinking the Power of Maps*. New York: Guilford, 2010.

Wood, Denis, and John Krygier. "Critical Cartography." In *International Encyclopaedia of Human Geography*, edited by Nigel Thrift and Rob Kitchin, 340–44. Oxford: Elsevier, 2009.

Wood, Jeremy. "Skywriting" and "Can't Be Elsewhere When GPS Drawing." In *Else/Where Mapping: New Cartographies of Networks and Territories*, edited by Janet Abrams and Peter Hall, 268–75. Minneapolis: University of Minnesota Design Institute, 2006.

Woods, Alan. *Being Naked Playing Dead: Art of Peter Greenaway*. Manchester: Manchester University Press, 1996.

Woodward, David. "Introduction." In *Art and Cartography: Six Historical Essays*, edited by David Woodward, 1–9. Chicago: University of Chicago Press, 1987.

———. "Maps and the Rationalisation of Geographic Space." In *Circa 1492: Art in the Age of Exploration*, edited by Jay A. Levenson, 83–87. New Haven CT: Yale University Press, 1991.

WREC (Warwick Research Collective). *Combined and Uneven Development: Towards a New Theory of World-Literature*. Liverpool: Liverpool University Press, 2015.

Wylie, Alison. "Feminist Philosophy of Science: Standpoint Matters." *Proceedings and Addresses of the American Philosophical Association* 86, no. 2 (November 2012): 47–76.

Young, Julian. *Heidegger's Philosophy of Art*. Cambridge: Cambridge University Press, 2001.

Zeiderman, Austin, Sobia Ahmad Kaker, Jonathan Silver, and Astrid Wood. "Uncertainty and Urban Life." *Public Culture* 27, no. 2 (2015): 281–304.

Žižek, Slavoj. *Living in the End Times*. London: Verso, 2010.

Zook, Matthew, Mark Graham, Taylor Shelton, and Sean Gorman. "Volunteered Geographic Information and Crowdsourcing Disaster Relief: A Case Study of the Haitian Earthquake." *World Medical & Health Policy* 2, no. 2 (2010): 7–33.

Index

Page numbers in italic indicate illustrations

map art, 5–6, 7, 9, 10–11, 12, 13–14, 26, 30–31, 67, 105, 110, 143–44, 145–46, 177–79, 210–11, 225, 243–47; definition of, 6, 249n4; and digitization, 12, 22, 31–32, 34, 175, 180, 193, 204, 209; scholarly accounts of, 30–31, 254n90, 254n92; specificity of, 11, 13, 31–32, 34, 193–94, 204, 208, 227

The Map Is Not the Territory, 145, 212

Map of Tenderness (de Scudéry), 25, *147*, 148

Map of Utopia (Matoba), 145, 146, 148, 149, 162, 165, 170, 174, 175

mappamundi, 14, 71, 72

mapping: allegorical, 146, 148; digital, 6, 9, 13, 18–24, 34, 139, 175, 184–85, 191–97; global, 10, 37–65, 244, 249n1, 262n32; instinct, 7; paradigms, 18, 24, 181, 201, 205, 219, 243; performative, 13, 16, 25, 34, 35, 107, 122, 124, 143, 149, 155–57, 172, 178, 180, 209–10, 222–23, 224, 227–28, 232, 235, 236, 239–41, 243, 244, 267n27; and planning, 118–24; as a spatial practice, 130

MapQuest, 21

maps: in advertising, 24; ancient and premodern, 14; annotations on, 19, 105, 107, 124–26, 130, 134, 222, 236; and capitalism, 9, 250n23; in cartoons, 24, 157–59, 253n77; choropleth, 70; cinematic, 208, 211–16, 222, 224, 232; and colonialism, 4, 6, 9, 16, 72, 250n23; in computer games, 25; in corporate icons, 24, 253–54n77; decoration of, 252, 46; feminist, 2, 55, 148; of imaginary worlds, 25, 34, 146–49, 254n77; insets in, 2, 16; of literary lands, 25, 148; and masculinism, 5, 6, 25, 134–35, 148; materiality of, 90, 235–36; military, 4, 70, 105–7, 124–28; in modern

history, 4; origins in the modern state, 9, 15, 26, 250n22, 251n38, 259n10; on postcards, 24, 157–59, 253n77; and secularization, 9, 250n23; of the self, 25; on television, 24, 25; universality of, 14; of the world, 1, 2, 4, 5, 23, 24, 32, 43, 71–72

Martin, Niall, 196

Matoba, Satomi, 33–34, *142*, 143–75, 177, 211, 212, 239, 241, 244, 246; *Asian Archipelago*, 146; *Map of Utopia*, 145, 148, 149, 162, 165, 170, 174, 175; other works by, 146; *Shores of a River*, 161, 162–66, 167, 169, 171, 174, 212; *Utopia*, 33–34, *142*, 143, 144, 145, 149–69, 170–77, 212, 239, 241, 244, 246

Melville, Herman, 200, 201; *Moby Dick*, 183, 197

memento mori tradition, 84, 91

Mercator projection, 23

Meridians (Wood), 34, 180, 181, 183, 190, 194, 196–204, 209, 218, 219, 228, 246

Microsoft, 21

migration, 166, 168–69; avian, 214–15, 266n25

Ming empire, 72

Moby Dick (Melville), 183, 197

modernism, 10, 40, 43, 53, 58, 64, 83, 138, 183, 186, 218, 244; and collage, 76; and truth, 23, 217–18

modernity: conceived as multiple, 8; and ecological crisis, 96, 98–99, 102–3; European, 8; global, 4, 5, 7–10, 11, 13, 14, 15, 29–31, 107, 144, 243, 244; liquid, 167, 196; and representational function, 14–15, 173; Romantic rejection of, 85–93; spatial character of, 40; and the state, 106–7, 110–24, 126–28, 132, 252n45

modernization, 49, 52, 82; Soviet, 32, 38

In the Cultural Geographies + Rewriting the Earth series

Topoi/Graphein: Mapping the Middle in Spatial Thought
Christian Abrahamsson
Foreword by Gunnar Olsson

Mapping Beyond Measure: Art, Cartography,
and the Space of Global Modernity
Simon Ferdinand

Psychoanalysis and the GlObal
Edited and with an introduction by Ilan Kapoor

To order or obtain more information on these or other
University of Nebraska Press titles, visit nebraskapress.unl.edu.

CPSIA information can be obtained
at www.ICGtesting.com
Printed in the USA
LVHW090022051119
636192LV00005BA/54/P

9 781496 212115